D0891794

Italian Drawings 1780-1890

Italian Drawings 1780-1890

by Roberta J. M. Olson

Indiana University Press

Bloomington and London

The American Federation of Arts

New York

NC
255
.042

Olson, Roberta J. M.

Italian drawings,
1780-1890

741.945 05

The exhibition and publication have been supported by a grant
from the National Endowment for the Arts. Additonal support
for the publication was contributed by The Drawing Society,
Inc., New York.

MUSEUMS PARTICIPATING IN THE TOUR

National Gallery of Art, Washington
March 16–May 11, 1980

The Minneapolis Institute of Arts
July 11–September 7, 1980

The Fine Arts Museums of San Francisco
California Palace of the Legion of Honor
November 8–January 4, 1981

THE AMERICAN FEDERATION OF ARTS

The American Federation of Arts is a national, non-profit,
educational organization, founded in 1909, to broaden the
knowledge and appreciation of the arts of the past and pres-
ent. Its primary activities are the organization of exhibitions
which travel throughout the United States and abroad, and
the fostering of a better understanding among nations by the
international exchange of art.

Copyright © 1980
The American Federation of Arts

Published by The American Federation of Arts
41 East 65th Street
New York, N.Y. 10021

Clothbound edition published by Indiana University Press 1980
in association with The American Federation of Arts

NC255.042 741.945'074'013 79.9648
 79.91608 (pbk.)
ISBN 0-253-11963-4
ISBN 0-917418-64-6 (pbk.) 1 2 3 4 5 84 83 82 81 80

AFA Exhibition 80-2
Circulated March, 1980–January, 1981

Designed by Pauline DiBlasi
Type set by Finn Typographic Service, Inc., Stamford, Connecticut
Printed by Eastern Press, Inc., New Haven, Connecticut

DABNEY LANCASTER LIBRARY
LONG COLLEGE
FARMVILLE. VIRGINIA 23901

Foreword

As Dr. Roberta J. M. Olson, Guest Curator of this exhibition and author of its catalogue, has pointed out, it is only in recent years that scholars, outside of Italy, have focused attention on nineteenth-century Italian art. Prior to that time, work of that period was over-shadowed by interest in Italian art of previous centuries, and both misunderstood and underrated in the United States.

It is, therefore, with particular pride that The American Federation of Arts has undertaken the organization of this exhibition, the first selective exploration of Italian drawings of the nineteenth century. Over the last three and one-half years, Dr. Olson has traveled to Italy several times to research the subject and to select and arrange for the specific drawings to be included.

The one hundred and two works included in the exhibition vary both in media and subject—landscapes, genre scenes, mythologies and portraits of historic figures—and are executed in pen and ink, graphite, watercolor and pastel. The sixty-three artists represented are not generally well known. However, notable works by Appiani, Canova, Pinelli, Fattori, Boldini, Segantini and others are included. Approximately one-half of the works have been borrowed from important Italian museum collections; the remaining half have been drawn from both public and private collections within the United States, which will hopefully help to reveal the rich holdings of art of this period in this country.

We are indebted to many individuals and organizations which have made this project possible. First and foremost, we are deeply appreciative of the thorough research and scholarship of Dr. Roberta J. M. Olson, Assistant Professor of Art, Wheaton College, Norton, Massachusetts. Her initial trip to Italy to research this particular exhibition was supported by The Drawing Society, Inc., to whom we express our thanks. Others to whom we are indebted have provided informative essays on the particular Italian museum collections from which drawings have been loaned. They include: Dottoressa Mercedes Precerutti-Garberi of the Civico Gabinetto dei Disegni, Castello Sforzesco, Milan; Dottoressa Anna Forlani Tempesti of the Gabinetto Disegni e Stampe degli Uffizi, Florence, and Dottoressa Enrichetta Beltrame-Quattrocchi of the Gabinetto Nazionale delle Stampe, Rome. Unfortunately, an essay by Dottore Stefano Susinno of the Galleria Nazionale d'Arte Moderna, Rome arrived too late to be included in this publication.

Many on the staff of The American Federation of Arts have been instrumental in bringing the exhibition and publication to fruition: Jane Tai coordinated the exhibition and its catalogue; Konrad Kuchel negotiated the loans to the exhibition; Susanna D'Alton scheduled the tour; Mary Ann Monet and Fran Falkin proofread the manuscript; Melissa Meighan and Carol O'Biso attended

80— 3207

to the safety of the works while under AFA's care, and Pauline DiBlasi designed the catalogue. To all of them I express my deep appreciation and respect.

Without the generosity of all the lenders to this exhibition, it would, of course, have been impossible to realize. We are particularly indebted to four Italian museums: Civico Gabinetto dei Disegni, Castello Sforzesco, Milan; Gabinetto Disegni e Stampe degli Uffizi, Florence; Gabinetto Nazionale delle Stampe, Rome, and Galleria Nazionale d'Arte Moderna, Rome. Added to these Italian sources, we must acknowledge with appreciation the American museums and private collectors who have allowed us to include their works.

All three of the American museums presenting this exhibition have made the continuous collecting and exhibiting of drawings an integral and important part of their program: the National Gallery of Art, Washington; the Achenbach Foundation for Graphic Arts, Department of Prints and Drawings of The Fine Arts Museums of San Francisco and The Minneapolis Institute of Arts.

Finally, we wish to thank the National Endowment for the Arts for its generous support of the exhibition and publication.

Wilder Green, *Director*
The American Federation of Arts

Preface

The field of Italian nineteenth-century scholarship has been long ignored or pursued dilettantishly. It is now being re-evaluated and documented by a new generation of interested scholars. Museums are mounting exhibitions and displaying nineteenth-century Italian works which have long been neglected in storage. Just as Italian nineteenth-century art was the result of a national self-consciousness during the Risorgimento (the nineteenth-century movement for Italian unity), the contemporary interest in this period seems to coincide with a recent Italian political crisis; Italy is endeavoring to re-examine its own national development and the artistic culture of that century.

There have been only a few specialized exhibitions in the United States dealing with Italian nineteenth-century art. Whereas the English, French and German Schools of the period have been considered in numerous specialized and generalized exhibitions, the Italian School has been comparatively ignored, remaining a *terra incognita*.

This exhibition is the first comprehensive, panoramic consideration of Italian nineteenth-century draftsmanship (or any art of the period) in the United States. The exhibition has two primary purposes, to define and to illuminate the multiple artistic trends operative between 1780 and 1890 in Italy and to present and to publish nineteenth-century Italian drawings in American collections (supplemented by important loans from several Italian museums). Since drawings and watercolors are more intimate and direct artistic statements than most works in other media, they seem especially appropriate to introduce the development of the period.

It is virtually impossible in only one exhibition to represent all significant artists, regions and trends of the nineteenth century. The choice of works for this exhibition often depended on their availability in American collections — which are concentrated in the late eighteenth, early nineteenth and late nineteenth centuries — and the holdings of the four major Italian museum lenders. Since scholarship in the area is in a fledgling stage, discrepancies exist (especially in dates), hopefully to be reconciled by future research in this fertile field.

In addition to joining Wilder Green's expressions of appreciation, I wish to personally thank the various institutions and private collectors who most generously agreed to lend to this exhibition. Moreover, I would like to extend my gratitude to those institutions and individuals whose collections are not represented but who kindly allowed me to study their Italian nineteenth-century drawings and watercolors during the preparatory stages of this exhibition. My sincere thanks also go to the directors, curators of drawings and staffs of the three participating museums and to the National Endowment for the

Arts, The Drawing Society and Wheaton College whose contributions furthered my research and were essential to the realization of the exhibition.

My grateful thanks are also given to: all of the dedicated staff of The American Federation of Arts; the directors, curators and extremely helpful staffs of the four major Italian lenders (especially Enrichetta Beltrame-Quattrocchi, Mercedes Precerutti-Garberi, Maria Teresa Fiorio, Maria Catelli Isola, Stefano Susinno, Anna Forlani Tempesti, Anna Maria Petrioli Tofani); and the kind staffs of the three rich libraries where the majority of my research was accomplished, i.e. the libraries of the Kunsthistorisches Institut in Florence, The Metropolitan Museum of Art and the New York City Public Library.

There were many individuals who contributed to the various stages of this project, beginning with its inception in 1976 (after completing the catalogue for *Italian Nineteenth Century Drawings and Watercolors: An Album,* an exhibition at the Shepherd Gallery in New York). My special thanks go to: Alexander B. V. Johnson for assistance in all aspects of the exhibition and editorial advice; Adelaide Batchelor and Martin L. H. Reymert for editorial comments; David Daniels for his early enthusiasm and support of the fledgling exhibition; Thomas J. McCormick, Agnes Mongan, Edgar Peters Bowron and Susan Bodo for locating works of art; Roland Kuchel of the American Embassy in Rome for expediting processes; Robert J. F. Kashey, Ulrich Middeldorf, Vincent Cuccaro, Ann Percy, Phyllis Dearborn Massar, Lee Johnson and Ulrich Hiesinger for their valuable suggestions; and Joan Silva for typing many documents related to this exhibition, as well as Alice Peterson and Nancy Shepardson for typing the bulk of the final manuscript.

Roberta J. M. Olson

Introduction

*I*n the nineteenth century (or Ottocento), Italy asserted its identity for the first time in what is called the "Risorgimento." It is one of the major themes of this exhibition that the art of this period revealed a national consciousness long before Italy's actual political unification in 1870. A seminal factor in this development was the city of Rome, a center for native and foreign artists alike from the mid-eighteenth through the mid-nineteenth centuries. Even in the second half of the nineteenth century, when artists also visited Paris and traveled extensively throughout Europe, Rome remained an artistic wellspring. Amidst the turmoil of the Risorgimento, culturally and politically acute people visited Rome in order to experience the remnants of Italy's two past ages of greatness–Antiquity and the Renaissance.

Despite Rome's culturally unifying role, Italian art remained regional, even after 1870. Unlike French art, centered in Paris, Italian art more nearly resembled the contemporaneous situation in Germany with its autonomous regional academies. However, Italy was even more hydra-headed than Germany, and each region had an urban center with its own academy of fine arts, its own teachers and its own internal stylistic progression. Although there were cultural exchanges among the regions, the artistic climate remained insular, just as most people's loyalties remained fixed to the concept of a particular city or region rather than to a united Italy.

The nineteenth century's artistic heterogeneity creates obvious problems in any attempt to analyze the period logically and comprehensively. While it is frustrating to confine artistic developments to broad stylistic trends, it is most helpful in order to properly introduce the Ottocento. It must also be remembered that many artists cross these artificial boundaries, and that their styles defy any radical simplification. Only a few, such as the Macchiaioli or the Scapigliati, who actually belonged to constituted groups, fit comfortably into this type of consideration.

The direct statements found in drawings and watercolors provide the most expeditious route to examine the evolution of nineteenth-century art. Academies and artists emphasized drawing as an essential part of artistic training, not only during artists' student years but also throughout their careers. As with the Neoclassicists or the Purists, drawings were often valued over the finished work of art for their conceptual immediacy. The Romantics valued their spontaneous recording of feelings and the Realists believed that nature could best be studied in drawings and oil sketches.

Italian nineteenth-century art and artists cannot be understood without a general knowledge of the country's political growth during the period. Until 1860, the word "Italy" was not a popular characterization for the peninsula,

which had been fought over by European monarchs and carved up by alliances for centuries. At the close of the eighteenth century, the Austrian Hapsburgs dominated the North, the Spanish Bourbons the South, while the Papal States controlled the major portion of Central Italy. In addition, the country was culturally disparate, with parochial customs, politics and arts, a trait which lasted throughout the century.

In 1796, Napoleon Bonaparte crossed the Alps and swept through the peninsula, creating in his wake a series of republics with constitutions; he even exiled the Pope, establishing the short-lived Roman Republic in 1798. He also signed a treaty with the Pope, granting Napoleon one hundred of the greatest works of Italian art. Because of the failure of his Egyptian campaign, Bonaparte temporarily lost control of Italy, but reconquered it in 1800, after which he established the French Empire (1804) and proclaimed the Kingdom of Italy (1805), crowning himself in the Duomo of Milan with the iron cross of the Lombard kings. In addition to his influence on the arts, Napoleon's occupation provided Italy with a prototype for unification, via a puppet government based on a single administration and constitutional principles. Although the French exposed Italy for the first time to the concept of liberty, the Italians were disappointed in the early promise of French rule, encouraging them to depend on purely Italian resources, as seen in the writings of the poet Ugo Foscolo.

In 1813, the Austrians began their reconquest of Italy, culminating in the Congress of Vienna and the Restoration of 1815. Simultaneously, wars of liberation and nationalism occurred throughout the rest of Europe. The post-Napoleonic idea of unification soon sparked a series of patriotic but abortive insurrections in Italy, first sponsored by the secret society of the *Carbonari*. Their eventual failure stimulated Giuseppe Mazzini to found, in 1831, a new revolutionary organization, *Giovane Italia* (Young Italy), to which several artists belonged, e.g. Giovanni (Nino) Costa. Members staged raids and insurrections until 1846. During this period, the ideas of the artist, patriot and statesman Massimo d'Azeglio were especially influential. A more unified culture emerged during these early decades of the Risorgimento, as evidenced in such works as Giovanni Berchet's manifesto of Romanticism, *Lettera semiseria di Crisostomo* (1816) and Alessandro Manzoni's *I Promessi Sposi* (1823), which confirmed Tuscan as the classical form of Italian prose. This new spirit is also evident in Giacomo Leopardi's patriotic odes, for example, *To Italy*: "Weapons, give me weapons / And I alone will fight, and fall alone. / Oh Heaven, grant me this: / May my blood enflame the hearts of all Italians."

Too late, the Pope and the various foreign monarchs attempted to institute reforms in their respective sections of Italy. The Sicilian Revolution of 1848, the first in a series of insurrections, sparked the 1848-49 War of Independence, which rocked not only Italy but all of Europe, and again many artists participated in the conflict. The War of Independence failed, bringing disillusionment and a second restoration of the old despotic regimes. Thus, the most violent

phase of the Risorgimento ended and a more diplomatic period began.

Only the Piedmont in northwestern Italy retained an initiative toward independence. Its king, Victor Emmanuel II, wisely chose the economist Camillo Benso di Cavour as prime minister. A ruthless, practical man, Cavour instituted economic and political reforms and, after initially condemning Mazzini's aims of unification, gradually converted to his point of view. Cavour prepared for war with Austria and persuaded Napoleon III to form an alliance with him. The 1858-59 War for the Kingdom of Upper Italy was not a total success, but it freed the northern territories from European interference. Giuseppe Garibaldi subsequently liberated Naples and Sicily and organized a plebiscite which proclaimed Victor Emmanuel King of Italy (1860). Only Rome, symbolic capital of Italy, remained in foreign hands. In 1870, after the French garrison stationed in Rome had been recalled (because of the Franco-Prussian War and the collapse of Napoleon III's Empire), Garibaldi marched on Rome and took the city, depriving the Papacy of its temporal power and restricting it permanently to the Vatican. The Risorgimento had created the modern state of Italy, with Rome as its capital. The last thirty years under King Umberto brought solidification and internal reforms.

The spirit of change and political reform of Ottocento Italy were paralleled by developments in the artistic sphere. The earliest episode in the evolution of nineteenth-century Italian art was its participation in the international classical revival called "Neoclassicism," which corresponded to the historical period which can roughly be dated to the second half of the Enlightenment (espousing such ideals as the perfectability of mankind). From the voluminous literature on the subject, it is clear that Rome was not only the birthplace of Neoclassicism, but that it also played a crucial role in its development. Although there had been earlier rejections of the prevailing rococo taste, it is generally agreed that Anton Raffael Mengs's *Parnassus,* frescoed in the Villa Albani in Rome (1761), was the primary manifesto of the style.

Neoclassicism was born of a quasi-religious search for eternal truths and spiritual resurrection. Deliberately didactic, it was characterized by intense intellectualism and formal restraint. The excavations of ancient sites–most spectacularly those begun by King Charles of Naples in 1738 at Herculaneum and Pompeii–together with the doctrines of Gotthold Lessing and Johann Joachim Winckelmann (*Reflections on the Imitation of Greek Art in Painting and Sculpture,* 1755, and *The History of Ancient Art,* 1764) spurred the interest in recapturing the spirit of the Greeks and Romans. Winckelmann stated categorically that the only way for an artist to attain greatness was to employ purity of line and form to imitate, rather than copy, the Ancients.

Although Rome is the acknowledged cradle of Neoclassicism, a comprehensive study of the Italian contribution to the style remains to be written. The initial stirrings of Italian Neoclassicism appear in the early works of

Pompeo Batoni (1708-1787), an acknowledged link between traditional classicism centered in Bologna and the neoclassical style. Giovanni Battista Piranesi (1720-1780), who arrived in Rome in 1740, quickly busied himself with his series of prints recording the antiquities of Rome, as well as various pre-romantic imaginary series like the *Carceri*. As Neoclassicism gained wider acceptance, its principles were adopted to a greater or lesser extent by more transitional artists, such as Giuseppe Bernardino Bison (q.v.)*, Giuseppe Cades (q.v.) and Domenico Corvi (1721-1803), who was significantly the teacher of Vincenzo Camuccini (q.v.) and Gaspare Landi (1756-1830), two of the most important Roman Neoclassicists. For a variety of reasons, Roman Neoclassicism was characterized by more sculptural qualities than were found in other regions of Italy.

Rome was an exciting melting pot, an artistic colony filled not only with temporary pensioners, but also with expatriates. Perhaps the most famous Neoclassicist to spend the major portion of his career in Rome was Mengs. The Scottish artist, Gavin Hamilton, one of the most influential early Neoclassicists, was trained in Rome, settling there permanently in 1754. Angelica Kauffmann, who had previously traveled to Italy, finally settled in Rome in 1782. Rome seemed, in fact, a paradise; every artist aspired to win a stipend to study there, either in the "informal academy" of the city itself or in one of the established academies, e.g. the Academy of San Luca and the French Academy in Rome.

Although the generation of Joseph Marie Vien, Mengs and Gavin Hamilton established an early stage of Neoclassicism, the style did not achieve intellectual rigor until the arrival in Rome of the French painter Jacques-Louis David in 1775 and the Italian sculptor Antonio Canova (q.v.) in 1779. These two artists, the acknowledged geniuses of the style, were stimulated not only by Antiquity itself, but also by the large international artistic community of the city. David's *Oath of the Horatii* (1785), which was painted in Rome, stamped Neoclassicism as political and rational rather than aesthetic and emotional; and Canova, who was from the Veneto, refused several offers of residency elsewhere from European heads of state, claiming that he could only work in Rome.

The tormented political situation in Italy in the late eighteenth century created a second, highly individualized phase of Italian Neoclassicism, which was heavily influenced by the conquests and iconography of Napoleon Bonaparte. It began with his conquest of Milan (May 15, 1796) and extended through subsequent victories, reconquests, the reorganization of Italy into republics, and the formation of the Kingdom of Italy (1805). The phase lasted beyond his fall in 1814 but is roughly equivalent to the French Empire style. Although there were several centers for this second phase of Neoclassicism, each with its own artists—e.g. Lorenzo Bartolini (q.v.) in Carrara—Milan can legitimately claim pre-eminence, spawning a style sometimes termed "Lombard Neoclassicism."

Lombard Neoclassicism was dominated by Andrea Appiani (q.v.), who

*(q.v.) is used to indicate that the artist is included in this exhibition. It only appears the first time the artist is mentioned in the Introduction, in the biographies and in the entries.

painted Napoleon's portrait twenty days after his arrival in Milan; Bonaparte preferred Appiani's painting to that of David and appointed him as his official court painter in Italy. In comparison to the sculptural Neoclassicism of Camuccini, Appiani's art is painterly, lyrical and was greatly indebted to his study of Renaissance and Baroque artists. But Appiani also made the customary pilgrimage to Rome in the early 1790's, where he studied the works of Antiquity and those of Raphael, Mengs and David. After Napoleon Bonaparte's fall, the restoration of foreign rulers and the consequent subdivision of Italy, Neoclassicism, practiced by artists such as Pietro Benvenuti (*q.v.*) in Florence and Giuseppe Cammarano (*q.v.*) in Naples (and still dependent on the Roman experience), continued in the curricula of the major regional academies.

The cultural transformations of the late eighteenth century, together with the theories of Winckelmann, revived the art academies in Italy and increased their eclectic nature, placing even greater emphasis on drawing, intellectualism, analytical methodology and Antiquity. Unlike France, the Italian academies were rarely considered an inhibiting force until the middle of the nineteenth century and remained an important component in artistic education throughout the century, with new developments frequently occurring in these academies. Within this milieu, Neoclassicism flourished and Purism and Romanticism developed.

Hints of Romantic sentiment and evocative formal exaggerations appeared in Neoclassicism long before the style crystalized, as early as the works of Piranesi and Edmund Burke's *Philosophical Inquiry into the Origin of our Ideas on the Sublime and the Beautiful* (1757). Burke's vastly influential treatise articulated elements already present in the art and literature of earlier periods. Briefly, his thesis stated that the beautiful is regular and harmonious (i.e. Neoclassicism), whereas the sublime is irregular, awe-inspiring and irrational (i.e. Romanticism or Nature).

Some scholars view romantic art as a reaction against the contrived logic and rationalism of the Enlightenment; others believe that it was a continuation of the Enlightenment – that it represents an extension of the intellectual quest, essaying into such areas as dreams, the occult, the infinite, the exotic and the emotions. Neoclassicism itself was inherently romantic in its desire to reform and to research moral and formal values of the past. With the advent of Romanticism, "the past" was broadened beyond Antiquity to include colorful periods such as Medieval and Gothic. (The less generalized historicism of the later nineteenth century was much more accurate and sophisticated.) There arose an interest in civilizations other than those of classical Greece or Rome, for example Madame de Staël's focus on Germany or the interest in eastern and Moorish motifs. One can clearly see in Neoclassicism of the Napoleonic era a

marked increase in sentiment and a softening of rigid forms, as in the portraits of Appiani, certain of Canova's sculptures, the works of Giuseppe Bossi (q.v.), the later works of David and the paintings of Anne-Louis Girodet de Roucy Trioson. It is important to note that Antoine-Jean Gros, the French romantic artist tragically caught up in the Romantic dilemma, was in Italy from about 1793 to 1801, influencing the work of Appiani and Luigi Sabatelli (q.v.).

Difficult to define, this amorphous style has been gropingly called "pre-romantic," "romantic neoclassical" or "proto-romantic." It includes a diverse group of independent, even eccentric artists who have often been incorrectly identified as Neoclassicists. William Blake and Nicolai Abildgaard may be regarded as members of this group, as could John Henry Fuseli, who was in Rome for eight years after 1770, where he copied the figures of the damned (with their *terribilità*) from Michelangelo's *Last Judgment*. Fuseli seems to have exerted an influence on other artists gathered in Rome, such as Giovanni Battista Dell'Era (1765-1798) and the decorator and prolific graphic stylist, Felice Giani (q.v.). (Giani was the only Italian artist considered in the 1979 exhibition which addressed this group, *The Fuseli Circle in Rome: Early Romantic Art of the 1770's* at the Yale Center for British Art, catalogue by Nancy L. Pressly.) Sabatelli, with his horrific illustrations for Dante, *The Death of Cleomene* and *The Plague of Florence,* properly belongs to the group, as does the "mad" Fortunato Duranti (q.v.), with his arcane iconography and graphic indulgence. The violence of Canova's *Hercules and Lichas* can be placed in the same category, as well as the work of Bartolomeo Pinelli (q.v.) on the evidence of his graphic stylization, his interest in the grotesque and his preoccupation with his own image.

This eclectic group executed works with sublime, erotic or bizarre themes and favored figures in dramatic or violent poses, with deliberate anatomical exaggerations which recall the work of the sixteenth-century Mannerists. They all share a simplified but obsessive draftsmanship and have been called "extravagant." Their drawings seem to have a life of their own, a tendency also evident in John Flaxman's illustrations of the works of Dante and Homer (Flaxman had resided in Italy between 1787-94). Many of these artists were also illustrators and/or printmakers, combining a new romantic spirit with an eclectic taste for classical and Renaissance literary and artistic motifs. This group's pre-romantic traits are most accessible in their drawings.

The linear quality stressed in neoclassical art also led to Purism, a hybrid of Neoclassicism and Romanticism. Purism reacted against the pagan and excessively rational elements of Neoclassicism and like the pre-romantic style can also be understood as an extension of neoclassical motives. Whereas neoclassical artists seized upon Greek and Roman Antiquity, the Purists looked to Christian art for inspiration. Both the Italian and French Purists were influenced by the art and doctrines of the German Nazarenes, who were founded as

the anti-academic *Lukasbund* in 1809 in Vienna and then established themselves in Rome in the monastery of San Isidoro a Capo le Case (in 1810). Like the Nazarenes, the Purists were stimulated by the religious attitudes of the Roman Catholic revival that followed in the wake of the French Revolution and the French Empire. They were also encouraged by the romantic writings of Ludwig Tieck, Friedrich and Wilhelm Schlegel and Wilhelm Heinrich Wakenroder, who in his *Outpourings of the Heart of an Art-Loving Monk* admonished artists to abandon themselves entirely to irrational inspiration. Tommaso Minardi (*q.v.*), who dropped his neoclassical style acquired from Camuccini at the Academy of San Luca, and Luigi Mussini (*q.v.*) were the leading Italian Purists. Both artists were extremely influential teachers and purist ideas consequently enjoyed a great longevity in Italy and were preserved in the academies. For example, the Purist Alessandro Franchi (*q.v.*), a pupil of Mussini at the Sienese Academy in 1853, eventually succeeded his master in his teaching position, perpetuating purist ideas until his death in 1914, even though the movement itself was spent by 1860.

Purism as a movement was not officially defined until 1843, when Antonio Bianchini produced his manifesto and defense of Purism: *Del purismo nelle arti.* It was endorsed and signed by Minardi, the Nazarene Johann Friedrich Overbeck and the sculptor Pietro Tenerani (1798-1869). The Purists advocated a study of and return to the principles of the early Renaissance artists (i.e. before the late works of Raphael), such as Cimabue, Giotto, Fra Angelico and Perugino. Like the Neoclassicists, they enshrined drawing but strived to add emotional content by depicting religious subject matter. Consequently, purist works tend to be linear with cool colors, while their drawings are precise and controlled. There was a parallel Purist movement in Italian literature, which attempted to reform language to the purity of Dante. Beneath both the visual and literary trends lay an unvoiced desire for a national identity, which expressed itself through the conscious choice of Medieval and Renaissance themes and attempts to imitate their styles. The same disguised nationalism can be seen in the work of the German Nazarenes, who looked back to their great Renaissance masters like Dürer, as well as to the Italian painters.

The French manifestations of Purism were also associated with Italy, especially with the French Academy in Rome. The "Primitif" group, which preceded the Nazarenes, was comprised of rebellious pupils of David. Led by Maurice Quaï, they rejected all but the most primary sources of art, stressing the purity of outline drawing. Other significant French Purists include Jean-Auguste-Dominique Ingres, who spent a great deal of time in Italy, and his pupils: Eugène-Emmanuel Amaury-Duval, directly influenced by Overbeck; Hippolyte Flandrin, influenced by the works of Giotto; Ary Scheffer, whose more controlled works reflect purist ideas; and Paul Delaroche, who studied early Italian painting.

Whether understood as a reaction to or a continuation of Neoclassicism, the Romantic movement developed out of the disillusionment following the French Revolution. It was indebted to the ideas of J. J. Rousseau, Burke, Wackenroder and the Schlegel brothers, as well as to Napoleon's radical transformations of Europe. Romanticism substituted expression for reason and generally expanded upon the pre-romantic notions which had already cracked the foundations of Neoclassicism. Like the Neoclassicists, the Romantics endeavored to reform society. The study of Nature and the individual became paramount and the interest in past cultures led to a fascination, even obsession, with national identities.

In Italy, Romanticism corresponded more directly to the nationalistic movement than in any other western country. Napoleon's occupation (c. 1796-1814) planted the seed of a united Italy, providing the disparate Italian peninsula with its first taste of unified political, monetary and legal systems. People began to overlook their provincial prejudices and seek unity and independence, but the process of unification was laborious, lasting until 1870. It has been mistakenly suggested that Italy did not participate actively in the artistic Romantic movement, instead devoting its energies to politics. Certainly a great deal of artistic effort was subordinated to the struggle for national identity, and the Risorgimento itself emerged as the most prominent monument of Italian Romanticism. Prior to the political crisis following the Congress of Vienna (1815), Italy had already found a source of pride in its rich classical and Renaissance heritage with which to assert its own identity and independence.

Italian Romanticism, as in other European countries, first appeared in literature with Berchet's *Lettera semiseria di Crisostomo* (1816). This Italian manifesto of Romanticism defended liberty of form and subject, while Manzoni's *I Promessi Sposi* (completed in 1823) employed a historical theme in a thinly disguised expression of contemporary nationalistic and artistic aspirations. Although there were perhaps earlier examples, the birth of Romanticism in the visual arts is generally assigned to Francesco Hayez' (*q.v.*) painting *Pietro Rossi Prisoner of the Scaligeri* (1820), which was taken from Sismondi's *Storia delle Repubbliche Italiane.* This painting, with nationalistic overtones, was composed of figures based on life studies rather than on casts or ancient works of art and employed other romantic characteristics such as a historical setting, dramatic lighting and emotional subject matter.

Italian Romanticism differed profoundly from its French counterpart, whose artists developed a great technical freedom in their paintings, e.g. Ferdinand-Victor-Eugène Delacroix and Jean-Louis-Théodore Géricault. Italian romantic artists approached similar technical innovations only in their drawings and oil sketches. They were frequently more technically conventional, more academically oriented in style and more directly tied to content. For example, Benvenuti and Giuseppe Bezzuoli (*q.v.*) tended to adopt romantic

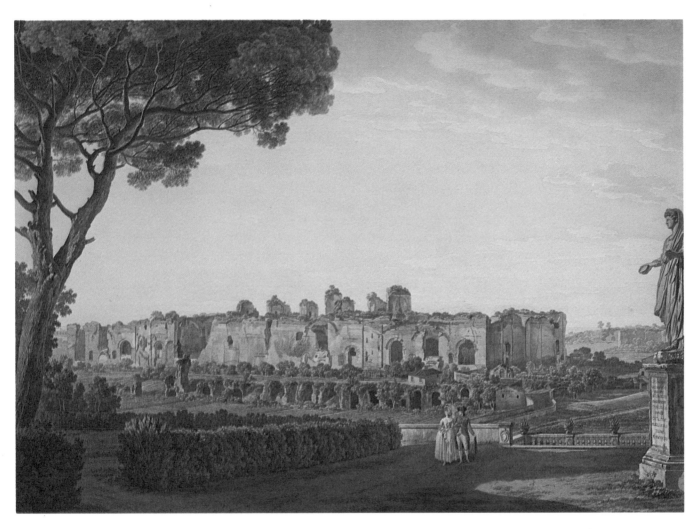

GIOVANNI BATTISTA LUSIERI
The Baths of Caracalla from the Villa Mattei, 1781
(see also cat. no. 26)

subject matter but, like Hayez, never abandoned the smooth finish and contours of the academic mode. Hayez himself had been working in a neoclassical manner shortly before painting *Pietro Rossi*. Many of these romantic subjects were expressions of nationalism, deriving from important events in Italian history and literature, as in Antonio Puccinelli's (*q.v.*) *Savonarola Refusing Absolution to Lorenzo Il Magnifico*. Such paintings embodied latent patriotic sentiments which nurtured a national consciousness.

Within Romanticism, most notably with the Macchiaioli in Florence, the intense interest in Nature and naturalistic painting gave way to a realistic trend after the 1848-49 War of Independence. Due to the prolonged struggle for unification, a romantic thread (political and artistic) runs throughout the century. This trait pertains both to the academically-oriented and the more experimental artists like Vincenzo Cabianca (*q.v.*), who painted *Dante at Poppi among the Exiled Florentines* (1863), and Domenico Morelli (*q.v.*) who, despite his realism, never relinquished romantic subject matter. As the Risorgimento gained momentum, contemporary romantic subjects were also painted. During the last two decades of the century, there was a flourish of romantic themes, as seen in the work of Gaetano Previati (*q.v.*).

The rise and form of nineteenth-century naturalism, which began with the Romantics' return to Nature, varied in each region of Italy. The various centers reacted against the Romantic language, so happily adopted by the academies at different times and in divergent manners. Naturalism, a bridge between Romanticism and Realism, was viewed contemporaneously as yet another reforming trend and turned the quest for truth toward the immediate social environment.

After the Bourbon Restoration (1815), a novel approach to nature first appeared in Naples with the School of Posillipo. In opposition to both the intellectualism of the second half of the eighteenth century and the rigid academic system, it focused on spontaneously painted genre scenes and landscapes. The School of Posillipo was founded about 1820 by the Dutch painter Anton Sminck van Pitloo (*q.v.*), who studied in Paris and settled in Naples in 1815. He held the chair of landscape painting at the Neapolitan Academy from 1824 until his death, but defied the standard academic curriculum by having his students paint *en plein air* in the nearby town of Posillipo. It is noteworthy that this practice predates the activity of the Barbizon painters about 1830.

There was a complex, polyglot tradition underlying the School of Posillipo's innovations. Stylistically, the group was influenced by Dutch naturalism, the local seventeenth-century landscape tradition of Salvator Rosa and by the Venetian *veduta*. Moreover, geography was a strong determinant. The port of Naples was stunningly picturesque, with its backdrop of Mt. Vesuvius and the surrounding villages on the Gulf of Naples which included Posillipo and

Sorrento, while the climate and natural light were exceedingly conducive to the development of landscape painting.

In the early nineteenth century, Naples was an international center for both tourists and artists. They flocked to Naples, many on their way to the nearby excavations at Pompeii and Herculaneum, and purchased the *vedute* of the School of Posillipo as souvenirs in lieu of photographs. Many foreign artists then flooding into Italy were attracted by the scenery in and around Naples, but the role which they played in the development of the styles of the School of Posillipo is debated. Some scholars hold that they had little impact, but the technical influence of the English watercolor tradition cannot be denied. The foreign artists in Italy that might have affected members of the School of Posillipo included Richard Wilson (1750), John Robert Cozens (1782), Joseph Rebell (1813), J. M. W. Turner (first in 1819), Johan Christian Clausen Dahl (1820), Richard Parkes Bonington (1825) and Jean-Baptiste-Camille Corot (first in 1825). None of these foreign painters, however, joined the School of Posillipo, which was comprised primarily of regional artists.

The members of the School of Posillipo specialized in lyrical, documentary views of the Neapolitan landscape in oil, tempera, gouache or watercolor. Their work departed from both the purely topographical tradition and the carefully composed landscapes of the academies and embodied a poetic vision, freedom, spontaneity and an innovative treatment of light. Giacinto Gigante (*q.v.*), the School's most poetic and outstanding representative, was the only member who neither studied nor taught at the Academy of Naples. The other members of this informal group included: the Carelli family (*q.v.*), Teodoro Duclère (1816-1867), Salvatore Fergola (1799-1877), the Gigante family, Gabriele Smargiassi (1798-1882) and Achille Vianelli (*q.v.*). Pitloo's early death in 1837 marked an unofficial end of the group, but individual members continued to pursue their own naturalistic styles.

As the century progressed, Naples continued as a center of naturalistic painting. The Palizzi brothers, Filippo (1818-1899), who as a youth painted in the style of the School of Posillipo, and Giuseppe (1812-1888), who spent ten years (1845-55) painting in the Forest of Fontainebleau with the Barbizon School, developed the Neapolitan tendency toward realism inaugurated by the School of Posillipo. Filippo Palizzi gradually adopted a veristic style that was more daringly objective, less romantic and panoramic than that of the School of Posillipo. By 1837, he had begun to focus on animals, his speciality, and pastoral landscapes painted directly from nature in thick impasto. Filippo Palizzi's friends, Saverio Altamura (1826-1897) and Morelli,clung to more conservative subject matter and were also involved with verism.

In the second half of the century, Naples produced the group called the "School of Resina" or the "School of Portici," a name which derived from Morelli's derisive appellation "Repubblica di Portici." Founded about 1863 by

Marco De Gregorio (1829-1876), Federico Rossano (1835-1912) and Giuseppe De Nittis (*q.v.*), the group painted under the guidance and inspiration of the Florentine *macchiaiolo* Adriano Cecioni (1836-1886), who was in Naples until 1867. In their *plein-air* study of light and atmospheric effects, the members of the School of Resina paralleled the Florentine Macchiaioli.

During the 1870's, the bravura style of the Spanish expatriate Mariano Fortuny y Carbò (*q.v.*), which reflected the influence of Jean-Louis-Ernest Meissonier and the French academics, overwhelmed the earlier, humbler realism of the School of Posillipo and the School of Resina. Significantly, De Nittis soon departed permanently for Paris. Antonio Mancini (*q.v.*) carried the lush style of Fortuny to its experimental limits, often mixing sand, glass and pieces of gold paper into his visual showpieces, while still preserving a germ of Neapolitan Realism in his candid compositions.

The most systematic, anti-academic movement for pictorial reform within Realism occurred in Florence with the Macchiaioli group. Their name derives from the word *macchia* (meaning sketch, spot or forest). Although the term "macchiaioli" was first used in 1861, it gained prominence after it appeared in a derogatory review of Macchiaioli paintings in 1862, in a strikingly similar manner to which the term "Impressionism" was later coined in France. The name was immediately adopted by Telemaco Signorini (*q.v.*), one of the group's spokesmen, and by the other two theorists of the group, Adriano Cecioni and the critic Diego Martelli, who was the only contemporary Italian critic to have realized the importance of the group and who in an 1879 lecture compared them to the Impressionists.

The first ideas of the group appeared after the failure of the Italian War of Independence in 1848-49. The attitudes of its members, some of whom were Garibaldian activists and most of whom would eventually involve themselves in subsequent campaigns for liberation, fused political aspirations with revolutionary conceptions of art. Their formative period thus dates from 1849-61. Although the nucleus of the artistic group, T. Signorini, Cabianca and Odoardo Borrani (*q.v.*), first met in Florence at the Caffè dell'Onore in Borgo La Croce, they soon gravitated (c. 1855) to the Caffè Michelangiolo in the Via Larga (now the Via Cavour).

The Caffè Michelangiolo was then notorious as an arena for political discussions. In 1855, its caustic, stormy atmosphere became dominated by aesthetic issues. The Caffè consisted of two rooms: the first for normal clients and the second for the inner circle, which had its walls filled with paintings donated by artists (as seen in Cecioni's caricature of 1861). It enjoyed a temporary but important reputation, for unlike the Caffè Greco in Rome which witnessed many artistic movements, the Caffè Michelangiolo was allied only with the Macchiaioli. Coincidentally, it was located between the Palazzo Medici and the

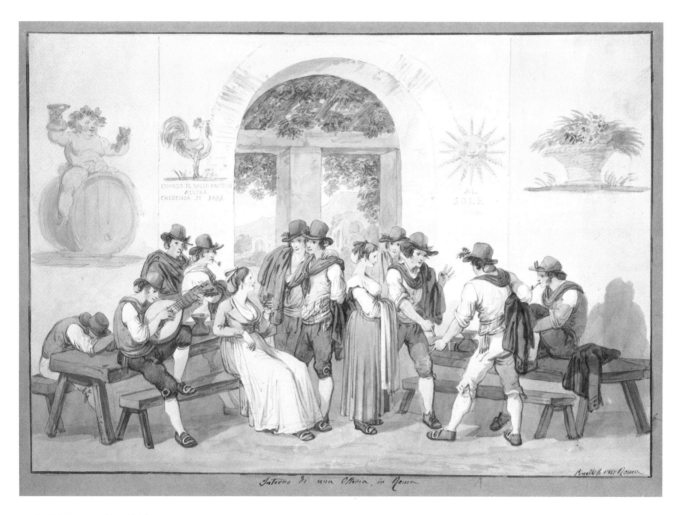

BARTOLOMEO PINELLI
Interior of a Roman Inn, 1817
(see also cat. no. 28)

Church of San Marco on the very route which most artists traveled to the Academy of Florence.

The group of young artists, many of whom had been trained in the academies, congregated at the Caffè Michelangiolo during its most decisive year, 1855-56, when several catalysts were present (the group remained relatively autonomous of other European influences). The first was the presence of certain non-Tuscan artists, some of whom were in voluntary exile after fighting in the 1848-49 insurrection. These included the three Neapolitan Realists: Morelli, Altamura and Serafino De Tivoli (1826-1892). All three had attended the Universal Exposition of 1855 in Paris and had returned to Florence with reports of what they had seen, particularly the paintings of Gabriel-Alexandre Décamps, Constantin Troyon and Rosa Bonheur. This was the same year that Gustave Courbet distributed his "manifesto of Realism" after his paintings were rejected by the Universal Exposition and were subsequently exhibited in his large wooden "Pavillion of Realism." Edgar Degas was the most famous of the foreign artists who frequented the Caffè in 1855. In that year, the Russian expatriate Prince Anatole Demidoff opened to the public his villa at San Donato outside Florence, with its spectacular collection which has since been dispersed. There, the Macchiaioli were exposed to the works of Ingres, Delacroix, Bonington, Corot, Troyon, Décamps, Delaroche and François-Marius Granet, most of whom had visited Italy but due to the country's regionalism were largely unfamiliar to the Macchiaioli. Cecioni specifically mentioned only one work from the Demidoff collection, Décamps' *Samson*. The Macchiaioli were said to have been especially impressed by the sharp contrasts of light and dark in Décamps' work. In 1861, Cristiano Banti (1824-1904), T. Signorini and Cabianca traveled to Paris to personally familiarize themselves with contemporary French art. Eventually, artists from all over Italy congregated at the Caffè Michelangiolo. After 1859, the progressive Roman artist Giovanni (Nino) Costa (1826-1903) spent ten years in Florence and frequented the Caffè. Antonio Fontanesi (*q.v.*) and Guglielmo Ciardi (*q.v.*) also participated in these discussions and debates on Realism.

Macchiaiolism was a polemical movement. Two of its artists, Cecioni and T. Signorini, along with Martelli, its major critic, were energetic and persuasive writers. Their principles, which were first published in two periodicals, *Gazzettino delle arti del disegno* (1867) and *Giornale artistico* (1873-74), included a then radical approach to Realism, with certain similarities to the work of Courbet, the Barbizon School, Edouard Manet and the early Impressionists. Their artistic and social ideas were stimulated by the writings of the French proto-socialists Proudhon, Champfleury and Castagny. Martelli was also influenced by the writings of Hugo and Zola. The Macchiaioli were iconoclasts who rebelled against the pedantic artistic and literary values of the academies and their Purist and Romantic teachers. Their goal was to create a contemporary, empirical art,

reflecting their own era, the Risorgimento. They were also strongly influenced by Positivism. Most of the Macchiaioli painted either fragmentary, sunlit, outdoor scenes (of a decidedly non-topographical nature, unlike the traditional *veduta*) or genre scenes (relatively free of anecdotal content). All of their works were structured geometrically with a great simplicity and they were dedicated to nature and to the immediacy of their impressions. Occasionally, as in the more ambitious battle paintings of Giovanni Fattori (*q.v.*), a topical Risorgimento subject was introduced. The role which photography played in Macchiaioli works has yet to be assessed, although several books have offered intriguing suggestions (including Forte di Belvedere, Florence, *Gli Alinari: Fotografi a Firenze 1852-1920* [by Wladimiro Settimelli and Filippo Zevi], Florence, 1977 and Piero Becchetti, *Fotografi e Fotografia in Italia 1839-1880,* Rome, 1978).

Unlike the artists of earlier generations, the Macchiaioli did not generally look to the art of the past for inspiration. At the age of eighteen, T. Signorini instructed Borrani to paint subjects which he encountered outdoors rather than study the frescoes of Uccello and Ghirlandaio. However, despite their reliance on contemporary subject matter, the Macchiaioli did tolerate a study of Italian quattrocento painters. But unlike the moral sentiment sought by the Purists in the quattrocento artists, the Macchiaioli studied them for their structural compositions and unabashed naturalism. T. Signorini, in *Il Risorgimento* (1874), wrote: "... not in Tiepolo or Tintoretto, but in Lippi, in Benozzo and in Carpaccio ... modern art finds that which it intends to conquer for itself, that is, the sincerity of sentiment and love for all Nature and childish simplicity with which the Quattrocento carressed every form." Cecioni also instructed artists to study the frescoes of Masaccio in the Brancacci Chapel in S.M. del Carmine and the works of Fra Angelico in the Church of San Marco. The influence of the Quattrocento seems obvious in Macchiaioli drawings, not only in their copies after Renaissance paintings but also in the simple linearity of their draftsmanship.

The Macchiaioli predate the French Impressionists, but their investigation of light *en plein air,* although more advanced than that of the Barbizon painters, did not achieve the sophistication of the Impressionists, neither in their scientific attitude nor in their attempts to break down the pictorial plane. The Macchiaioli clung to a more traditional chiaroscuro technique, which was based on an elementary visual theory that involved the application of color to the canvas in flat, geometrical shapes. Their impressions were constructed by the juxtaposition of these areas of color, each with its own value. As a result the Macchiaioli broadened the rigorous pictorial solidity of the traditional chiaroscuro method which they believed had disappeared from painting. By the mid-1860's, the characteristics generally associated with the group were firmly established and the Macchiaioli, who continued to develop their individual

styles, progressed no further in their optical experiments. Only T. Signorini adopted a more Impressionist palette after 1875 and blurred his brushstrokes to capture the transient effects of light and air. The Macchiaioli continued to record *en plein air* their fleeting perceptions of Tuscan landscape at their favorite locations, among which were Castiglioncello, Pergentina and Settignano. Some of their finest, simplest works are their small, spontaneous paintings on wood, which have a genuinely experimental feeling.

The Macchiaioli represent one of the century's most original contributions to the history of art. This group, which had its genesis in the revolutionary hopes of the Risorgimento, never abandoned its idealism and iconoclasm, and the more important painters retained a revolutionary inquietude. In his later work, Fattori, one of Italy's most outstanding nineteenth-century painters whose drawing dominated his use of color, turned to the bleak landscape and rustic people of Maremma. Silvestro Lega (1826-1895), who received his education from the Purist Mussini and was known for his intimate representations of Tuscan middle-class life, spent his last years as an itinerant. And T. Signorini, the intellectual spokesman of the group, refused a professorship at the Academy of Florence.

While the Macchiaioli movement grew logically out of the political and artistic *ambiente* of mid-century Florence, no group followed in their wake to expand upon their ideas, as the French Post-Impressionists succeeded the Impressionists. The Macchiaioli were exposed to the innovations of the French Impressionists about 1880, after Martelli attempted to bring the two groups together and published his lectures on Impressionism. Even though Camille Pissarro is known to have exhibited two paintings at the Florentine *Società Promotrice di Belle Arti* in 1879, Impressionism remained virtually unknown in Italy outside of Florence and Tuscany. The French Post-Impressionists were better known, especially in northern Italy, even though the cultural and diplomatic isolation of the peninsula still prevented an easy flow of ideas after unification in 1870.

The artist, critic, patriot and cultural organizer Nino Costa was a member of Mazzini's *Giovane Italia* and dominated Roman artistic activity throughout the last half of the century. His early anti-academic development included a novel, broad approach to landscape, which he painted outdoors. He was influenced by English and French artists such as Corot, whom he met in 1844 in the Roman countryside. In 1859, Costa traveled to Florence and became involved in the artistic and political ferment at the Caffè Michelangiolo. He was an important stimulus for the Macchiaioli and his organizational ability helped them to consolidate their own program. Although he never became a *macchiaiolo*, he remained in exile in Florence for ten years.

Costa pioneered cultural exchanges between Italy, England and France.

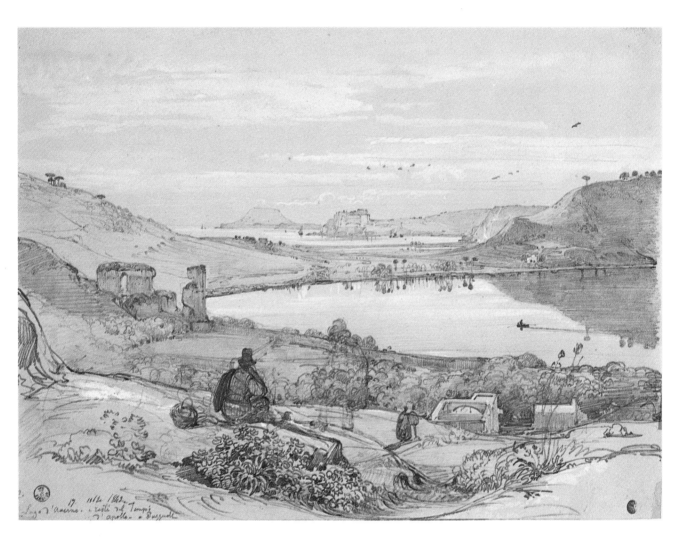

GIACINTO GIGANTE
View of Lake Averno, 1842
(see also cat. no. 46)

In 1863 he exhibited at the Paris Salon, where his work was praised by Troyon and Corot, who had influenced his own development. After the unification of Italy in 1870, Costa returned to Rome where both his art and polemics became increasingly aesthetically oriented. In contrast to his earlier Macchiaioli sympathies but in harmony with his reforming spirit, he was convinced that a national art could only be achieved by looking back to the Renaissance and he turned to Pre-Raphaelitism. To carry out his reforms Costa founded a series of artistic groups. The first, *Circolo degli Artistici Italiani* (1879), attempted to give art dignity by combating the commercialism then rampant in tourist-besieged Rome. Four years later, he founded the *Scuola Etrusca.* The third and most important group, *In Arte Libertas,* which Costa founded in 1885, exhibited works in Rome of foreign artists including Arnold Böcklin, Edward Burne-Jones, Corot, Charles-François Daubigny, Frederick Lord Leighton, who was a close friend from 1853, Pierre-Cécile Puvis de Chavannes, Dante Gabriel Rossetti and George Frederick Watts. He also exhibited Italian artists, including the Macchiaioli, Previati and Giovanni Segantini (*q.v.*), in Rome and in England. Other members of *In Arte Libertas* in this exhibition include Giulio Aristide Sartorio (*q.v.*) and Cabianca.

Another anti-academic reaction occurred in the North, centering in Milan, where first Sabatelli and then Hayez presided over the Brera Academy. One can find in the romantically inclined art of Giovanni Migliara (*q.v.*), who early in the Ottocento specialized in realistic/fantastic *vedute,* an attempt to chronicle contemporary life in a manner akin to the art of Constantin Guys and Louis-Léopold Boilly. Narrative and patriotic realism first appeared during the 1840's in the art of the Milanese Domenico Induno (*q.v.*), who was influenced by Migliara. Induno's talent provided genre painting with a new dignified status. Together with his younger artist brother, Gerolamo (1827-1890), Induno concentrated on popular, humble subjects, which occasionally had Garibaldian themes, such as *The Peace of Villafranca.* Domenico Induno's pioneering sensibility of social realism also included stylistic innovations that dispensed with the rigorous contours and structured chiaroscuro of academic painting and substituted natural color and light based on his studies of seventeenth-century Dutch painters in the Florentine museums. The Milanese *ambiente* also produced a number of noted landscapists.

Giovanni Carnovali (1804-1873), called "Il Piccio," from the neighboring town of Bergamo, settled in Milan in 1836. He too rejected the chilly conventions of the academy, developing an atmospheric style and a vivid palette. Unlike Induno, who is remembered for his innovative subject matter, Carnovali's major contribution was his painterly technique, involving a fusion of drawing, color and image derived from his studies of earlier masters, Correggio and Parmigianino (after Appiani's example), Lotto, Luini and

Tiepolo. Although Carnovali's style and romantic intensity are technically similar to the work of Delacroix, he held fast to tradition and specialized in intimate, sentimental subjects that lack Delacroix's imagination. Carnovali influenced Federico Faruffini (1833-1869), with whom he traveled to Paris in 1855. Prior to Faruffini's encounter with Carnovali, his style had become relaxed under the guidance of his teachers Giacomo Trécourt (1812-1882) and Giuseppe Bertini (1825-1898). Bertini was also the master of Tranquillo Cremona (q.v.) and Mosè Bianchi (1840-1904). Faruffini continued to shed academic principles and concentrated on chromatic effects, which he derived from an intensive study of Venetian sixteenth-century masters and applied to subjects from Medieval, Renaissance and contemporary history. In turn, he exerted a strong influence on Milanese artists of the next generation, the group known as the Scapigliati.

During the 1860's the fragmented Milanese rebellion against academic practice coalesced into a movement called "La Scapigliatura" (disheveledness). Their name derived from the title of a novel by a member of their group, Carlo Righetti. Their knowledge of Baudelaire enabled them to use his idea of the *poète maudit* as a role model. As a diversified group of writers, musicians and artists, they opposed orderly bourgeois life and addressed broad aesthetic issues. The group tended to rebel more through their bohemian, raucous and self-indulgent behavior than their art. One of their centers was the *Milanese Famiglia Artistica,* founded in 1873. Like the Caffè Michelangiolo of the Macchiaioli, it provided a meeting place for the members, and also sponsored exhibitions, lectures and, briefly, an art school. While the literary and musical factions of the Scapigliatura group reached their peak in the 1860's, the visual contingent did not mature until a decade later.

The two greatest visual representatives of the Scapigliati, Cremona and Daniele Ranzoni (q.v.), derived their vaporous technique and sensuous palette from Il Piccio, Faruffini and the Piedmontese artist, Fontanesi. Scholars have previously termed them "quasi-Impressionist," which is misleading because it only addresses the superficial flickering of light and brushwork in their paintings. The Scapigliati lacked the rigor of both the Macchiaioli and the French Impressionists and instead created vague, dreamy, romantic statements that are best understood as a reaction against the contours and chiaroscuro of contemporary academic painters. This technique is best suited to small works and both Cremona and Ranzoni excelled in portraits and intimate subjects. Significantly, by de-emphasizing subject matter, by stressing color over line and by making the expression of light their primary aim, the Scapigliati inaugurated a pictorial revolution. Their style remained influential in the Milanese *ambiente* until the end of the century and prepared the way for the more disciplined technique of the Divisionists in the 1880's.

Italian Divisionism is said to have been officially born at the Brera Triennale in 1891, although there had been evidence of the style long in advance of that year. The artist, critic and impressario Vittore Grubicy de Dragon (1851-1920) and his businessman brother, Alberto, who later took over the art gallery established by Vittore, are credited with introducing and propagandizing Divisionism in Italy. Vittore Grubicy was well-acquainted with contemporary European art and made annual trips to France. He was a friend of the Dutch artist Anton Mauve and seems also to have been influenced by Rood's treatise on color and the optical fusion of color. After 1886, the year in which Georges Seurat's *Sunday Afternoon on the Island of the Grande-Jatte* was exhibited, he promoted the cause of Divisionism in Italy, publishing numerous articles in important journals such as *Cronaca d'Arte.* Grubicy denied any connection between Italian and French Divisionism (also called Pointillism, although Seurat himself preferred the term Divisionism). In his preface to the Milan Triennial exhibition of 1896, Grubicy characteristically claimed that Italian Divisionism was an independent movement and that Ranzoni was in fact a "proto-Pointillist." However, it seems questionable whether Italian Divisionism would have developed in the manner in which it did without the French precedent. Italian Divisionism was broader than French Pointillism and more akin to French Post-Impressionism. It was heterogeneous, incorporating not only the work of highly individual artists, but also many other trends of the late nineteenth century. Several pan-European phenomena contributed to its rise: the development of optical theory, the proliferation of studies on color, the invention and popularization of photography, which concommitantly encouraged the study of optics, but removed the necessity to strive for verism in art. There was also a crisis in the philosophies of Positivism and Realism which surfaced about 1880, as seen in the art of Böcklin, Max Klinger, Previati, Odilon Redon and Segantini. This crisis had been prefigured earlier in the century by the art of the Nazarenes, the Purists and the Pre-Raphaelites. It was argued that objective reality was an inadequate form of expression and outbursts of mysticism and idealism swept throughout Europe in the late 1880's, expressed in art by Symbolism.

Milan was fertile territory for the development of Divisionism. The Scapigliatura group had set the stage with their anti-academic, pictorial revolution which focused on the independence of light and color. Grubicy developed his gallery as a focal point for Divisionism, envisioning it as the Italian equivalent of Durand-Ruel in Paris. One of Grubicy's major discoveries was Segantini, who began his studies during the 1870's *ambiente* of the Scapigliati. When Grubicy discovered Segantini through his painting *The Choir of Sant'Antonio,* exhibited in 1878, his work already displayed a nascent divisionist technique with an intuitive ability to depict light by juxtaposing facets of color. Segantini became Grubicy's protégé. In later years, his allegorical art blended naturalism and

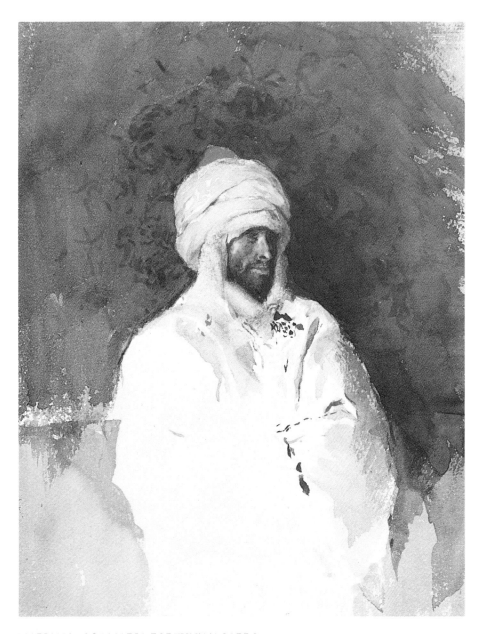

MARIANO JOSE MARIA FORTUNY Y CARBO
Portrait of an Arab
(see also cat. no. 79)

symbolism in pantheistic subjects. Previati, another important Divisionist, entered Grubicy's circle about 1880. He was the most intellectual Divisionist, publishing several treatises on scientific principles and art (e.g. *I Principii Scientifici del Divisionismo*, 1905-06). His paintings are more Symbolist than Segantini's and contain expressive formal patterns characteristic of the *fin de siècle* and Art Nouveau through which he consequently influenced the Futurists. The divisionist style is generally characterized by a juxtaposition of individual brushstrokes of pure pigment, often of complementary colors, that create vibrating effects, flat but infinite suggestions of space and destruction of contours. Other divisionist painters include: Plinio Nomellini (1866-1943); Giuseppe Pellizza da Volpedo (1868-1907), who often painted socialist themes; and Angelo Morbelli (1853-1919), who specialized in humanitarian subjects. Giacomo Balla and the other Futurists–Umberto Boccioni, Carlo Carrà, Gino Severini and Luigi Russolo–began painting in a divisionist style, with kinetic flickerings of light which would eventually blossom into Futurism's celebration of motion and change.

After political unification in 1870, Italy moved into closer contact with the culture of the rest of Europe, although it was still divided into regional pockets. Italy first experienced the widespread triumph of Realism and the dissemination of Positivism after 1860. The subsequent decline of Positivism led to mysticism, aestheticism and a literary romantic art parallel to the *fin de siècle* phenomenon throughout Europe. The Milanese Divisionists were only part of this trend. (The 1891 Triennale at the Brera not only marked the official presentation of Divisionism, but also the first Italian Symbolist exhibition.) In Rome, there was Sartorio with his D'Annunzian, symbolist orientation, and Costa, whose *In Arte Libertas* exhibited works by Symbolist and Pre-Raphaelite artists. The period also witnessed the final spasms of Realism in Mancini's virtuoso but superficial brushwork, the portraits of Giovanni Boldini (*q.v.*), who had been associated with the Macchiaioli, the genre scenes of Giacomo Favretto (*q.v.*) and the sculpture of Vincenzo Gemito (1852-1929). At the close of the nineteenth century, artists focused on formal problems, anticipating the twentieth century. The official end of Italy's isolation in the realm of art occurred with the founding of the Venice Biennale in 1895.

Roberta J. M. Olson

The small but significant group of drawings in the exhibition from the Gabinetto Nazionale delle Stampe in Rome represents only a tiny nucleus of the ample and varied national collection, whose formation dates from 1895. This collection also includes rare codices which date back to the fourteenth and fifteenth centuries.

The drawings in the collection have diverse provenances and include gifts of institutions, such as the famous sheet by Leonardo (F.N. 4), given by Harvard University and frequently exhibited in Italy and abroad. Others were gifts of private collectors such as the Marchese Incisa della Rocchetta, or of collectors of specialized subjects as in the case of the majority of the Neapolitan drawings. Others still, especially those of the Ottocento, came directly from artists' heirs or students, as in the case of Fattori. The collection is especially rich in Ottocento drawings, even though some important groups such as the Purists and the Nazarenes are almost absent, and the Neoclassicists and the academics are weakly represented. Nevertheless, the Gabinetto Nazionale delle Stampe possesses over 500 drawings by Felice Giani, whose complex artistic language walks a tightrope between Neoclassicism and Romanticism. The eccentric, "mad" Fortunato Duranti is also broadly represented. In addition, there are a great number of preparatory studies by significant nineteenth-century artists of the Roman School, e.g. Francesco Coghetti and Cesare Mariani. There are extensive holdings of drawings by foreign artists. For example, five large volumes by Nicolas Didier Boguet contain numerous views and landscapes of Italian cities, while many drawings by Vervloet record *vedute* of Venice and Rome.

Various themes are found in the drawings belonging to the Gabinetto Nazionale. Naturally, the Roman campagna was drawn by a great number of artists, by famous and not so familiar figures alike. Many of these landscapes were executed in sketchbooks typical of the nineteenth century, where artists recorded their impressions in a visual diary during their long trips by coach or on foot. Artists were also seduced by the city of Rome with its ruins, monuments and narrow, twisting streets, as well as by Naples with its picturesque port and adjacent towns on the Gulf of Naples. These Neapolitan scenes were treated both as pure landscape and as representative of the folklore tradition, as vibrantly embodied in the works of the famous Neapolitan School of Posillipo. Portraits were another popular thematic trend in the Ottocento. Many drawings in various media and techniques in our collection provide a succession of diverse but interesting visages: e.g. Bison's smooth, delicate portrait of a young woman, Appiani's effective portrait of Ugo Foscolo, Ingres' portraits and the quick drawings of Telemaco Signorini.

The selection of drawings in this exhibition from the Gabinetto Nazionale delle Stampe, while necessarily limited, have been wisely chosen. These sheets are by artists from the Lombard, Venetian, Tuscan, Neapolitan and Roman Schools. They not only help us to understand the individual artists but also to confirm the validity and importance of graphic expression.

Dottoressa Enrichetta Beltrame-Quattrocchi, *Curator*
The Gabinetto Nazionale delle Stampe

The Civico Gabinetto dei Disegni, Castello Sforzesco, Milan

The collection of the Gabinetto dei Disegni of the Castello Sforzesco in Milan is based on bequests and gifts. As a public collection, its history is closely connected to the evolution of the Civic Museums of Milan (formed June 2, 1878 with the inauguration of the Museo Artistico Municipale di Milano in the Public Gardens, which later, in 1900, was moved to the Castello Sforzesco).

The civic graphic collection, which was not systematically formed, is interesting both for the study of its material and for research on Italian and Lombard collecting habits, especially at the end of the Ottocento. The Gabinetto dei Disegni (which is a sector unto itself within the framework of Milanese artistic institutions) has grown from a few hundred examples to its current size of about 40,000 sheets dating from the Quattrocento to the present. Among its holdings are groups of drawings from the sixteenth and seventeenth-century Lombard School, a large group of nineteenth-century drawings representing various schools and a sizable number of modern and contemporary drawings (including about seventy works by Umberto Boccioni and examples by Modigliani). While the older drawings were gifts and bequests, the modern drawings were acquisitions.

The following private collections helped to form the nucleus of the drawing collection: Antonio Guasconi (1863); Pompeo Marchesi (given by the lawyer Salvatore Fogliani in 1862); Count Gian Giacomo Bolognini-Attendolo (1865) and Tanzi (1881).

Guasconi, a state official, was a "modern" man without an artistic background who was able to balance dry administrative work with collecting art. Among the most significant works from his collection, which he hoped would "instruct the members of this city," are works by Vincenzo Foppa, Cerano, Tiepolo and Guardi, together with a rich collection of drawings by Quarenghi, Bonomini, Bison and two hundred other variously attributed sheets.

The expansion of the graphic collection continued in the twentieth century. One of the most interesting people responsible for this was Vittore Grubicy de Dragon (1851-1920), who straddled the fence between the nineteenth and twentieth centuries. He was a painter, dealer, critic and avid promulgator of Divisionism, as well as a friend and devoted sponsor of Previati and Segantini. A short time before his death, Grubicy donated to the museum about one hundred paintings and drawings (Daubigny, Calame, Couture, etc.), as well as major works like Tranquillo Cremona's *Highlife,* vibrant canvases of Giovanni Carnovali, called "Il Piccio," and works by Daniele Ranzoni, whose luministic Lombard poetry is represented by a drawing in this exhibition.

Other collections given to the Gabinetto dei Disegni include: Giovanni Morelli (1911); Gaffuri (1931); Spinelli (1932); Mariani (1934); Prior (1934); the bequest of the Durini Foundation (1939); and the collection of Prince Trivulzio (1935), which included many famous objects and a group of drawings which only became part of the museum in 1943. Another very significant addition was the acquisition of a group of drawings from S. M. presso S. Celso (1924), together with the Maggiolini, Amati and Martinelli collections.

A separate discussion should be made of the Carlo Grassi collection, given to the Comune di Milano in 1956 and exhibited at the Galleria d'arte moderna since 1958. Grassi's collecting habits over twenty years spanned diverse artistic interests, from archaeology (the more important objects are today part of the Vatican Museums) to such areas as prints, drawings, oriental art, books and old master and modern paintings. Because of Grassi, the Milanese public collection possesses the most important nucleus of French Impressionist and Post-Impressionist art in Italy. In addition, the Grassi collection includes major works from the Italian Ottocento and our own century (e.g. Giacomo Balla's *Young Girl Running on the Balcony*). A personal preference guided Grassi in his selection of graphic works. Among the Italian masters of the nineteenth century, one finds the sketchbooks of Giuseppe Canella, Federico Faruffini, Silvestro Lega, Giovanni Migliara and Enrico Reycend (which often have illuminating annotations). And, among the French, there are the etchings and *clichés verre* of Corot, the delicate etchings of Helleu, the lithographs and posters of Toulouse-Lautrec and the block prints of Vallotton.

Even though the examples selected for the exhibition *Italian Drawings 1780-1890* are not great in number, they nevertheless reveal a common Lombard denominator. This Lombard quality is present in the soft chiaroscuro (how can one forget Leonardo's influence in Lombardy?) and a poetic, realistic sentiment (the lesson of Foppa continued through the centuries) which recurred with originality up to the threshold of the Boccionian revolution (Futurism).

Dottoressa Mercedes Precerutti-Garberi, *Director*
The Civiche Raccolte d'Arte

The Gabinetto Disegni e Stampe degli Uffizi, Florence

It is not surprising that the more than 6,000 nineteenth-century drawings in the Uffizi are not as well known as the older part of the collection, which is one of the most important in the world. The collection has good and even exceptional examples by the major Italian artists of the nineteenth century, with a concentration on works by Tuscan artists. Whoever wishes to study Sabatelli, Bezzuoli, Benvenuti, Bartolini, Ussi, Fattori, Borrani, or certain *petits maîtres* like Burci or Moricci must consider the Uffizi collection. (The collection is now integrated with the graphic collection of the Galleria d'Arte Moderna of Florence.)

On the other hand, scholars involved with specific aspects of the nineteenth century will encounter lacunae. There are few drawings by foreign artists, as well as some false sheets attributed to Canova and only one drawing each of Hayez, Gemito and De Nittis.

The reason for these lacunae are found in the history of the collection. As with the other Florentine artistic collections formed from the Medici treasures and enlarged by the Lorena, it suffered an arrest during the disruptive political circumstances of the first half of the nineteenth century. It lost its autonomy

and individuality with the creation of the Savoyard Kingdom in 1860, when it became one of the many public collections of this new kingdom.

Even before 1860 its growth had been curtailed due to a lack of funds. In fact, one finds futile requests to acquire drawings and prints in the records of the Florentine galleries from the time of the Napoleonic occupation. Only prints (not by contemporary masters), which were more easily found, slightly enlarged the collection during these difficult years. And so, the opportunities to acquire works by the major masters of the nineteenth century were curtailed, even though these choice pieces could have been easily purchased either on the market or directly from the artists, their heirs or students. This had been the practice of the initial owners of the collection, beginning with its founder, Leopoldo de'Medici in the seventeenth century. Even during the Ottocento the Gallery did not lack directors who were especially sensitive to the graphic arts, from Tommaso Puccini, himself a collector of drawings (many of which, like the beautiful Sabatelli's, entered the Uffizi in 1915), to Antonio Ramirez di Montalvo, the enthusiast of engraving.

The situation changed in the final decades of the century, due in great part to its new director, Aurelio Gotti. In 1866, when Florence was the capital of Italy, Gotti purchased a very modest study by Tommaso Minardi with the chief intention of enriching the collection of contemporary masters. Encouraged by the patriotic fervor of a united Italy and the newly formed public collections, collectors and artists gave the nuclei of their works intact to the State for study. The most exemplary case is that of the sculptor Emilio Santarelli, who in 1866 gave more than 12,600 drawings which he had lovingly gathered (including drawings by Italians, foreigners, Old Masters and contemporaries). Among the nearly three hundred contemporary sheets, there are six by Bartolini (sketches for his sculptural monuments), fifteen by Benvenuti (studies for his important paintings), thirteen by Bezzuoli, twenty-six by Giani, three beautiful works by Gigante, and about thirty by Luigi and Francesco Sabatelli. Ten years later, the architect Giuseppe Martelli left about 1,200 architectural drawings and about one hundred figure drawings to the Gallery, among which there are about twenty portraits by Bezzuoli and about thirty by Emilio Lapi. Descendants donated about four hundred drawings by the architect Poccianti (1888), about twenty by Carlo Markò the Elder (1873 and 1884) and about twenty by Ciseri (1893).

Because of the interest of the *conservatore* Nerino Ferri, a growing number of modern acquisitions appeared at the turn of the century. From 1878 to 1890 Ferri was not only devoted to the complete inventory and to the publication of the first catalogues of the collection, but was also active in soliciting gifts and acquisitions of Ottocento artists. His activity, however, was not without error. For example, he purchased sheets in lots of ten, by and large attributed to nineteenth-century sculptors, from the sculptor and collector Egisto Rossi, who was much later discovered to be a forger. Not all of these sheets are suspect and some are autograph. There were a good many other ottocento works which entered under the guidance of Ferri, i.e. those of Dupré, Pampaloni, Pollastrini, Gherardi, Mussini, Cassioli, Franchi and the rare Visconti drawing (given by Ferri). In addition, there were one hundred fifty drawings by Burci, a great corpus of five hundred drawings by Ussi (left by the artist in 1901), more than two hundred by Michele Ridolfi (given by his son in 1903, who had been a director), more than three hundred by Borrani (directly acquired from his son-in-law in 1906, 1912 and 1916), drawings by Fattori, Signorini, Puccinelli, Sorbi, Giani, ten beautiful Fontanesi's from the collection of Cristiano Banti and about fifty by Pasini acquired in 1914. Also included were works by artists of the new generation, such as Boldini and Michetti.

After the first world war, the collecting of nineteenth-century drawings almost ceased, and those acquired served principally to enrich the holdings of the Galleria d'Arte Moderna. The growth of the collection during the last ten years is tied to the new interest in the less celebrated aspects of the nineteenth century. This new interest was evidenced at the Gabinetto Disegni e Stampe of the Uffizi by the exhibition of ottocento drawings curated in 1971 by Carlo Del Bravo. To the important gifts already registered at that time, others have been recently added, from Pointeau to Canovai, from Sabatelli to Moricci (both treated in monographs in 1978 and 1979 in relation to exhibitions at the Gabinetto Disegni e Stampe). After the Moricci exhibition, one hundred drawings by that artist were donated. One can only hope that, in light of the present economic difficulty of acquiring additional drawings, further generous gifts will be forthcoming for study purposes and for the general enjoyment of the public.

Dottoressa Anna Forlani Tempesti, *Director*
The Gabinetto Disegni e Stampe degli Uffizi

Catalogue

Gaetano Gandolfi (San Giovanni in Persiceto 1734–Bologna 1802)

Gaetano Gandolfi was the younger brother of Ubaldo, both of whom were major figures in eighteenth-century Bolognese art. Their father, Giuseppe Antonio, was an agent for the Ranuzzi, a patrician Bolognese family. Gaetano probably began his studies with Ubaldo, seven years his senior, continuing them at the Accademia Clementina under Ercole Lelli. In 1760, the brothers traveled to Venice under the patronage of the Bolognese merchant, Antonio Buratti. The following year, during which they studied Venetian painting—especially the works of Sebastiano Ricci and Giovanni Battista Tiepolo, profoundly affected the formation of their styles, and led them to combine the tradition of Bolognese decoration with the luminescent grace and sensuous color of Venice. Returning to Bologna, they pursued active artistic careers. Both artists were members of the Accademia Clementina, where Gaetano taught classes in anatomy. During his career, Gaetano worked mainly for secular and ecclesiastical patrons in the Italian provinces of Emilia and Romagna, but also received commissions from Vienna, St. Petersburg and Moscow. In 1787-88, Gaetano traveled to London.

There are problems in separating the hands of Gaetano and Ubaldo, who painted in a similar manner (there is less of a problem with Gaetano's son Mauro, also a painter). Nominally, Gaetano's style, which was touched by Neoclassicism during the 1790's, seems bolder, richer and more imaginative. He was a virtuoso draftsman, producing a great number of drawings as well as sculpture.

Lidia Bianchi, *I Gandolfi,* Rome, 1936.

1. Apelles Painting Campaspe 1797

Black chalk, heightened with white on brownish paper. 12$\frac{1}{16}$ x 16$\frac{7}{8}$ in. (306 x 429 mm.). Foxing.

Verso inscribed in black chalk at lower center: *G. Gfi f. 1797.* Verso inscribed in graphite at lower right with Colnaghi's no.: *n 25725.*

Bibliography: The Metropolitan Museum of Art, New York, *Drawings from New York Collections,* III, *The Eighteenth Century in Italy* (by Jacob Bean and Felice Stampfle), New York, 1971, 113, no. 291, pl. 291.

Provenance: Waddingham and Son, London; P. & D. Colnaghi, London, 1962.

Lent by The Metropolitan Museum of Art, New York, Rogers Fund, 62.132.3.

An oil painting of the same subject (signed and dated 1793) was in the E. Sonnino Castelfranco collection, Bologna (see: Bianchi, *I Gandolfi,* pl. XLVIII). Although the subjects of the two works are identical and the dates close (if one accepts the 1797 date on the verso of the drawing), there are many differences between the two. The Metropolitan drawing is the more neoclassical, in its severer, isocephalic compositon and in its costumes.

Bean and Stampfle (*The Eighteenth Century in Italy,* 113) state that this is one of a series of four drawings exhibited in London in 1962. The others depict the Rape of the Sabines, the Death of Germanicus and Tullia Driving over the Body of Her Father. These four appear to have once been part of an even larger series seen in Bologna (Mimi Cazort Taylor connects the series to a similar sheet, *David and Abishai Stealing the Spear and the Cruse of Water from Saul's Tent,* in the National Gallery of Canada, Ottawa).

These late drawings reveal Gaetano's concession to contemporary taste, for they are neoclassical in both subject matter and composition. The present drawing is more restrained than earlier works by Gandolfi. Also, its simplicity arises from his return to the Bolognese classical tradition of academic draftsmanship (beginning with the Carracci). Although he was influenced by Neoclassicism, Gandolfi was never truly a neoclassical artist. His settecento elegance and grace always surface in such things as the treatment of drapery, feathers and hair.

Giuseppe Cades (Rome 1750 – Rome 1799)

Although Cades (whose father was French) died in the last month of the eighteenth century, he was an artist with one foot firmly implanted in the culture of the new century. He was trained by Francesco Mancini and Domenico Corvi who, in 1766, expelled the young Cades because of his independent nature. Although he won many prizes, Cades—a painter, sculptor and printmaker—only became a member of the Academy of San Luca late in his life (1786). He was a protégé of the aristocratic Chigi family and, among other commissions, decorated their palace in Ariccia. He was also patronized by other great families and, for example, painted the story of Gualtiero d'Angers from a novella by Boccaccio in the *palazzina* of the Villa Borghese; Catherine II of Russia was another patron. Cades' style was eclectic: more exactly, it was a pre-romantic interpretation of Neoclassicism. In addition, his decorative, linear tendencies pay a debt to the seventeenth-century Bolognese tradition of the Carracci School and Guido Reni.

From the beginning of his career, Cades' facility as a draftsman was apparent—it is said that he sold more drawings than any other contemporary artist living in Rome. Among other endeavors, he produced convincing drawings in imitation of the Old Masters, both to amuse people and to sell. For instance, one of his ''Raphael'' drawings was purchased by the Dresden Cabinet of Drawings. Since the supply of old master drawings was scarce, many artists produced copies. Reputedly, Cades was honest, selling his drawings as imitations.

In the 1770's, Cades became a well-known history painter (Englishmen on the Grand Tour often referred to him as the best history painter in Rome), although he seems to have partially supported himself by copying old master paintings and drawings. Later in the decade, his studio became the common meeting place of the grandees, also the patrons of Gavin Hamilton and Canova (*q.v.*). A great number of his historical works were set in the Renaissance.

In the last years of his life (which parallel the short-lived,

(continued on page 40)

2. Academic Male Nude 1781

Black chalk, heightened with white gouache on a blue-grey ground over ivory paper. 20½ x 15⅛ in. (521 x 384 mm.).

Signed and dated in black chalk at lower right: *Giusep Cades 1781.*

Provenance: H. M. Calmann, London, 1964.

Lent by Mr. and Mrs. George B. Young, Chicago.

This male academic nude reveals a seldom-seen side of the artist, who is known as an accomplished and prolific draftsman. Assuming that the signature and date were not added at a later time, this sheet demonstrates that Cades, like many artists, continued to draw *académies* throughout his life. In the drawing, he has ignored the model's support staff, positioning him in a pose reminiscent of the *ignudi* of Michelangelo's Sistine Ceiling. He has also employed the heroic proportions of Michelangelo's nudes, with distortions in the right hand and left foot. Both the figure's firm outline and the plastic modeling are subtly but tightly handled, lending a marble-like quality to the flesh. The shaded, rubbed background increases the sculptural quality, pushing the figure forward and giving it the effect of a bas-relief. Cades' treatment of the head—its abstract quality, its classical profile and treatment of the hair—reflect his studies after antique sculpture. A basic paradox between the lyrical, rococo elegance of the style and the powerful neoclassical nude animates this drawing, while revealing Cades' transitional artistic nature.

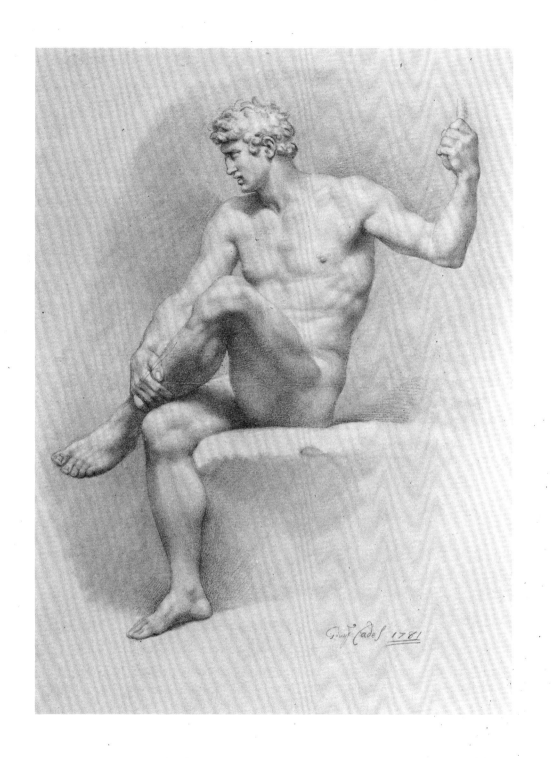

ill-fated Roman Republic), Cades supplied drawings to be engraved both by his brother-in-law, Leonetti, and other noted engravers. During these difficult years for Italy, he received little patronage, designing letterheads for the Republic and such trivial items as calling cards.

In the rather sketchy appraisals of Cades' career, it is often said that his "grand manner" version of Neoclassicism achieved a greater simplicity after 1784, due to the influence of David. Other views (e.g. Clark) hold that this change in style was entirely distinct from the art of David and resulted from the artist's coming to terms with his earlier work. Cades' simplified, bravura draftsmanship is totally Italian and, in its pre-romantic qualities, a prelude to that of Giani (*q.v.*) and Pinelli (*q.v.*) in the next generation.

Anthony M. Clark, "An Introduction to the Drawings of Giuseppe Cades," *Master Drawings,* II, 1, 1964, 18-26.

3. The Rape of Lucretia

Pen and dark brown and black ink, with brown wash over black chalk on ivory paper. 17⅛ x 10¹³⁄₁₆ in. (435 x 275 mm.).

Signed in brown ink at lower right: *Gius. Cades.*

William F. E. Gurley collection stamp at lower right.

Verso: Leonora Hall Gurley Memorial Collection stamp at lower center (Lugt Suppl. 1230b).

Bibliography: The William Benton Museum of Art, Storrs, Connecticut, *Rome in the Eighteenth Century: The Academy of Europe* (by Frederick den Broeder), n.p., 1973, 125-26, no. 121; The Art Institute of Chicago, *Italian Drawings* (by Harold Joachim and Suzanne Folds McCullagh), Chicago, in press, no. 151, pl. 161.

Provenance: William F. E. Gurley, Chicago; Leonora Hall Gurley, Chicago.

Lent by The Art Institute of Chicago, the Leonora Hall Gurley Memorial Collection, Chicago, 1922.648.

Religious subject matter dominates Cades' œuvre, although there is a group of drawings of mythological subjects from his later years. The Rape of Lucretia, a virtuous Roman matron, by Sextus Tarquinius, from Livy's *History of Rome,* was a favorite subject of artists since the late Quattrocento. It offered a classical source, republican political symbolism and eroticism. The drawing reveals Cades' ability as a draftsman, as well as his experience copying the Old Masters. Certain areas of the sheet, for example Tarquin's musculature and drapery and the figures' hands, reveal the influence of sixteenth-century draftsmen, while the diagonally oriented compositon and the treatment of the draperies are baroque. There is a classical restraint, however, together with decorative eighteenth-century elements, which betray Cades' transitional artistic status at the close of the Settecento. A more finished drawing of the same subject, signed and dated 1795, exists in the Thorvaldsen Museum in Copenhagen. In addition, the drawing is stylistically related to *The Birth of the Virgin* of 1784 (see: Clark, "An Introduction to the Drawings of Giuseppe Cades," 20, pl. 9).

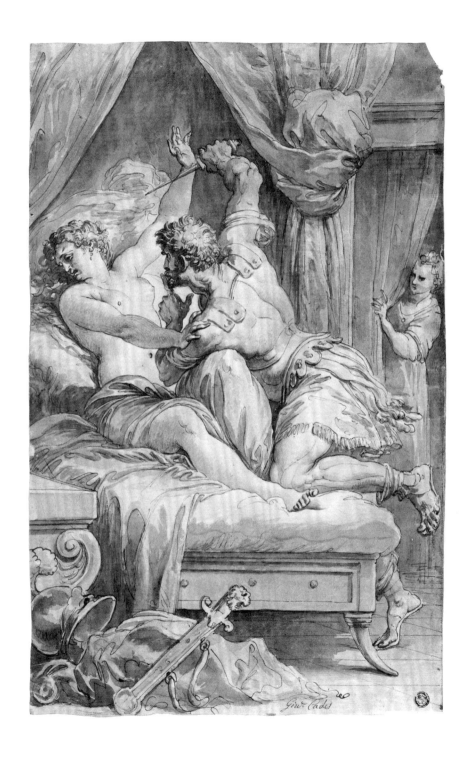

Andrea Appiani (Milan 1754 – Milan 1817)

Appiani, one of the premier neoclassical painters of Italy, first attended Carlo Maria Giudici's school of drawing. He then enrolled at the Brera Academy, where he studied under A. De Giorgi (also studying the works of Leonardo and Luini). Later, he perfected the fresco technique, for which he was famous, under Giuliano Traballesi (trained in an eighteenth-century tradition) and Martin Knoller (inspired by Mengs and Winckelmann). Appiani fused these two traditions into a personal brand of lyrical Neoclassicism. He specialized in mythological subjects, e.g. the 1778 series of four tempera paintings depicting the story of Europa, and created a tremendous reputation as a frescoist, e.g. the 1789 cycle of Psyche in the Villa Reale, Monza. In the early 1790's, Appiani traveled to Rome and Naples (1791) and to Parma and Bologna (1793). On these trips, he was strongly influenced by Correggio's works in Parma and by those of Raphael, Mengs and David in Rome.

Appiani befriended the intellectual elite of his time: Giovanni Berchet, Canova (*q.v.*), Ugo Foscolo and Stendhal. Linked with the Bonapartists, he aided the French in Milan (1796) and was a partisan of the Italian Kingdom. Appiani first painted Bonaparte twenty days after Napoleon's arrival in Milan. In fact, Bonaparte preferred Appiani to David, appointing him as his official painter in Italy. Accordingly, Appiani painted frescoes in the Palazzo Reale (1803-10), including his famous *Apotheosis of the Emperor* (1808) in the throne room, many of which were destroyed during the 1943 bombing. His *Parnassus* (1810-12), which is still extant in the Villa Reale, is one of the best examples of Appiani's lyrical fresco style. Appiani was in great demand during the Napoleonic era and painted many commissions for the Beauharnais family. In 1801, he traveled to Paris to consult about the projected Forum of Bonaparte in Milan, and later assisted in Bonaparte's coronation. He was also an agent for the Selection Committee, which chose works of art for churches and museums in Venice, Milan and Paris.

Appiani's style was not strictly neoclassical. His charm and treatment of light partially derive from his training in an eighteenth-century style, but also reflect his romantic tenden-

(continued on page 44)

4. Aurora: Study for the Casa Passal'acqua

Pen and brown ink with wash over graphite on off-white paper. 7⅜ x 11½ in. (187 x 292 mm.). Border slightly stained.

F. Dubini collection stamp at lower right (Lugt Suppl. 987a).

Provenance: F. Dubini, Milan; Seiferheld and Co., New York, 1969.

Lent by Mr. Mario Amaya, New York.

This freely drawn composition was preparatory for a decorative scheme in the Casa Passal'acqua in Milan (see: Nicodemi, *La Pittura Milanese Dell'Età Neoclassica,* 113ff), which was engraved in an oval-shaped composition by Michele Bisi and Giuseppe Marri. Because Aurora, her chariot and the seven accompanying putti are viewed from below, the composition was probably for a ceiling fresco. There are many differences between this drawing and the print, especially in the number and location of the putti, indicating that it was an early idea for the fresco. Appiani has, with an economy of pen strokes and wash, conveyed the light brought by Aurora and her entourage. The drawing indicates his debt to the Baroque painters and the lyrical grace which made him a popular decorator. Another more detailed study in black and white chalk of only Aurora is in the Gallerie di Venezia (see: *Ibid.,* pl. XXXIX, mislabeled as for the Casa Bevilaqua). Appiani executed a similar oval oil painting of *Cephalus and Aurora* in 1801 (see: Precerutti-Garberi, *Andrea Appiani,* 22, no. 7, fig. 4).

cies, which blossomed most fully in his portraits, e.g. of Canova, Princess Belgioioso d'Este, General Desaix and Napoleon as First Consul. He was most active as a portraitist between 1800 and 1813, producing numerous portraits of the personalities surrounding Napoleon. It is also believed that Appiani met Baron Gros in Milan in 1796.

His contemporaries termed Appiani the "*pittore delle grazie*," the painter of grace, allying him with Correggio and Raphael. Appiani's work also reveals a study of the classical masters of decoration, the Carracci, Domenichino and Poussin. Appiani suffered a stroke in 1813 and was unable to work during the last four years of his life. In his funeral oration, Berchet eulogized him as a second Raphael.

Giuseppe Beretta, *Le Opere di Andrea Appiani,* Milan, 1848.

Mino G. Borghi, *I Disegni di Andrea Appiani nell'Accademia di Belle Arti di Brera in Milano,* Milan, 1948.

Galleria d'arte moderna, Milan, *Andrea Appiani: Pittore di Napoleone* (by Mercedes Precerutti-Garberi), Milan, 1969.

5. Tondo Portrait of Napoleon Bonaparte c. 1796

Colored chalk on tinted pink paper. 5½ in. (140 mm.) in diameter. Border stained.

Provenance: Tanzi, 1881.

Bibliography: Alberto Neppi, *Andrea Appiani,* Rome, 1932, pl. 19.

Lent by the Civico Gabinetto dei Disegni, Castello Sforzesco, Milan, gift of Tanzi, A 49/1.

Appiani has represented a youthful, sensitive Napoleon Bonaparte. The drawing is presumably one of his early studies of Bonaparte (which Appiani used in subsequent portraits), after the French general's arrival in Milan (May 15, 1796). It is very similar to and may actually be a study for the head of Bonaparte in an equestrian portrait painted for Francesco Visconti Aimi, now in ruinous condition but preserved in a 1796 print (see: Precerutti-Garberi, *Andrea Appiani,* 60, no. 120, fig. 73). There is another related portrait by Appiani (dated 1796-97) which is, however, more romantic, painted in a freer style close to that of Baron Gros (see: *Ibid.,* 60, no. 121, fig. 74).

6. Cartoon for *Apollo and Daphne* c. 1800

Charcoal and stumping with white heightening on a pieced sheet of grey paper, squared for transfer. 39¾ x 26⅜ in. (1010 x 670 mm.).

Bibliography: *Angelika Kauffmann und ihre Zeitgenossen*, Bregenz, 1968, no. 110g, fig. 270; Galleria d'arte moderna, Milan, *Andrea Appiani: Pittore di Napoleone* (by Mercedes Precerutti-Garberi), Milan, 1969, 39, no. 35, pl. 25.

Provenance: Bolognini, 1865.

Lent by the Civica Galleria d'arte moderna, Milan, bequest of Bolognini, G.A.M. 576.

Squared for transfer, this large cartoon was preparatory for the figures of Daphne and Apollo in one scene from the decorative cycle of the story of Apollo, originally frescoed in the Casa Sannazzaro, Milan (then belonging to the Minister Prina). The delicately colored fresco (see: Precerutti-Garberi, *Andrea Ap-piani*, 26, no. 14, fig. 9, pl. VIII), which represents Appiani's mature poetic style, was later transferred to canvas and is now in the Pinacoteca di Brera. Appiani initialed and dated the cycle (1800) in the scene depicting the Contest of Apollo and Marsyas (the signature and date, which were damaged in 1814, are preserved in Michele Bisi's engraving). Except for the quick outlines of the trees, Appiani has, in this drawing, all but ignored the landscape in the fresco. By outlining the figures' contours and only suggesting the drapery and details, the artist focused on their positions and anatomy – Apollo's aggressive diagonal stance and Daphne's struggle. These two figures form an erotic vortex in the center of Appiani's compositon. Unlike the painting, where Daphne's metamorphosis is illustrated (with her hands sprouting leaves and her feet growing roots, as in Bernini's sculpture of the same subject), Appiani has only suggested it in the *pentimenti* of her arms and hands.

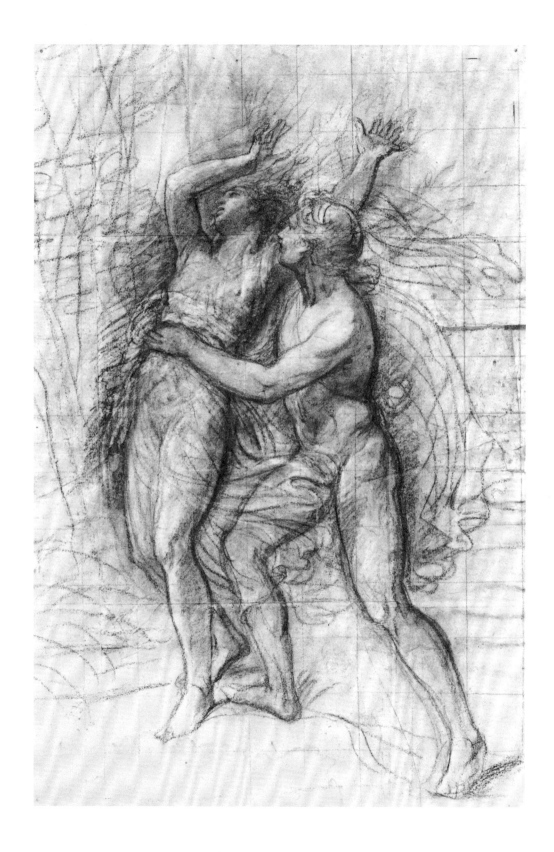

7. Head of a Woman

Black and white chalk with stumping on greenish-blue paper. $11^{1}/_{16}$ x $8^{15}/_{16}$ in. (280 x 227 mm.). Slightly stained.

Bibliography: Giorgio Nicodemi, *Appiani: 34 Disegni,* Milan, 1944, pl. X; Galleria d'arte moderna, Milan, *Andrea Appiani: Pittore di Napoleone* (by Mercedes Precerutti-Garberi), Milan, 1969, 50, no. 77 (with incorrect inv. no.), pl. 64.

Provenance: Marchesi-Fogliani, 1862.

Lent by the Civico Gabinetto dei Disegni, Castello Sforzesco, Milan, bequest of Marchesi-Fogliani, B 37-66.

The haunting grace of this drawing clearly reflects Appiani's study of the works of Leonardo da Vinci. Leonardo, who spent the major part of his mature years in Milan, remained a strong artistic force, a kind of sacred cow with which subsequent Milanese artists had to contend. In the smoky, rubbed technique of the drawing, Appiani has presented his version of Leonardo's *sfumato*. The model's androgyny and mysterious "Gioconda" smile also reveal Appiani's studies after Leonardo, as well as Correggio. It is not a Renaissance-style drawing, however, but is firmly rooted in the nineteenth century and recalls the work of the French artist, Prud'hon.

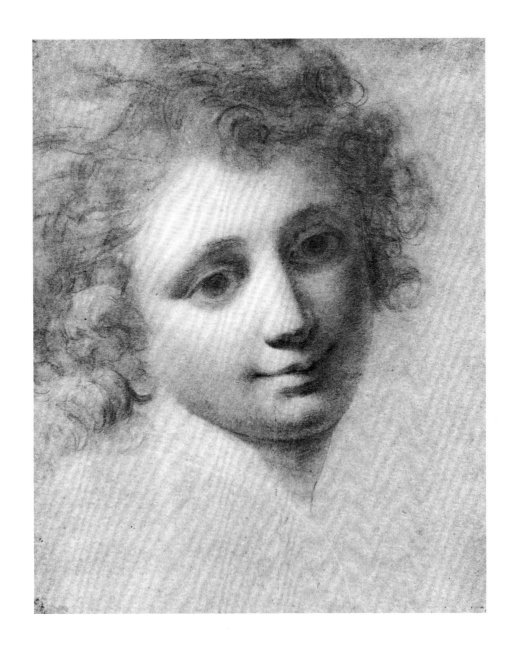

Antonio Canova (Possagno 1757–Venice 1822)

At his death, Canova, the most famous Italian neoclassical artist, was considered the greatest contemporary sculptor in Europe. Canova was first apprenticed to Giuseppe Torretti, with whom he moved to Venice (1768), where he studied casts of antiquities. In 1773, he received his first important commission, the *Orpheus and Eurydice*. In 1779, he traveled to Naples and Rome on a scholarship. Except for brief absences, Canova settled in Rome after 1780 for the rest of his career. There, he met Gavin Hamilton, Pompeo Batoni, Cades (*q.v.*) and Giuseppe Angelini, as well as archaeologists, theorists and restorers of antique statues. These contacts had a profound effect on the impressionable Canova. He began to develop his characteristically severe, revolutionary style (which seemed to fulfill Winckelmann's demand for a noble simplicity and a calm grandeur), first seen in his *Theseus and the Minotaur*. A series of papal commissions followed, which established his reputation. In 1800, the Academy of San Luca, which had heretofore jealously blocked Canova, finally elected him a member; in 1810, he was appointed president and, in 1814, "Perpetual President." The Pope made him a *cavaliere* in 1801 and, in 1816, the Marchese d'Ischia, after Canova had served as the agent for Pius VII in the 1815 negotiations to restore to Italy the works of art taken by Napoleon.

Canova, an influential teacher, enjoyed an international reputation, traveling to Paris in 1802 to work on a portrait of Napoleon. During this period, he was employed by the Bonaparte family, although that did not prevent Napoleon's enemies from also patronizing Canova. On his return to Italy, Canova completed the funeral monument of Maria Christina, journeying to Vienna in 1805 to supervise its installation. The sculptor traveled relatively infrequently, yet received numerous commissions from patrons throughout Europe. Catherine the Great, Emperor Francis II and Napoleon all invited him to remain in their countries; Canova replied that he could only

work in Rome. His famous American commission, the 1820 statue of George Washington for the capitol of North Carolina, was destroyed in a fire (the gesso remains at the Gipsoteca Canoviana).

Canova, who was also a painter, combined elegance with a cold sensuosity. He was celebrated by writers, including Byron, Dickens, Flaubert and Keats. Stendhal placed him among the three greatest men that he had met, while Heine dreamed that he had made love to Canova's *Venere Italica*. His contemporaries viewed Canova as heir to Italy's lost ages of greatness (the Antique and the Renaissance) and he therefore became a nationalistic symbol during the Risorgimento. In the end, Canova was ill and after 1820 spent more time at Possagno.

Canova produced 176 finished works which vary in style and range from the tension of *Hercules and Lichas* to the lyricism of *The Three Graces*. He employed assistants, but personally did the preparatory modeling and the final carving. Much of the criticism of Canova's œuvre is based upon replicas, executed years after the originals; in addition, some ideas were not realized until a commission was received years later. (See: Hugh Honour, "Canova's Studio Practice," *The Burlington Magazine*, CIV, 1963, 146ff; 214ff.)

Canova established the notion of the "modern" sculptor, liberating sculpture from the supremacy of the past. Although he assiduously studied the Antique in order to attain the Ideal, Canova was believed by many contemporaries to have surpassed it.

Elena Bassi, *La Gipsoteca di Possagno: Sculture e Dipinti di Antonio Canova*, Venice, 1957.

Elena Bassi, *Antonio Canova a Possagno*, Treviso, 1972.

Giuseppe Pavanello and Mario Praz, *L'opera completa di Canova*, Milan, 1976.

8. Lady Reclining in a Chair

Pen and brown ink on white paper faded to tan, with a black ink border. 6¼ x 7¾ in. (158 x 196 mm.).

Verso inscribed at lower right: *Nro:42*.
Verso inscribed at lower left: *19*.

Collection stamp of sphinx with one paw encircling a shield.

Bibliography: The Cleveland Museum of Art, Cleveland, *Neo-Classicism: Style and Motif* (by Henry Hawley), Cleveland, 1964, no. 151, ill.; The William Benton Museum of Art, Storrs, Connecticut, *Rome in the Eighteenth Century: The Academy of Europe* (by Frederick den Broeder), n.p., 1973, 136, no. 137, fig. 37.

Lent by the Fogg Art Museum, Harvard University, Meta and Paul J. Sachs Collection, Cambridge, 1948.25.

Canova frequently drew seated women in classical dress, occasionally in an identical *klismos* chair, who are either grieving or in a contemplative mood. He also rendered them in more finished monochrome studies for funeral monuments (for related drawings and monochromes, see: Il Museo Civico, Bassano, *I Disegni di Antonio Canova* [by Elena Bassi], Venice, 1959). These figures ultimately derive from the grieving women represented on Greek stelae and funeral vases. Canova, who more often drew with chalk, also used ink. A comparison with his ink drawings and the style of his handwriting (see: *Ibid.*, 138, no. E-6-99-1110-verso) supports the attribution of this drawing to Canova. Its abstract elegance and delicacy are hallmarks of Canova's style, while its notational quality is typical of the vast quantity of extant Canova drawings.

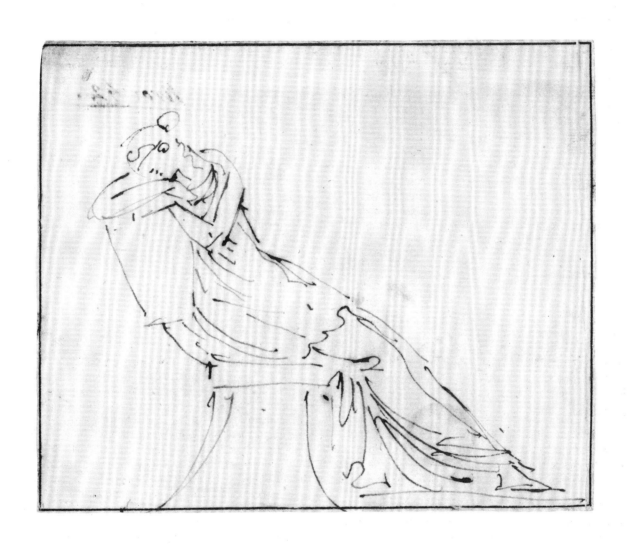

Felice Giani (San Sebastiano Curone 1758 – Rome 1823)

Born near Genoa, Giani was trained by practitioners of the eighteenth-century style, first in Pavia by Carlo Bianchi and Antonio Galli Bibiena (architect and scion of the scenographic family). Peripatetic his entire life, Giani moved to Bologna in 1778, where he continued his studies with Domenico Pedrini and Ubaldo Gandolfi. Two years later, he transferred to Rome, studying with Pompeo Batoni, Giuseppe Antolini and Christoph Unterberger at the Academy of San Luca. Giani began his independent career as a decorator of Roman *palazzi*. Although he was influenced by the prevailing neoclassical aesthetic, he developed a singular style combining light, decorative elements of the eighteenth century with classical compositions and themes. All influences, however, were tempered by his own fluid and imaginative calligraphy. Between 1784 and 1794, he lived in Bologna and Faenza, executing decorative commissions in the provinces of Emilia and Romagna. In 1803, he was summoned to Paris as one of the Italian designers who were imported to establish the French Empire style. There, it is believed, he decorated rooms in the

Tuilleries as well as the Malmaison, residence of the Empress Josephine. It is certain, however, that in 1812-13 he participated in the decoration of the villa at Montmorency (near Paris), belonging to Antonio Aldini, a Bolognese lawyer and early patron of Giani, who became Napoleon's Secretary of State for the Kingdom of Italy. (The works from this French period are unfortunately lost. Some scholars believe that they would support the hypothesis that Giani's free style had an influence on the French Romantics.) Until the fall of Napoleon, Giani divided his time between Paris and Italy. After the death of the Emperor, and until his own death, he successfully survived the stormy political changes and continued to execute decorative schemes in Rome.

Giani was a facile draftsman whose linear style asserted itself even in his paintings. Many of his extant decorative programs have never been studied; they are currently being rediscovered and researched, enabling scholars to reconstruct his œuvre. (The exhibition *L'Arte del Settecento Emiliano* [Sept. 8-Nov. 25,

(continued on page 54)

9. Aurora: Drawing for a Circular Ceiling Painting

Pen and brown ink with watercolor over graphite on off-white paper, squared for transfer in graphite. 13¹/₁₆ x 11¹³/₁₆ in. (331 x 300 mm.).

Inscribed in ink at lower center: . . . *L'aurora.* . . .

Bibliography: Richard P. Wunder, *Extravagant Drawings of the Eighteenth Century*, New York, 1962, no. 32, ill.; The Cleveland Museum of Art, Cleveland, *Neo-Classicism: Style and Motif* (by Henry Hawley), Cleveland, 1964, no. 157, ill.

Provenance: Giovanni Piancastelli, Rome.

Lent by the Cooper-Hewitt Museum, The Smithsonian Institution's National Museum of Design, New York, 1901-39-3213.

In this delicately colored tondo, Aurora, goddess of the dawn, throws flowers on the earth from a container supported by three putti. A fourth putto pours the morning's dew from a jar, while in the left background, Apollo, in his chariot with the sun at his back and the zodiacal band over him, begins his journey across the sky. Since the sheet is squared and numbered for transfer, it appears to be a preparatory study for a decorative ceiling commission, either as a presentation drawing, since it is highly finished, or as a more complete idea for the artist's own use. Two other drawings in the Cooper-Hewitt Museum are related to this watercolor in style, technique, composition and interest in light. The first, *Iris and the Rainbow* (1901-39-1807), is nearly identical in size and in its tondo format; the second, *Hymen, Bacchus and Venus* (1901-39-1806), is in an oval format. Two other pairs of oval, lightly-tinted drawings (see: Massar, "Felice Giani," figs. 11, 12; pls. 36, 37) depict scenes for an unknown decorative scheme involving Apollo and Phaeton. All four of these less-finished drawings include a floating figure of Aurora who carries a torch.

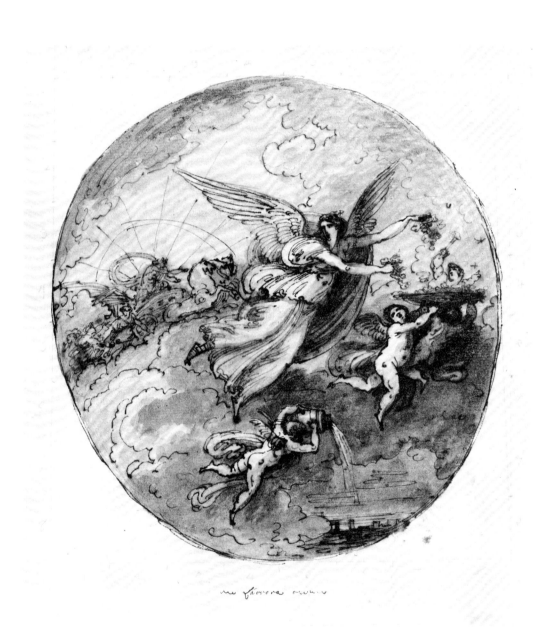

mu faccera mun

53

1979], should contribute to a greater understanding of Giani and his *ambiente*.) Giani's style is personal; it has a subjective and expressive dimension which has led to his designation as a "pre-romantic" artist. His fluid, stylized calligraphy is unmistakable. Like his contemporaries Pinelli (*q.v.*) and Duranti (*q.v.*), Giani possessed a fertile imagination and rarely lapsed into the rigid, rhetorical formulas of Neoclassicism. Rather, his forms are simplified, while his often-repeated themes are frequently derived from the classical repertoire. Giani, who was also an illustrator, was a prolific draftsman, with over 1,000 of his drawings in the Cooper-Hewitt Museum, as well as large deposits in Faenza, Forlì, Bologna and Rome.

Istituti Culturali ed Artistici, Forlì, *Disegni Inediti di Felice Giani nella Raccolta Faella,* Forlì, 1952.

Phyllis Dearborn Massar, "Felice Giani Drawings at the Cooper-Hewitt Museum," *Master Drawings,* XIV, 4, 1976, 396-420.

Stefano Acquaviva and Marcella Vitali, *Felice Giani,* Faenza, 1979.

10. Odysseus and the Greeks in the Cave of Polyphemus

Pen and brown ink with brown-grey wash over traces of graphite on off-white paper, with an ink border. 21 x 15^{1}/16 in. (533 x 382 mm.). A few wrinkles.

Inscribed in graphite at lower left: *831*

Bibliography: Yale Center for British Art, New Haven, *The Fuseli Circle in Rome: Early Romantic Art of the 1770's* (by Nancy L. Pressly), New Haven, 1979, 108, no. 109, ill.

Provenance: Giovanni Piancastelli, Rome.

Lent by the Cooper-Hewitt Museum, The Smithsonian Institution's National Museum of Design, New York, 1901-39-3226.

This drawing depicts Odysseus and the Greeks inside the huge cave of the giant Cyclops, Polyphemus (Homer, *The Odyssey,* IX, 187ff). Giani has depicted the one-eyed giant lording over his precinct, littered with the bones and armor of some of Odysseus' men. In the foreground, Odysseus and two other Greeks pour huge quantities of wine into Polyphemus' cup in order to dull his senses, while in the middleground, two men heat up the log with which to blind him. A third man in the middleground points out the barricaded sheep to another companion. It was by clinging to the bellies of these sheep that the Greeks eventually escape from Polyphemus. Although Giani is known to have painted scenes from *The Odyssey* (e.g. in the Palazzo Milzetti, Faenza), this drawing is not related to a commission, but is rather an independent drawing. The extravagant draftsmanship and horrific aspects of the subject reveal Giani's pre-romantic tendencies (similar to those of Fuseli). Pressly (*The Fuseli Circle in Rome,* 108) has suggested that this drawing was inspired by Pellegrino Tibaldi's *Blinding of Polyphemus* in the Institute of Bologna, especially the pose of the giant, his pipes, his club and the skeletal debris. Giani's cave setting, however, was his own invention and its massive size agrees with the description in Homer.

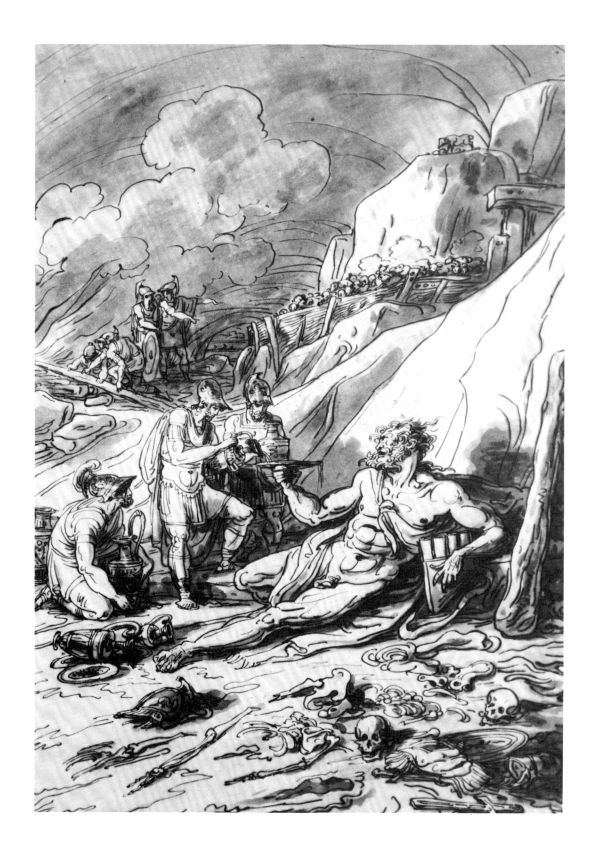

11. Sheet of Various Studies from a Sketchbook
c. 1810

Pen and brown ink with wash on off-white paper. 14¾ x 10¹/₁₆ in. (375 x 255 mm.).

Inscribed in brown ink, starting at the upper right: *150/ andrea Pisano. . . . sibille su/le porte/ di S Petro/nio in/Bologna/del/ senese/ detto/della/ fonte. . . . Monu del 2 cento Bologna. . . . 87 . . . Ludovico Caracci Bologna. . . . Cortile del palazzo Mattei ornato di belissimi antichi al uso/di un museo Roma. . . . monumento gia (?) nel corte del Sg Mattei Roma.*

Cooper Union collection stamp at right center (Lugt Suppl. 645b).

Verso: Studies of four horses' heads.

Pen and brown ink.

Provenance: Giovanni Piancastelli, Rome.

Lent by the Cooper-Hewitt Museum, The Smithsonian Institution's National Museum of Design, New York, 1901-39-2463.

This drawing is one page of a large Giani sketchbook (in the Cooper-Hewitt Museum) with drawings from Emilia, Romagna and Rome. Several other sheets from the sketchbook, which are dated 1810, similarly contain sketches of Bolognese monuments, including the Church of San Petronio. Since the drawing is comprised of five vignettes from Bologna and two from Rome, it is conceivable that Giani might have transferred each one to this sketchbook as a *ricordo* from another sheet. All of the inscribed vignettes are accurately labeled as to location, but often incorrectly attributed. They provide a valuable insight into the working methods of this prolific draftsman. Beginning in the upper right and reading clockwise, there are three suc-

cessive vignettes of sibyls, which Giani noted were from the façade of San Petronio. He also ascribed them to the Sienese artist *detto della fonte,* i.e. Jacopo della Quercia, but contradicts himself to the left of the first sibyl, where he inscribed the name Andrea Pisano. Della Quercia was only responsible for the main portal of San Petronio and not the right lateral door, where Giani's three sibyls are found. He has depicted the three central sibyls (of five) on the right pilaster of that door, attributed to the sixteenth-century sculptor, Niccolò Tribolo. With his graphic stylization, Giani has changed their proportions and made them more elegant. Below these figures, he has drawn an Annunciation, which is not duecento (thirteenth-century) as he indicates, but rather dates from c. 1480-82. These half-length figures by Francesco di Simone are actually on two separate plaques under the eighth window on the Pavaglione side of San Petronio (see: I. B. Supino, *L'Arte nelle Chiese di Bologna,* 2, Bologna, 1938, 173). Again, Giani has retained the basic configurations of the sculpture, but here, in addition to converting them into his own types, he has taken greater liberties. To the left, a vignette of the Creation of the Sun and the Moon, which Giani inscribes as after a painting by Ludovico Carracci in Bologna, may also come from San Petronio. The two remaining vignettes are from Rome. The first, the largest and most carefully drawn sketch on the sheet, depicts the courtyard of the Palazzo Mattei which, according to Giani, served as a museum adorned with antique monuments. In the upper left corner, the artist has drawn a monument from the Palazzo Mattei, a Roman funeral relief of a consul's family (inscribed: *TOMBA FAMIGLIA CONSOLARE ROMANA*).

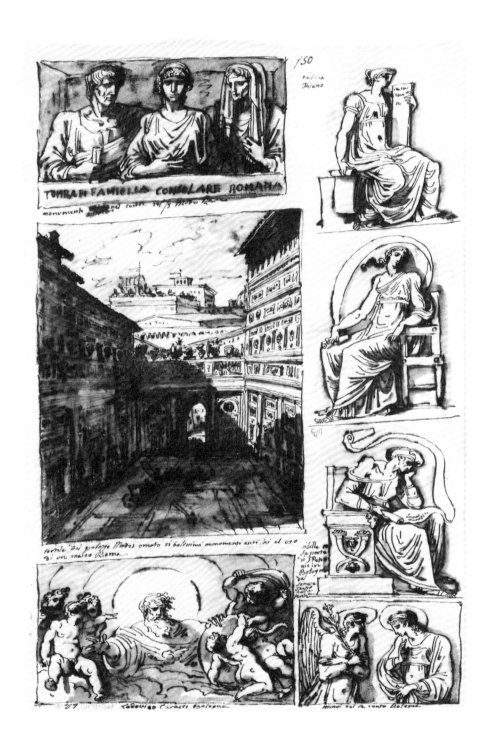

TOMBA DI FAMIGLIA CONSOLARE ROMANA

monumenti *nel conte* *tal fa Mateo* *la*

andria
Diano

150

cortile del palazzo Mateo ornato di baltinini monumenti antichi al uso
di un museo Roma

sibille m
la posta
di S.Patro
nio in
Bologna
del
senato
dalla
fonte

Lodovico Carracci Bologna

minn del n canto Bologna

Giuseppe Bernardino Bison (Palmanova 1762 – Milan 1844)

Bison studied in Brescia and later at the Venetian Academy (1777) where he was a pupil of Anton Maria Zanetti, Constantino Cedrini and the scenographer and vedutist Antonio Maurei, but the major influences on his work were the paintings of Gian Domenico Tiepolo, Marco Ricci and Francesco Guardi. Venice, because of its settecento tradition, had strongly resisted Neoclassicism. After traveling in northern Italy, Bison resided in Trieste (c. 1800-31), where he acquired certain neoclassical tendencies and became popular as a decorative painter. Later, romantic traits emerged in his paintings: he had been nominated as an associate of the Academy of Fine Arts in Venice, but moved to Milan (1831), which was at that time dominated by the Romantic style. In Milan, he worked as a vedutist in a vein similar to that of Migliara (q.v.), though he retained a sense of Venetian fantasy and light. Bison was a prolific draftsman who worked mainly in a decorative, eighteenth-century style with a decidedly Venetian flavor. He was a transitional artist who bridged the eighteenth and nineteenth centuries.

Carolina Piperata, *Giuseppe Bernardino Bison*, Milan, 1940.

Terisio Pignatti, "Drawings by Bison in Udine," *Master Drawings*, I, 3, 1963, 56-57.

Aldo Rizzi, *Disegni del Bison*, Bologna, 1976.

12. Scene of Antique Sacrifice

Pen and brown ink, brown and pink wash over traces of black chalk on yellowish paper, with brown ink border. 9⅛ x 13¹¹/₁₆ in. (231 x 347 mm.).

Inscribed in pen and brown ink at lower left: *G. Bison Veneziano.* Inscribed at lower right: *391.*

Verso inscribed in graphite at lower right with Colnaghi's no.: *31278 cxx.*
Verso inscribed in blue chalk at lower center: *9.*

Bibliography: The Metropolitan Museum of Art, New York, *Drawings from New York Collections*, III, *The Eighteenth Century in Italy* (by Jacob Bean and Felice Stampfle), New York, 1971, 115, no. 297, pl. 297.

Provenance: Seiferheld and Co., New York, 1960; David Rust, New York; P. & D. Colnaghi, London, 1970.

Lent by The Metropolitan Museum of Art, New York, Rogers Fund, 1970.177.

The frieze-like compositon and the neoclassical subject matter date this fine drawing to Bison's later career. Its subject derives from the type of Imperial Roman sacrificial scenes that were *de rigueur* on triumphal arches and other monuments. On the right, behind the wreathed emperor/priest, a sacrificial bull is led by two executioners with axes, while on the left a sheep is restrained prior to sacrifice. Three helmeted soldiers in quasi-Roman armor stand in the middle of the composition. This drawing is an interpretation of a Roman type, rather than an actual copy after the Antique. The delicate, eighteenth-century style of the draftsmanship contrasts with the neoclassical subject. It also reveals the artist's Venetian heritage, especially in the awareness of light, in the pink wash and in the Tiepolesque wash technique and types. This drawing resembles a series of grisaille panels in a decorative scheme in the Palazzo Carciotti, Trieste, c. 1806 (see: Franca Zava Boccazzi, "Gli Affreschi del Bison," *Arte Veneta*, XXII, 1968, pls. 231-36).

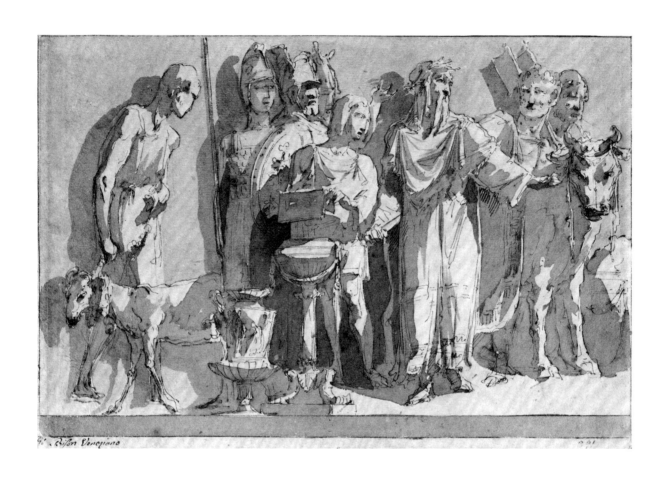

G.ᵗᵗ Bison Venesiano

59

13. Salome with the Head of John the Baptist

Watercolor over graphite, pen and brown ink on off-white paper. 11 x 9 in. (279 x 229 mm.).

Lent by Mr. Joseph F. McCrindle, Princeton.

This watercolor depicts the New Testament subject of Salome holding the head of John the Baptist on a tray, while Herod looks over his shoulder at her. Although the delicate, almost wispy line and the pastel colors appear to be eighteenth-century, Bison's close-up treatment of the figures creates a sense of monumentality in keeping with both neoclassical taste and the gravity of the subject. The enlarged physiognomies serve to date this drawing to Bison's later Milanese period, c. 1835. (It is similar to another drawing in the Brera, Milan; see: Beltrame-Quattrocchi, *Disegni dell'Ottocento*, 16, fig. 7).

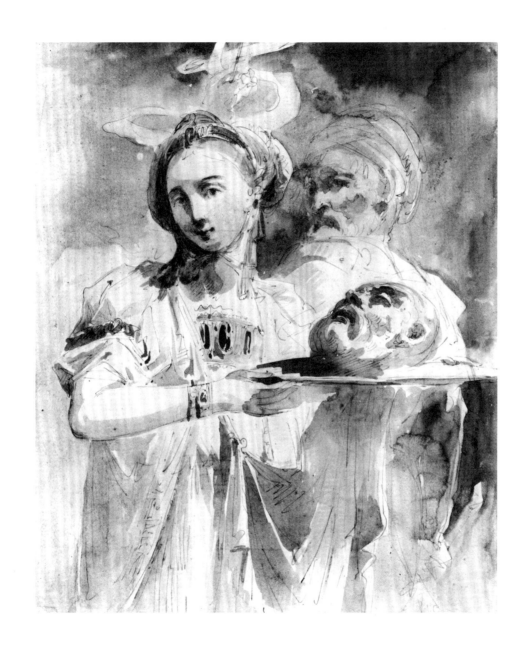

Giuseppe Cammarano (Sciacca 1766–Naples 1850)

Cammarano studied at the Academy of Fine Arts in Naples. At the age of thirteen, he painted scenery for the Teatro San Carlo under the direction of his teacher, Chelli. The two subsequently traveled to Rome. Upon his return, Cammarano frequented the school of Fedele Fischetti, traveling again to Rome in 1786 on a stipend from King Ferdinand IV. Two years later, he returned to Naples to work for the Bourbons, restoring and decorating the Palazzo Reale of Caserta. He also frescoed rooms in the Palazzo Reale of Naples with allegories celebrating the Bourbon family. In 1817, Cammarano returned to the Teatro San Carlo to paint the apotheosis of the grand poets and the glory of the Bourbons.

Cammarano was a neoclassical painter who executed a great number of portraits for both the Bourbons and the aristocracy of Naples. He also received commissions to decorate many *palazzi* of important Neapolitan families, as well as churches throughout southern Italy. He returned to his alma mater, the Academy of Naples, as a professor and was a member of the Royal Bourbon Academy. Cammarano was one of the representatives of the transition in style from that of the late eighteenth century to the academic mode which dominated the artistic establishment of Naples in the first half of the nineteenth century. Today, Cammarano is most noted for his idyllic landscapes. Many of his works are in the Museo di San Martino in Naples.

14. Amor and Psyche 1821

Pen and black and brown ink with brown wash, heightened with white gouache on brown paper with a black ink border, mounted on heavier paper. 13⅞ x 16¹³/₁₆ in. (352 x 427 mm.).

Signed and dated in black ink at lower right: *Giu.ᵉ Cammarano Napoli/ F. 1821.*

William F. E. Gurley collection stamp at lower right.

Verso: Leonora Hall Gurley Memorial Collection stamp (Lugt Suppl. 1230b).

Provenance: Puttick and Simpson, 1915; William F. E. Gurley, Chicago; Leonora Hall Gurley, Chicago.

Lent by The Art Institute of Chicago, the Leonora Hall Gurley Memorial Collection, Chicago, 1922.643.

Cammarano's finished drawing is an example of a late neoclassical formula applied to an erotic, almost rococo theme. It post-dates, by only four years, David's *Amor and Psyche* (1817), which is organized in the same compositional formula, but illustrates a different moment in the story of Cupid and Psyche. (Apuleius, *Metamorphoses*, IV, 28-VI, 24, records this allegorical folktale of the soul and divine love.) While David's painting depicts the moment just before daybreak, when Cupid coyly sneaks away from Psyche's bed in order to retain his secret identity, Cammarano illustrates the climax of the narrative, when Psyche, curious to discover the identity of her unknown night lover, shines her lamp on him. Cammarano's work is more serious and spartan, reminiscent of earlier Neoclassicism, whereas David's painting is more luxurious and sentimental. In this drawing, Cammarano employed the dramatic light effects inherent in the story which are, like everything else in the work, subservient to his strong linearity. The drawing exemplifies the conservative, academic style sanctioned by the Neapolitan court in the 1820's after the Bourbon Restoration.

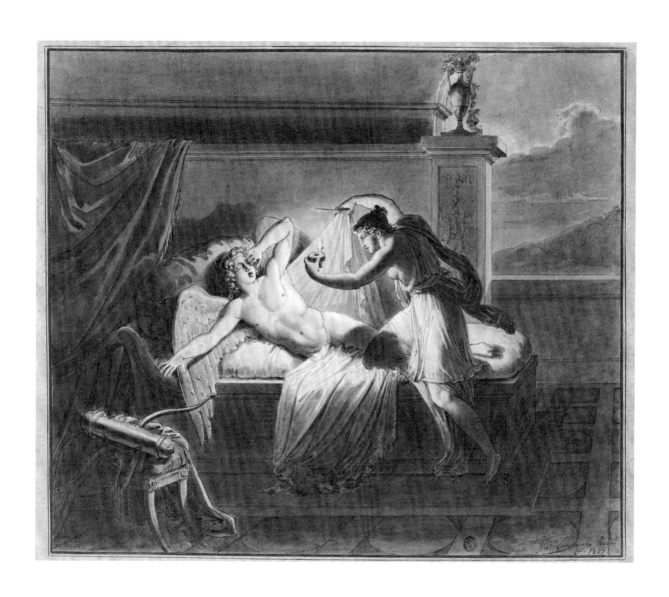

Pietro Benvenuti (Arezzo 1769 – Florence 1844)

At the age of twelve, Benvenuti was already a student at the Academy of Florence. In 1792, he traveled to Rome, where he remained until 1803, except for brief trips to Arezzo and Naples. In Rome, he was a student of Antonio Cavalucci, a follower of Batoni and Mengs, and studied the works of Raphael, Michelangelo and the other treasures of the city. He was involved with Davidian Neoclassicism and became friends with Camuccini (*q.v.*). In 1803, he accepted a chair of painting at the Florentine Academy and, in 1807, was elected director of the Academy, a post which he held until his death.

Benvenuti was one of the most important Tuscan neoclassical painters. He was also an accomplished draftsman, a dedicated and influential teacher and a staunch opponent of Romanticism. For a short time, he was court painter to Elisa Baciocchi, Napoleon's sister. He also served in an official capacity when, in 1815, he traveled to Paris with Canova (*q.v.*) as part of the commission to recover the paintings and sculptures which Napoleon had taken from Italy.

Benvenuti painted religious and mythological subjects, as well as portraits. Two of his most noted paintings are *Judith Displaying the Head of Holofernes* – the first version (1798), which was sold to Lord Bristol, is now in the Cathedral of Arezzo – and the decoration of the Room of Hercules in the Pitti Palace (1829).

Mario Salmi, "Per Pietro Benvenuti nel Primo Centenario della Morte, 1844-1944," *Reale Accademia Petrarca di Scienze, Lettere ed Arti, Arezzo Atti e Memorie*, XXXIII, 1945-46, 95-121.

Galleria Comunale d'Arte Contemporanea, Arezzo, *Pietro Benvenuti 1769-1844* (by Mario Mercantini and Dario Tenti), Arezzo, 1969.

15. Study for the *Oath of the Saxons to Napoleon* c. 1809-12

Black chalk on ivory paper. $7^9/_{16}$ x $12^3/_{16}$ in. (192 x 310 mm.). Slightly stained with a few spots.

Inscribed in black chalk at lower right: *96567*.

Uffizi collection stamp at lower center (Lugt 930).

Verso: Reclining female nude over male nude and sketches.

Pen and brown ink; black chalk.

Bibliography: Gabinetto Disegni e Stampe degli Uffizi, Florence, *Disegni Italiani del XIX Secolo* (by Carlo Del Bravo), Florence, 1971, 47-48, no. 23, fig. 17; The Royal Academy and the Victoria and Albert Museum, London, *The Age of Neo-Classicism*, London, 1972, 305, no. 494.

Lent by the Gabinetto Disegni e Stampe degli Uffizi, Florence, 96567.

This bold drawing is a compositional study for the large painting of the same title, signed and dated 1812, in the Galleria d'Arte Moderna in Florence (see: *La Galleria d'Arte Moderna a Firenze*, Rome, 1934, 25). The painting depicts the Saxon officers taking an oath before Napoleon to cease hostilities after the Battle of Jena (1806). Napoleon commissioned the painting from Benvenuti; in October 1809 Hayez (*q.v.*) saw a *bozzetto* for it in the artist's studio in Florence (Francesco Hayez, *Le mie memorie*, Milan, 1890, 11). The painting was in Paris for several years, but was returned to Florence by Benvenuti after he traveled to Paris as part of the commission to recover the works of art taken from Italy by Napoleon (1815).

The drawing is one of four known compositional studies for the painting (the other three belong to the Sandrelli family and were exhibited in Arezzo; see: Galleria Comunale d'Arte Contemporanea, *Pietro Benvenuti*, nos. 10, 11, 89z). Del Bravo believes (*Disegni Italiani del XIX Secolo*, 47-48) that the present drawing is the second in the series (he proposes the following sequence: Arezzo no. 10, Uffizi no. 96567, Arezzo no. 89z, Arezzo no. 11). Although the arguments for his sequence are persuasive, it seems difficult to determine whether the Uffizi drawing precedes or follows Arezzo no. 10. It is possible that either drawing was the first in the series (based on the positions of the figures in relationship to the final painting).

After Benvenuti fixed the final idea for the composition, he executed more detailed studies of the individual figures. There are fifteen related drawings in the Uffizi (one reproduced in Del Bravo, *Ingres e Firenze*, 147, ill.) and two exhibited in Arezzo (see: Galleria Comunale d'Arte Contemporanea, *Pietro Benvenuti*, nos. 12, 13).

96567

Born an aristocrat, Camuccini served no formal apprenticeship, although he did study under Domenico Corvi and Pompeo Batoni. Afterward, he studied independently under the supervision of his older brother Pietro, a dealer and restorer. During this period, he undertook an exhaustive investigation of antique sculpture and old master paintings, copying works of the Renaissance, the Seicento and Batoni. According to his own account, he spent three years (1787-89) studying the Vatican frescoes of Michelangelo and Raphael, and his fascination with them endured throughout his career. Camuccini, more than any other Italian neoclassical artist, was influenced by Raphael and published in 1806-07 a volume of drawings after Raphael's *Transfiguration.* At the same time, Camuccini is known to have painted copies of old masters for his brother to sell to traveling Englishmen. In the decade of the 1790's, his reputation grew together with his independent commissions. Although he worked under the shadow of Canova (*q.v.*), he befriended the new generation of Italian Neoclassicists – Benvenuti (*q.v.*), Bossi (*q.v.*) and Sabatelli (*q.v.*) – with whom he formed an informal academy, sharing models and studios. Camuccini's public stature was established with the *Death of Julius Caesar* and the *Death of Virginia,* commissioned in 1793 (exhibited later) by Frederick Hervey, Earl of Bristol and Bishop of Derry (who had previously ordered copies of old master paintings from Camuccini). He worked scrupulously on his paintings and was strongly influenced by the ideas of Winckelmann and Mengs, focusing on a more rigorous attitude toward Antiquity. For example, he spent three years preparing the cartoon for the *Death of Julius Caesar,* searching for antique models and consulting with archaeologists. The most enduring influences, however, were the Italian masters of the sixteenth through eighteenth centuries. In 1796, he began his association with the Borghese family by illustrating a catalogue of their antique sculpture collection.

During the first decades of the 1800's, Camuccini began to emerge from under Canova's shadow, becoming the almost uncontested premier neoclassical painter in Rome. In 1802, he was elected to the Academy of San Luca and assumed its presidency from 1805-10, and again after the death of Canova, from 1822-27. Like his mentor Raphael, Camuccini maintained a long association with the Vatican, beginning in 1803 when Pius VII appointed him as the director of the Vatican mosaic works. This position was followed by a lengthy term as superintendent

(continued on page 68)

16. The Education of Bacchus

Brush and brown wash over graphite on off-white paper, with a graphite border. 4½ x 6⅝ in. (114 x 168 mm.).

Inscribed in graphite at lower left: *Cammuccini Rome 1843.*

Verso: Partial study of a dead Christ.

Graphite.

Bibliography: Rhode Island School of Design, Providence, *The Age of Canova* (by Anthony M. Clark), Providence, 1957, 11, no. 41.

Provenance: Robert Gilmor, Junior, purchased in Rome, 1843.

Lent by The Peabody Institute of The Johns Hopkins University, Baltimore, P.I.13.57.

This drawing depicts the Education of Bacchus by the Nymphs of Nysa, which Camuccini frequently drew, together with Mercury Consigning Bacchus to the Nymphs (see: De Angelis, *Vincenzo Camuccini,* 21-22, nos. 47-50, four drawings in the Galleria d'Arte Moderna, Rome). Ovid, in his *Metamorphoses,* III, 236ff, relates the genesis of Bacchus: having discovered that Semele was pregnant with Bacchus by Jupiter, the jealous Juno asked Semele to have Jupiter appear to her in his true form, a thunderbolt. In granting her wish, Jupiter unavoidably burned Semele, but rescued her fetus (which he carried in his thigh until Bacchus was born). The infant was then taken by Mercury to be raised by the Nymphs of Nysa. The four drawings in the Galleria d'Arte Moderna depict the moment in the narrative when Mercury is actually handing the baby to the Nymphs.

The Baltimore drawing depicts the Education of Bacchus, shortly after he has been presented by Mercury to the Nymphs (the infant is the same size and age as in the four drawings illustrating the earlier incident). The four Nymphs surrounding Bacchus are either playing with or nursing him, while Mercury (in a winged helmet) looks on. The drawing, with its Poussinesque composition, has a number of elements in common with the works in the Galleria d'Arte Moderna – the reclining river god and the Nymph with her upraised arm (to the left in the Baltimore drawing), Mercury and a cluster of Nymphs in the center of the composition, with spectators in the background to the left. The free style of the sheet is similar to the wash technique which Camuccini employed in quick working drawings. In an 1824 inventory of his works, Camuccini lists two drawings depicting the Education of Bacchus, one given to G. G. De Rossi and the other to W. Y. Ottley (see: De Angelis, *Vincenzo Camuccini,* 21-22; 100, no. 10, for photographs of the inventory in the Archivio Camuccini, Rome). A drawing of this subject is also in the Albertina in Vienna (no. 14309 or R964).

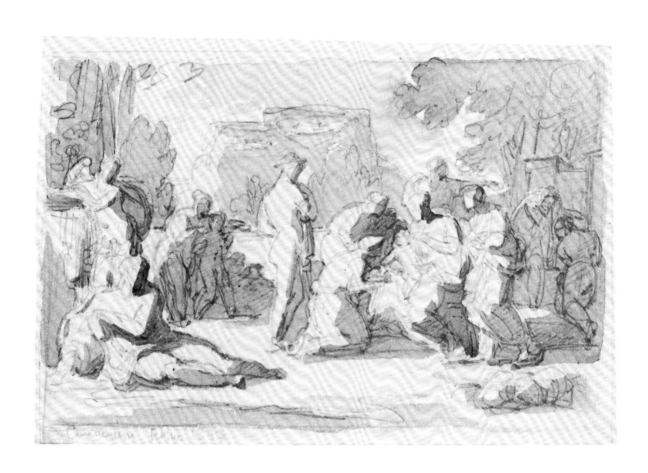

Vincenzo Camuccini

of the Vatican picture galleries (beginning in 1809), and another as inspector of public paintings for Rome and the Papal States between 1814 and 1843. The Catholic heads of Europe followed the Papacy's example and patronized Camuccini, as did Napoleon and the aristocratic families of Rome. Virtually all of the European academies eventually honored him with membership; he was appointed director of the Neapolitan Academy in Rome (1827); and Pius VIII made him a Baron in 1830.

David's influence on Camuccini has been exaggerated. It seems that during and just after the occupation of Rome, between 1809 and 1814, Camuccini was influenced by several non-Italian painters–Mengs, Gavin Hamilton, Peyron, Drouais and Suvée–more than David (who had admired Camuccini's works in Rome). In 1810, Camuccini traveled to Paris, where he encountered David, as well as Gros, Géricault and Jean-Baptiste Regnault, and was presented to the Emperor. Several Napoleonic commissions followed, but they remained unexecuted. Upon his return to Rome, he was commissioned in 1811, together with his rival Gaspare Landi, to head the group of Italian painters selected to decorate the Quirinal Palace for Napoleon's visit (he executed two paintings in the Emperor's apartments). Although his reputation was based on his history paintings, Camuccini also executed religious works and was

most accomplished as a portraitist; he painted many psychologically penetrating portraits gratis for writers and artists. He believed in factual authority and, for this reason, amassed a large library, to which he added the library of Angelica Kauffmann in 1814. In additon, Camuccini formed a distinguished private collection of art. Most of his major commissions were recorded by the artist in an inventory preserved by his heirs in Cantalupo (see: Hiesinger).

Camuccini's œuvre shows a great consistency of style, although in his late years he developed a preference for more baroque, diagonal compositions and freer brushstrokes. In the last decade of his life, Camuccini's fortunes changed–commissions tapered off, his brother Pietro died in 1833, and his conservative standards were attacked by exponents of Romanticism. He suffered a paralyzing stroke in 1842 and was unable to paint during the remaining two years of his life.

Carlo Falconieri, *Vita di Vincenzo Camuccini,* Rome, 1875.

Ulrich Hiesinger, "The Paintings of Vincenzo Camuccini, 1771-1844," *The Art Bulletin,* LX, 1978, 297-313.

Galleria Nazionale d'Arte Moderna, Rome, *Vincenzo Camuccini* (by Gianna Piantoni De Angelis), Rome, 1978.

17. Romulus and Remus

Brown wash over graphite on off-white paper mounted on heavier paper. 5^{1}/16 x 7^{1}/16 in. (129 x 180 mm.). Foxing.

Inscribed in graphite on paper mount: *Cammuccini.*

Bibliography: Rhode Island School of Design, Providence, *The Age of Canova* (by Anthony M. Clark), Providence, 1957, 11, no. 42.

Provenance: Robert Gilmor, Junior, purchased in Rome, 1843.

Lent by The Peabody Institute of The Johns Hopkins University, Baltimore, P.I.13.58

Plutarch relates the myth of Romulus and Remus, founders of Rome, in his *Lives,* "Romulus," 3ff: Rhea Silvia was imprisoned and her babies (fathered by Mars) were placed afloat in the flooded Tiber. They drifted ashore near the Ficus Ruminalis, where a She-Wolf nursed them. The twins were discovered by Faustulus, the royal herdsman who, with his wife Acca Laurentia, raised them as their own. It is clear that Plutarch was Camuccini's source–the drawing contains the woodpecker (in the tree) mentioned in "Romulus," 4, which, like the

She-Wolf, was sacred to Mars. The Baltimore drawing depicts the moment when Faustulus discovers the She-Wolf nursing the twins–the River God symbolizes the Tiber.

Several sources, including an inventory of Camuccini's work, refer to a painting and a replica which represent another episode in the myth, *Faustulus Delivering Romulus and Remus to His Wife.* It was painted in a Poussinesque style for the Minister of Bavaria in 1824. Camuccini produced various episodes and versions of the Romulus and Remus myth (see: De Angelis, *Vincenzo Camuccini,* 60, no. 130 and Hiesinger, "Camuccini," 307, 316, no. 29, pl. 15, a painting in the estate of Anthony M. Clark). De Angelis reproduces two drawings which are related to the Baltimore sheet: (1) a very finished study for a frontispiece of a history of Rome (55, no. 119, ill.), which only includes the twins, the She-Wolf and the reclining River God, and (2) a sketchy composition (60, no. 130, ill.), which De Angelis believes was a first idea for *Faustulus Delivering Romulus and Remus to His Wife.* The drawing in this exhibition, with its broad wash technique and blocky, abstract forms, is typical of Camuccini's careful initial studies.

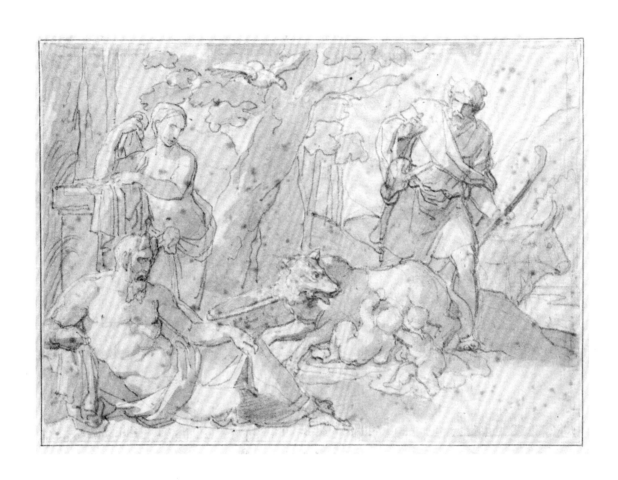

Born into a poor family, Sabatelli demonstrated his aptitude for art at an early age. At fifteen, he was commissioned by a wealthy Englishman to draw statues at the Academy of San Matteo. Under the patronage of Marchese Pier Roberto Capponi, Sabatelli studied at the Academy of Florence and journeyed to Rome and Venice. He was later patronized by Tommaso Puccini, the intellectual connoisseur from Pisa, who would become director of the Galleria di Firenze. In Rome, Sabatelli studied Fuseli's works after Michelangelo. His paintings of this period also reveal an affinity with the pre-romantic style (such as that of Fuseli), as do his engravings for Dante's *Divine Comedy* (begun in 1793) and his renowned etching of 1801, *The Plague of Florence*.

In 1808, Sabatelli was appointed to the chair of painting at the Brera Academy in Milan (where he remained over forty years), although he continued to carry out commissions in Tuscany. During his mature years, Sabatelli established himself as a decorator and fresco painter, with numerous public and private commissions. In 1820-25, he painted his most famous work: the enormous tondo of the vault in the Sala dell'Iliade in the Palazzo Pitti. It reveals his propensity for the style of sixteenth-century Mannerism, especially the works of Michelangelo, and his own brand of Neoclassicism. During this period, Ingres, who also turned away from a strict neoclassical style, was establishing himself in Florence and the two artists

became friends. Sabatelli was regarded as a strong draftsman in his own time, although his work reveals the French artist's influence, especially in his sensitive ink portraits. Sabatelli's portraits are, however, more robust in line and less elegant. His painting style, although it might be termed "neoclassical," is influenced by pre-romantic tendencies – an interest in Medieval themes, action, elegance and grand dramatic effects. He was also influenced by the work of Baron Gros.

No less interesting is Sabatelli's print production. An accomplished and innovative engraver himself, he furnished other engravers with drawings. He was a respected teacher and his students included Bezzuoli (*q.v.*) and the Induno brothers (*q.v.*). In 1848 (or 1850), he left the Brera and was replaced by Hayez (*q.v.*). In his later works, Sabatelli was assisted by his sons: Francesco, Gaetano, Giuseppe and Luigi, all painters.

Ugo Ojetti, "Ritratti di Luigi Sabatelli," *Pan*, II, 1934, 231-44.

Museo Civico, Pistoia and Gabinetto Disegni e Stampe degli Uffizi, Florence, *Disegni di Luigi Sabatelli della Collezione di Tommaso Puccini* (by C. Mazzi and C. Sisi), Pistoia, 1977.

Gabinetto Disegni e Stampe degli Uffizi, Florence, *Luigi Sabatelli: Disegni e Incisioni* (by Beatrice Paolozzi Strozzi), Florence, 1978.

18. Orestes Pursued by the Erinyes

Pen and brown ink over graphite on white paper. $16^{15}/_{16}$ x $23^7/_{16}$ in. (430 x 595 mm.).

Inscribed in blue ink at lower left: *Canova*.

Lent by Mr. Frederick J. Cummings, Detroit.

Orestes avenged the murder of his father, Agamemnon, by killing his mother, Clytemnestra, and, according to some authors, also her lover, Aegisthus. Only the non-Homeric tradition introduced the Erinyes (or Furies), the horrific snaky-haired avengers. Sabatelli's illustration follows the tradition established by Aeschylus, in which the Erinyes were supernatural apparitions rather than psychological phantasms. He has drawn Orestes in the middle of the sheet, still clutching the knife with which he murdered his mother. Orestes recoils in horror from her corpse, while the three Erinyes (Trisiphone, Alecto and Megaera) reproach him. The unfinished figure at the left, turning in grief and restraining Orestes' right arm, is probably Aegisthus. In style, this drawing is similar to many others executed by Sabatelli for the *literato* Tommaso Puccini (see:

Strozzi, *Luigi Sabatelli* and Pistoia, *Disegni di Luigi Sabatelli*), and is closest to the 1796 drawing of *The Death of Alcibiades* (see: Strozzi, *Luigi Sabatelli*, 46, no. 34, fig. 37). Sabatelli was influenced by the pre-romantic tendencies of Fuseli (e.g. his works after Michelangelo), as seen in the entire composition of this sheet – especially in the dramatic manner in which the figures interact, the exaggerated anatomy, the fierce expressions on their faces and the extravagant quality of the draftsmanship. The careful crosshatching, however, is tighter than Fuseli's freer style and betrays Sabatelli's activity as a printmaker. The Fuseli-like, visionary qualities dominate the classical isocephaly and poses, which derive from ancient sculpture, so that despite its neoclassical veneer, the drawing is essentially romantic. As with many of the drawings that Sabatelli made for Puccini (who, incidentally, owned a copy of Edmund Burke's *Philosophical Inquiry into the Origin of our Ideas on the Sublime and Beautiful*, published in London in 1776), its subject derives from a sublime and terrible literary source.

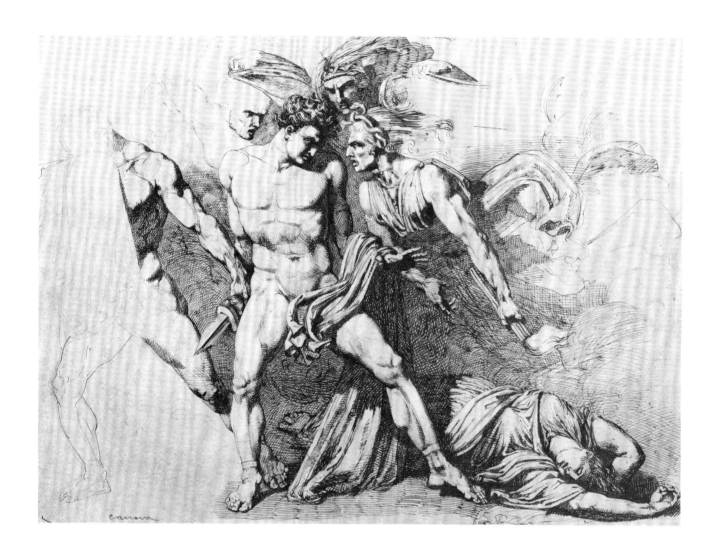

Antonio Giuseppe Basoli (Castel Guelfo di Bologna 1774 – Bologna 1843)

In 1803, Basoli began to teach at the Academy of Bologna, where he had studied in the *ambiente* of the Gandolfi and Bibiena families. He passed most of his life in the Bolognese area, except for several trips to Trieste (1801), to Florence and Rome (1805), to Ravenna (1816) and to Milan (1818). Basoli's reputation was primarily as a scenographer and decorator, and his work often involved collaboration with his two brothers, Luigi and Francesco. Basoli decorated numerous Bolognese *palazzi*, theaters (e.g. the Teatro Comunale) and villas, many of which have been destroyed. There are drawings in various museums which also preserve his work. (*Libretti* in the Biblioteca Marucelliana in Florence document his extensive work as a scenographer from 1808 to 1820.) He also collaborated with his brothers on a series of didactic books, e.g.: (1) *Raccolta di prospettive serie, rustiche e di paesaggio* (1810); (2) *Guernizioni diverse di maniera antica* (1814); (3) *Porte della città di Bologna* (1817); (4) *Vedute pittoresche della città di Bologna* (1833); (5) *Raccolta di diversi ornamenti* (1838); (6) *Alfabeto pittorico* (1839); etc.

Although Basoli's style developed from the same Bolognese decorative tradition as that of Giani (*q.v.*), he only occasionally approached that artist's refined elegance. His work also exhibited both neoclassical and romantic traits.

19. Stage Design: Roman Baths

Pen and black ink with wash over traces of brown ink on off-white paper, with an ink border. 14¹³/₁₆ x 22¼ in. (376 x 564 mm.). Slightly stained.

Provenance: Giovanni Piancastelli, Rome; Mr. and Mrs. Edward Brandegee, Brookline.

Lent by the Cooper-Hewitt Museum, The Smithsonian Institution's National Museum of Design, New York, 1938-88-437.

Basoli's idea for the interior of a Roman bath is depicted in this large scenographic design. Although he has employed barrel vaults with coffers and the severe Doric order of the classical vocabulary, Basoli's representation is highly eclectic and imaginative, as in the cascades of falling water. The manner in which the architectural elements are combined, together with the visual drama of the space and light, ally it to the romantic tradition. Basoli, who developed out of the Bibiena line, was indebted to Piranesi; this coldly classical drawing is also surprisingly close to the theater designs of his contemporary, Karl Friedrich Schinkel. The drawing is part of a group of related sheets in the Cooper-Hewitt Museum (1938-88-430-439), of which no. 430 was published in Basoli's *Collezione di Varie Scene Teatrali*, Bologna, 1821. In other works, Basoli represented exotic interiors (Eastern, Gothic, etc.) which, in comparison with this Roman bath design, reflect the changing aesthetic from Neoclassicism to Romanticism.

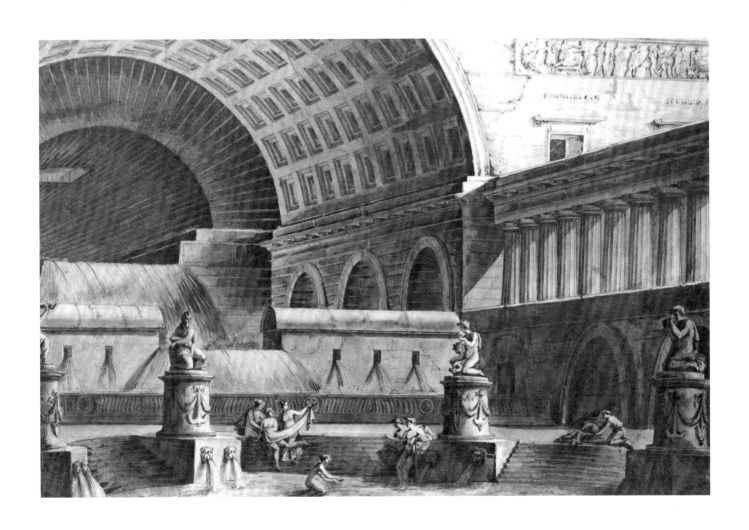

Pietro Bargigli (Livorno second half of the 18th century – Rome after 1814)

Little is known about Bargigli, an architect who worked in Rome during the first years of the nineteenth century. According to Alizieri (*Proceedings of the Professors of Drawing in Liguria*, 1864), Bargigli was one of the official architects of the short-lived Roman Republic. In 1801, he was invited to Milan by Count Sommoriva, who had presented his name to Napoleon, to assist in decorating the city in celebration of Napoleon's victories in Italy.

His Napoleonic ties continued to supply Bargigli with commissions. After 1802, he was summoned to Carrara by Princess Elisa Baciocchi, Napoleon's sister and a patroness of the arts, to teach architecture and ornament at the Academy of Fine Arts. He remained there until 1814 and died a few years later (the exact date is unknown).

20. View of a Circular Temple 1791

Pen, brown ink and watercolor on off-white paper. $17^{15}/_{16}$ x $22^{3}/_{4}$ in. (456 x 578 mm.).

Signed and dated at lower left: *Pietro Bargigli fecit 1791.*
Inscribed at lower right: *Paolo Brizzio 1791. Roma 1843*(?).

Bibliography: Anthony M. Clark, "Roman Eighteenth Century Drawings in the Gilmor Collection," *BMA News*, XXIV, Spring 1961, 5-12, fig. 9; The Cleveland Museum of Art, Cleveland, *Neo-Classicism: Style and Motif* (by Henry Hawley), Cleveland, 1964, no. 164, ill.

Provenance: Robert Gilmor, Junior, purchased in Rome, 1843.

Lent by The Peabody Institute of The Johns Hopkins University, Baltimore, L.38.

Gilmor mistakenly attributed the drawing to Paolo Brizzio (as is evidenced by the inscription at the lower right) and added the date when he acquired it (1843). The central portion of the idealized architecture in this watercolor appears to be a fanciful interpretation of the Round Temple at Tivoli. In contrast, another watercolor by Bargigli, entitled *Landscape with a Sacrificial Scene* (see: Stanza del Borgo, *Eco Neoclassica*, 26, no. 8, ill.), depicts a more topographically accurate view of this temple on its rocky precipice. Bargigli worked in the tradition of Pannini and Piranesi, but his treatment of ancient architecture differed profoundly. Rather than depicting a dead civilization, Bargigli, caught up in the spirit of Neoclassicism, created an ideal and energetic world in full bloom. His works often suggest the lost Golden Age; as in this watercolor, his precise linear style and limpid colors add to the lyrical quality.

Based on an analysis of the figures, Clark ("Roman Eighteenth Century Drawings," 10-12) has suggested the following theme for the drawing: the Allegory of the Poet Weaned from Envy or from Uncontrolled Passion to True Imagination. In the foreground, a young poet is shown the way to the temple by Victory (with a palm) and Eros (with a torch). A genius (with the wreath of Immortality) sits waiting, while two putti scorn the old woman (Envy) to the left, from whom the poet has been called. The path is clear to the ideal temple above, where a statue of Apollo is enshrined. Clark believed that the watercolor also reveals Bargigli's awareness of other neoclassical artists in Rome, e.g. Giani (*q.v.*) in the treatment of the figures and Giuseppe Valadier in the scenographic architecture.

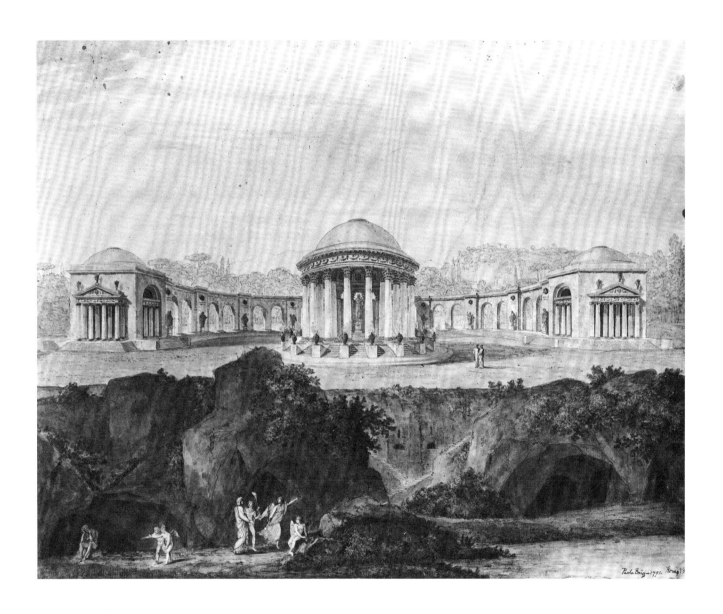

Agostino Aglio (Cremona 1777–London 1857)

Aglio, who spent most of his mature years in England, can also
be considered an Italian artist. He first studied at the Brera
Academy in Milan with Giocondo Albertolli, and then with the
landscape painter Luigi Campovecchio. After 1797, Aglio
traveled to Greece and Egypt with the English architect William
Wilkins, with whom he went to London (in 1803) and illustrated
The Antiquities of Magna Graecia (1807). Aglio also illustrated *A
Collection of Capitals and Friezes Drawn from the Antique* (1820-30)
and collaborated on the large *Antiquities of Mexico* (1831-48).
Concurrently, he continued his activities as a decorative painter
in the Italian tradition, embellishing theaters, villas and
churches in England and Ireland. He also painted portraits (e.g.
two portraits of Queen Victoria) and was an accomplished
landscapist in watercolor. His later works reflect the English
watercolor tradition (e.g. Constable). Aglio was a printmaker
and was, in fact, among the first to practice lithography in
England. Many of his prints were exhibited at the Royal
Academy in London.

21. Idyllic Landscape 1803

Gouache on paper mounted on heavier paper. 18½ x 18⅛ in.
(470 x 461 mm.).

Signed and dated in white bodycolor at lower right: *A. Aglio
1803*.

Bibliography: Sotheby Parke Bernet and Co., sale catalogue,
London, *Nineteenth Century Drawings and Watercolors*, London,
May 1979, no. 6, ill.

Provenance: Sotheby Parke Bernet and Co., London, 1979;
Shepherd Gallery, New York, 1979.

Lent by Mr. Paul T. Zappert, New York.

The decorative quality of this imaginary mountainous land-
scape derives from an established eighteenth-century Italian
tradition. The work itself, dated 1803, the year of Aglio's depar-
ture for England, reveals no influence of the English School. It
was, therefore, executed either while Aglio was still in Italy or
soon after his arrival in England.

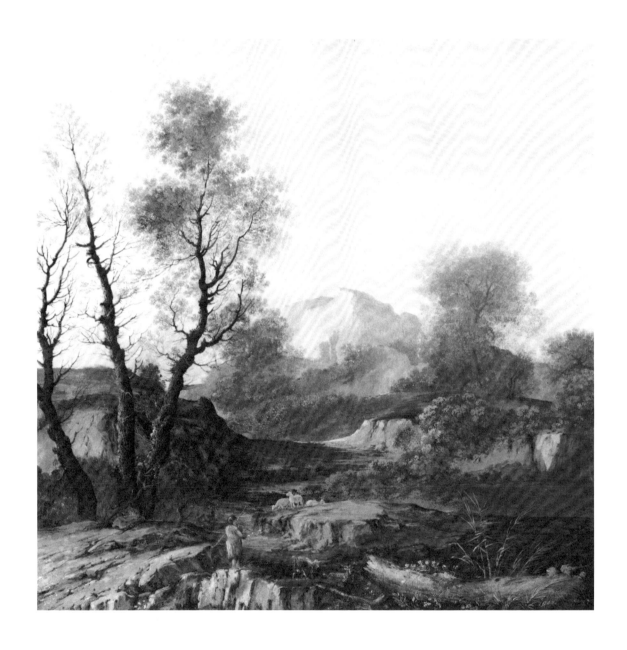

Bartolini, the most important Italian sculptor after Canova (*q.v.*), was born near Prato into a poor laborer's family, and moved to Florence when he was twelve. He was first trained as an artisan: he was apprenticed to the Pisani marble works in Florence and was later employed (in 1795) at an alabaster factory in Volterra, where he discovered Flaxman's engravings for Homer and Aeschylus. He also studied briefly at the Florentine Academy under Angelo Corsi, producing a sculpture of a satyr. Full of enthusiasm for Bonaparte, he entered the service of a French general, eventually arriving penniless and alone in Paris in 1799. Jacques-Louis David provided Bartolini with a place in his atelier, where he became a close friend of Granet and a life-long friend of Ingres (Ingres painted a portrait of Bartolini in 1805). Canova invited Bartolini to Rome in 1802, but he chose to remain in Paris, where he established a reputation as a neoclassical sculptor in the service of the Emperor. While in Paris, he executed about fifteen works, including a bust of Bonaparte and a bas-relief of the Battle of Austerlitz for the Vendôme Column.

In 1808, Bartolini was appointed director of sculpture at the Academy of Carrara by Elisa Baciocchi, Napoleon's sister. Many of his works for the Emperor and members of his family from this period were destroyed in 1814 when a mob broke into Bartolini's studio. After 1814, Bartolini's well-known Napoleonic sympathies alienated the conservative elements of Italian society. However, he established himself in Florence by producing a great number of portrait busts, many of foreigners such as Byron and Madame de Staël, which display his growing naturalism, in contrast to the severity of Canova's classicism. In 1820, upon Ingres' arrival in Florence (for a four year stay), their friendship resumed (Ingres again painted Bartolini's portrait) and they shared a studio. At this time, Bartolini's close study of Florentine quattrocento sculpture, which also displayed certain naturalistic qualities, became evident, e.g. in the *Carità Educatrice* (1824). This work represented a marked departure from the prevailing neoclassical tradition; its subject was not heroic, and Bartolini modeled the gesso directly from a woman and children posed in candlelight. It was followed by several more romantic sculptures: the sentimental *Fiducia in Dio* (1835), the dramatic *Astyanax* (1840-49) and the *Ninfa dello Scorpione* (exhibited at the Paris Salon of 1845 and praised by Baudelaire).

For some years after his arrival in Florence, Bartolini struggled for recognition. His application for the position of professor of sculpture at the Academy in Florence was rejected in 1825 (Stefano Ricci, who worked more in the tradition of Canova, was appointed). However, after Ricci's death in 1837, Bartolini gained the post (1839). Bartolini's unorthodox approach to art continued to make him a controversial figure. In 1840, after his appointment to the Academy, the infamous incident of the hunchback (*Il Gobbo*) occurred. Bartolini brought a hunchback

(continued on page 80)

22. Studies After Antique Sculpture 1818

Black chalk on white paper. 22½ x 16½ in. (572 x 418 mm.). Foxing.

Inscribed in black chalk at lower left: *questa tonica/ è bella e si/ osservi le/ pieghe* [sic].

Bibliography: Palazzo Pretorio, Prato, *Lorenzo Bartolini*, Florence, 1978, 202, no. 19, ill.

Lent by a Private Collection, U.S.A.

This drawing is one of four academic studies (for the other three, see: Palazzo Pretorio, *Lorenzo Bartolini*, 202-03, nos. 20-22) which reveal Bartolini's direct debt to antique sculpture. The subjects of these sheets were drawn from various Elgin Marbles; according to the July 16, 1818 issue of the *Gazzetta di Firenze*, casts of the Elgin Marbles (in the British Museum) were exhibited at the annual exposition at the Academy of Fine Arts during that year. Bartolini did not frequent the Academy, where the casts were stored after 1818, and thus did not otherwise have access to them until 1839, when he was appointed a professor. In this drawing, Bartolini has carefully studied the plasticity of the figures and focused on their modeling in a tight style which corresponds to a date around 1818.

The upper, more highly finished section of the sheet is drawn from the western frieze of the Hephaesteum (Theseum) in Athens, illustrating the Battle of the Centaurs and the Lapiths. Bartolini focused on two combatants arranged in a metope-like pose, drawing them in a more detailed and precise manner than is evident in the weathered originals. In the lower half of the sheet, on a smaller scale, Bartolini sketched four figures from the frieze of the Nike Temple on the Athenian Acropolis, illustrating the Battle of the Greeks and the Persians. The two left figures are more completely drawn than the lightly indicated running and fallen warriors on the right, which foreshadow the freedom of his late style.

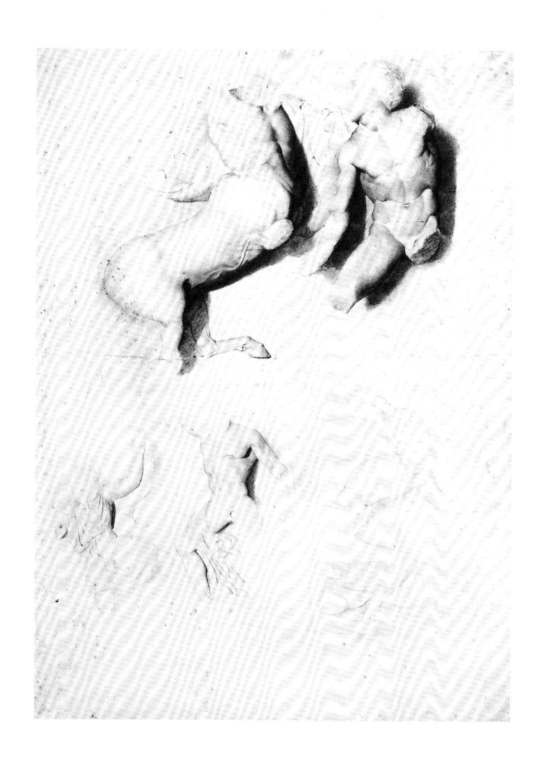

Lorenzo Bartolini

into his class as a model for "Aesop composing his Fables," which shocked the conservatives, who espoused an art of the Ideal. The sculptor turned on his critics, replying (in the *Giornale del Commercio* of 1842) that an artist must copy accurately and that everything in nature should be studied. Afterward, Bartolini incorporated the motif of the hunchback into his personal emblem, which he placed on his seal and a stele in his garden. The tondo crowning the stele, like his seal, depicts a bearded, nude hunchback wearing a helmet, who holds in his left hand a mirror (truth to Nature) and with his right strangles a serpent with the head of an ass (the beast of academic classicism). Bartolini lived to see the triumph of his naturalistic ideas; when he traveled to Rome in 1847, to model a bust of Pius IX, he observed that his principles had replaced those of Canova.

Mario Tinti, *Lorenzo Bartolini*, 2 vols., Rome, 1936.

Palazzo Pretorio, Prato, *L'Opera di Lorenzo Bartolini*, Prato, 1956.

Palazzo Pretorio, Prato, *Lorenzo Bartolini*, Florence, 1978.

23. Study for the *Astyanax* c. 1840-49

Brown ink over black chalk on off-white paper with an irregular bottom. 11¼ x 7½ in. (286 x 191 mm.).

Inscribed (?) in graphite at upper left: *L. Bartolini*.

Verso: Studies of hands (tracings?).

Graphite.

Bibliography: Shepherd Gallery, New York, *Italian Nineteenth Century Drawings and Watercolors: An Album* (by Roberta J. M. Olson), New York, 1976, no. 153, pl. 8; Roberta J. M. Olson, "The Preparatory Drawings for Bartolini's *Astyanax*," *Master Drawings*, XVI, 3, 1978, 302-08, pl. 54.

Provenance: Giovanni Piancastelli, Rome; Reverend Father Francis Agius, Inwood, Long Island; Shepherd Gallery, New York, 1976.

Lent by Mr. and Mrs. Harry Glass, Old Westbury, Long Island.

This is the final drawing in an evolutionary series (eight sheets, two with versos) for one of Bartolini's most celebrated sculptures, his *Astyanax* of 1840-49 (see: Olson, "Bartolini's *Astyanax*," 302-08). The *Astyanax* (inspired by the *Paralipomeni to the Iliad* of Quintus Smyrnaeus) is seminal in Bartolini's œuvre; it has a dynamism rare in his sculpture. Commissioned by the Countess Rosa Poldi Trivulzio of Milan, it depicts Astyanax, son of Hector, about to be thrown from the walls of Troy while his mother, Andromache, pleads for his life. Since Bartolini was a Bonapartist, the sculpture has been interpreted as showing, epigrammatically, the tragedy that befell Napoleon's supporters after his defeat. There were two distinct conceptions for the sculpture, and two gessos which relate to them. Bartolini also began carving on a flawed block of marble and had to turn to a second. An unsolved mystery surrounds the fate of the final gesso and marble, although they both probably perished either in the bombing of the Palazzo Poldi Pezzoli in 1943 or were lost during the storage and shipment of the contents of the palace prior to that attack. Today, only a posthumous bronze cast of 1896 survives on the terrace of the Museo Poldi Pezzoli.

This drawing is broader and more quickly rendered than the other larger sheets in the series. In it, Bartolini has solidified his final conception for the sculpture. The slight *pentimenti* in black chalk, together with the overworked left side of the warrior's torso, indicate that it is no mere *ricordo* after the sculpture, but rather a working drawing. The fact that neither the final positions of Astyanax's arms, nor the final form of the warrior's drapery, nor the final attitudes of Andromache's head and body have been rendered in the drawing, reinforces this conclusion. It is, however, very close to the work, e.g. the dramatic expression on the warrior's face approaches the sculpture's ferocity.

The borders of the drawing may have been cropped, tempting one to conclude that the drawing once included the base. It is a bold, powerful sculptor's drawing and is close to other drawings of the same medium and period (see: Palazzo Pretorio, *Lorenzo Bartolini*, no. 57, Uffizi 92749; no. 61, Uffizi 12034S; no. 62, Uffizi 92750).

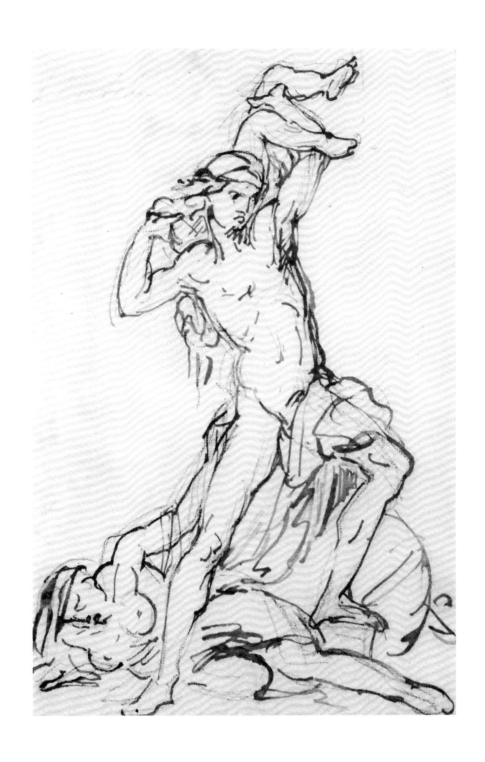

Giuseppe Bossi (Busto Arsizio 1777–Milan 1815)

In addition to being trained as a designer and academic painter, Bossi was an intellectual, a scholar and an official of the Belle Arti. He first studied painting at the Academy of Milan with Giuliano Traballesi and Appiani (*q.v.*), a good friend with whom he later collaborated. In 1795, he traveled to Rome where he studied with Domenico Conti and made the aquaintance of Canova (*q.v.*). In Rome, he became involved with archaeological excavations, and acquired certain Roman stylistic characteristics. Returning to Milan in 1801, Bossi won the *Concorso della Riconoscenza* competition with his painting, *The Allegory of Gratitude toward Bonaparte*. He passed the remainder of his life in Milan, where, together with Appiani, he founded the Pinacoteca di Brera, serving as the secretary; he also initiated the Brera's annual exhibitions. Although Bossi is sometimes considered a neoclassical artist, he was an exponent of the early romantic movement. These romantic tendencies are seen in the sensual grace and freedom of drawing in his works and are especially evident in his portraits.

During his short life, Bossi wrote poetry, criticism and art history, and formed an important collection of old master drawings, as well as a rich library. He studied the masters of the Italian Renaissance, focusing (1807-10) on Leonardo da Vinci, who had spent the greater portion of his mature years in Milan and whose style had haunted Milanese artists for generations. He copied Leonardo's decaying *Last Supper* for later translation into mosaic (destroyed in the 1943 bombing of Milan) and in 1810 wrote *Del Cenacolo di Leonardo dà Vinci* in four volumes. He also wrote a theoretical work on the political usefulness of the art of drawing (1803). Bossi maintained a private school for painters and was involved with several important decorative programs, most notably in the Brera and the Archaeological Museum in Milan. Toward the end of his life, Bossi's poor health interrupted his work.

Giorgio Nicodemi, ed., *Giuseppe Bossi: Le Memorie*, Busto Arsizio, 1925.

Sergio Samek Ludovici, *I Disegni di Giuseppe Bossi,* Milan, 1948.

Brera, Milan, *Mostra di disegni di Andrea Appiani e Giuseppe Bossi* (by G. Ballo), Milan, 1966.

24. Three Figures Recoiling in Fright

Pen and brown ink with wash on white paper. 8⅛ x 9¹⁵⁄₁₆ in. (206 x 252 mm.).

Bibliography: Palazzo della Permanente, Milan, *Mostra dei Maestri di Brera,* Milan, 1975, no. 105.

Lent by the Civico Gabinetto dei Disegni, Castello Sforzesco, Milan, B 425-1124.

Bossi's pre-romantic tendencies are revealed in this quickly drawn sheet. The graphic freedom, dramatic subject matter and the figures' exaggerated expressions and postures are hallmarks of this evocative style of the late eighteenth century, caught between Neoclassicism and Romanticism. The accomplished draftsmanship is similar to several other assured but rapid sketches by Bossi in the Castello Sforzesco, while also revealing an affinity with the drawings of certain sixteenth-century Mannerists.

Nicola Monti (Pistoia 1780–Cortona 1864)

After studying at the Florentine Academy under Benvenuti (*q.v.*), Monti settled in Florence, where he painted ceilings in the Palazzo Pitti and frescoes in the Cathedral of Pistoia. Monti specialized in historical subjects, although he also painted portraits and decorative schemes. In 1818, Pavel Cieskowsky invited him to Poland; he spent two years decorating his patron's palace and a church. Monti also traveled in Russia, visiting Moscow and Leningrad, where he painted portraits of Czar Alexander and also decorated the palace of the Grand Duke Michael in Leningrad. After he returned to Florence, Monti continued to exhibit at the Academy. He was a neoclassical painter, although in his *Dell'arte della pittura,* published in 1834, he argued for the authority of nature over art. Monti also wrote an autobiography, *Memorie inutili,* published in 1860. He signed his paintings "Monti" or "Nicola Monti di Pistoia," adding an "E" (for Eleonora, the woman he loved) to the works that he considered especially good.

Niccola Monti, *Pollantea di Niccola Monti pittore pistojese,* Lucca, 1829.

Pietro Bandini, *Il Resuscitamento di Lazzara, Dipinto Afresco del Prof. Niccola Monti,* Florence, 1837.

25. God Cursing Cain

Black and brown ink and reddish-brown wash over traces of graphite on off-white paper, with a brown ink border. 9½ x 11¹/₁₆ in. (241 x 281 mm.).

Inscribed in brown ink at lower center outside of border: *Monti Nicola di Pistoia.*

Bibliography: Shepherd Gallery, New York, *Italian Nineteenth Century Drawings and Watercolors: An Album* (by Roberta J. M. Olson), New York, 1976, no. 276, pl. 11.

Provenance: Giovanni Piancastelli, Rome; Reverend Father Francis Agius, Inwood, Long Island; Shepherd Gallery, New York, 1976.

Lent by Mr. and Mrs. Harry Glass, Old Westbury, Long Island.

This drawing is related to Monti's famous fresco *God Cursing Cain,* painted in the atrium of the Basilica of the Madonna dell'Umilità in Pistoia about 1820 (Mazzi and Sisi, *Cultura dell'Ottocento a Pistoia,* 100, cite a letter of April 26, 1820, which refers to the finished fresco). The Michelangelesque configuration of Jehovah surrounded by angels is similar (but not identical) to the group in the fresco, although it is reversed in the two works. While the drawing is horizontal in format, the fresco is vertical; in addition, there are major differences in the settings, postures (Cain's face is fully exposed in the painting) and bodies (Cain is nearly nude in the fresco). The drawing may therefore represent an early idea for the Old Testament scene.

The theme of Cain, as man corrupted and exiled, was very popular in the early years of the nineteenth century–the moral and romantic implications of this fratricide appealed to the Romantics. Byron wrote his *Cain* in Ravenna (published in 1821), while Benvenuti (*q.v.*) and Dupré (*q.v.*) executed representations of this villain.

Monte... Rocha... di ffhri

Giovanni Battista Lusieri (active in Rome 1781 – Athens 1821)

Lusieri, known to his friends as "Don Tita," is documented in Naples during the 1780's. Little is known about Lusieri, who was a topographer and landscapist specializing in archaeologically exact, minutely detailed renderings of ancient monuments. He was court painter to the King of Naples, commissioned before the advent of photography to draw the antiquities of Sicily. His interest in and knowledge of classical ruins must have been substantial, for he served as the contracted draftsman and traveling companion (to Constantinople and Greece) of Lords Elgin and Hamilton, two renowned English collectors. For Lord Elgin (Thomas Bruce, seventh Earl of Elgin), he served as an agent, supervising the team of Italian workmen brought to Greece to gather antiquities and to make casts of them, among which were the Parthenon sculptures – the Elgin Marbles. (J. M. W. Turner had refused the position on the grounds that Elgin would not allow him to retain some of his own works from the expedition.) Lusieri's relationship with Elgin lasted from 1799 to 1821. The first twelve years were intensive and productive, during which time Lusieri was successful as steward of the venture. Even though Lusieri continued to supervise the operation, the last nine years were frustrating. It seems from the correspondence between Elgin and Lusieri, published by Smith, that the artist was ill and unable to produce the watercolors for which he had contracted. At his sudden death in 1821, half of Lusieri's drawings were in Malta (those from his Italian period and one from Greece), while the other half were in Athens. When the latter were being transported from Greece, the ship sank and all the Athenian drawings were lost. Only one drawing from the Grecian period therefore survived (later in Elgin's collection), a view of the Monument of Philopappos at Athens (see: Smith, "Lord Elgin and His Collection," fig. 8). Eventually, the Italian drawings and watercolors found their way into Lord Elgin's collection.

A. H. Smith, "Lord Elgin and His Collection," *The Journal of Hellenic Studies*, XXXVI, 1916, 163-372 (especially 163-294).

26. The Baths of Caracalla from the Villa Mattei 1781

Watercolor on off-white paper. 18⅛ x 25⅛ in. (460 x 638 mm.).

Signed and dated at lower left on original mount: *Titta Lusier 1781.*

Verso of mount inscribed by the artist: *Veduta delle Terme di Caracalla presa della Villa Mattei/Monte Celio.*

Bibliography: Rhode Island School of Design, Providence, Rhode Island, *The Age of Canova* (by Anthony M. Clark), Providence, 1957, 15, no. 97, ill. p. 24; The Cleveland Museum of Art, Cleveland, *Neo-Classicism: Style and Motif* (by Henry Hawley), Cleveland, 1964, no. 163, ill.

Lent by the Museum of Art, Rhode Island School of Design, Providence, anonymous gift, 57.098.

The Roman subject matter and the eighteenth-century costumes agree with the 1781 date on this watercolor's mount. The work provides evidence of Lusieri's activity in Rome, before he is documented in Naples and Sicily, while the precise beauty of this *veduta* demonstrates why Lusieri was sought as a topographer by a king and lords. One is tempted to connect this large sheet with a group of ten described by Lord Hamilton in a letter of February 16, 1824 to Lord Elgin (in a description of nearly 140 of Lusieri's works, counting a sketchbook as one item): ". . . ten large, coloured drawings – finished views near Naples, Rome, etc. . . ." (Smith, "Lord Elgin and His Collection," 290). This exacting view of the mighty Baths of Caracalla before excavation is a fine illustration of how Italian artists were fascinated by Roman ruins and the past glories of Italy.

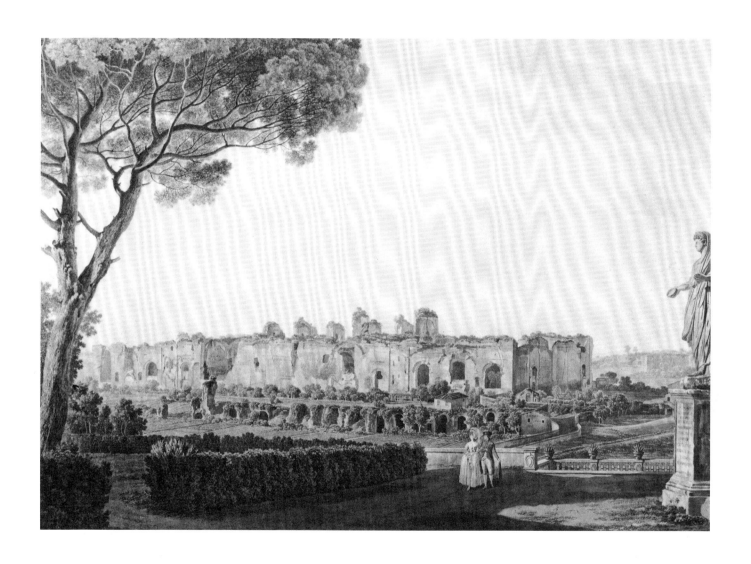

27. Peasant on a Donkey

Watercolor over graphite on off-white paper. 13⁷/₁₆ x 17⅛ in. (341 x 435 mm.), with horizontal addition (1⁷/₁₆ in.) at upper margin of original sheet. Slight foxing.

Inscribed in graphite at lower right with Colnaghi's no.: *n28635.*

Verso inscribed in black chalk at upper right: *No. 1.*
Verso inscribed in graphite at left: *Lady Palmerston.*
Verso inscribed in graphite at upper left: *Miron G.* (erased) *on.*

Inscribed in graphite on mat: *Titta Lusieri/(active 1785-1820)/ Coll: L.⁰· Bruce.*

Provenance: Seventh Earl of Elgin; Christie, Manson and Woods, Ltd., London, 1965; P. & D. Colnaghi, London, 1966.

Lent by The Metropolitan Museum of Art, New York, Rogers Fund, 66.93.1.

This is one of a group of three similar watercolors executed in a simple, abstract style, all with an English provenance (Lord Elgin's collection), in the United States. The other two depict: (1) a standing woman in a Neapolitan costume (lot 105 in the 1965 Christie's sale), in The Metropolitan Museum of Art (66.53.2 with a verso inscribed *M' Palmerston*); and (2) a woman seated on a donkey, in a private California collection (verso inscribed *Milady Bessborough* — the Metropolitan records that the drawing and the *Peasant on a Donkey* were sold in tandem [lot 104] in the 1965 Christie's auction and were included in the Colnaghi exhibition). The Metropolitan has a photograph of a fourth watercolor with a Lord Elgin provenance, also in the 1966 Colnaghi sale, present whereabouts unknown, of a nurse and child (verso inscribed *Sig.ᵃ Rosalina Scala*).

All of these watercolors belong to a group painted by Lusieri in the 1790's before his departure for Greece. Following complicated negotiations (see: Smith, "Lord Elgin and His Collection"), the watercolors were obtained by Elgin after Lusieri's death. Their unfinished nature and the concentration on figures and the bleaching effects of the Mediterranean sun relate them stylistically. In the present watercolor, the most striking of the four, Lusieri has noted the ground line in graphite and, except for red accents, confined his palette to earthy tones.

Bartolomeo Pinelli (Rome 1781 – Rome 1835)

A famous illustrator, Pinelli may be termed the "Rowlandson of Italy." He acquired both his intuitive understanding of plastic values and his interest in small genre groups of figures (which he depicted in terracotta as well as in prints and drawings) from his father, a modest sculptor of figures for Nativity scenes. Pinelli received his formal education at the Academy of San Luca, with a brief interlude in Bologna under the patronage of Prince Lambertini. In spite of his academic training, Pinelli remained enamored of both popular subjects and a spontaneous style. After completing his studies, he began to sell his vivid and amusing drawings of vernacular subjects in the cafés.

Pinelli was strongly influenced by Giani's (*q.v.*) free and abstract figural style, as well as the landscapes of the German painter, Franz Kaiserman, and the foreign *veduta* painters of the monuments and ruins of Rome. Like Giani, Pinelli combined neoclassical and pre-romantic elements. He would often superficially refer to the repertoire of neoclassical forms without conveying the underlying spirit.

Although Pinelli did execute works with classical themes, he specialized in depictions of popular scenes, folklore and rustic traditions. His knowledge of the everyday life in Rome's bohemian quarter of Trastevere furnished him the material for his most inspired works. Many of these celebrate the *brio* and dignity of his protagonists, the lower classes. Despite their rustic character, they gain grace and elegance from the artist's fluid draftsmanship. Again, like Giani, Pinelli's breadth and abstraction remove him from the purely eighteenth-century aesthetic.

Pinelli, best known as a prolific printmaker executed oils, as well as a great number of drawings and watercolors, which are among his most beautiful works. In 1809, with *Costumi Romanae*, he began his caricature-like series of engravings of the costumes, customs and views of Rome and Naples. They proved popular with tourists and were, therefore, followed by a second collection, as well as other editions (until 1828). Pinelli also created a number of romantic series concerned with bandits (1818-19) and their leader, Massaroni (1823), to-

(continued on page 92)

28. Interior of a Roman Inn 1817

Watercolor over graphite on off-white paper with a black ink border, mounted on heavier paper. 11⅜ x 16⅝ in. (288 x 427 mm:).

Signed and dated in black ink at lower right: *Pinelli fc. 1817 Roma.*

Inscribed by the artist in black ink at center of mount: *Interno di una Osteria, in Roma.*

Provenance: Janos Scholz, New York.

Lent by The Metropolitan Museum of Art, New York, gift of Janos Scholz, 56.541.2.

Pinelli's ability to capture local color can be seen in this large, fresh watercolor, signed and dated 1817, which is the initial idea for the first plate in *Costumi Diversi*, 1822 (see: Mariani, *Bartolomeo Pinelli*, pl. XLI). *Costumi Diversi*, designed and engraved by Pinelli, was published by Luigi Fabri in Rome. There are many differences between the watercolor and the print, including: the dimensions; a large barrel which dominates the right foreground in the print and is absent in the watercolor; the gigantic capitals and upper shafts of two columns in the print in place of the pergola beyond the arch in the watercolor; and alterations in the number and positon of all the *dramatis personae*. In the right foreground of the print, Pinelli has included

himself sketching, with his two dogs (his personal emblem) at his feet (see: Andrea Busiri Vici, "Autoritratti di Bartolomeo Pinelli," *L'Urbe*, XLI, 1-2, 1978, 45-57, which reproduces a drawing [fig. 8] in a private Roman collection that is nearly identical to the print, and Ceccarius, "Bartolomeo Pinelli a Cento Anni dalla sua Morte," *Capitolium*, XI, 4, 1935, 160). In addition, the composition of the watercolor (inscribed: *Interno di una Osteria, in Roma*) is centered, while the print (inscribed: *Interno di una Osteria di Roma, ai Monti*) is oriented toward the right (with floor tiles in perspective).

The watercolor depicts the interior of an inn with ten men and two women genially drinking wine, flirting, arguing, smoking and sleeping. Through the arch and rustic pergola, there is a view of Roman ruins. The walls are frescoed with amusing decorations; on the left is probably Bacchus, the god of wine, as inscribed in the print, astride a flowing wine barrel (flanked by baskets of flowers in the print) and on the right a basket of flowers (a moon in the print), symbolic of abundance. There is a rooster in profile flanking the arch on the left (under which is inscribed: *QUANDO IL GALLO CANTERÀ/ ALLORA/CREDENZA SI FARÀ* – "when the cock crows this inn gives credit") and, to the right of the arch, a smiling sun (under which is inscribed: *AL/SOLE*). All of these motifs belong to the popular tradition of tavern decoration.

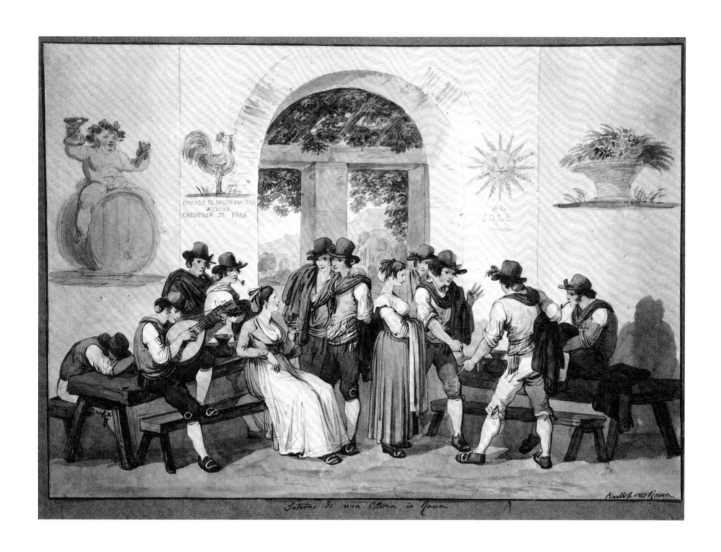

QUANDO IL GALLO CANTERÀ
ALLORA
CREDENZA SI FARÀ

AL
SOLE

Interno di una Osteria in Roma

gether with *The Events of Napoleon's Spanish War, A History of Rome* (1816), *A History of Greece* (1821), inspired by the writings of Winckelmann, *The Seven Hills of Rome* and *The Views of Rome* (1827). Pinelli also illustrated the great works of Romance literature, among which are: Virgil's *Aeneid* (1811); the comic-heroic poem *Meo Petacca* by Giuseppe Berneri (1823); Dante's *Divina Commedia* (1825); Tasso's *Gerusalemme Liberata*; Ariosto's *Orlando Furioso*; Cervantes' *Don Quixote*; and a *Mythology*. His first experience with lithography occurred late in his life, resulting in eighteen illustrations for Alessandro Manzoni's *I Promessi Sposi* (1830), whose picaresque, melancholic characters and insouciant humor are the literary parallels of Pinelli's visual statements.

Renato Pacini, *Bartolomeo Pinelli e La Roma del Tempo Suo,* Milan, 1935.

Valerio Mariani, *Bartolomeo Pinelli,* Rome, 1948.

Palazzo Braschi, Rome, *Bartolomeo Pinelli* (by Giovanni Incisa della Rocchetta), Rome, 1956.

29. The Dioscuri 1819

Graphite on off-white paper. 18½ x 24½ in. (470 x 622 mm.).

Signed and dated at lower left: *Pinelli fece Roma 1819.*

Inscribed in graphite on the base of the obelisk: *PIUS . VII . . .* (with an illegible indication of the inscription carved on the base).

Bibliography: The William Benton Museum of Art, Storrs, Connecticut, *Rome in the Eighteenth Century: The Academy of Europe* (by Frederick den Broeder), n.p., 1973, 142, no. 148, fig. 40.

Lent by Mr. Joseph F. McCrindle, Princeton.

Pinelli, who is best known for his genre illustrations, began to draw the monuments of Rome after 1799. This large drawing, dated 1819, is an exacting view of the Dioscuri (Castor and Pollux) of Monte Cavallo, one of the most famous and impressive landmarks of Rome. It may have been preparatory for an illustration in one of his books of Roman views.

The Dioscuri are early Hadrianic copies of fifth-century Greek sculptures, which were found near the Baths of Constantine. In 1783, Pius VI had the group moved to its present location in the Piazza Quirinale. The obelisk, placed between the figures in 1784, was found near the Mausoleum of Augustus. The basins below the sculptures, discovered in the Temple of the Dioscuri in the Roman Forum, were moved there by Pius VII in 1818, at which time his name was placed on the base of the obelisk.

Pinelli drew the group during the following year, focusing on the figure of Castor. Since the group is seen from below, Pinelli clearly studied it *in situ* in the Piazza. The artist was intent on accuracy, as seen in the several areas of *pentimenti*, e.g. the raised arm of Castor. One feels, however, that Pinelli had to check his natural inclination toward graphic stylization.

30. Standing Peasant Man 1823

Black chalk on white paper. 20^{13}/$_{16}$ x 13^{5}/$_{8}$ in. (529 x 346 mm.).

Signed and dated in black chalk at lower right: *Pinelli fece Roma 1823 in un ora e mezza.*

Lent by Mr. Frederick J. Cummings, Detroit.

As the inscription indicates, Pinelli drew this portrait of a rustic peasant in an hour and a half. Pinelli, best remembered for his generalized depictions of peasant life, also produced more specific portraits without the graphic stylization that dominates his vast production of prints and drawings. Only in a few areas, e.g. the edges of the cloak, is Pinelli unable to suppress his extravagant draftsmanship. This portrait, drawn from life, is similar in technique and feeling to other portraits from the 1820's (for two full-length examples, dated 1821, see: Incisa della Rocchetta, *Bartolomeo Pinelli,* pls. XX, XXI). The artist's respect for the common man and empathy with his model is seen in the strength and calm dignity of the peasant.

Pinelli fece Roma 18/13
in un ore e mezza

31. The Rape of Persephone

Pen and ink with watercolor on off-white paper, squared for transfer. 10⅜ x 10⅜ in. (264 x 264 mm.).

Bibliography: The William Benton Museum of Art, Storrs, Connecticut, *Rome in the Eighteenth Century: The Academy of Europe* (by Frederick den Broeder), n.p., 1973, 142, no. 149.

Lent by Mr. Joseph F. McCrindle, Princeton.

The delicate unfinished watercolor reveals yet another aspect of Pinelli's chameleon nature and the influence of Giani's draftsmanship. In style, it is similar to an illustration of the Fall of Phaeton (see: Alfred Ruhemann, "Die Göttersagen von Bartolomeo Pinelli," *Allgemeine Kunst Chronik*, XIX, 1895, 504). Since it is squared for transfer, den Broeder (*Rome in the Eighteenth Century*, 142) suggests that the drawing is a study for a print; it may have been preparatory for Pinelli's *Mythology*, his *Fatti della Storia Greca*, an unedited collection of mythological works, or for a rare painting.

Giuseppe Bezzuoli (Florence 1784 – Florence 1855)

Although born Bazzoli, the artist signed his name *Bezzuoli* or *Bezzoli* after 1822. In 1807, Bezzuoli began his studies at the Florentine Academy under Benvenuti (*q.v.*) and Sabatelli (*q.v.*). Even in his early, more neoclassical period, Bezzuoli was interested in rich color and a seventeenth-century manner, which he continued to cultivate throughout his career. In 1813, with *Ajax Defending the Corpse of Patroclus,* he won a stipend to study in Rome, where he concentrated on the works of Raphael and Domenichino. Upon his return to Florence, where he decorated many palaces, Bezzuoli initiated his literary romantic style with *Paolo and Francesca* (1816). In the same year, Giovanni Berchet published his *Lettera Semiseria,* a manifesto of literary Romanticism, which also preceded Hayez' (*q.v.*) famous romantic painting of *Pietro Rossi* (1820).

In 1829, Bezzuoli was appointed professor at the Academy of Florence, where he became a very influential teacher and introduced the ideas of French Romanticism. His painting style always retained a highly finished quality which reflects his academic training and the influence of Ingres (especially in his portraits), whom he befriended in Florence. Bezzuoli, however, believed that he was part of the new Romantic trend. In reference to his *Entrance of Charles VIII into Florence* (1827-29), he wrote to Bartolini (*q.v.*) that "the victory is ours," and that nature was being elevated to its proper place in the realm of art. Bezzuoli's later subject matter is romantic, frequently illustrating great moments and figures in Italian history and literature, e.g. Galileo, Boccaccio's *Decameron,* Lorenzo de' Medici, Giovanni delle Bande Nere and Dante's episode of Paolo and Francesca. Bezzuoli also painted landscapes and horses (like Horace Vernet) and participated in important exhibitions in London and Paris.

Demostene Macciò, *Giuseppe Bezzuoli pittore fiorentino,* Florence, 1884.

Ugo Ojetti, "Giuseppe Bezzuoli Ritrattista," *Dedalo,* I, 1924, 263-77.

Galleria Giorgi, Florence, *Giuseppe Bezzuoli,* Florence, 1972.

32. Study for a Figure in *The Inhabitants of Borgo San Lorenzo* 1836

Black chalk with white heightening on grey paper. 7$^{1}/_{16}$ x 12$^{5}/_{16}$ in. (179 x 313 mm.).

Carlo Parri collection stamp at lower left.

Verso inscribed in chalk at lower left: *Giulio Cesare/a Pitti.*

Bibliography: Gabinetto Disegni e Stampe degli Uffizi, Florence, *Disegni Italiani del XIX Secolo* (by Carlo Del Bravo), Florence, 1971, 54, no. 29, fig. 30.

Provenance: Bezzuoli heirs; Carlo Parri, 1971.

Lent by the Gabinetto Disegni e Stampe degli Uffizi, Florence, gift of Carlo Parri, 105560.

This drawing is a study for the figure of an injured survivor in Bezzuoli's painting *Gli abitanti di Borgo San Lorenzo ottengono da Cristo la fine dei terremoti del 6 febbraio 1835.* The painting was commissioned for the Church of the Crucifixion (formerly the Oratorio dei Neri) in Borgo San Lorenzo by Luigi Monti at the end of 1836, shortly after the tragic earthquake commemorated in the painting. There are differences between this drawing and the painting, e.g. the addition of bandages and drapery to the figure in the painting. Del Bravo (*Disegni Italiani del XIX Secolo,* 54) discusses how Bezzuoli derived and transformed the pose of this figure from the wounded official in the left foreground of Benvenuti's (*q.v.*) painting *Oath of the Saxons to Napoleon* (1812).

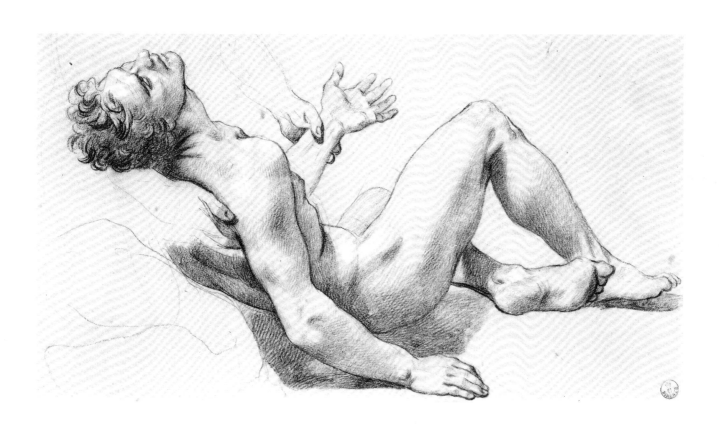

Duranti grew up in a small town of the Marches near the Adriatic and first studied art with a Camaldese monk near Iesi. Later, Cardinal Luigi Ercolani brought him to Rome to study in the school of Abate Conti, a follower of Pompeo Batoni. While in Rome, he befriended Giani (*q.v.*) and Minardi (*q.v.*), whose studio he frequented. Few other facts are known about his troubled life. The available information is recorded in the annals of Montefortino, his native city, where he spent the majority of his life. In addition to being an artist, Duranti was a collector, dealer and antiquarian. (Some of the most important works from his collection now form the nucleus of the Pinacoteca Comunale of Montefortino. The artist donated some 300 odd works in exchange for cancellation of his debts and a stipend.) Duranti's life was plagued by both actual and imagined catastrophes. He was constantly in financial difficulties; for example, he lost many of his paintings in a shipwreck. In connection with his activities as a dealer, he made several trips abroad. During one trip to Austria, shortly after the opening of the Congress of Vienna in 1815, he attempted to sell a collection of paintings and engravings to foreigners who had gathered at the conference. (An account is preserved in a letter by Luigi Consonni, president of the Academy of San Luca, to the town council of Montefortino.) For certain reasons, he was arrested and imprisoned. He never recovered from this incident, for it seemed to confirm his fears of betrayal and murder. Until 1840, he traveled between Rome and Montefortino. Afterward, he lived in seclusion and poverty (on a city pension of £2,000) in Montefortino, tortured by ill health and his fevered phantasms. During his final decades, Duranti almost exclusively produced drawings of his inward visions. Although a definitive Duranti chronology has not been established, it is thought that in his last years, his work became more gloomy and probably tapered off, although he was occasionally capable of lucid statements until his death (the last dated drawing is 1848). He often tried to give his sketches the look of old master drawings by using old papers and diluted inks. A group of late drawings are after the etchings of Rembrandt.

Drawings form the major portion of Duranti's œuvre. Only a few extant paintings are known, including a bizarre self-portrait and copies after his mentor, Raphael. But it is thought that additional copies of Italian Renaissance masters might exist in assorted collections. Several people speculate that Duranti, in the capacity of a dealer, might have sold his copies as originals. Like Pinelli (*q.v.*) and Giani, Duranti imaginatively reacted against the formal rigidity of Neoclassicism–fashionable when he was a student–and invented an original, simplified and more fluid calligraphy. But unlike either Giani or Pinelli, he was

(continued on page 102)

33. The Continence of Scipio

Brown ink and wash on white paper with a brown ink border. 5⅜ x 7¾ in. (137 x 197 mm.).

Verso inscribed in ink at bottom: *anni scali scalin. t. T. Tenta –/ zioni/ continenza di scipione. 91 vardagrano.in aresto ava Giustizia. cosi i 6 mila.*

Bibliography: Felton Gibbons, *Catalogue of Italian Drawings in the Art Museum*, 2 vols., Princeton, 1977, 76, no. 202, pl. 202.

Provenance: Frank Jewett Mather, Jr., 1948.

Lent by The Art Museum, Princeton University, Princeton, gift of Frank Jewett Mather, Jr., 48-1837.

One facet of Duranti's bizarre imagination is presented in this drawing. A cryptic inscription on the verso identifies the classical subject as the Continence of Scipio from Roman history. In the inscription, Duranti typically emphasized the temptation to sin, rather than the virtue inherent in the subject. The classical theme is echoed formally in Duranti's planear composition, reminiscent of Poussin, while the background architecture of the sheet, the steps and the domed building at the left, recall contemporaneous designs for scenography. Duranti's figures are abstract cubic masses, which reveal his debt to the sixteenth-century artist, Cambiaso.

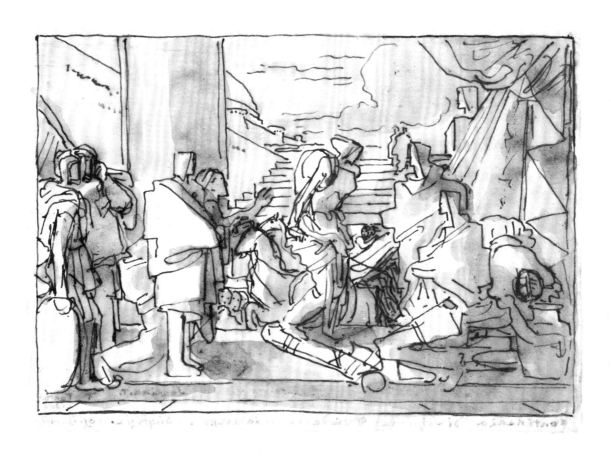

a visionary, suffering from hallucinations and obsessions like Fuseli, or more exactly like Blake (both were fixated on a private, unconventional religious mythology). His drawings are independent fantasies, monologues on his own ideas, which reveal the influence of classical compositional principles and architectonic elements; his bold calligraphy is notational and innovative. His original style is paradoxically eclectic, owing a debt to Raphael, Michelangelo and various Mannerists. For example, his reductionism, with its cubic volumes, is akin to the style of Luca Cambiaso; the neurotic ambiguities of his spaces and themes connect him with Pontormo (as does the manner in which he renders eyes), while his perspective interests ally him with Uccello. Despite all of these backward glances, Duranti's art pointed to the future, for in his stylistic singularity and subjectivity, Duranti is very "modern," the paradigm of a romantic artist. Most of Duranti's themes are either classical or religious. His favorite motif consists of fleeing figures, his preferred subject is a free interpretation of the Flight into Egypt, while his favorite characters are a Madonna and Child or children. The cryptic notes that cover the sheets, in stream of consciousness form, often reveal his ambivalent attitude toward women. Due to the personal iconography of Duranti's symbols, most of his inscriptions remain indecipherable. They are perfect equivalents of his dream-like drawings. They par-tially but never completely represent the phantasms of his psyche. His self-portrait, with eyeglasses of enigmatic medals with Greek inscriptions (Roberto Longhi Foundation for Art History, Florence), shows most clearly the melancholy and madness of Duranti's œuvre.

After his death in 1863, the people of Montefortino placed the following epitaph on Duranti's grave: "Artist of Extravagant Genius Most Skilled at Painting" ("*Artista Di Genio Stravagante Nei Dipinti Peritissimo*"). They ironically recognized his genius, but not his forte, drawing. About 1,800 of his drawings exist in the Biblioteca of Fermo. Other extensive collections are at the Pinacoteca of Montefortino, the Dania collection at Porto San Giorgio, the Roberto Longhi Foundation, the museums of Bologna and Rome and the Cooper-Hewitt Museum.

Alberto Francini, "Un Singolare Ottocentista, Fortunato Duranti," *Pinacotheca*, 1928-29, 335-48.

The Stanford University Museum of Art, Stanford, *Fortunato Duranti: 1787-1862* (by Lorenz Eitner and Luigi Dania), Stanford, 1965.

Stanza del Borgo, Milan, *Tenebre e Luci – L'Arte del Duranti* (by Alessandra Pino and Liliana Dal Pozzo), Milan, 1968.

34. Madonna and Child with Two Evangelists

Pen and brown ink with wash on ivory paper. 8⅝ x 6⁵⁄₁₆ in. (220 x 160 mm.).

Lent by the Stanford University Museum of Art, Stanford, Francis Alward Eames Fund, 73.51.

One of Duranti's favorite subjects was the Madonna and Child, here flanked by two seated, haloed and unorthodox Evangelist figures. The one on the right is rendered in profile reading his book, while the one on the left stares disconcertingly and shows his illustrated book to the viewer. The Madonna also appears to be holding a book in her left hand, identifying her as a Madonna of Wisdom. Duranti has whimsically drawn two huge butterflies, traditionally symbols of resurrection, in the upper left corner of the composition, and has incorporated his "fleeing motif" in the trailing hair and smoke. Although the scene is set in a circular, coffered building, reminiscent of the Pantheon, the space is as ambiguous as the personal iconography of the drawing. The central figure of the Madonna appears on a ledge directly in front of the sprawling and disproportionate legs of the right Evangelist. She is clearly the most important element in the composition.

From the cryptic notes which cover certain of Duranti's other drawings, it is evident that he had very unconventional attitudes toward religion and women. On one drawing, he refers to himself as Joseph, husband of the Madonna, and speaks of a nude Mary as his wife and model. He is also said to have identified with St. Luke, who painted the Virgin. At times, he referred to an unknown "sow-wife," a "whore," and a "Sabina amor." Despite the many strange elements in this drawing, it is clearly less bizarre than others by the artist. It is more traditional, in fact eclectic, looking back to Raphael (*The Sistine Madonna*) and Parmigianino.

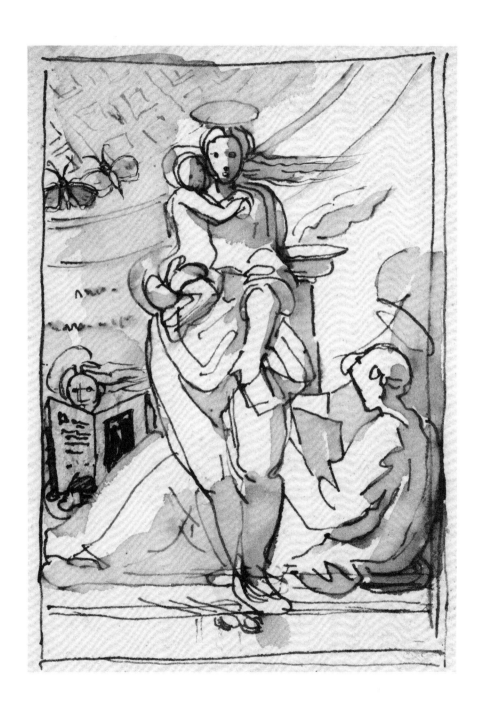

35. Two Knights in Armor Confronting a Crocodile and a Pig

Pen and brown ink on white paper with an ink border. 7⅞ x 10¾ in. (200 x 272 mm.). Stained, with top edge torn as though out of a sketchbook.

Inscribed in ink outside lower border: *asisini Cardi Dazini (?). Finit il Seni. 6 mila ani Senet. gl mont. Sinai. Cucudrillo libraria Rom papini sto.*

Bibliography: The Stanford University Museum of Art, Stanford, *Fortunato Duranti: 1787-1862* (by Lorenz Eitner and Luigi Dania), Stanford, 1965, no. 50, fig. 6.

Provenance: Giovanni Piancastelli, Rome; Mr. and Mrs. Edward Brandegee, Brookline.

Lent by the Cooper-Hewitt Museum, The Smithsonian Institution's National Museum of Design, New York, 1938-88-8334.

The artist's eccentric imagination is revealed in this enigmatic drawing. It depicts two knights in armor, mounted on horseback, who pause before an exotic plant, under which hides a quickly drawn pig. To the left, a crocodile stands on his hindquarters with his mouth open as though speaking. In the background, there is a mound of earth with several trees – from the inscription, apparently meant to signify Mount Sinai. Most of Duranti's œuvre illustrates his private fantasies, but the various crosshatching techniques in this drawing seem technically closer to an actual illustration than his more typical line and wash drawings.

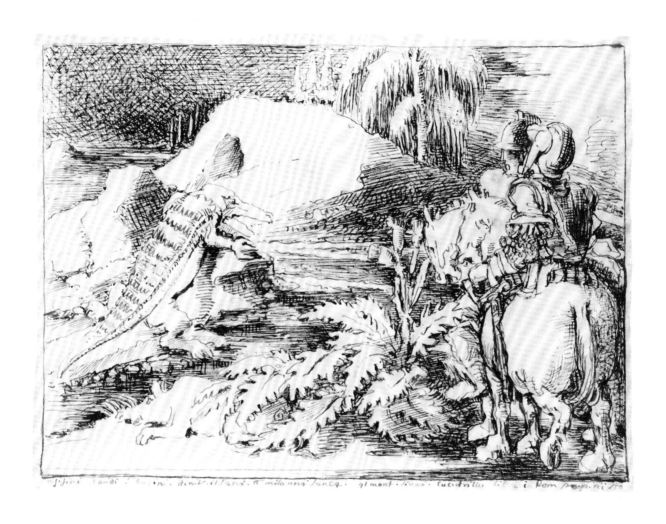

Si fini . Candi . l'come . ni . sia l' . il . taro . o . mila anni . Tante . . gl mont . Sinai . Cuccibitti . litera . io . Rom . p. p. nisto

Giovanni Migliara (Alessandria 1785 – Milan 1837)

Migliara first worked with the engraver Giuseppe Bonzanigo in Turin. It appears that after his arrival in Milan (about 1801-02), he studied with the scenographer Gaspare Galliari, while also attending classes in perspective at the Brera Academy under Giacomo Albertolli. In 1804, he collaborated with Galliari on scenery for the Teatro Carcano in Milan and, in 1806, for the Teatro alla Scala, where he worked for the next four years (Migliara collaborated with Galliari until 1810). Between 1808 and 1810, while living with Felicita Baldoni (whom he subsequently married in 1814), he contracted a serious lung disease which interrupted his career as a scenographer. Migliara consequently turned to small paintings, specializing in jewel-like miniatures on silk under glass. In 1812, he exhibited two types of *vedute* at the Brera: one, imaginary, based on the eighteenth-century Venetian *capriccio,* as in the works of Canaletto; the other, more realistic, based on Milanese and Lombard locales. He continued to develop the latter type throughout his career, although there is always a fantastic element in Migliara's œuvre.

Migliara was also a prolific printmaker. In 1815, he produced his first etching, and in subsequent years experimented with lithography. By 1817, Migliara had exhibited his first monastic interior at the Brera, which resembled the paintings of François-Marius Granet. During the 1820's following the example of Hayez (*q.v.*) and other artists and writers, he turned to more romantic themes. His work was popular with German collectors, as evidenced by the number of Migliara's works in German museums (this taste coincided with the Biedermeier period). In 1822, Migliara became a member of the Brera Academy; a document in the Brera (dated 1823) records that he also maintained a private school, like Hayez and Pelagio Pelagi.

During this late period, Migliara continued to produce architectural and perspective studies, with almost Flemish light effects, and genre subjects. He became a chronicler of contemporary life, similar to Constantin Guys and in the tradition of Hubert Robert. In 1825, he refused the chair of perspective at the Brera, preferring to concentrate on private commissions. In order to expand his repertoire of *vedute,* he also began to travel: to Tuscany, Emilia, Verona and Venice (1825); to Liguria (1828); to the Piedmont and Savoia (1832) and to the Marches, Lazio and Campania (1834). Migliara's type of genre/landscape painting persisted throughout the nineteenth century in Lombardy and its influence can be found in the work of many artists, e.g. the Induno brothers (*q.v.*).

Pinacoteca Civica, Alessandria, *Giovanni Migliara Catalogo della Mostra Commemorativa,* Alessandria, 1937.

Giuseppe Morazzoni, *Giovanni Migliara: Disegni,* Milan, 1945.

Palazzo Cuttica di Cassine, Alessandria, *Mostra della Grafica di Giovanni Migliara* (by Maria Cristina Gozzoli and Marco Rosci), Alessandria, 1977.

36. Portico of a Fantastic Palace with Figures

Brush and Chinese ink on white paper, mounted on other paper. 6 x 7^{15}/$_{16}$ in. (152 x 201 mm.).

Lent by the Civico Gabinetto dei Disegni, Castello Sforzesco, Milan, B 1681-4596.

In style, dimensions and treatment of the architectural elements, the sheet is close to Migliara's frontispiece for an album of his drawings (see: Gozzoli and Rosci, *Mostra della Grafica di Giovanni Migliara,* no. H.31, ill.). Its delicate, monochromatic technique is representative of Migliara's tendency toward charming, small-scale depictions of architecture with genre incidents. Based upon the costumes and the technique, a date in the middle of Migliara's career may be assigned. The artist has drawn the *cortile* of a palace, embellished with tombs and sculpture, with the stairs to the *piano nobile* on the left and a view of the courtyard on the right. Although the setting resembles numerous courtyards throughout Italy, it is probably an imaginary *capriccio,* typical of Migliara's blending of real and fantastic elements.

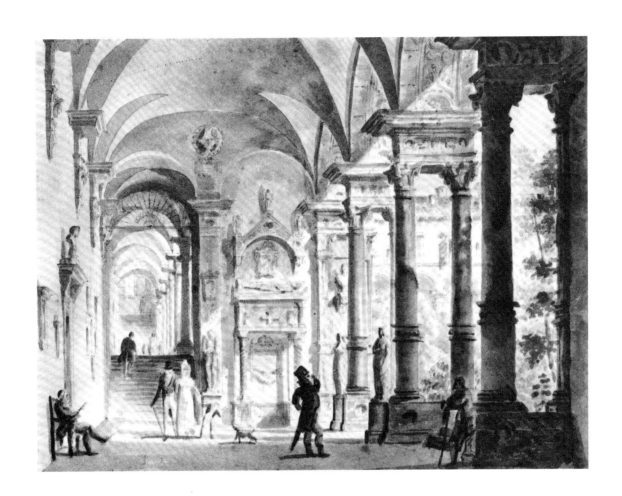

107

Tommaso Minardi (Faenza 1787–Rome 1871)

Minardi received his first drawing lessons from Giuseppe Zauli, a modest painter and etcher who was–importantly for Minardi's development–a serious student of classical antiquity. Minardi won a scholarship to study at the Institute of San Giorgio in Faenza and later transferred to the Academy of San Luca in Rome (1803), where he met Giani (q.v.) and studied with Camuccini (q.v.). In 1804, he traveled to Bologna and Milan, where he met Appiani (q.v.), Bossi (q.v.) and Monti (q.v.). During this period, he had become interested in the Renaissance and traditional Catholicism. His early paintings, e.g. *Self-Portrait in His Studio* (1807), reveal the influence of Italian and Flemish Renaissance painting, which after he became acquainted with the Nazarenes, contributed to the development of his purist style. About 1820, Minardi seems to have almost entirely abandoned painting for a purist drawing technique, based on late quattrocento Umbrian painting, i.e. the works of Perugino and early Raphael. His religious convictions, together with the influence of the Nordic Academy (which reflected the ideas of Wackenroder, Schlegel and Tieck), led him to accept religious commissions almost exclusively.

Minardi was one of the most skilled draftsman of his time. In 1819, through the influence of his friend Canova (q.v.), he was appointed director of the Academy of Perugia and given the chair of drawing. He was nominated professor of painting at the Academy of San Luca in Rome in 1821 (see: Anna Maria Corbo, "Tommaso Minardi e la Scuola Romana di San Luca," *Commentari,* XX, 1969, 131-41), a position which he held for the next forty years, while also serving as director of the Vatican mosaic works. In 1824, after many years of work, Minardi completed his copy of Michelangelo's *Last Judgment,* commissioned (in 1812) by the Milanese publisher Longhi. Together with Friedrich Overbeck, leader of the Nazarenes, and Pietro Tenerani, he signed the Purist Manifesto, published by Antonio Bianchini.

The works of Minardi are characterized by purist principles and a tendency toward dramatic light effects. Minardi was an influential teacher, instructing a great number of important artists. Today, the largest cache of Minardi drawings is in the Galleria Nazionale d'Arte Moderna in Rome.

Guglielmo De Sanctis, *Tommaso Minardi e Il Suo Tempo,* Rome, 1900.

Ernesto Ovidi, *Tommaso Minardi e La Sua Scuola,* Rome, 1902.

Italo Faldi, "Il Purismo e Tommaso Minardi," *Commentari,* I, 1950, 238-46.

37. Academic Male Nude with a Staff

Black and white chalk on a brown ground over blue-grey paper. 19⅛ x 15⁷/₁₆ in. (486 x 392 mm.).

Inventory stamp at lower right, no. 223.

Lent by a Private Collection, New York.

Minardi, who won a prize for draftsmanship in 1812-13, continued throughout his career to be more concerned with drawing than painting. This powerful academic study of a male nude displays one facet of the artist's wide-ranging talents. Minardi, especially prior to 1820, drew numerous studies after live models, but few depict such a demanding pose. The model's aggressive stance and fierce expression are complemented by the bold, albeit regular crosshatching. Several areas of black chalk have been rubbed to lend a softer quality to the background and certain parts of the anatomy. Minardi's treatment of the anatomy is only slightly marred by the awkward foreshortening of the upraised arm.

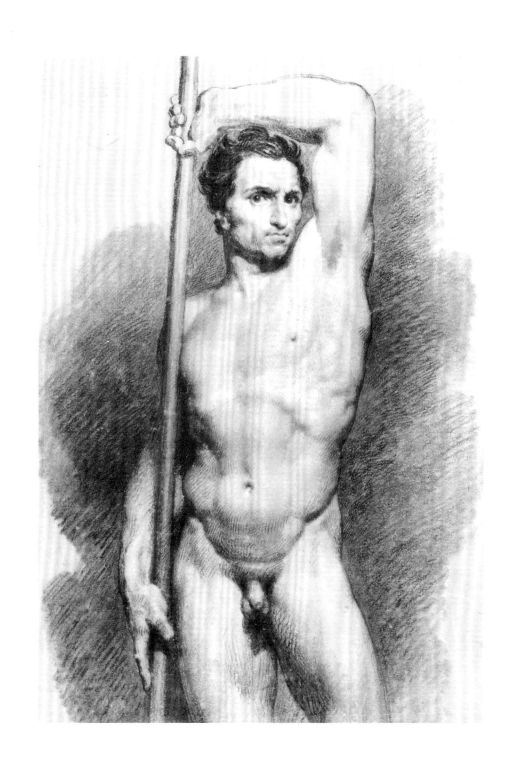

38. Drapery Study with a Male Head

Black and white chalk on a greyish-green ground over off-white paper. 16⅞ x 21¹⁄₁₆ in. (429 x 535 mm.).

Inventory stamp at lower right, no. 546.

Verso inscribed in graphite at lower left: 3.

Lent by a Private Collection, New York.

The massive drapery on this sheet, arranged on a settee, is treated like an academic still-life. Minardi has concerned himself with the study of light and shade in order to convey the weight and volume of the cloth. The drawing is unfinished, as seen in the upper right, where only the contours of the material have been indicated. At some point, Minardi turned the paper to draw a male *académie,* focusing on a portrait of his model. Here, the artist's accomplished modeling is apparent in the gentle curves of the face juxtaposed against the dark hair. Minardi also rubbed areas of the background and face to create softer transitions and a sense of depth. Another faint, indecipherable study is found at the lower right of the sheet.

39. Study after an Antique Sculpture of Marsyas

Black chalk on off-white paper. 19⅝ x 15⅜ in. (498 x 391 mm.).
Slightly stained.

Inventory stamp at lower right, no. 222.

Verso inscribed in graphite at lower right: *Origen.*

Lent by a Private Collection, New York.

Contrary to belief, Minardi drew a wide variety of subjects,
including sculpture from Antiquity, as in this drawing after the
damaged Marsyas (or a cast of it) in the Torlonia collection,
Rome. Marsyas, a satyr musician, challenged Apollo to a music
contest (*Apollodorus mythographis,* I, 24), which he lost. Apollo
subsequently tied Marsyas up (the pose of the sculpture) and
flayed him alive. Minardi meticulously studied the antique
sculpture, capturing the marmoreal quality of the bearded head
and torso, while only suggesting the hips and thighs. He em-
ployed tight crosshatching, like the chisel marks of a sculpture,
on the left side of the sheet and loose, rubbed crosshatching on
the right to accent the sculptural qualities. In the drawing,
Minardi displays his knowledge of anatomy, but his true inter-
est is the play of light across the surface of the sculpture.

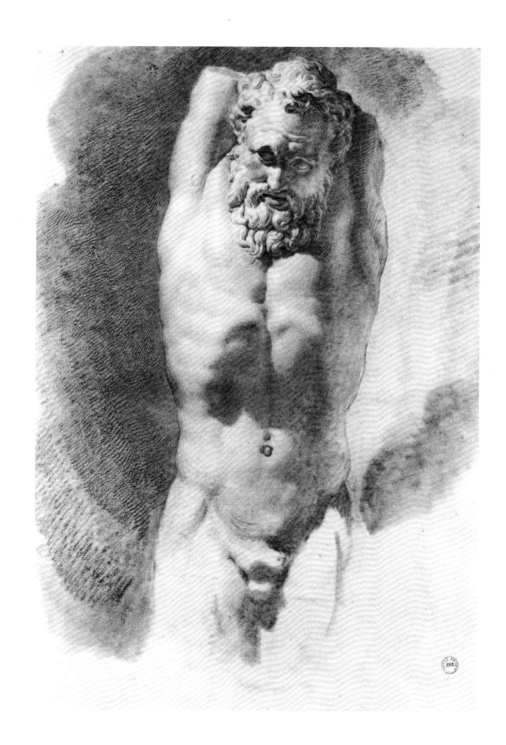

40. Erminia from Tasso's *Gerusalemme Liberata*, Canto VII, Stanza 20

Graphite and brown wash, heightened with white on off-white paper. 13¹⁵/₁₆ x 8¹¹/₁₆ in. (354 x 221 mm.).

Inscribed in white in lower frieze panel: *Poscia dicea piangendo: in voi serbate/questa dolente istoria, amice piante.*

Verso: Mary Brandegee collection stamp (Lugt Suppl. 1860c).

Provenance: Giovanni Piancastelli, Rome; Mary Brandegee, Brookline; Janos Scholz, New York.

Lent by Mr. Frederick J. Cummings, Detroit.

In this refined drawing, Minardi represented Erminia, the pagan princess from Torquato Tasso's *Gerusalemme Liberata* (finished in 1575). The inscription in the lower ornamental border translates: "Amid her tears, she says: 'Oh, friendly trees, keep this doleful story, within your shade . . . ;'" (Canto VII, Stanza 20). (In his inscription, Minardi mistakenly omitted the "h" in *amiche*.) In this section of the *Gerusalemme Liberata*, Erminia, seeking her wounded lover Tancred, hides in the woods, where she masquerades as a shepherdess and carves her beloved's name in the tree trunk. Minardi drew the composition according to a quattrocento formula, replete with an arcuated top, while his delicate draftsmanship, like Erminia's facial type, is reminiscent of Perugino's work. The drawing is an excellent example of Minardi's Purism, both in form and content. Faldi comments (in "Il Purismo e Tommaso Minardi," 240) that Minardi abandoned the Neoclassicism of Camuccini for themes drawn from a catholic religious and cultural (philosophical/ literary) tradition, e.g. the *Bible*, the *Evangelists*, the *Gerusalemme Liberata*, etc.

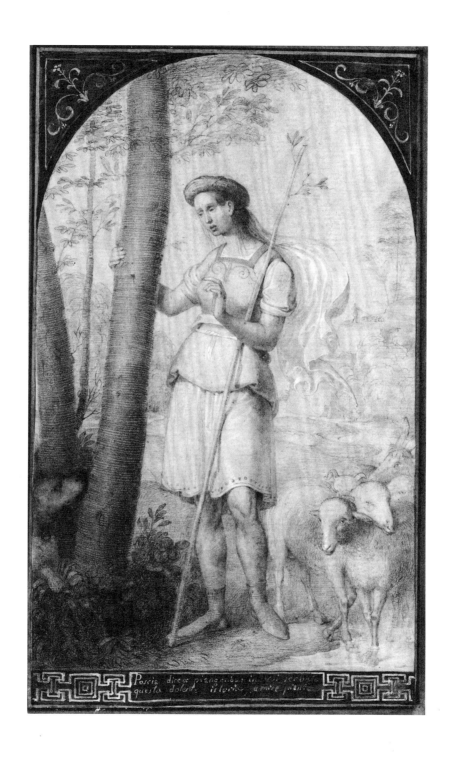

Poscia dire: piangendo in
questa dolente amare piante

Anton Sminck Van Pitloo (Arnheim, 1790–Naples 1837)

Born Anton Sminck Van Pitloo in Holland, the artist later Italianized his name (Antonio Pitloo). As a youth in Holland, Pitloo studied with H. J. van Ameron, a noted genre painter and watercolorist. Between 1808 and 1811, he studied in Paris with Jean-Victor Bertin, the master of Corot. His impressions of Paris are found in a letter of 1809, in which he expressed an appreciation of Girodet's *The Entombment of Atala* and the work of Gérard and Canova (*q.v.*). In 1812, Pitloo received a French stipend; he studied in Rome for three years, where he shared a studio with Abraham Teerlink and was exposed to current neoclassical ideas. After the final defeat of Bonaparte, Pitloo accepted the patronage of the Russian writer, Count Gregory Orloff, and settled in Naples in 1815.

Pitloo's artistic personality was formed during his Roman period and his early years in Naples, which had been the center of a strong native landscape tradition since the seventeenth century. There, Pitloo had the opportunity to study the work of many contemporary landscapists from northern Europe who traveled to Naples to paint the colorful scenery, e.g. John Robert Cozens, Johan Christian Dahl and Joseph Rebell. About 1820, he founded a "school" of painting, attended by some of the most gifted local talents of his time–Gigante (*q.v.*), Gabriele Smargiassi, Raffaele Carelli, Teodoro Duclère and Vianelli (*q.v.*). Pitloo defied the customary academic practice by directing his students to paint outdoors in the nearby town of Posillipo.

In 1822, Pitloo began teaching at the Neapolitan Academy and, in 1824, was appointed by the King to a chair of landscape painting, succeeding the neoclassicist Cammarano (*q.v.*). He led a quiet life, dedicated to his work, until his premature death from cholera. He married Giulia Mori, sister of the noted Roman engraver (Ferdinando Mori).

Pitloo's art is a synthesis of seventeenth and eighteenth-century Neapolitan landscape painting with the traditions of Holland and the Venetian *veduta*. Rather than painting traditional, documentary views for tourists, Pitloo simplified his compositions (painted *en plein air*), concentrating on light and atmosphere rather than the folklore associated with a place. His works are closer to pure generic landscape than those of his contemporaries. Some of his interests parallel those of the English school–Constable, as well as Bonington and Turner, both of whom traveled in Italy in the 1820's–and Corot, who was in Italy by 1825 and Naples in 1828.

A. Consiglio, *Antonio van Pitloo*, Rome, 1935.

C. Lorenzetti, "Precisioni critiche e documenti sul pittore Pitloo," *Archivio storico per le province napoletane*, IX, 1935, 390-412.

Raffaello Causa, *Pitloo*, Naples, 1956.

41. View of the Port of Naples 1819

Pen and brown ink on tracing paper with an ink border, mounted on grey board. 12⅞ x 18½ in. (327 x 470 mm.). Paper yellowed and stained with residue of old glue at borders; foxing.

Signed in black ink at lower left: *A. Pitloo.*

Inscribed outside lower ink border: *Vue de la Strada S. Lucia al mare et du fort dell'Uovo prise du Balcon del l'Hotel Garni la Città di Roma à Naples.*
Inscribed below: *Isle de Caprèe. . . . Fort del Uovo. . . . Hotel ou* [sic] *nous logions audessus . . . la fin du Pizzo Falcone. . . . 24 mai 1819.*

Bibliography: Gabinetto Nazionale delle Stampe, Rome, *Disegni dell'Ottocento* (by Enrichetta Beltrame-Quattrocchi), Rome, 1969, 53, no. 42, pl. 48.

Provenance: Maggiore, 1942.

Lent by the Gabinetto Nazionale delle Stampe, Rome, F.N. 807.

This topographically exact drawing of the Port of Naples also contains the Forte dell'Uovo (in the middleground) and the Island of Capri (on the distant horizon to the left). With great precision, Pitloo has observed the miniscule details of the port's teeming life, the boat traffic and the fishermen's activities, in a tight style which is more controlled than his later technique, influenced by Gigante (*q.v.*). Pitloo always remains tied to a more conservative Dutch tradition and rarely achieves the stylistic breadth and poetic sentiment of Gigante. As in most of the works by painters of the School of Posillipo, the sky and sea dominate the composition.

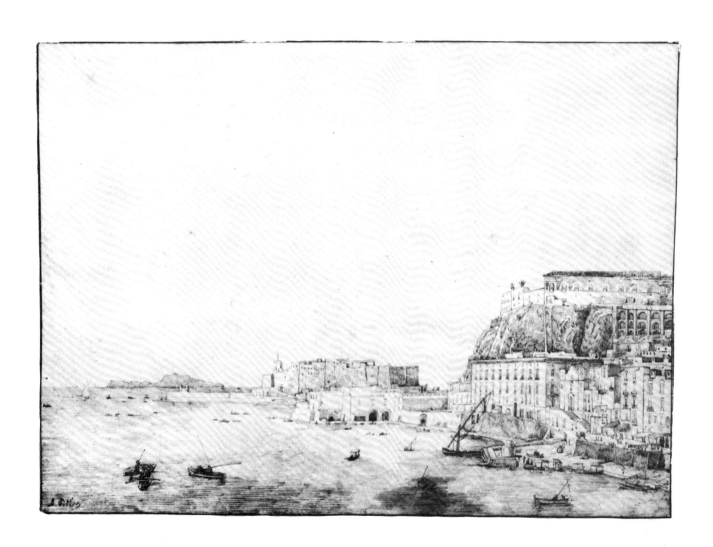

Francesco Hayez (Venice 1791 – Milan 1882)

Hayez was born into a French family living in Venice. Although he began studying the techniques of restoration and the rudiments of painting, his first formal studies were with Francesco Maggioto and Lattanzio Querena, and at the Venetian Academy from 1804 to 1809 (with Teodoro Matteini in 1808). In 1809, he traveled to Rome on scholarship with a letter of introduction to Canova (q.v.), who helped Hayez find work and influenced him toward Neoclassicism. While in Rome, Hayez copied from the Antique. He also became acquainted with many prominent artists: the neoclassical painters Pelagio Pelagi and Camuccini (q.v.), as well as the German Nazarenes, Ingres, and the Purists, e.g. Minardi (q.v.). In 1815, with Canova's aid, Hayez won the prize for nudes at the Academy of San Luca, in which Ingres also competed. After brief trips to Florence and Naples, Hayez returned to Venice in 1817. In 1820, he finally settled in Milan to teach at the Brera Academy, where he assisted (from 1822) and eventually succeeded Sabatelli (q.v.) to the chair of painting in 1850 (which he held until 1879).

At this time, the battle between Neoclassicism and Romanticism was being waged in Milan; Hayez and Sabatelli were both caught up in the struggle. At first, Hayez remained true to neoclassical ideals. But, with the exhibition of *Pietro Rossi Prisoner of the Scaligeri* at the Brera (1820), he quickly became leader of the Romantics and this painting the standard of Romanticism. In 1822, Hayez painted *I Vespri Siciliani* and, in 1823, the *Last Kiss of Romeo and Juliet*, considered two of the most significant works of Italian Romanticism. Hayez, who specialized in history subjects, was a friend of many of the romantic writers and frequently drew his subjects from their works. His paintings are considered to be the pictorial equivalent of the period's literature. Consequently, Hayez ranked as a major and profound influence on the Lombard romantic movement.

Although Hayez is considered a romantic artist, his style retains a serene, smooth quality indebted to his native Venice, which has been further filtered through a classical ideal arising from his contacts with the Roman School. He was an accomplished and successful portraitist; it is here, without the melodrama of his history paintings, that Hayez' genuine poetic and intellectual Romanticism surfaces. Although he executed portraits of famous men–e.g. Alessandro Manzoni, Ugo Foscolo, Massimo d'Azeglio and Camillo Cavour–his portraits of women are his most refined, sensuous statements. Hayez was also a printmaker; he illustrated Sir Walter Scott's *Ivanhoe* with twenty-two lithographs (1828).

Franceso Hayez, *Le mei memorie*, Milan, 1890.

Giorgio Nicodemi, *Francesco Hayez*, 2 vols., Milan, 1962.

Sergio Coradeschi and Carlo Castellaneta, *L'opera completa di Hayez*, Milan, 1971.

42. Portrait of Vincenzo Bellini

Black chalk with stumping on white paper. 8 x 5⅝ in. (203 x 143 mm.). Border stained.

Inscribed and signed in graphite at lower right: *ritratto di Vincenzo Bellini/Hayez.*
Inscribed in graphite at lower right: $\frac{140}{200}$ / 10/2.

Bibliography: Sergio Coradeschi and Carlo Castellaneta, *L'opera completa di Hayez*, Milan, 1971, 111, ill.; Charles Ryskamp, ed., *The Seventeenth Report to the Fellows of the Pierpont Morgan Library 1972-1974*, New York, 1976, 169.

Lent by the Pierpont Morgan Library, New York, Cary Fund, 1974.8.

Vincenzo Bellini (1801-1835) was known for his ability to compose operas with elegant vocal melody, both pure in style and sensuous in expression (and strongly allied to the *bel canto* style of the great contemporary singers). After studying at the Conservatory in Naples, he was invited to Milan, where his first important opera, *Il Pirata*, was enthusiastically received at La Scala in 1827. Since Bellini departed Milan for London and Paris in 1833, this drawing must date between 1827 and 1833.

This portrait, drawn from life, reveals a sensitive, frail young man in dress of the late 1820's. In all aspects, the drawing is similar to Hayez' 1825 *Portrait of Count Ninni* (see: Coradeschi and Castellaneta, *L'opera completa*, 91, no. 83, pl. XI). Since Hayez painted portraits of other composers, e.g. Chopin and Rossini, one is tempted to conclude that the drawing is a study for a portrait of Bellini.

Antonio Porcelli (Rome (?) 1800–Rome 1870)

Porcelli, a painter of figures and landscapes, specialized in subjects like bacchanals and public festivals. He rendered quick and amusing impressions of local customs and costumes–two of his better-known works are *The Cobbler's Monday* and *Roman Carnival.* He also painted episodes from the romances of Sir Walter Scott. He was a member of the *Congregazione dei Virtuosi* of the Pantheon (after 1838).

43. Caricature of a Carnival Scene

Watercolor over graphite on cream paper. 7 x 9¼ in. (178 x 235 mm.).

Signed faintly at lower right: *A. Porcelli* (?).

Lent by a Private Collection, U.S.A.

This drawing satirizes the costumed participants in Rome's perennial Carnival. (The dome of St. Peter's and the obelisk in the Piazza San Pietro are drawn at the far left of the sheet.) The caricatured figures in dress typical of Carnival are either stock characters (some from the *Commedia dell'arte*) or similar to types found in more straightforward, popular depictions of this Roman festival. Pinelli (*q.v.*) was among the artists who frequently depicted the rowdy event, e.g. in an 1834 series of prints. Caffi (*q.v.*) painted a more realistic version, *The Carnival on the Corso,* and Reginaldo Bullica, a caricature of a single costumed celebrant (see: Salone dell'Antiquariato, Rome, *Mostra del Costume di Roma 800* [by Maurizio Fagiolo and Maurizio Marini], Rome, 1978, 13, nos. 8, 7). Porcelli also painted more straightforward representations of the Roman Carnival. The fine lines and delicate washes of this drawing have a decidedly eighteenth-century feel.

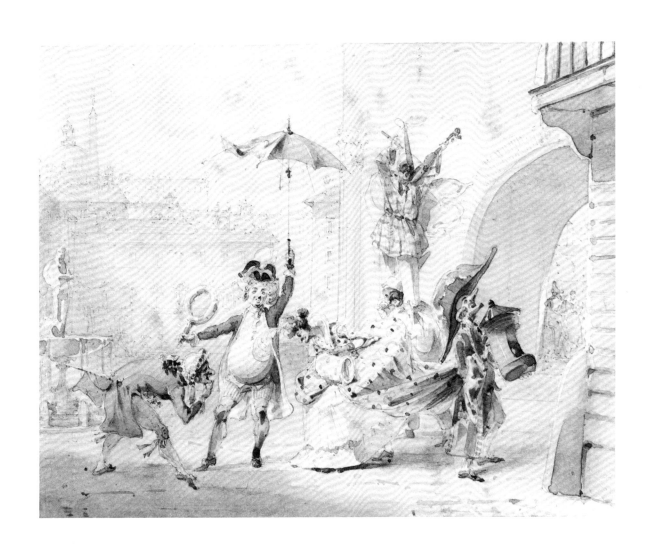

121

Achille Vianelli (Porto Maurizio 1803 – Benevento 1894)

The artist's father, a Napoleonic agent from the Veneto, married a Parisian woman and chose to become a French citizen (spelling the family surname Vianelly or Viennelley). The family later moved to Otranto, where Vianelli began to draw. In 1819, after his father and a sister returned to Paris, Vianelli moved to Naples to study, quickly becoming close friends with Gigante (q.v.). The two studied with W. Hüber and then with Pitloo (q.v.) at the School of Posillipo. Gigante demonstrated a temperament for painting landscapes outdoors, but Vianelli preferred to depict the urban life of Naples – the city's monuments, church interiors and the beach at Mergellina. His large œuvre is dominated by fresh, elegant watercolors and precise sepia drawings, his specialty.

Vianelli was popular in Italy as well as France, where he resided for many years, signing his name *Vianelly* (until c. 1838-40). Returning to Italy, he became a citizen of Benevento in 1848 where, in 1850, he organized a minor school of art. He continued to paint his characteristic interiors, as well as landscapes in an earlier Gigantesque mode. Vianelli was a member of an artistic family: his son, Alberto, was a landscape painter, one of his sisters married a German landscapist and engraver, while a second married Giacinto Gigante.

Museo del Sannio, Benevento, *Achille Vianelli* (by Mario Rotili), Naples, 1954.

G. Doria, *Di Achille Vianelli e delle sue scene napoletane,* Naples, 1955.

44. A Tavern at Baia

Chalk, pen and black ink with watercolor and white heightening on yellow paper. 6⅝ x 9³⁄₁₆ in. (168 x 233 mm.). Slight foxing.

Inscribed in ink at lower left: *disegno di S. Achille/Vianelli.* Inscribed at bottom: *in questa taverna di Baia mangiavamo sempre che venivamo a disegnare. La donna chiamasi Annarosa e l'uomo seduto/il suo marito e colui che beve, Ercole Gigante e l'altro anche un pittore.*

Bibliography: Museo del Sannio, Benevento, *Achille Vianelli* (by Mario Rotili), Naples, 1954, 37, no. 286, fig. 24; Gabinetto Nazionale delle Stampe, Rome, *Disegni dell'Ottocento* (by Enrichetta Beltrame-Quattrocchi), Rome, 1969, 62, no. 57, pl. 57.

Provenance: Maggiore, 1934.

Lent by Gabinetto Nazionale delle Stampe, Rome, F.N. 281.

Vianelli has drawn the pergola of the inn in Baia, the resort town on the Gulf of Pozzuoli near Naples, which was a gathering place for artists. His inscription explains that he drew this *taverna* because he and his friends always ate there when drawing nearby; the standing woman in the middleground is identified in the inscription as Annarosa, the wife of a seated man, who is drinking with Ercole Gigante and another unidentified painter. Vianelli's art was different from the other members of the School of Posillipo; his style has elements close to the popular but refined taste of Pinelli (q.v.) and he enjoyed depicting genre scenes, as in this drawing. Like Pinelli, he is more interested in people and customs, whereas the other painters of the School of Posillipo treated figures as a mere adjunct to landscape. But Vianelli's loose draftsmanship, highlighted with spots of white heightening and watercolor, is very close to that of Giacinto Gigante (q.v.).

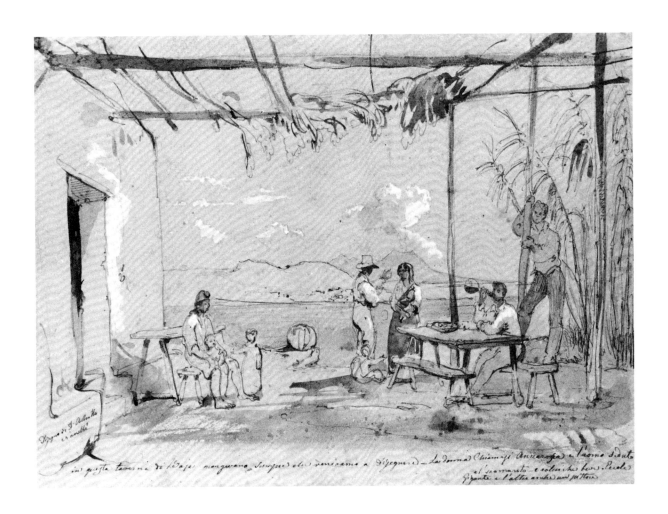

Giacinto Gigante (Naples 1806 – Naples 1876)

Gigante's early training – like that of his siblings, Achille, Ercole and Emilia – was with his father, Gaetano, who worked in an eighteenth-century Neapolitan style. He later studied with W. Hüber, a Swiss artist specializing in academic topographical views, and eventually with Pitloo (*q.v.*), founder of the School of Posillipo, who encouraged painting outdoors. Gigante, who became the most outstanding representative of the School of Posillipo group, often painted with Vianelli (*q.v.*) and married his sister, Eloisa. He also worked in the Royal Topographical Office, which enabled him to travel throughout the Kingdom of Naples, to study optics and to develop the precision required in cartography. In 1828, he published a series of lithographs illustrating *The Picturesque Journey in the Two Kingdoms of Sicily* and, in 1830, collaborated on a series of *Views of Naples and Environs.* When he traveled to Sicily in 1846 with the Czar and the Czarina of Russia, he illustrated yet another series, *An Album of Views of the Island.*

In the 1820's, Gigante adopted a freer technique of painting, executing oils and watercolors in a more poetic style, with an emphasis on light and on silvery atmospheric effects. Whereas Pitloo's landscapes tend to be generic, Gigante's are more specific. His lyrical, spontaneous works are painted in rich colors, indicating his debt to the seventeenth-century Neapolitan tradition. Gigante's loose brushwork and luminous studies may be compared to the work of contemporary British painters such as Turner and Constable. It is believed that Gigante knew Turner's work, especially since Turner visited Italy several times after 1819 and exhibited in Rome in 1828.

At Pitloo's death in 1837, Gigante moved into his house, a center for the School of Posillipo. Subsequently, Gigante taught Ferdinand II's children and later became court painter to Francesco II. He also produced many landscapes for visiting foreigners and dignitaries. With the unification of Italy, Gigante adapted easily to the realities of the new political situation and painted Garibaldian subjects for Victor Emmanuel II. Gigante traveled to Rome several times during his life and in 1869 visited Paris. Large collections of his drawings and watercolors are located in the Museo di San Martino in Naples and at the Museo Correale in Sorrento.

Mattia Limoncelli, *Giacinto Gigante,* Naples, 1934.

Alfredo Schettini, *Giacinto Gigante,* Naples, 1958.

Sergio Ortolani, *Giacinto Gigante,* Naples, 1970.

45 · Approach from the Land to the Casa de'Spiriti near Posillipo

Watercolor with traces of graphite and albumen on white paper, with another piece of paper attached at the bottom. 9½ x 6⅞ in. (241 x 175 mm.). Tear at upper left.

Signed in red gouache at lower left: *Gigante.*

Verso: Architectural sketches.

Graphite.

Inscribed in red ink on attached piece of paper: *Approach from the Land to the Casa de'Spiriti/* (in faded brown ink) *being a walk from Naples.*

Lent by the Pierpont Morgan Library, New York, gift of Decoursey Fales, MA 1976, no. 2.

This watercolor was received with memorabilia of Sir Walter Scott, including an anonymous drawing of the Casa de'Spiriti (probably by Marianne Talbot), dated January 26, 1832 and inscribed as drawn in the company of Sir Walter Scott. Another piece of paper – with an inscription in the same red ink and hand as the paper attached to this watercolor – explains that Sir William Gell, a British writer on Pompeii and Rome, Anne Scott and Miss Talbot accompanied Sir Walter Scott (known to have been in Italy in 1832) to the ruins of a "haunted" Roman villa (Casa de'Spiriti) on a promontory near Posillipo. The villa was reputedly that of Pollio, the Roman orator, poet and historian; however, the inscription curiously adds: "It was by no means the recollections of Pollio that induced Sir Walter Scott to make the excursion."

From the inscriptions and its provenance, the watercolor seems to have been acquired by English visitors to Italy during 1832. Therefore, in spite of certain affinities with the style of Ercole Gigante (1815-1860) – (see: Causa, *La Scuola di Posillipo,* 73, pl. XLVII) – it must be attributed to his older brother, Giacinto, who would have been twenty-six in that year. Moreover, the style of the graphite drawing on the verso is typical of Giacinto's work. The atmospheric quality of the sky contributes to the romantic sentiments of the subject, while also revealing the influence of the British watercolor tradition on the School of Naples. The treatment of the sky contrasts markedly with the architectural solidity of the land.

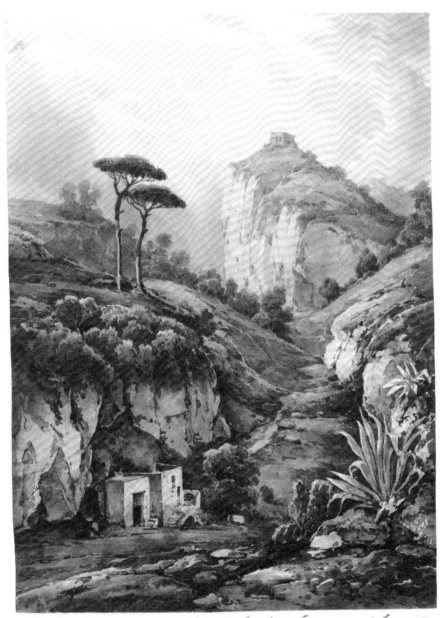

Approach from the Level to the Casa de' Spirali
being a walk from Naples.

46. View of Lake Averno 1842

Black chalk with white heightening and watercolor on greenish-blue paper. 10¼ x 13¾ in. (260 x 350 mm.).

Signed and dated in graphite at lower left: *2.17 . . .* [illegible] *1842/Lago d'Averno e resti del Tempio/d'Apollo a Puzzuoli.*

Uffizi collection stamp at lower left (Lugt 930); Santarelli collection stamp at lower right (Lugt 907).

Verso inscribed in chalk at upper middle: *Raccolta Santarelli/ Cartella 123/ Giacinto Gigante/n. 12247.*
Verso inscribed in chalk at lower right: *Gigante.*

Bibliography: *Catalogo della raccolta di disegni autografi antichi e moderni donati dal prof. Emilio Santarelli alla R. Galleria di Firenze,* Florence, 1870, 838, no. 2; Odoardo H. Giglioli, "Disegni Italiani di Paese nella Galleria degli Uffizi," *Dedalo,* X, 1928-29, 190, fig. a.p. 187; Galleria d'Arte Moderna, Florence, *Mostra di Disegni Italiani dell'Ottocento nella R. Galleria d'Arte Moderna,* Florence, 1942, 10; Gabinetto Disegni e Stampe degli Uffizi, Florence, *Disegni Italiani del XIX Secolo* (by Carlo Del Bravo), Florence, 1971, 63, no. 40, fig. 34.

Provenance: Emilio Santarelli.

Lent by the Gabinetto Disegni e Stampe degli Uffizi, Florence, 12247 S.

Gigante's own inscription identifies this drawing as a view of Lake Averno – a small crater lake in Campania (southern Italy), near the Gulf of Pozzuoli – ten miles west of Naples. Gigante drew a section of the lake (set in the Phlegraean Fields), looking toward the north. In ancient times, its sulfurous vapors were said to kill birds flying over it, while the Romans believed that the lake was the entrance to Hades. To the left are ruins of the Temple of Apollo, once part of Cumae which, according to Strabo, was the earliest Greek settlement in Italy or Sicily.

Gigante drew the scene during the late afternoon, since the hill on the right casts a shadow across the calm surface of the lake, disturbed only by the wake of a single boat. There are black chalk *pentimenti* of two figures at the lower left of the sheet. The classical equilibrium and limpid poetry of the drawing reflect Gigante's earlier style. His draftsmanship is refined – free, yet exacting at the same time.

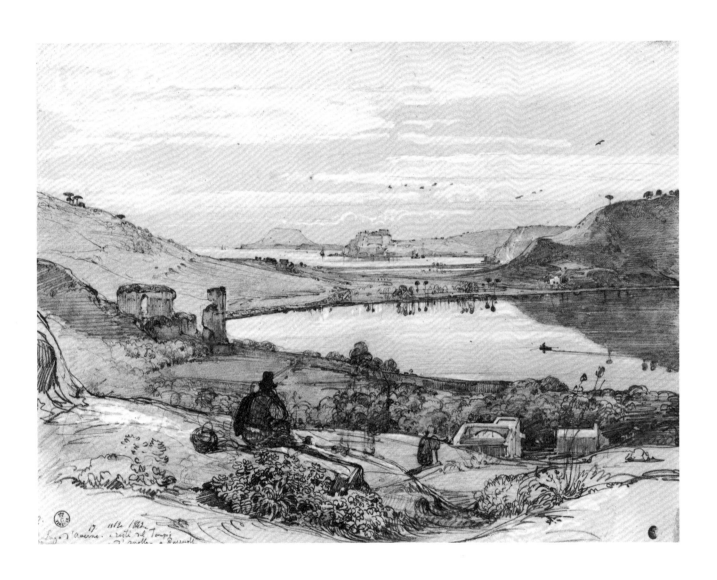

Lag d'averno. cuth del Tempio
d' apollo. a Puzzuoli

47. Study of a Tree Trunk 1847

Watercolor on off-white paper. 17¹¹/₁₆ x 22³/₁₆ in. (450 x 563 mm.).

Dated in brown watercolor at lower left: *27. Giug. 47.*

Verso: An old label inscribed in pen and ink: *Study of an Olive by Gigante bt. fr. Dr. 3.60 in 1850.*

Bibliography: Galleria Nazionale d'Arte Moderna, Rome, *Da Canova a De Carolis* (by Stefano Susinno and Livia Carloni), Rome, 1978, 26, no. 12, fig. 12.

Lent by the Galleria Nazionale d'Arte Moderna, Rome, 5708.

The date of 1847 at the left probably refers to the date of execution, while the inscription in English at the right of the sheet refers to the year when it was acquired (1850). Many works by artists of the School of Posillipo were purchased by British tourists. In contrast to the other works by Gigante in the exhibition, this study focuses on one specific object, rather than on a building or landscape. The style recalls Gigante's earlier work, especially in the detailed treatment of the branches and leaves, and looks forward to the breadth of his later period.

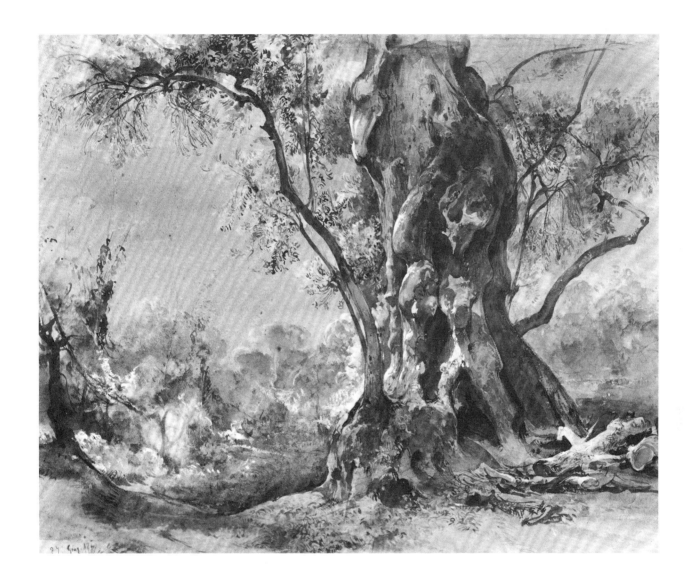

48. The Stabian Baths of Pompeii 1861

Watercolor with touches of bodycolor over graphite on brown paper. 13⅝ x 20½ in. (345 x 520 mm.). Paper discolored and torn at lower right.

Signed and dated in red watercolor at lower right: *G. Gigante.*

Inscribed in graphite at middle lower right: *Terme Stabiane/ di Pompeii 16 8ᵇʳᵉ/ 1861-.*

Bibliography: Sergio Ortolani, *Giacinto Gigante e La Scuola di paesaggio a Napoli dal'600 all'800,* Naples, 1970, 212, pl. 20.

Lent by the Museo Nazionale di S. Martino, Naples, courtesy of the Galleria Nazionale d'Arte Moderna, Rome, 13769 (B12511).

Gigante painted this view of the changing room of the Stabian Baths in Pompeii in 1861. Other watercolors of Pompeian scenes dated 1861-62 (see: Causa, *La Scuola di Posillipo,* pls. XXXVI, XXXVIII) are rendered in the same virtuoso watercolor technique which, in its calligraphic freedom, sharply contrasts with the artist's tighter, earlier style. In his later period, Gigante relied less heavily on the use of line per se (as in *View of Lake Averno* in this exhibition) and developed a more painterly technique. With quick, liquid strokes of white, Gigante has captured the pattern of light on the wall surfaces of the geometric interior of the ruined barrel-vaulted structure. He has also suggested the delicacy of the decorative stucco reliefs with *grotteschi* on the walls. The application of white pigment further suggests the ruinous condition of the Roman building. The three figures in the middleground, the eloquent backs of two women and the silhouette of a man, are clearly not Gigante's primary concern and serve only to establish scale.

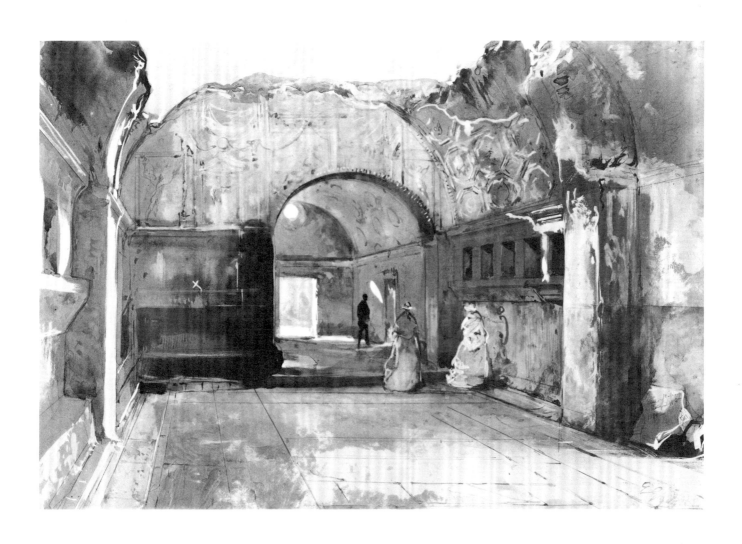

Ippolito Caffi (Belluno 1809 – At sea, Battle of Lissa 1866)

In Belluno, Caffi frequented the night school of Antonio Federici and studied with his cousin, Pietro Paoletti. He subsequently became a student of Giuseppe Borsato, among others, in Venice and Giovanni Demin in Padua. He was fascinated by the eighteenth-century masters and his first works (consisting of genre pieces, marine scenes and architectural subjects) reveal the heritage of Canaletto. The sale of his *Stations of the Cross* to a church in the Veneto enabled Caffi to join his cousin Paoletti in Rome (1832), where Paoletti had become a master restorer, specializing in the work of Venetian painters and Roman decorative artists. In 1843, he traveled to Greece, the Near East, Nubia and the Sudan, returning to Rome with numerous sketches which he later translated into larger canvases. In 1844, he received critical acclaim for *Venetian View from the Public Gardens in Winter* and *Festival of Painters near La Torre degli Schiavi in Rome*. He painted his most famous subject, the *Festival of Candles in Rome,* forty-two times. His *vedute* fuse the traditions of the eighteenth-century Venetian and Roman vedutists, and he was influenced by Valenciennes and Corot. Caffi was also an accomplished lithographer.

Caffi was a complex individual, always traveling, searching for adventure and new problems. He was also a dedicated patriot, participating in many of the political activities for the Independence of Italy. Caffi painted many battle scenes – in 1866, fighting in the revolution of Venice, he lost his life in the naval Battle of Lissa, when the *Re d'Italia* sank.

Palazzo delle Esposizioni, Rome, *Vedute Romane di Ippolito Caffi,* Rome, 1969.

Mary Pittaluga, *Il Pittore Ippolito Caffi,* Vicenza, 1971.

Museo d'arte moderna Ca'Pesaro, Venice, *Ipplito Caffi: 1809-1866* (by Guido Perocco), Venice, 1979.

49. The Grotto at Belluno

Watercolor and gouache on off-white paper with a white ink border. 9 x 12 in. (237 x 305 mm.). Lower left corner creased.

Signed in white ink at lower left: *Caffi Dis.*

Lent by a Private Collection, New York.

Caffi was born in Belluno, a tourist resort in the Veneto fifty miles north of Venice. A romantic vedutist, Caffi was interested in spectacular effects of light – caused naturally, as in this work, or as a result of artificial illumination, e.g. the *Nocturnal Festival of S. Pietro di Castello* or the *Festival of Candles in Rome*. This work, with the intense light beyond an arched format and the free surface treatment, is very similar to the *Colosseum Illuminated by Fireworks* (1845). It has both picturesque and sublime romantic elements, i.e. the jagged branches, the waterfall and the cavernous space. Two men in silhouette scramble precariously across the rocks in the lower center, dwarfed by Nature. The mood is further established by elements of danger and adventure, similar to those in Caffi's painting of 1847 recording his trip in a balloon.

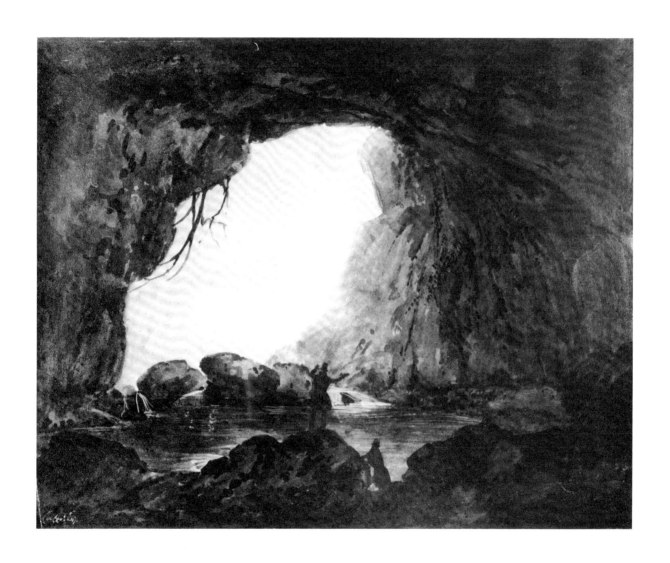

Luigi Mussini (Berlin 1813 – Florence 1888)

Born in Berlin of Italian parents, Mussini was introduced to painting by his brother, Cesare. In 1830, he enrolled in the Florentine Academy, where he was taught by Benvenuti (*q.v.*) and Bezzuoli (*q.v.*). Early in his studies, he exhibited purist qualities, influenced by the fifteenth-century Umbrian painters. In 1840, with his *Flight of Aeneas from Troy,* Mussini won a stipend to study in Rome, where he met Ingres, becoming even more intensely involved with the artistic and moral ideals advocated by the Purist/Nazarene group. Then, in 1844, he returned to Florence where, with his friend Franz Adolph von Stürler, a disciple of Ingres, Mussini founded an influential private art school. The school (which remained open for four years) taught concepts derived from the fifteenth-century masters, with a strong emphasis on drawing, and also expounded patriotic, liberal ideas.

Mussini, an energetic patriot, fought in the 1848-49 War of Independence. He subsequently traveled to Paris (staying until 1851), where he encountered the art of Hippolyte Flandrin and Chassériau, although Ingres' influence continued to dominate his work. In 1851, he became director of the Academy of Siena. Among his pupils were many important artists with both academic and progressive tendencies: Cassioli (*q.v.*), Fattori (*q.v.*), Franchi (*q.v.*), Silvestro Lega, Cesare Maccari and Angelo Visconti. In 1863, Mussini married the painter Luisa Piaggio, who died in 1865 in childbirth. Mussini's work – tempered by romantic, poetic aspirations and humanistic ideals – exemplifies the sophisticated academic style at its best. His strong academic principles are evident in his writings on art, e.g. *Scritti d'Arte* and *Epistolario Artistico,* moral and critical essays published posthumously.

P. Selvatico, *Del Purismo,* Venice, 1851.

In Memoria di Luigi Mussini Pittore, Siena, 1888.

L. F. M., "Due Nobili Pittori Cristiani del Secolo XX. Luigi Mussini e Luisa Piaggio," *Arte Cristiana,* II, 1914, 207-14.

50. Self-Portrait 1858

Black chalk and grey wash on white paper. 11⁵/₁₆ x 8¾ in. (287 x 223 mm.).

Signed and dated in black chalk at bottom: *L. Mussini/Siena 1858.*

Inscribed in chalk at upper left: *3.*
Inscribed in ink at lower left: *N. Ferri dona alla R. Galleria di Firenze.*

Pasquale Nerino Ferri collection stamp at lower left; Uffizi collection stamp at lower right (Lugt 930).

Verso inscribed in blue chalk at upper left: *623.*

Bibliography: Galleria d'Arte Moderna, Florence, *Mostra di Disegni Italiani dell'Ottocento nella R. Galleria d'Arte Moderna,* Florence, 1942, 7; Carlo Del Bravo, "Angelo Visconti, e la gioventù di Amos Cassioli," *Antichità viva,* VI, 1967, 7, fig. 4; Carlo Del Bravo, *Ingres e Firenze,* Florence, 1968, 167, ill.; Gabinetto Disegni e Stampe degli Uffizi, Florence, *Disegni Italiani del XIX Secolo* (by Carlo Del Bravo), Florence, 1971, 92-93, no. 71.

Provenance: Pasquale Nerino Ferri, 1858.

Lent by the Gabinetto Disegni e Stampe degli Uffizi, Florence, gift of Pasquale Nerino Ferri, 19007 F.

In this drawing, dated 1858, Mussini has portrayed himself at forty-five, holding a pencil as though interrupted while drawing. (For two other self-portraits – one early, the other late – see: L. F. M., "Due Nobili Pittori," 207 and Olson, *Italian Nineteenth Century Drawings and Watercolors: An Album,* no. 73, pl. 23). He was, at this time, director of the Institute of Fine Arts of Siena. The drawing reveals Mussini's debt to Ingres' brand of Purism, acquired during his 1849-51 trip to France, as evidenced in the exacting linearity, the elegant but casual pose and the finished treatment of the face.

L. Mussini

Siena 1838

N.º VIII; dona alla R. Galleria di Firenze.

51. Study for the Head of the Blind Woman in the *St. Crescentius Altarpiece* c. 1868

Red, white and black chalk on tan paper. $14^7/_{16}$ x $13^{15}/_{16}$ in. (367 x 354 mm.).

Inscribed in red chalk at lower right: *L. Mussini.*

Verso: Sketch of two seated figures.

Black chalk.

Lent by Mr. Frederick J. Cummings, Detroit.

This striking female profile is the preparatory study for the head of the blind Roman woman in the foreground of Mussini's most important painting, the *St. Crescentius Altarpiece* (see: L. F. M., "Due Nobili Pittori," 209). The painting, in the Duomo of Siena, was exhibited at the Florentine Academy in 1868. It depicts the moment when Crescentius, accompanied by Roman soldiers, pauses on the way to his martyrdom to restore the sight of a kneeling blind woman. St. Crescentius (beheaded on the Salarian Way in Rome on September 14, 303 A.D.) is a minor patron saint of Siena; his remains were transferred to the Sienese Duomo in 1058. Mussini was working on the painting when his wife, the painter Luisa Piaggio, died while giving birth to their second child in 1865. After a period of mourning, he completed the painting.

Mussini rendered this drawing directly from a model; except for the fact that the woman in the drawing is younger, the head in the painting has an almost identical attitude and expression. In both, Mussini has emphasized her closed eyes and thus her blindness. The skill and manner in which the sheet is drawn reveals Mussini's grounding in the principles of Purism.

Nicola Consoni (Ceprano di Rieti 1814 – Rome 1884)

Consoni first studied at the Academy of Fine Arts in Perugia and later under Minardi (*q.v.*) in Rome. His contemporary reputation was based on paintings of religious subjects and on his activity as a professor at the Academy of San Luca in Rome. Today, Consoni's portraits, which are more realistic and vital than his academic paintings, are considered to be his best work. Consoni painted many cycles for churches and palaces. Among his most famous commissions are the frescoes of the Story of Christ in the Vatican Logge (adding to those of Raphael and his School), frescoes in San Paolo fuori le Mura and the decoration of Prince Albert's mausoleum in Windsor for Queen Victoria.

52. Portrait of a Woman

Watercolor with touches of white heightening and traces of chalk on brown paper. 16¾ x 13¹¹/₁₆ in. (426 x 348 mm.). Discolored paper, spotted and stained at upper left, with numerous small perforations.

Bibliography: Gabinetto Nazionale delle Stampe, Rome, *Disegni dell'Ottocento* (by Enrichetta Beltrame-Quattrocchi), Rome, 1969, 48-49, no. 38, pl. 44.

Provenance: Consoni heirs, 1912.

Lent by the Gabinetto Nazionale delle Stampe, Rome, F.N. 745.

The immediacy and expressive quality of the watercolor demonstrate why Consoni's portraits are currently more highly regarded than his academic religious commissions. In contrast to another portrait of a woman in the Gabinetto Nazionale delle Stampe in Rome (see: Beltrame-Quattrocchi, *Disegni dell'Ottocento*, 48, no. 37, pl. 43), a relatively early drawing (dated 1837), there is a breadth and spontaneity which, together with the coiffure and dress of the sitter, would indicate that this watercolor is a more mature work (dating from the early 1850's). Interestingly, the colors are similar to the palette of English Victorian painters.

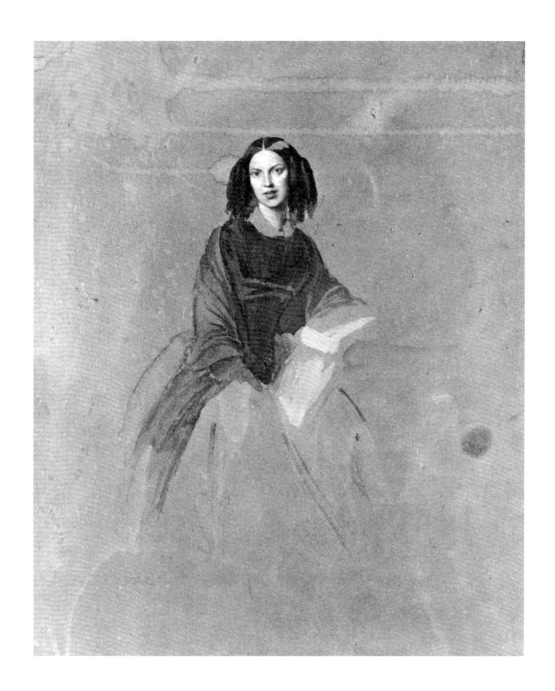

Domenico Induno (Milan 1815 – Milan 1878)

Induno first studied in the workshop of Luigi Cossa, an engraver for the mint. Subsequently, he enrolled at the Brera Academy and studied with Hayez (*q.v.*) and Sabatelli (*q.v.*). He easily distinguished himself, winning commissions which reflected his academic training, although between 1845 and 1848 (with Risorgimento ideas as a catalyst) romantic tendencies began to dominate his art.

Because of his liberal political beliefs, Induno soon turned from the exclusivism of academic principles and dedicated himself to painting popular genre subjects. With his lifelong friend, the artist Massimo d'Azeglio, Induno shared ideas about politics as well as art. Both were political activists, passionately committed to a secure and united Italy. After Induno and his younger artist brother, Gerolamo, were implicated in an 1848 Risorgimento insurrection, Domenico fled to Switzerland. Later, he moved to Tuscany where, in Florence, he met the Macchiaioli and experimented with new styles and patriotic themes, e.g. *The Arrival of the Announcement of the Peace of Villafranca.*

Induno is considered to be the first artist to elevate the status of genre painting in nineteenth-century Italy. Like the Macchiaioli, his deliberate choice of contemporary subject matter reflects his revolutionary political ideologies. Rather than the historical and piously religious themes of the academies, Induno featured contemporary events, many of which are filled with political implications. Induno's art, however, was more narrative than the paintings of the Macchiaioli: he favored scenes of human comedy and anecdotal incidents rather than depictions of general, non-specific events. Induno's compositions also never achieved the broad, flat and simplified style of the Macchiaioli's more luminous works.

Giorgio Nicodemi, *Domenico e Gerolamo Induno,* Milan, 1945.

53. Portrait of a Seated Woman

Graphite on cream paper. 10³/₁₆ x 7³/₈ in. (259 x 187 mm.).

Signed in graphite at lower right: *Dco Induno.*

Unidentified leaf-shaped collection stamp at lower right.

Bibliography: Shepherd Gallery, New York, *Italian Nineteenth Century Drawings and Watercolors: An Album* (by Roberta J. M. Olson), New York, 1976, no. 43, pl. 29.

Provenance: Giovanni Piancastelli, Rome; Reverend Father Francis Agius, Inwood, Long Island; Shepherd Gallery, New York, 1976.

Lent by Mr. Frederick J. Cummings, Detroit.

Induno frequently included a woman in a similar pose, costume and mood in the foreground of his compositions. The subject is very close to the seated lady in his *L'Attesa dello Speso,* and resembles another in *Antiquario* and a third (reversed) in *Matrimonio di Convenienza.* Her coiffure and face also recall Induno's portrait of Donna Augusta Piccini. These similarities, together with the sitter's costume and hair, suggest a date about 1853 for this sheet. The drawing definitely has the mood of contemplative melancholy which dominated Induno's later œuvre. The sitter, who is drawn in a realistic technique for which Induno was famous, rests her hand on a high table or the top of a piano. Her carefully drawn figure contrasts with the freely sketched violinist on the left (Induno also depicted several violinists in his paintings), and with another figure (?) on the right. The artist's focus is clearly on the woman's pose and garment. Induno has used a crosshatching technique of various strengths and widths to define the crisp folds of her dress. The drawing may have functioned either as an early preparatory study for one of his genre paintings or as a life study.

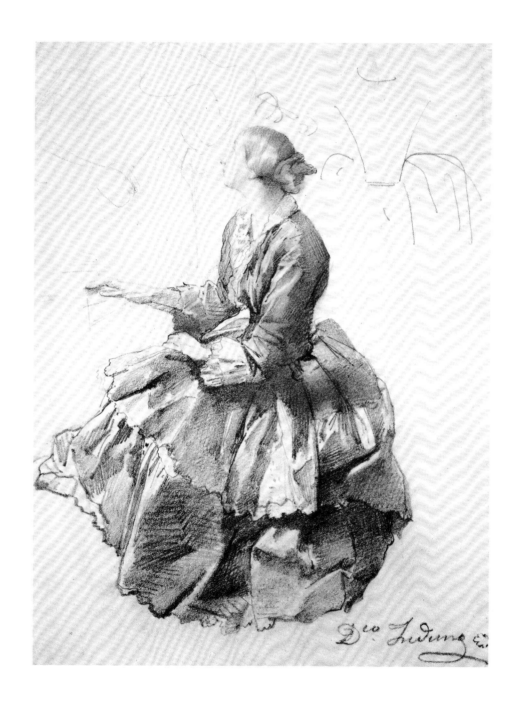

54. Study for *The Rosary* 1864 (?)

Watercolor on off-white paper. 10⅞ x 9 in. (276 x 229 mm.).

Inscribed and dated in ink at lower right: *D. Induno 1864*.

Provenance: Henry Clay and Martha Bartlett Angell.

Lent by the Museum of Fine Arts, Boston, gift of Martha B. Angell, 1919.106.

There are striking similarities between this watercolor and a finished oil of the same subject–signed, dated and exhibited at the Brera in 1850–in the Galleria d'arte moderna, Milan (see: Nicodemi, *Domenico e Gerolamo Induno,* pl. 5). If it were not for the 1864 date, one might conclude that the watercolor is a study for the oil painting. While the style of the watercolor is clearly autograph–close to Induno's smaller paintings, oil sketches and watercolors, e.g. *The False Friend*–the signature appears to have been added by another hand. Induno usually signed his works "D·co Induno" in a bolder script, slanting to the left. Since it is not in the artist's hand, the date of 1864 cannot

absolutely be assigned to the work. Perhaps the inscription was added when the watercolor was acquired by a former owner. It is also known, however, that around 1865 Induno began to repeat many of his earlier compositions, and it is possible that the watercolor represents a reworking of the earlier painting. There are differences between the two works, which include: a more detailed still life on the mantel in the watercolor, changes in the figure of the grandmother and the costume of the child on the left, as well as in the treatment of the background.

Both the composition and theme of this domestic interior scene are typical of Induno's œuvre. It is an intimate, sentimental depiction of family solidarity and religious devotion (note the sketchy indications of a religious icon in the background and the rosary held by the grandmother). This watercolor, like the oil, is rendered in the earth colors characteristic of Induno's realistic style.

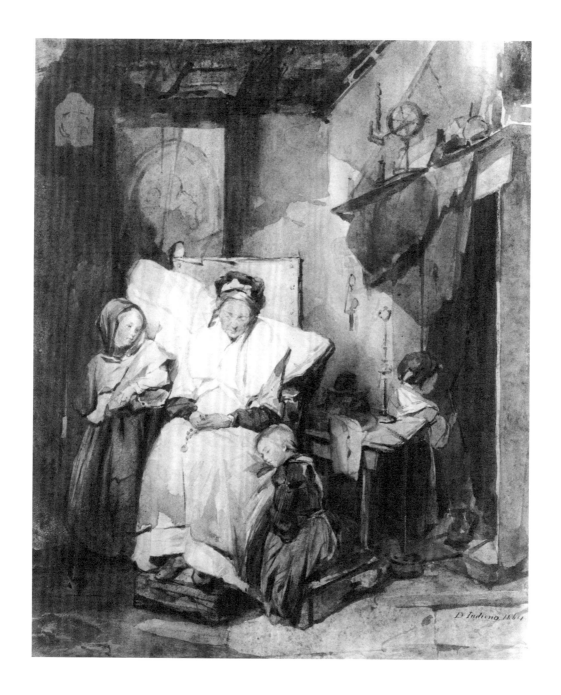

Giovanni Dupré (Siena 1817–Florence 1882)

Dupré is the most important Tuscan ottocento sculptor after Bartolini (q.v.), with whose style his work has many affinities. In 1821, his family moved to Florence, where he settled for life. He had an artisan's background, having worked in a wood carver's shop; he later studied drawing under Luigi Magi (1837). By 1840, he had assisted Ulisse Cambi and, in 1842, exhibited his first great work, the famous *Abel*, which was sold to the Russian imperial family. The *Abel* was so naturalistic that many of his contemporaries charged Dupré with casting from a live model. It was followed by the *Cain* (1843), which was severely criticized, and the *Giotto* (1844) for the Uffizi. In 1856, Dupré traveled to London to submit his unsuccessful model for the Wellington Monument competition. The second triumph of his career came with the *Pietà* (1862-63) for the Camposanto in Siena, followed in 1867 by a medal of honor at the Paris Exposition. His final years were less successful, with such works as: the *Cavour Monument* (1873) in Turin, the *St. Francis* (1881) and the *St. Zanobius,* completed posthumously by his daughter, Amalia Dupré.

Dupré was an accomplished naturalistic sculptor. Although not an educated man, he published an illuminating autobiography, *Pensieri sull'arte e ricordi autobiografici* (1879). As with most sculptors of the period, including Canova (q.v.) and Bartolini, the gessos for Dupré's sculptures are often more immediate and appealing than the final marbles. Today, many of his drawings and the gessos are in the possession of his heirs at the Villa Dupré in Fiesole.

Giovanni Rosadi, *Giovanni Dupré Scultore,* Milan, 1917.

Francesco Sapori, *Giovanni Dupré,* Turin, 1918.

Ettore Spalletti, "Note su alcuni inediti di Giovanni Dupré," *Paragone,* 271, 1972, 78-88.

55. Study for the *Abel* c. 1842

Graphite with white heightening on brownish paper. 9⅞ x 16¾ in. (250 x 425 mm.).

Inscribed in black chalk at upper right: *11 G.A.M.*

Verso inscribed in pen at upper edge: *Disegno di Giovanni Duprè/L'Abele morente/Dalla raccolta di Orazio Lelli formatore in gesso/passò poi a quella di Mario Galli;* in graphite at right: *di Dupré;* in chalk at lower right: *18,* together with the Mario Galli collection stamp; in chalk at lower right: *Giornale n. 11.*

Bibliography: Gabinetto Disegni e Stampe degli Uffizi, Florence, *Disegni Italiani del XIX Secolo* (by Carlo Del Bravo), Florence, 1971, 78-80, no. 56, fig. 45; Carlo Del Bravo, "Il bozzetto Dell' 'Abele' di Giovanni Dupré," *Paragone,* 271, 1972, pl. 28.

Provenance: Orazio Lelli; Mario Galli.

Lent by the Gabinetto Disegni e Stampe degli Uffizi, Florence, 1201 G.A.M.

This drawing is a study for the work which established Dupré's reputation: the *Abel*, sculpted in gesso (see: Del Bravo, "Il bozzetto dell' 'Abele,'" pls. 29, 30) and controversially exhibited at the Florentine Academy in 1842. It was subsequently sculpted in marble for the Grand Duchess Maria of Russia (1844) and cast in bronze for the Pope (1851). The model, Antonio Petrai, called "Brina," was one of the most popular models at the Academy. Dupré's *Abel,* which evidences the naturalism abhorred by many academics of the period, continues in the tradition of Bartolini's (q.v.) hunchback (*Il Gobbo*) incident. When his *Abel* was unveiled at the Academy, it was so naturalistic that many recognized the model and Dupré was accused of merely casting the sculpture from life. So vehement were his critics that they forced the model to undress and to strike an identical pose, in order to compare his measurements with the sculpture. In Chapter VI of his *Pensieri,* Dupré narrates this incident and, with some pride, notes his vindication. When compared to this drawing, the *Abel* illustrates how far Dupré actually was from copying nature. There are many differences between the two works: e.g. the smile on Petrai's face is transformed into Abel's death agony, while his genitals are covered by an animal skin.

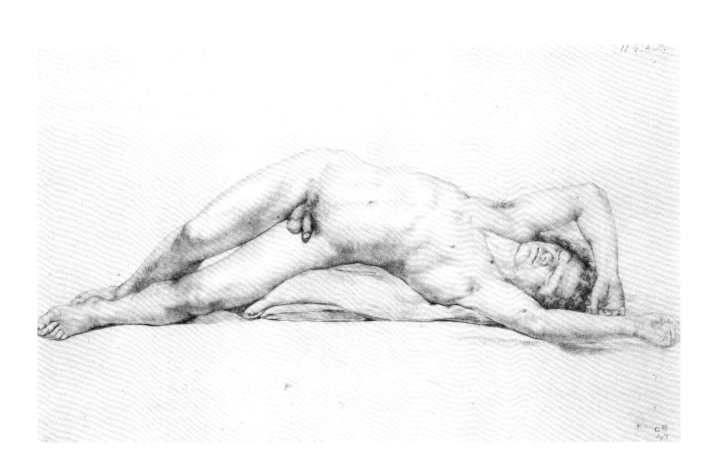

Gonsalvo Carelli studied with his father, Raffaele, also a noted artist and a member of the School of Posillipo. Later, he entered the Italian studio of William Leighton Leitch, the English painter, where he became an accomplished watercolorist. After 1837, he worked in Rome, painting views of the Roman campagna. Because of his revolutionary political activities, he was obliged to flee to Paris in 1841, where he participated in the Salon exhibitions of 1842 and 1843, befriending Alexandre Dumas, Père. He was very successful in Paris, but, as soon as possible, returned to Italy in 1844. Carelli was a good friend of the artist and political leader, Massimo d'Azeglio, and was the teacher of Princess Margherita of Savoy. As a patriot, Carelli participated in the *Cinque Giornate* in Milan and, in 1860, fought at Volturno. After the Bourbons were banished, he returned to Naples to teach at the Academy; in 1862, he began teaching at the Academy of San Luca in Rome.

Carelli specialized in freshly rendered landscapes, which still reflected the influences of the School of Posillipo, but incorporated contemporary ideas of Realism. He was also an inspired writer on art.

56. View of the Amalfi Coast

Watercolor on off-white paper, mounted on cardboard. $12\frac{3}{8}$ x $17^{11}/_{16}$ in. (314 x 449 mm.). Slightly faded; foxing.

Signed in red body color at lower right: *G. Carelli. ROMA.*

Lent by Miles and Marcial Chappell, Williamsburg.

Since this watercolor of the Mediterranean town of Atrani (?) resembles many works by Gonsalvo Carelli's father, Raffaele, it is probably earlier in date than the other work by Gonsalvo in this exhibition (dated 1858, after his return from Paris). The clear Mediterranean sense of color is also closer to the palette popular in the earlier decades of the century, while the coastline's sweep is characteristic of compositions of the School of Posillipo.

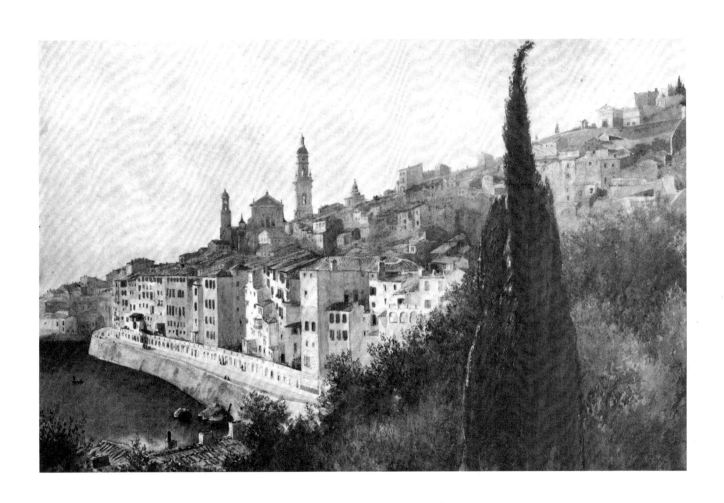

Gonsalvo (Consalvo) Carelli

57. The Beach at Pozzuoli 1858

Graphite with white heightening on brown paper. $8^1/_{16}$ x $12^1/_{16}$ in. (205 x 307 mm.). Paper discolored.

Inscribed in chalk at lower right: *Gonsalvo Carelli/Pozzuoli-Ottobre/1858.*

Bibliography: Gabinetto Nazionale delle Stampe, Rome, *Disegni dell'Ottocento* (by Enrichetta Beltrame-Quattrocchi), Rome, 1969, 65, no. 61, pl. 59b.

Provenance: Carelli heirs, 1914.

Lent by the Gabinetto Nazionale delle Stampe, Rome, F.N. 3969.

This drawing, dated 1858, exemplifies Carelli's mature style after returning from Paris in 1844. It depicts the beach at the town of Pozzuoli on the Gulf of Naples. Although the paper has darkened over the years, Carelli clearly intended to juxtapose the white heightening against a dark background. The eerie light transforms the buildings and boats into an abstract pattern of ghostly shapes. Carelli was one of the last painters of the School of Posillipo group, which frequently employed a similar technique and medium, but never in such a broad, simplified and dramatic manner.

Antonio Fontanesi (Reggio Emilia 1818 – Turin 1882)

Even though he only settled in Turin after 1847, Fontanesi is considered the finest representative of the Piedmontese group of landscape painters. As a young man, after studying in the local art school under Prospero Minghetti, he began as a painter of decorative motifs and picturesque *vedute*. Tiring of provincial life, Fontanesi joined the Lombard legions under the command of Luciano Manaro; he participated in the brief campaign of Lake Maggiore under Garibaldi. Afterward, he traveled to Switzerland, living in Geneva until 1867, except for several trips to Paris, where he encountered the works of Corot and the Barbizon painters, and to London, where he saw works by Bonington, Constable and Turner. In Switzerland, Fontanesi worked for a time with the Swiss landscapist Calame, concentrating on landscapes with luministic effects.

In 1867, Fontanesi traveled to Florence where he met the Macchiaioli, and then to Lucca to teach anatomy, a subject which was not in harmony with his interests. In 1869, he was awarded the chair of landscape painting at the Albertina Academy in Turin. He was uncomfortable in that academic environment and, as a result, traveled to Tokyo, Japan, where he taught at the Academy from 1876 to 1879. Exhausted and in poor health, Fontanesi returned to Turin in 1879, where he died a few years later.

Because Fontanesi's style was intensely personal and his life was so restless, he rightfully belongs to no school of painting. His poetic, pastoral works depend on chiaroscuro and brilliant light effects, together with a nervous brushstroke, to create a mood of melancholy and solitude. He often painted in a distinctive impasto technique with heavy flat areas scratched by a palette knife. Fontanesi was also a prolific draftsman and an excellent printmaker. He exerted a strong influence on many contemporary artists, e.g. Cremona (*q.v.*) and Ranzoni (*q.v.*).

Calcografia Nazionale, Rome, *Fontanesi e il suo Tempo*, Rome, 1954.

Marziano Bernardi, *Antonio Fontanesi*, Milan, 1968.

Carlo L. Ragghianti, "Un appunto su Fontanesi," *Critica d'Arte*, CXIII, 1970, 63-68.

58. Landscape with Trees

Black and white chalk on greenish-grey paper. 6⅞ x 4¾ in. (174 x 120 mm.). Slightly stained.

Uffizi collection stamp at lower left (Lugt 930).

Verso inscribed in black chalk at lower right: *Fontanesi 191278*.

Lent by the Gabinetto Disegni e Stampe degli Uffizi, Florence, 91278.

This drawing may have come to the Uffizi, together with other Fontanesi drawings (see: Del Bravo, *Disegni Italiani del XIX Secolo*, nos. 119-23) from the collection of Cristiano Banti, a Macchiaioli painter and one of the first collectors of Macchiaioli works, as well as a friend and patron of Fontanesi. In 1867, Fontanesi, who never became a member of the Macchiaioli himself, stayed with Banti in Florence. In fact, the style and visionary mood of this drawing correspond to a date around 1867. The romantic sheet contains all of Fontanesi's motifs for nocturnal scenes of this period: silhouettes of trees, shadows, moonlight behind clouds and an insignificant human figure dwarfed by the expanse of Nature. Even in such an economical drawing, the artist has successfully created the haunting, silvery effects of pastoral moonlight.

Antonio Ciseri (Ronco di Canton Ticino 1821 – Florence 1891)

In 1833, Ciseri's father took him to Florence to work in the family trade as a decorative painter. Later, after an apprenticeship with Ernesto Bonaiuti, he enrolled at the Academy of Florence, becoming a student of Benvenuti (q.v.) and Bezzuoli (q.v.). Until 1848, under the influence of Bezzuoli and his brand of Romanticism, he painted many historical and romantic subjects, e.g. *Dante in the Studio of Giotto,* although after 1848 his style evolved toward greater realism. This change can be seen in a series of portraits which are considered anti-academic, e.g. his *Portrait of the Bianchini Family,* which was shown at the Universal Exposition in Paris in 1855. These portraits reflect the influence of such French painters as Ingres and Charles Gleyre, who had both worked in Italy. Ciseri, a friend of Dupré (q.v.), painted in a style similar to that of Ingres, but with a less distinct elegance. His shift toward Realism, which coincided with the unification of Italy and the spread of Positivism, inclined Ciseri toward greater attention to detail and dramatic light effects, as seen in the *Massacre of the Maccabees* (1863). In Ciseri's later œuvre, one can also see the influence of Manet and Degas, both in Italy in the 1850's.

Above all, Ciseri was an accomplished draftsman. In 1852, he began to teach drawing at the Florentine Academy and became a member of the Commission to Conserve the Fine Arts in 1862. From 1855 until 1863, he worked on the *Massacre of the Maccabees,* which earned him a reputation as one of the foremost painters of his time. In 1864, he traveled to Rome where he was influenced by the French painters at the Villa Medici – e.g. Léon Bonnat and Jean-Jacques Henner – and became interested in Antiquity. In 1874, he was appointed the provisional director of the Florentine Academy. Ciseri was also a noted teacher outside of the Academy; in 1860, he founded the very influential School of the Nude, where many important artists, such as Silvestro Lega and Raffaelo Sernesi, studied.

Giovanni Rosadi, *La Vita e l'Opera di Antonio Ciseri,* Florence, 1916.

Museo Civico di Belle Arti, Lugano, *Mostra celebrativa Antonio Ciseri,* Lugano, 1971.

Carlo Del Bravo, "Milleottocentosessanta," *Annali della Scuola Normale di Pisa,* V, 2, 1975, 779-95.

59. Reclining Semi-nude Youth: Study for *The Maccabees* c. 1855-63

Black chalk with stumping on white paper. 14³/₁₆ x 19¹¹/₁₆ in. (360 x 500 mm.).

Inscribed in black chalk at lower right by Francesco Ciseri: *Studio del Prof. Ant. Ciseri pel quadro/dei Maccabei/F.G. Ciseri figlio.*

Uffizi collection stamp at lower right (Lugt 930).

Verso: Incomplete study of a reclining figure.

Black chalk.

Bibliography: *Mostra di "Firenze capitale d'Italia,"* Florence, 1953, 18; Gabinetto Disegni e Stampe degli Uffizi, Florence, *Disegni Italiani del XIX Secolo* (by Carlo Del Bravo), Florence, 1971, 86-87, no. 63, fig. 50.

Provenance: Francesco Ciseri.

Lent by the Gabinetto Disegni e Stampe degli Uffizi, Florence, gift of Francesco Ciseri, 19024 F.

Ciseri executed many preparatory studies in both chalk and oil for his large painting *The Maccabees* (1855-63) in Santa Felicità, Florence. The painting, which concerns the family of Jewish patriots, had a long period of gestation. Ciseri first exhibited a *bozzetto* for the work in 1855, and a large cartoon in 1857 (Uffizi, no. 100812), which is similar to the final painting. Because of certain differences between the cartoon and the painting, Del Bravo (*Disegni Italiani del XIX Secolo,* 87) believes that the drawing in the exhibition, which is closely related to the figure in the painting, should be dated after the 1857 cartoon. A more exacting oil study of the reclining figure on the recto of the Uffizi drawing (see: Del Bravo, *Ingres e Firenze,* 164, ill.), together with an oil study of a figure related to the verso in the Galleria d'Arte Moderna, Rome (see: Susinno and Carloni, *Da Canova a De Carolis,* 32, no. 17, ill.), were presumably executed after the drawing. The style and technique of the drawing certainly demonstrate Ciseri's indebtedness to Ingres. (For additional information on the painting, see: Ettore Spalletti, "Per Antonio Ciseri un Regesto Antologico di Documenti Dall'Archivio Dell'Artista," *Annali della Scuola Normale Superiore di Pisa,* II, 1975, 563-778.)

19034

Antonio Puccinelli (Castelfranco di Sotto 1822–Florence 1897)

Puccinelli frequented the Academy of Florence after 1839, studying with Bezzuoli (q.v.). He was awarded various prizes, together with a pension from the Grand Duke of Tuscany, enabling him in 1849 to travel to Rome, where he frequented the studio of Minardi (q.v.). However, he continued to paint traditional subjects in a more or less academic manner, still indebted to Bezzuoli and Ciseri (q.v.).

During the 1850's, Puccinelli's style began to evolve toward the later innovations of the Macchiaioli and the Impressionists. For example, in the first months of 1852, he executed his famous *Walk at the Twisting Wall,* a contemporary, *plein-air* scene, in which he concentrated on the effects of light; it is rendered in bold, flat areas of pigment. In 1852, he returned to Florence, where he participated in the progressive artistic and political society at the Caffè Michelangiolo. Although Puccinelli's draftsmanship became freer in his larger works, he remained close to a purist style; it is only in preparatory studies for landscapes and portraits that one finds a pervasive frankness and fresh color akin to that of the Macchiaioli.

Puccinelli's stylistic change serves as a transitional point in the evolution of the Italian academic style and points toward a freer form of expression. However, during the decade of the fifties, the artist's most fertile period, Puccinelli returned to seemingly more traditional subjects, e.g. *The Platonic Academy, Cosimo the Elder Surrounded by Famous Men of His Time, Leo X at Careggi, Savonarola Refusing Absolution to Lorenzo Il Magnifico.* Other paintings depict important Renaissance figures such as Boccaccio, Michelangelo and Machiavelli. These subjects reflect the growth of Italian nationalism and a pride in the achievements of Renaissance art and history. They are progressive, ideological icons that relate the myths of Italy's most glorious period. Sylistically, these works recall the great painters of Renaissance and Baroque Italy.

In 1861, Puccinelli accepted the chair of painting at the Academy of Bologna. Afterward, he seems to have dedicated himself almost exclusively to teaching and to have largely abandoned painting. Puccinelli never left the crucible of academia, but his style always seems closer to the Macchiaioli in its freedom and breadth of expression; his late sketches anticipate the late works of Silvestro Lega and Cabianca (q.v.). In addition, Puccinelli was one of the most penetrating and significant portraitists of the nineteenth century.

Rodolfo Panichi, "Antonio Puccinelli," *Vita d'Arte,* IV, 7, 1911, 166ff; 196ff.

60. Study of Two Prelates for *Leo X at Careggi*
c. 1857

Black and white chalk on brown paper, squared for transfer. 19⅛ x 12⅝ in. (485 x 320 mm.).

Uffizi collection stamp at lower left (Lugt 930).

Bibliography: Rodolfo Panichi, "Antonio Puccinelli," *Vita d'Arte,* IV, 7, 1911, 177, ill.

Provenance: Dagnini, Bologna.

Lent by the Gabinetto Disegni e Stampe degli Uffizi, Florence, 91568.

In 1853-54, Puccinelli painted *Lorenzo the Magnificent and the Platonic Academy at Careggi.* He subsequently received commissions for two other works which relate the history of that famous Medici villa during the Renaissance, one concerning Cosimo the Elder and the other, Leo X. This drawing is a study of two prelates in the painting *Leo X at Careggi,* completed and exhibited in 1858. In 1861, it was again exhibited in Florence at the *Prima Exposizione Italiana* and was very highly praised. This drawing came to the Uffizi with a group of eleven (nos. 91563-91573), four of which relate to the same painting (another sheet, with a study of Pope Leo X, is reproduced in Del Bravo, *Disegni Italiani del XIX Secolo,* fig. 52). Since it is squared for transfer, the drawing represents an advanced stage in the evolution of the painting. The work straddles two worlds, conservative academic-Romanticism, as seen in its subject matter, and more progressive Realism, as shown in the chalk's freer application.

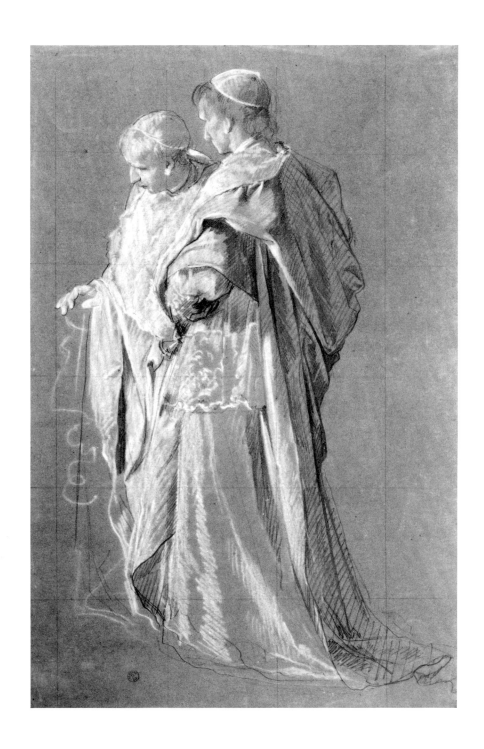

Against the wishes of his peasant mother, who urged him to become a priest, Morelli attended the Academy of Naples, studying with Costanzo Angelini, Camillo Guerra and Giuseppe Mancinelli. His rigorous academic education is evident in his early works. But by 1848, Morelli's work was tending toward a more personal romantic style, influenced by the Palizzi brothers, the writings of Lord Byron and images of the Middle Ages. In that year, he won a stipend to study in Rome and took part in the 1848 insurrection against the Bourbons in Naples. As a result, Morelli was wounded and imprisoned for several months.

In 1850, Morelli toured the European capitals with the businessman and collector Vonwiller; they visited Florence, where Morelli met Pasquale Villari. In 1855, Morelli was in Paris for the Universal Exposition and later, upon his return to Florence, reported his observations to the frequenters of the Caffè Michelangiolo. Morelli participated in the Macchiaioli discussions on Realism and is considered an important impetus in the theoretical development of their movement. His friend Filippo Palizzi, who advocated the study of nature as an end-in-itself, had introduced him to painting directly from nature,

although Morelli copied nature to make fantasy appear more believable. Morelli is credited with encouraging the Macchiaioli to study nature directly and they, in turn, helped him to develop a freer style. The several trips which he made to Paris between 1854 and 1867 seem to have encouraged his romantic nature. In the course of his travels, he saw the work of such artists as Delacroix, Décamps and Meissonier, although he knew only one French artist personally: Delaroche, who maintained a strong interest in foreign artists. The loose brushwork of several of these artists encouraged Morelli to develop a freer style and to experiment with color, although he remained bound to certain academic principles and subject matter throughout his career.

During the 1850's, Morelli produced his most noted paintings, including *I Vespri Siciliani* and *Cesare Borgia*. His first important public recognition came in 1855, after the exhibition of the *Iconoclasts*. In 1870, he became a professor at the Institute of Fine Arts of Naples. (He was also a professor at the Industrial Museum of Naples.) Morelli remained a popular and influential teacher, instructing pupils such as Michetti (*q.v.*). In 1874, he

(continued on page 158)

61. Study for *The Temptation of St. Anthony* c. 1878

Pen and brown ink on ivory paper. $11^{3}/_{16}$ x $16^{1}/_{4}$ in. (284 x 412 mm.). Some foxing.

Galleria Nazionale d'Arte Moderna collection stamp at upper left.

Bibliography: Primo Levi, *Domenico Morelli nella Vita e nell'Arte,* Rome, 1906, 220, ill.

Lent by the Galleria Nazionale d'Arte Moderna, Rome, 404/36F.

The drawing is one of a group of pen and ink studies in the Galleria d'Arte Moderna, Rome (see: Galleria Nazionale d'Arte Moderna, Rome, *Mostra dei Disegni di Domenico Morelli* [by Palma Bucarelli], Rome, 1955, 16-18, nos. 99-132) for Morelli's famous painting, *The Temptation of St. Anthony* (1878), in the same museum (see: Vittorio Spinazzola, *Domenico Morelli*, Mi-

lan, 1901, pl. 27). This painting was Morelli's most successful version of the theme, characteristic of his intention to infuse new immediacy into religious subjects. There are two other distinctly different versions: the first idea (1877-78), formerly in the Vonwiller collection in Naples, and a later reworking (1881), formerly in the Tassinari collection in Naples (see: *Ibid.*, pls. 26, 28). In this drawing, Morelli concentrated on the ascetic as he crouches against the wall of his cave. As in the 1878 painting, St. Anthony recoils from the voluptuous nude women (absent in this drawing) who leer at him while wriggling out from beneath the reed mat, outlined to the left of the saint in this sheet. Morelli visualized the saint's temptation in a directly carnal manner, which was a very modern approach. The quick, abrupt lines of the pen are characteristic of Morelli's draftsmanship.

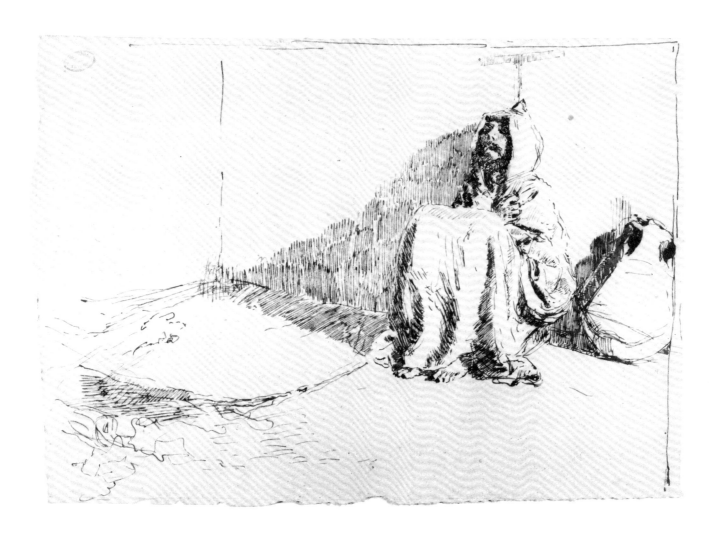

157

met Fortuny (*q.v.*), who became a life-long friend. The Spanish expatriate further contributed to the freedom of Morelli's style, although he continued to paint historical and religious subjects.

After 1880, Morelli's subject matter was largely religious, reflecting a curious blend of naturalism and mysticism (slightly tinged with Symbolism) that attempted to express a super-natural reality. His art of this period reveals the spiritual disorder of Italy after unification and the formal crisis latent in most symbolist works of the period. In 1879, Morelli met the French philosopher Ernest Renan, who encouraged his strange "modern" Christianity. Morelli believed in an historical attitude toward religion; for example, he would study a map of the Holy Land while reading the *Bible,* in order to better visualize Christ's life. He also collaborated on illustrations for the *Amsterdam Bible* (1895) with other European symbolist-oriented artists: Alma-Tadema, Lord Leighton, Burne-Jones, Holman Hunt, Michetti and Klinger.

Morelli was considered by his contemporaries to be among the major innovative artists of the Neapolitan School. Although his art spans the romantic trends of the nineteenth century (from Romanticism through Symbolism), he remained a divided man, attempting to synthesize realism and historical and religious subject matter.

Primo Levi, *Domenico Morelli nella Vita e nell'Arte,* Rome, 1906.

Angelo Conti, *Domenico Morelli,* Naples, 1927.

Christie, Manson and Woods, Rome, *Disegni e Autografi di Domenico Morelli e della sua epoca,* Rome, 1975.

62. Study for *Viene Gesù*

Black chalk, watercolor and pen and grey ink on off-white paper, mounted on cardboard. $6^{11}/_{16}$ x $16^{1}/_{2}$ in. (170 x 420 mm.). Border slightly stained.

Bibliography: Galleria Nazionale d'Arte Moderna, Rome, *Catalogo della Mostra Morelliana,* Rome, 1907, 25, no. 13.

Lent by the Galleria Nazionale d'Arte Moderna, Rome, 1207.

This vibrant watercolor has been identified as a *bozzetto* for *The Coming of Christ* (1883-84)—(see: Galleria Nazionale d'Arte Moderna, *Catalogo della Mostra Morelliana,* 25, no. 13). Its horizontal format and free style are similar to Morelli's mystical, symbolist works of the 1880's—e.g. *Maometto* (1883)—and the 1890's—e.g. *Gli Amori degli Angeli* (1893). Morelli, who had been preoccupied with religious themes since the 1870's, when he illustrated the Life of Christ, captured the movement of figures across the crest of the hill with his quick chalk lines and the bold spotting of clear watercolor. The free style reveals that Morelli, always a representational artist, was affected by the formal crisis of the late decades of the nineteenth century. The Galleria d'Arte Moderna records a painting entitled *Festive Welcome for Jesus* (in the Galleria Geri, 1928) and two studies for *Gesù Viene* (in the Galleria del Banco di Napoli, published in a 1951 catalogue, nos. 97, 108), which might relate to this watercolor.

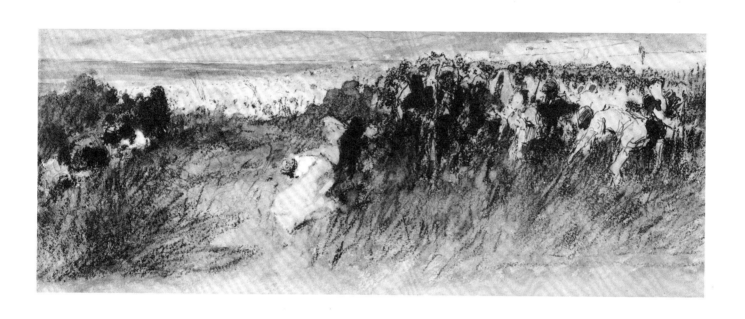

Giuseppe Raggio (Chiavari 1823–Rome 1916)

Although Raggio originally intended to join the merchant marine, he later decided to enter the Florentine Academy and was able to observe the innovations of young artists who later formed the Macchiaioli. In 1848, he traveled to Rome with the intention of studying religious art, but became fascinated by the melancholy Roman landscape. He also came under the artistic influence of Nino Costa, who encouraged verism and a rapid, more summary style. Raggio soon began to specialize in landscapes of the Roman campagna and animal paintings; his earlier exposure to and affinity with the art of Fattori (*q.v.*) and the Macchiaioli is evident in these more mature works. His favorite themes were melancholic, desolate depictions of simple rural life, while his favorite subjects were herdsmen, buffalo, cows,

horses and shepherds. Occasionally, a more exotic touch entered Raggio's œuvre, as with the French animal painters, in the form of a tiger.

Raggio was largely ignored by the public during his lifetime but achieved modest critical success. He belonged, however, to the *Gruppo dei XXV della Campagna Romana* and exhibited in Genoa in the 1850's and 1860's. Raggio was also honored by the Academy of San Luca in Rome and received other honors. Because he was impoverished, his close friends organized an exhibition (in 1913) in his honor to raise money. Many of his works are in the collection of the Opera Pia Regina Margherita in Rome and his œuvre is now being critically re-examined.

63. Man on a Horse in the Rain

Graphite on light grey paper mounted on off-white paper. 13¼ x 10⅛ in. (337 x 257 mm.).

Bibliography: Shepherd Gallery, New York, *Italian Nineteenth Century Drawings and Watercolors: An Album* (by Roberta J. M. Olson), New York, 1976, no. 69, pl. 31.

Provenance: Giovanni Piancastelli, Rome; Reverend Father Francis Agius, Inwood, Long Island; Shepherd Gallery, New York, 1976.

Lent by Mr. and Mrs. Harry Glass, Old Westbury, Long Island.

The rider's costume identifies him as a herdsman (*buttero*),

i.e. an Italian cowboy. These herdsmen and their horses were Raggio's favorite subjects (see: Galleria Scopinich, Milan, *All'Asta della Raccolta Eredi Bertollo,* Milan, 1928, pls. 27, 28). Fattori (*q.v.*), who influenced Raggio, frequently depicted *butteri* and their activities in his later works. Raggio effectively portrays the pelting, soaking quality of the rain. A feeling of loneliness is created by the rider's lowered head, covered by a *buttero's* hat, and the broad planes of the back of his heavy coat. The *pentimenti* – such as in the animal's legs, tail and bridle – have the effect of a succession of photographic stills, creating an illusion of movement that complements the diagonal of the composition.

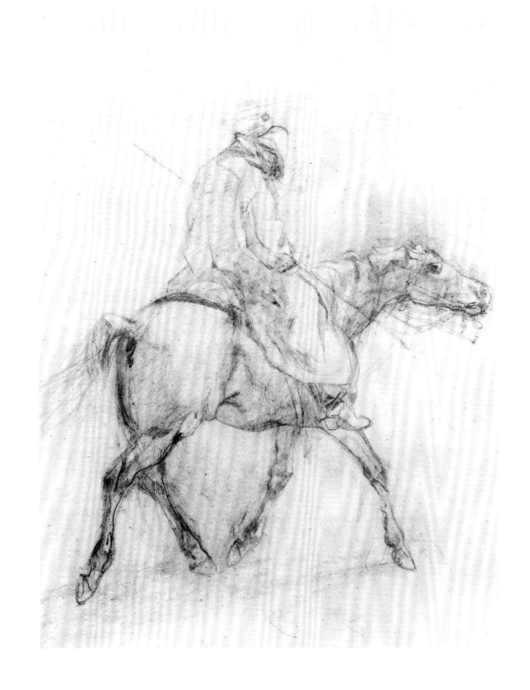

Giovanni Fattori (Livorno 1825 – Florence 1908)

In 1846, after studying in Livorno with Giuseppe Baldini, Fattori moved to Florence to attend the Academy under Bezzuoli (q.v.). He remained there until 1848, acquiring a reputation as a shy but independent, difficult person. During the first War of Independence (1848-49), Fattori served as a messenger, producing rapid annotations of military subjects in sketchbooks. These drawings would later serve as source material for his many military paintings, begun after 1850 when he returned to painting. During the early 1850's, Fattori joined the innovative artists meeting at the Caffè Michelangiolo; even though he was affected by the theories of the Macchiaioli, Fattori's style remained substantially independent. During this period, Fattori vacillated between academic Romanticism (his early training) and Realism. He also studied the Florentine masters of the Quattrocento, drawing from the paintings of Filippo Lippi and Ghirlandaio. Two other influences were crucial to his development: his friendship with the critic Diego Martelli (with whom Fattori stayed at Castiglioncello after the death of his first wife in 1867) and his contact with the artist Nino Costa (whom he met in 1859 and who supplied Fattori with a rich cultural background).

Fattori's prize-winning *Italian Encampment after the Battle of Magenta* (1862) was a decisive work. Based on earlier sketches, it was his first representation of contemporary history. Throughout his career, Fattori produced paintings of military and Risorgimento subjects (many on a very large scale). Among his finest works, however, are the small, simple paintings on wood, which reflect an honesty and spontaneity occasionally lacking in his larger compositions. After 1870, he executed numerous landscapes and, in 1873, traveled to Rome to paint the Roman campagna; he later painted subjects drawn from the country around Livorno – herdsmen, horses and cows. In 1875, Fattori traveled to Paris, exhibiting *I Barrocci Romani* at the Salon (his *L'Assalto alla Madonna della Scoperta* had won a prize at the Italian Exposition in Paris in 1868). He also studied paintings at the Paris Salon and was interested in the work of Manet; however, he was indifferent to the Impressionists.

Fattori's subjects display a love of nature and geometry; the structure of his compositions and the dark outlines of his forms reveal his study of the Quattrocento and Manet. Fattori was one of the most original and important figures of the Macchiaioli group. He was also a fine portraitist and printmaker. In 1880, he was nominated as an honorary professor at the Institute of Fine Arts in Florence (although he began teaching there in 1869) and was subsequently appointed a member of the academies of Florence and Bologna. In 1900, Fattori won a gold medal at the Universal Exposition in Paris.

Luciano Bianciardi and Bruno Della Chiesa, *L'opera completa di Fattori*, Milan, 1970.

Galleria Nazionale d'Arte Moderna, Rome, *Disegni di Giovanni Fattori del Museo Civico di Livorno* (by Dario Durbé), Rome, 1970.

Museo Civico, Livorno, *Disegni inediti di Giovanni Fattori*, Livorno, 1975.

64. Figure of a Young Peasant Woman Picking up an Object

Graphite with stumping on rose-pink paper. 10³/₁₆ x 8¼ in. (259 x 209 mm.).

Signed in graphite at lower right: *Gio. Fattori.*

Provenance: G. Malesci; Giorgio Nicodemi; Grassi.

Lent by the Civico Gabinetto dei Disegni, Castello Sforzesco, Milan, B 894-2494.

Fattori has transformed this profile of a woman bending over in the outdoors into a study of massive forms in sunlight. By employing the almost silvery quality of the black chalk on the rose paper, he has approximated the luministic effects and has communicated the simple nobility that one finds in Macchiaioli paintings. The woman is similar to other figures in several paintings by Fattori, e.g. *Contadini al Lavoro* (1870-75) and, reversed and with slight modifications, in *Contadina in un campo* (1880) – (see: Bianciardi and Della Chiesa, *L'opera completa*, 96, no. 22; 164, no. 423). Because of its tighter quality, this drawing belongs to an earlier period than the other two more linear works by Fattori in this exhibition.

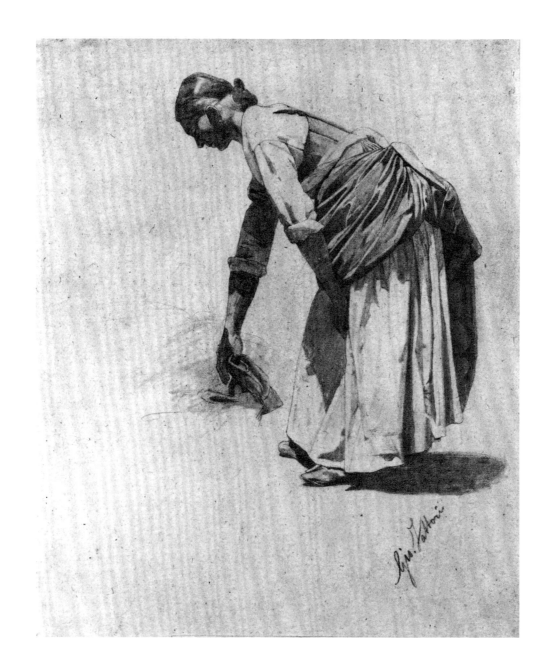

65. Study for *The Battle of Custoza* c. 1876-80

Chalk, pen and brown ink on yellowed paper. 8⅜ x 11⅞ in. (212 x 301 mm.). Some spots and oxidation of ink.

Bibliography: Gabinetto Nazionale delle Stampe, Rome, *Disegni dell'Ottocento* (by Enrichetta Beltrame-Quattrocchi), Rome, 1969, 84-85, no. 79, pl. 78.

Provenance: G. Malesci, 1911.

Lent by the Gabinetto Nazionale delle Stampe, Rome, F.N. 318.

This sheet and another military drawing in the Gabinetto Nazionale delle Stampe (see: Beltrame-Quattrocchi, *Disegni dell'Ottocento*, 85-86, no. 80, pl. 79) relate to the genesis of Fattori's famous Risorgimento painting, *The Battle of Custoza* (*Il Quadrato di Villafranca*). Executed between 1876 and 1880, it was presented at the *Esposizione Nazionale* in Turin in 1880 (for information on the painting, see: Durbé, *Disegni di Giovanni Fattori del Museo Civico di Livorno,* 35). Fattori drew this sheet in the field of battle and later, after clarifying certain figures in ink, used it as a preliminary study for the triangular formation of foot soldiers firing guns on the right side of the painting. Unlike the other preparatory drawing for the painting in the Gabinetto Nazionale, which is more closely related to the painting, there is no direct correspondence between the figures in this drawing and the painting. It presumably represents the artist's initial conception for the group of soldiers, and predates the other drawing in the Gabinetto Nazionale.

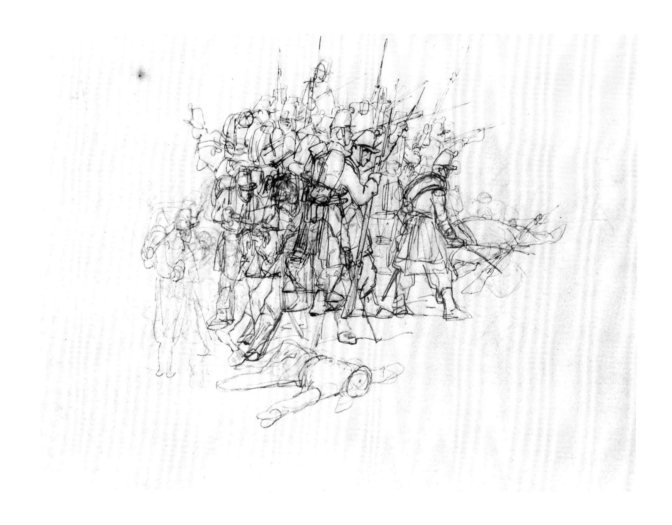

66. Study of a Herdsman on Horseback

Black chalk on sky-blue paper. $12^{3}/_{16}$ x $8^{5}/_{16}$ in. (310 x 211 mm.).
A few small spots.

Bibliography: Gabinetto Nazionale delle Stampe, Rome,
Disegni dell'Ottocento (by Enrichetta Beltrame-Quattrocchi),
Rome, 1969, 91, no. 87, pl. 87.

Provenance: G. Malesci, 1911.

Lent by the Gabinetto Nazionale delle Stampe, Rome, F.N. 321.

Fattori's favorite theme was the interaction of animals and
men–horses, soldiers, cows and herders (*butteri*); he painted
herdsmen from the early 1880's until his death. The artist dis-
cussed his attraction to the harsh life of these herders in a letter
of 1882 to Amalia Nolemberger, written during a trip to Prince
Corsini's estate, *La Marsigliana*. This drawing, which concen-
trates on the immobile profile of a herder–a pose which Fattori
favored–appears to date from approximately that time. As was
his practice, the artist used this figure, drawn from the actual
model, in paintings produced in his studio. The same herder or
a similar type reappears in many of Fattori's paintings and
several drawings after the 1880's. He inserted the figure in *The
Branding of the Colts in Maremma* (1887), and later in *The Drivers
of the Herd* (1907)–(see: Bianciardi and Della Chiesa, *L'opera
completa*, 107, no. 483; 116, no. 734).

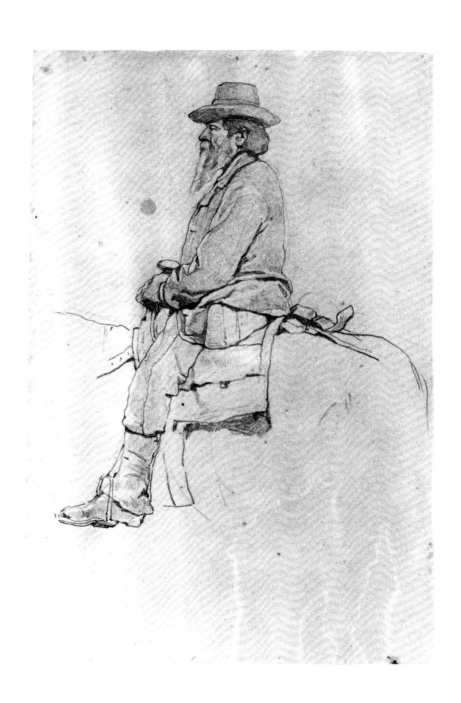

Cesare Mariani (Rome 1826 – Rome 1901)

Mariani's earliest work bears a resemblance to the verists of the Neapolitan School, like Morelli (q.v.) and Filippo Palizzi. He studied under Minardi (q.v.) and Giovanni Silvagni, becoming a painter of costume pieces in an academic mode. He dedicated himself to painting frescoes and was known for his refined drawing style and luminosity. After 1854, when he executed frescoes in the Roman church of S. Maria in Monticelli, he accepted only religious commissions and abandoned his progressive orientation based on studies from life. However, he retained his robust palette, delicate atmospheric qualities and his strong draftsmanship. During his career, Mariani painted numerous frescoes in churches and public buildings, e.g. the Church of San Rocco and the Palazzo delle Finanze. After the death of Cesare Fracassini in 1868, Mariani was selected to finish the frescoes in San Lorenzo fuori le Mura. He taught painting to the Prince of Naples for three years, was a member of many academies and became president of the Academy of San Luca. Mariani was also an accomplished printmaker.

R. Ojetti, *Cenni biografici di Cesare Mariani pittore e delle sue opere*, Rome, 1872.

V. Mariani, "Cesare Mariani pittore romano," *Roma*, II, 1924, 510-16.

67. Studies of a Reclining Female Nude

Black chalk with white heightening on blue paper. 12⅞ x 17⅛ in. (327 x 435 mm.).

Signed in black ink at lower right: *Cesare Mariani*.

Bibliography: Shepherd Gallery, New York, *Italian Nineteenth Century Drawings and Watercolors: An Album* (by Roberta J. M. Olson), New York, 1976, no. 101, pl. 34.

Provenance: Giovanni Piancastelli, Rome; Reverend Father Francis Agius, Inwood, Long Island; Shepherd Gallery, New York, 1976.

Lent by Mr. John Richardson, New York.

These Rubensian academic studies of a reclining female nude display a baroque lushness and an attention to light which Mariani derived from his teacher, Minardi (q.v.). Mariani has studied the model from three different angles, adding a detailed study of her feet and, at the left of the sheet, a partial outline of her hands. The several areas of *pentimenti* suggest that the artist quickly sketched the poses and then reworked the contours in a more complete manner. Mariani concentrated on the more highly finished figure of the model at the bottom of the page.

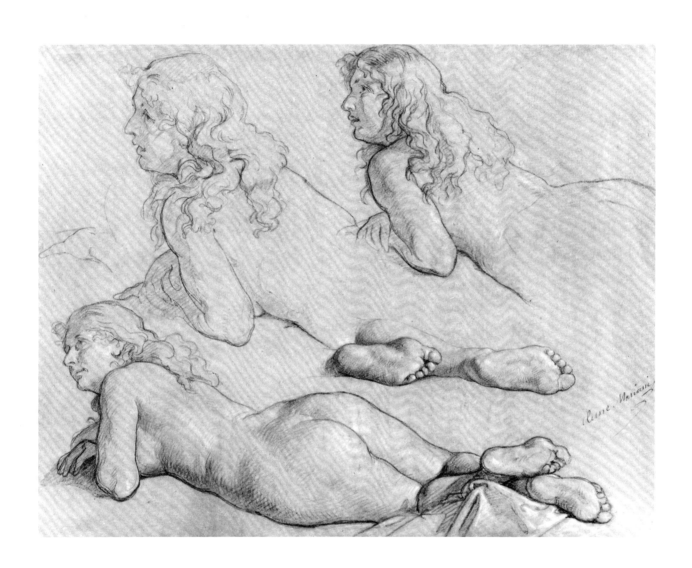

Amos Cassioli (Asciano 1832 – Florence 1891)

After a difficult youth, Cassioli (at eighteen) began his formal artistic instruction at the Academy of Siena under Mussini (*q.v.*), who had just returned from Paris, strongly influenced by Hippolyte Flandrin and Ingres. In November of 1856, he traveled to Rome on a stipend from the Grand Duke of Tuscany, Leopold II, remaining until May 1860. During this Roman period, Cassioli had considerable contact with artists studying at the French Academy in Rome and was especially interested in the art of his friend Degas, Jean-Jacques Henner and Gustave Moreau. Between 1859 and 1860, Cassioli worked on the cartoon for *The Battle of Legnano* (1863), which won a prize and critical acclaim. During his lifetime, Cassioli produced over 200 history paintings, including those depicting Machiavelli, Lorenzo de'Medici, Boccaccio, Paolo and Francesca, Bianca Cappello and Mary Stewart. In addition, he painted portraits and subjects from contemporary history with Risorgimento sentiments,

e.g. *Victor Emmanuel at Custoza*, many of which reveal a greater realism than occurs in his earlier, more purist works. Cassioli's decorative commissions include two for early Renaissance buildings: a cartoon for a stained glass window for the Florentine Duomo and a commission for the Palazzo Pubblico of Siena. Cassioli was an accomplished draftsman. His early style was a more lyrical, theatrical version of Mussini's Purism, which later became more realistic and relaxed.

Yorick (P. C. Ferrigni), *Amos Cassioli, pittore*, Florence, 1927.

L. Sbargli, "Amos Cassioli Pittore," *Bullettino Senese di Storia Patria*, IV, 1933, 213-34.

Carlo Del Bravo, "Angelo Visconti, e la gioventù di Amos Cassioli," *Antichità viva*, VI, 1967, 3ff.

68. Portrait of a Seated Man

Charcoal with traces of grey wash on blue paper. 14 x 10¾ in. (355 x 273 mm.).

Uffizi collection stamp at lower right (Lugt 930).

Bibliography: Carlo Del Bravo, "Angelo Visconti, e la gioventù di Amos Cassioli," *Antichità viva*, VI, 1967, 8, fig. 11; Gabinetto Disegni e Stampe degli Uffizi, Florence, *Disegni Italiani del XIX Secolo* (by Carlo Del Bravo), Florence, 1971, 95, no. 74, fig. 56.

Provenance: Giuseppe Cassioli, 1970.

Lent by the Gabinetto Disegni e Stampe degli Uffizi, Florence, gift of Giuseppe Cassioli, 105384.

Mussini's (*q.v.*) influence on his pupil Cassioli, whose style, like

that of his teacher, developed from the Purist tradition and bears a resemblance to that of Hippolyte Flandrin, is evident in this portrait. However, the line is bolder, yet softer and less exacting than that of either Mussini or the French artist. Cassioli's later birth date and contact with the young Degas – in Rome at the French Academy during the late 1850's – account for these differences. The contact between the two artists is neatly documented in Cassioli's portrait of Degas, which is similar in date, style and pose to this drawing (see: Del Bravo, *Disegni Italiani del XIX Secolo*, 96, no. 75, fig. 57). The pose and draftsmanship of both these drawings resemble Degas' early portraits.

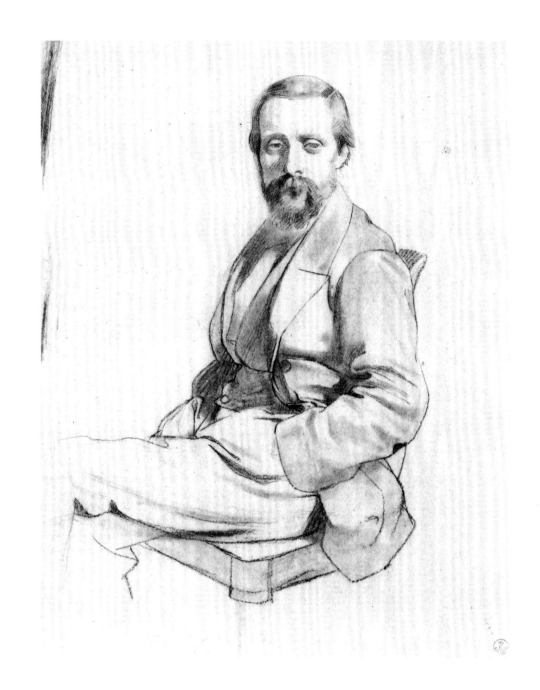

Odoardo Borrani (Pisa 1833 – Florence 1905)

Borrani first studied with Gaetano Bianchi, helping him restore paintings of Ghirlandaio, Uccello (in the Chiostro Verde in S. M. Novella) and Giotto (in Santa Croce). He also studied at the Academy of Florence with Bezzuoli (q.v.) and Enrico Pollastrini. At the Caffè dell'Onore in Borgo la Croce, the first meeting place of the Macchiaioli, he met the other charter members: T. Signorini (q.v.) and Cabianca (q.v.). Borrani was one of the first members of the Macchiaioli to paint outdoors near Florence, in the Appennines with Raffaello Sernesi and at Castiglioncello. For a time, he alternately painted academic works – e.g. the prize-winning *Pazzi Conspiracy* and *Michelangelo Directing the Fortification of Florence* – and landscapes, which he executed in the company of Signorini, Cristiano Banti and Cabianca in Liguria; with Sernesi in the Appennines and with Silvestro Lega at Pergentina. In 1859, Borrani volunteered to fight in the War of Independence.

Borrani's work during the 1860's, his strongest period, when he was most intensely involved with Macchiaioli ideas, is very close to Lega's. Both artists' work, in fact, reflects a study of the principles of quattrocento spatial construction. With Lega, Borrani opened an unsuccessful art gallery in the Palazzo Ferroni in 1875. He produced a vast number of watercolors and portraits, which are amongst the most luminous of all Macchiaioli works.

Adriano Cecioni, "Odoardo Borrani," *Scritti e Ricordi*, Florence, 1905, 337ff.

E. Cecchi, "Odoardo Borrani," *Dedalo*, VI, 3, 1926, 658-81.

69. Portrait of the Artist's Mother Praying

Black chalk on coarse, yellowed paper. 9⁷/₁₆ x 7 in. (239 x 177 mm.).

Signed in black chalk at lower right: *O. Borrani.*

Inscribed by the artist in black chalk at upper right: *Studio dal vero di/mia Madre.*

Uffizi collection stamp at lower right (Lugt 930).

Verso inscribed in chalk at upper edge: *Da Restituirsi.*

Bibliography: Gabinetto Disegni e Stampe degli Uffizi, Florence, *Disegni Italiani del XIX Secolo* (by Carlo Del Bravo), Florence, 1971, 112, no. 102, fig. 75.

Provenance: Zini, 1912.

Lent by the Gabinetto Disegni e Stampe degli Uffizi, Florence, 20998 F.

As drawings by Borrani are rare, it is difficult to date this example, even though the Uffizi owns another image of the artist's mother, Leopoldina (20561 F). Del Bravo (*Disegni Italiani del XIX Secolo*, 112) dates this drawing between 1865 and 1870, in comparison to the works of Giuseppe Abbati. The artist's concentration on a solitary seated woman and the tight draftsmanship relate the drawing to several of Borrani's paintings – *The 26th of April 1859*, signed and dated 1861, and *The Sewers of the Red Shirts*, signed and dated 1863 (see: Durbé, *I Macchiaioli*, 101, no. 45; 195, no. 157). However, Borrani has drawn his devout mother, with her eyes downcast, in an even more severe, geometric manner than the women in his paintings.

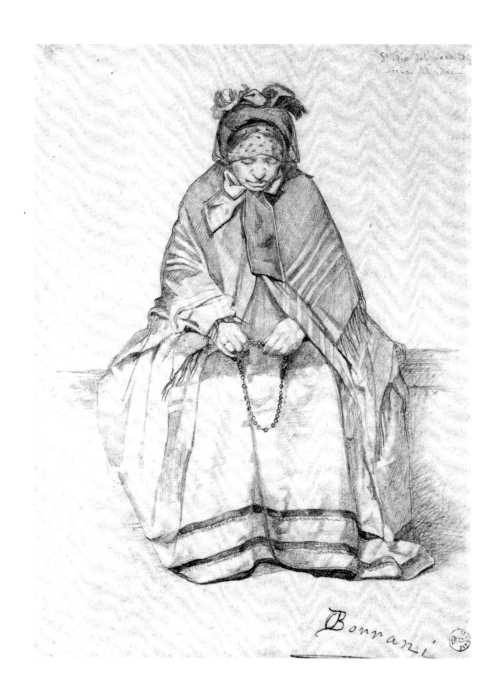

Telemaco Signorini (Florence 1835 – Florence 1901)

Signorini was first taught by his father, Giovanni, a court painter for the Grand Duke of Tuscany. He demonstrated literary interests and intellectual tendencies early in life, which are always reflected in his work. For a short period, he also studied at the Academy and the School of the Nude in Florence.

Signorini, like Adriano Cecioni and Diego Martelli, was a writer, chronicler and a theoretician of the Macchiaioli. Along with Borrani (*q.v.*) and Cabianca (*q.v.*), he was one of the charter members who first met at the Caffè dell'Onore. Signorini was the spokesman for the Macchiaioli, who later met at the Caffè Michelangiolo, where they first discussed the innovations of the Barbizon painters (in the Universal Exposition of 1855). He was also the first of the group, together with Borrani, to paint outdoors. As a patriot, Signorini espoused the most radical ideas, those of the revolutionary Mazzini and the socialist Proudhon. He was a passionate free spirit, who spent most of his life wandering in Italy and the capitals of Europe, always eventually returning to Florence.

In 1856, together with Vito d'Ancona, Signorini journeyed to Venice to paint outdoors in the unique light and to study in the museums. He also encountered many foreign artists (e.g. Lord Leighton). Upon his return to Florence, Signorini's work was attacked by conservative critics. In 1859, he volunteered to fight with Garibaldi, painting military subjects. With Cristiano Banti and Cabianca, he traveled to Paris in 1861, where he saw paintings by the Barbizon School (Corot, Troyon, etc.) and Courbet. After passing some time in Italy – at Castiglioncello with the critic Diego Martelli and other Macchiaioli artists – Signorini again traveled to Paris and London. He frequently returned to those cities to sell and exhibit his works, e.g. at the Royal Academy and the Grosvenor Gallery in London, and with Goupil and Reitlinger in Paris. Signorini also visited Boldini (*q.v.*) and De Nittis (*q.v.*) in Paris and became interested in the work of Manet and Degas. In 1888, he traveled to Scotland and was greatly impressed by Edinburgh.

Signorini's style was unique among the Macchiaioli group. His interest in nature and landscape was more objective and analytical; he portrayed simple themes of social content realistically. For a time, his palette was influenced by the Impressionists, but in his later period he returned to purer color. Signorini was a splendid draftsman, illustrator (e.g. he journeyed to Vinci to execute illustrations for Gustavo Uzielli's book on Leonardo) and printmaker, specializing in etching and drypoint. He refused the nomination of professor at the Florentine Academy, nevertheless accepting an honorary diploma in 1892.

Signorini is best understood as the theoretician of the Macchiaioli. In 1867, with Diego Martelli, he founded the *Gazzettino delle Arti del Disegno* and, in 1877, published among other things *Le 99 discussioni artistiche* (ninety-nine sonnets which were the apologia of his art).

Ugo Ojetti, *Telemaco Signorini*, Milan, 1930.

Enrico Somarè, *Signorini*, Rome, 1931.

Galleria Nazionale d'Arte Moderna, Rome, *Disegni di Telemaco Signorini* (by Dario Durbé), Rome, 1969.

70. Study of a Nude Girl

Black chalk on yellowish paper. 12⅝ x 9¼ in. (320 x 235 mm.).

Monogrammed in black chalk at upper right: $.

Uffizi collection stamp at lower center (Lugt 930).

Verso inscribed in chalk at upper left: *156*.

Bibliography: Gabinetto Disegni e Stampe degli Uffizi, Florence, *Disegni Italiani del XIX Secolo* (by Carlo Del Bravo), Florence, 1971, 119, no. 117, fig. 86.

Lent by the Gabinetto Disegni e Stampe degli Uffizi, Florence, 96414.

From this candid drawing, it is apparent why Signorini was sometimes called "the Degas of Italy." The sheet is one of a group of eleven related drawings in the Uffizi (nos. 96414-96424), all of which are similar to another group of nude young girls exhibited in Rome in 1969 (see: Durbé, *Disegni di Telemaco Signorini*, nos. 429, 449-52). Signorini, who often drew the same little girl who has posed for him on this sheet (see: *Ibid.*, nos. 386, 406, 411), also produced paintings and lithographs of similar subjects. The bold draftsmanship is characteristic of Signorini's late style and similar to that of Toulouse-Lautrec during the 1890's. The line is angular and essentially has the quality of a lithograph.

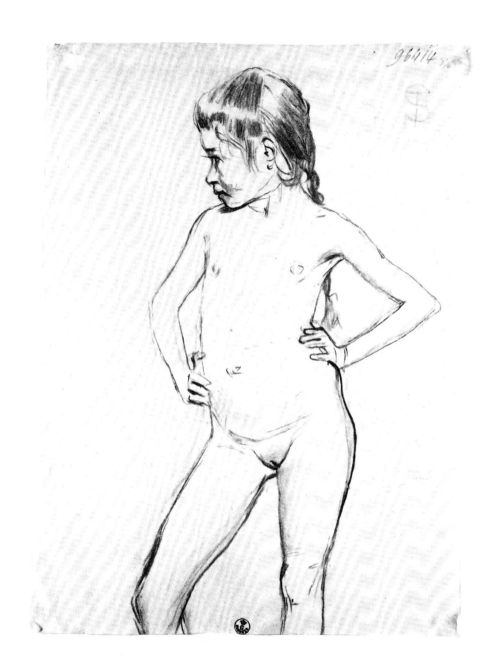

Vincenzo Cabianca (Verona 1827–Rome 1902)

Cabianca began his career as an academic painter, studying under Giovanni Gagliari at the Academy of Cignaroli, Verona. In 1845, he enrolled in the Academy of Venice for two years. He then traveled to Bologna and throughout Emilia, where he was imprisoned for his liberal political beliefs. After his release, Cabianca returned to Verona, except for an 1849 visit to Milan, where he was impressed by the genre works of Induno (*q.v.*). In 1853, he moved to Florence, where he became a charter member – with T. Signorini (*q.v.*) and Borrani (*q.v.*) – of the Macchiaioli group (which first met at the Caffè dell'Onore) and painted genre subjects similar to those of Induno. By 1856, the Macchiaioli were painting in a new style, stimulated by, among other things, the return of colleagues from the Universal Exposition of Paris in 1855 and the arrival of Morelli (*q.v.*). Between 1858 and 1859, Cabianca's work evidenced the simplified, broad areas of paint and the dramatic effects of sunlight on objects characteristic of Macchiaioli painting. Fattori (*q.v.*) claimed that Cabianca was the first to show a *quadro macchiaiolo* and to experiment with the new principles of light. In addition to contemporary subjects, Cabianca also painted historical costume pieces similar to those of Lord Leighton and Stefano Ussi; his drawings reveal detailed studies of paintings by Renaissance masters.

Cabianca, T. Signorini and Cristiano Banti traveled to Paris in 1861, where they were especially impressed by Décamps' work (they had already admired his paintings in the Demidoff collection in Florence). Cabianca moved to Parma in 1863, but he maintained contact with the Florentine *ambiente*. In 1868, he traveled to Florence and Rome, finally settling in Rome in 1870, where he frequented the progressive circle of Nino Costa and founded the Society of Watercolorists in 1876. In 1881, following Costa's example, he traveled to Paris and London, returning the following year to London in search of a market for his work. Although he enjoyed some success, Cabianca was disappointed in the results. In 1885, he joined *In Arte Libertas,* showing ten works at their first exhibition in 1886. Cabianca was among the famous artists who frequented the bohemian Caffè Greco in Rome. He contributed illustrations to Gabriele D'Annunzio's *Isotta Guttadauro* in 1886-88. Although he continued to contribute to important exhibitions in Italy, as well as abroad (London, Edinburgh, Glasgow, Amsterdam, Paris and Munich), he did not acquire a substantial reputation during his lifetime. Cabianca was paralyzed and unable to work during the last year of his life.

Romualdo Pàntini, "Artisti contemporanei: Vincenzo Cabianca," *Emporium,* XV, 1902, 405-23.

Comune di Verona, Verona, *Mostra Commemorativa, onoranze centenarie al pittore V. Cabianca,* Milan, 1927.

Galleria Nazionale d'Arte Moderna, Rome, *Vincenzo Cabianca: Disegni dallo studio* (by Dario Durbé et al), Rome, 1976.

71. Nuns at the Seashore 1869

Watercolor on board. 11^{13}/$_{16}$ x 22 in. (300 x 560 mm.).

Signed and dated at lower right: *V. Cabianca 1869.*

Bibliography: Giorgio Nicodemi, *La Raccolta Carlo Grassi, Comune di Milano,* Milan, 1962, 50, pl. 27; Galleria d'arte moderna, Milan, *Padiglione d'Arte Contemporanei: Raccolta Grassi* (by Luciano Caramel and Carlo Pirovano), Milan, 1973, 160, no. 326, pl. 361.

Provenance: Addeo; Carlo Grassi.

Lent by the Civica Galleria d'arte moderna, Grassi Collection, Milan, 20.

This watercolor is characteristic of Cabianca's paintings and drawings after 1860, particularly in his focus on the sea, white stonework and nuns in the habit of the Sisters of Charity (see: Durbé, *Cabianca,* 20, nos. 198-210). He also favored a horizontal format with its large expanse of vivid blue sky and strong sunlight. On a formal level, the watercolor is a study in extreme black and white of the sun's effects on the abstract forms of the nuns. The work reveals that Cabianca, of the three original Macchiaioli, remained closest to the traditional idea of genre painting, like that of Induno (*q.v.*). The watercolor postdates a group of related paintings from 1860-61, which were first exhibited in Turin and Florence in 1861 (see: Durbé, *I Macchiaioli,* 92-93, no. 34). Durbé discusses the popularity of the theme among ottocento painters (the Macchiaioli and other Italian painters, as well as Amand Gautier in *Les Soeurs de Charité,* exhibited at the Salon of Paris in 1859 and noticed by Baudelaire). He believes that the theme expresses the conflict between traditional religion and the new secular ethic, which in literature was already reflected in Diderot's *Religeuse* and Manzoni's "Nun of Monza" from *I Promessi Sposi.* Following Federico Pastoris, Durbé also suggests that Cabianca may have taken his inspiration for the works of this period from the poetry of Aleardi.

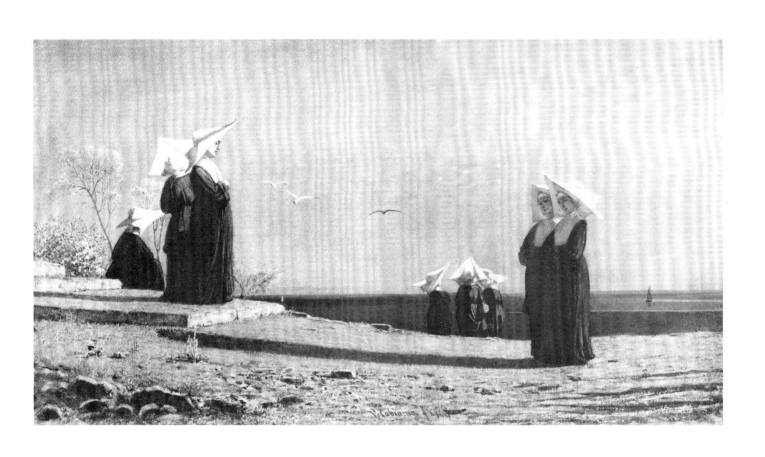

72. Daybreak on a Venetian Canal 1890

Watercolor on ivory paper. $27^{15}/_{16}$ x $41\frac{3}{4}$ in. (710 x 1060 mm.).

Signed and dated in brown watercolor at upper left:
V. Cabianca/1890.
Signed and dated in black watercolor at lower right:
V. CABIANCA MCCCLXXXX.

Lent by the Galleria Nazionale d'Arte Moderna, Rome, 1191.

After 1860, Cabianca painted numerous scenes with large,
centering arches (see: Durbé, *I Macchiaioli*, 87, no. 27 and
Durbé, *Cabianca*, 20)–a device used by many artists, including
Rembrandt, Granet and Décamps. In contrast to the earlier
work by Cabianca in this exhibition, a study of extreme sun-
light, this watercolor focuses on darkness and the smoky shad-
ows of a Venetian canal at daybreak. Its mood, as well as the
romantic setting, decadent and melancholic Venice, indicate
that by 1890 Cabianca had been affected by the *fin de siècle*
aesthetic, although the composition still relates to his earlier
works. During the eighties and nineties, a macabre element
enters Cabianca's work–e.g. *Rio Marin* (1881), *Riflessione
Macabre* (1882) and *Mistero* (1892)–(see: Pàntini, "Artisti Con-
temporanei: Vincenzo Cabianca," 410ff). Interestingly, another
version of the watercolor was successfully exhibited at the
Royal Academy in 1880 (*Ibid.*, 420).

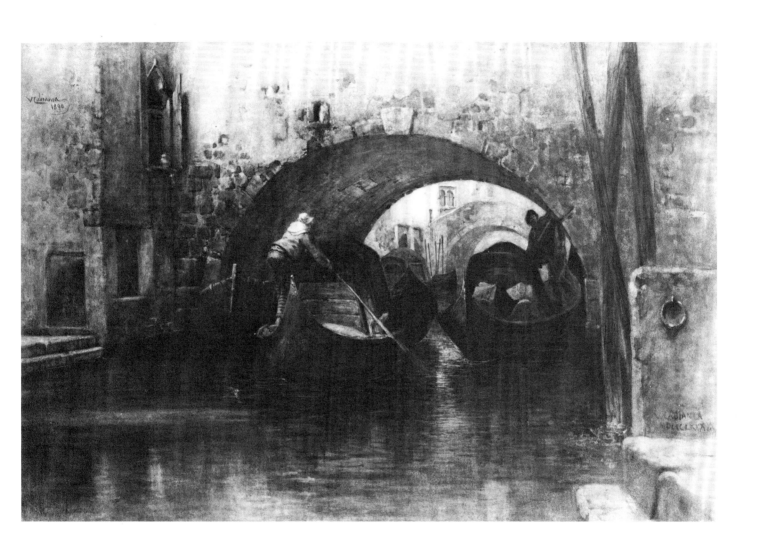

179

Tranquillo Cremona (Pavia 1837–Milan 1878)

As Giacomo Trécourt's student, Cremona attended the Civic School of Painting in his native Pavia. In 1852, he was orphaned and settled in Venice with his stepbrother, Giuseppe. There, he frequented the Academy, copying paintings by fifteenth and sixteenth-century Venetian masters, e.g. Carpaccio and Titian. These studies disposed Cremona's art toward light, color and sensuosity. In 1860, he moved to Milan–where Leonardo's spectre remained a vital force to contend with–studying under Giuseppe Bertini at the Brera Academy until 1863. His works before 1863 reveal that Cremona's academic training, with an accent on hard contour lines, had been tempered in both subject matter and color by his Venetian experience. In the painting *Marco Polo* (1863), a freer use of chiaroscuro and color becomes evident. Cremona's style relaxed even further through his involvement in the Milanese *ambiente* with the Scapigliatura group–with Il Piccio, Ranzoni (*q.v.*) and, most importantly, with Federico Faruffini. At the same time, Cremona became active in the major artistic/literary circles of Lombardy.

During the 1870's, Cremona's style matured, his subjects remaining romantic and sentimental while becoming increasingly immediate and intimate. As his style became more spontaneous, his reputation as an accomplished portraitist and watercolorist flourished. Cremona's vaporous brushwork and vibrant color always remained lighter than, but reminiscent of, Leonardo's *sfumato* and Titian's late brushwork. His simple, suggestively abstract, late improvisations foreshadow the *fin de siècle* ripeness portrayed by the international Symbolist painters, without their pedantry.

Enrico Somaré, *Catalogo della mostra commemorativa delle opere di Tranquillo Cremona nel cinquantesimo anniversario della morte,* Milan, 1929.

Luca Beltrami, *Il maestro Tranquillo Cremona,* Milan, 1929.

Giorgio Nicodemi, *Tranquillo Cremona,* Milan, 1933.

73. Portrait of Ada and Her Mother

Brown chalk with traces of black chalk on ivory paper. 8¾ x 6¹¹/₁₆ in. (222 x 170 mm.). Some small spots.

Monogrammed in brown chalk at upper left: ₵.

Verso: Various studies.
Chalk with blue and green pencil.

Bibliography: Gabinetto Nazionale delle Stampe, Rome, *Disegni dell'Ottocento* (by Enrichetta Beltrame-Quattrocchi), Rome, 1969, 70-71, no. 67, pl. 65.

Provenance: Mazzia.

Lent by the Gabinetto Nazionale delle Stampe, Rome, F.N. 252.

In this portrait of his wife Carlotta and their daughter Ada, Cremona, who specialized in intimate, emotional scenes, has focused on the warm bonds of maternal love. The two sitters can be identified from a photograph of Ada and Carlotta and several other works by Cremona, including a sketch of Ada sleeping (see: Nicodemi, *Tranquillo Cremona,* 85, 69) and two oval versions of *Maternal Love* (with an older Ada and her mother)–(see: Caramel and Pirovano, *Opere dell'Ottocento,* I, 45; no. 571, pl. 568; no. 572, pl. 569). Since Ada was born in 1873 and is approximately six years old in this drawing, it can be dated about 1879-80. With only brown chalk, Cremona has created a sense of vaporous, soft light and *sfumato* shade. He adeptly applied fine chalk lines, which he also rubbed, and allowed the ivory paper to serve as the highlights.

Tranquillo Cremona

74. Angelica 1877

Watercolor on off-white watercolor paper. 17½ x 10⅜ in. (445 x 264 mm.).

Verso inscribed in ink across top: *Nel Giugno 1877 Tranquillo Cremona in presenza del sottoscritto/ dopo aver lavato sotto la tromba/ (sino a ridurlo carta bianca console leggerissime traccie preesistenti) un tentativo andato a male di G. Barbaglia/ ne ricavò en breve ora il presente acquerello./ In fede, Vittore Grubicy De Dragon.*

Verso inscribed in ink at center: *861.*

Red seal of Vittore Grubicy.

Bibliography: Luigi Perelli and Primo Levi, *Tranquillo Cremona, l'uomo, l'artista*, Milan, 1913, opp. 38.

Provenance: Arturo Toscanini.

Lent by a Private Collection, U.S.A.

Grubicy (the impressario and art critic) inscribed the cardboard backing of the work with a variation of the inscription found on the verso of this watercolor, adding that it represented Angelica, tied to a rock, about to be devoured by a sea monster. He also noted that Pirelli and Levi identified the subject as Andromeda (see: *Tranquillo Cremona*, opp. 38). Does this work then represent Angelica (from Ariosto's *Orlando Furioso)* or Andromeda (from various mythological sources, including Ovid's *Metamorphoses*)? This ambiguity is not unusual. However, since Grubicy was present when the watercolor was painted, one tends to accept his identification (as Angelica).

More important than the subject of this watercolor are its genesis and technique, as explained by Grubicy in his inscription on the verso: in June of 1877, Cremona, in the presence of Grubicy, washed the sheet of paper (with an unfinished work by G. Barbaglia on it) under the faucet. Cremona subsequently painted the watercolor of Angelica in about an hour. Cremona's watercolor—described by Grubicy on the backing of the watercolor as "a brilliant improvisation"–is a tour-de-force in both conception and execution. The work is typical of Cremona's flamboyant, vaporous style, which evolved little after he abandoned his earlier, more highly finished technique. From the manner in which the watercolor pigments are spread on the sheet, one can see that Cremona applied them to wet paper, manipulating them to convey the tempestuous nature of the narrative–the sea pounding on the rocks and the anguish of the voluptuous heroine.

Alessandro Franchi (Prato 1838–Siena 1914)

Franchi began to draw at an early age and, in 1853, after preliminary art studies, received a scholarship to study with Mussini (*q.v.*) at the Academy of Siena. Mussini's letters report his rapid progress. Franchi won a prize which enabled him to travel to Florence in 1863, and in 1865 to Rome and Naples. In Rome, he discovered the works of the Nazarenes and the Purists, whose art had contributed to the formation of Mussini's style. He also encountered religious works by the French academic painters, such as Bougereau and Cabanel. When Mussini died in 1888, Franchi succeeded him in his teaching post at the Sienese Academy (where Franchi had previously taught drawing). In 1893, after leaving his wife of twenty-one years (Emilia Sampieri), Franchi married the daughter of his former teacher, Luisina Mussini.

Franchi's works reveal a predilection for classically-oriented forms and religious subject matter. He followed both Mussini's teachings and the tenets of Purism (influenced by the Nazarenes) by imitating the calm, timeless and simplified manner of the fifteenth and sixteenth-century masters. He was an excellent draftsman, rather than a colorist. Late in life, Franchi was influenced by the painter Ludwig Seitz – his paintings of this period are smaller and reflect Seitz's Gothic tendencies. Franchi maintained contact with Prato throughout his life and produced some of his most important works there. The largest collection of Franchi drawings was donated by the painter to the Musei Civici of Prato; today they are located in the Palazzo Pretorio in Prato.

Alessandro Franchi e le sue opere, Siena, 1915.

Carlo Del Bravo, "Per Alessandro Franchi," *Annali della Scuola Normale Superiore di Pisa,* II, 2, 1972, 737-59.

Palazzo Pretorio, Prato, *Alessandro Franchi. Disegni restaurati della Pinacoteca di Prato* (by Carlo Del Bravo), Prato, 1976.

75. Study of Adam in *The Expulsion from Paradise* 1872-73

Charcoal with stumping and white heightening on coarse off-white paper. 19⅝ x 12⅝ in. (499 x 320 mm.). Stained, with lacunae.

Bibliography: Carlo Del Bravo, "Per Alessandro Franchi," *Annali della Scuola Normale Superiore di Pisa,* II, 2, 1972, pl. L; Palazzo Pretorio, Prato, *Alessandro Franchi. Disegni restaurati della Pinacoteca di Prato* (by Carlo Del Bravo), Prato, 1976, 104, no. 212, pl. I, fig. 47c.

Provenance: Estate of the artist, 1915.

Lent by the Assessorato alla Cultura del Comune di Prato, Prato, gift of the artist.

Like the two other Franchi drawings in the exhibition, this work is preparatory for his Old Testament cycle in the Cappella Vinaccesi in the Duomo of Prato. It is an academic study from a model posed as Adam in *The Expulsion from Paradise* (see: Del Bravo, *Alessandro Franchi,* 54, ill.), frescoed (in 1873) in a lunette facing *The Sacrifice of Isaac.* Except for minor changes, for example the addition of a leaf loincloth and the placement of Adam's left foot in the fresco, the drawing is very close to the finished work. Franchi's style bears a resemblance to that of Flandrin, and his Adam reveals an awareness of Masaccio's *Expulsion* (c. 1427) in the Brancacci Chapel.

76. Studies for *The Brazen Serpent* 1873

Sanguine and white chalk with stumping on brownish paper. 12⅜ x 9⅜ in. (315 x 238 mm.). Paper stained and spotted, with traces of sanguine.

Bibliography: Carlo Del Bravo, ''Per Alessandro Franchi,'' *Annali della Scuola Normale Superiore di Pisa,* II, 2, 1972, pl. XLVIII; Palazzo Pretorio, Prato, *Alessandro Franchi. Disegni restaurati della Pinacoteca di Prato* (by Carlo Del Bravo), Prato, 1976, 102, no. 195, pl. III, fig. 50b.

Provenance: Estate of the artist, 1915.

Lent by the Assessorato alla Cultura del Comune di Prato, Prato, gift of the artist.

This drawing is one of three preparatory studies in this exhibition for Franchi's Old Testament cycle in the Cappella Vinaccesi in the Duomo of Prato. Franchi began working on *The Brazen Serpent* (see: Del Bravo, *Alessandro Franchi,* 54, ill.) in the fall of 1873, and the scene was completed by December 26, when the chapel was temporarily opened to the public to show Franchi's progress on the project. The model in the drawing has assumed the pose for the reclining figure in the right foreground of the fresco, where his lower torso is covered with massive drapery (unlike in the drawing). On this sheet, Franchi studied the distribution of weights and the pattern of light on the figure's muscular back. He has drawn an enlarged and more detailed study of the head in the upper right corner, wrapped in a turban as it appears in the fresco. At the upper left, there is a quick indication of the figure's left shoulder.

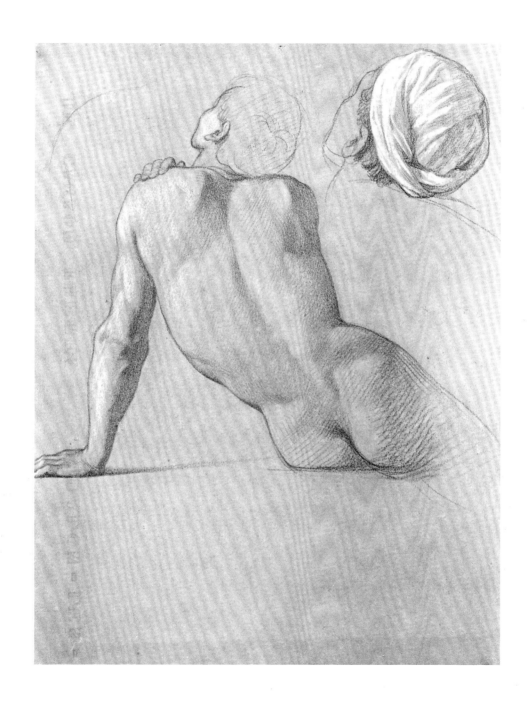

77. Study for *The Brazen Serpent* 1873

Sanguine and white chalk with stumping and traces of graphite on thick off-white paper. 10⅞ x 9¹³/₁₆ in. (276 x 249 mm.). Spots.

Verso inscribed in black chalk at lower left margin: *A Franchi.*

Bibliography: Carlo Del Bravo, "Per Alessandro Franchi," *Annali della Scuola Normale Superiore di Pisa*, II, 2, 1972, pl. XLVI; Palazzo Pretorio, Prato, *Alessandro Franchi. Disegni restaurati della Pinacoteca di Prato* (by Carlo Del Bravo), Prato, 1976, 103, no. 207, pl. IV, fig. 53b.

Provenance: Estate of the artist, 1915.

Lent by the Assessorato alla Cultura del Comune di Prato, Prato, gift of the artist.

This sheet is the last of the three drawings in the exhibition related to Franchi's Old Testament cycle in the Cappella Vinaccesi, the Duomo of Prato. Like the previous drawing, it is a preparatory study for a figure in *The Brazen Serpent* (see: Del Bravo, *Alessandro Franchi*, 54, ill.), completed by December 26, 1873. The subject traditionally calls for figures in poses of extreme contrapposto, as in Michelangelo's version on the Sistine Ceiling. In this drawing, Franchi's model assumed the pose for the figure struggling with a serpent (its coils quickly suggested by the lines sketched near the model's upper right arm). Although the figure in the fresco is only shown above the waist, Franchi has completed his lower torso and left thigh in the drawing, presumably because he was undecided on the final composition of the work.

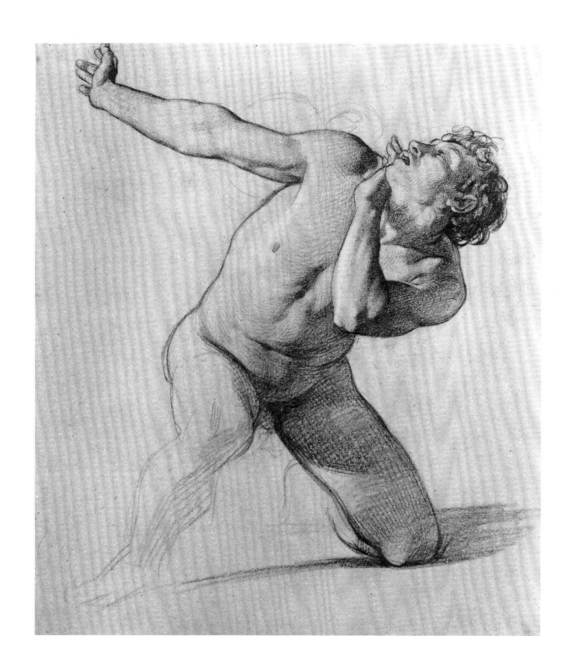

Mariano José Maria Fortuny y Carbó (Réus 1838 – Rome 1874)

Fortuny, who was born in Spain and orphaned at an early age, was largely self-taught. He was raised by his grandfather, who sold wax figures modeled by the young artist. Encouraged by the amateur painter Domingo Soberano, he later entered the studio of the sculptor Talarn Ribot in Barcelona, while also attending the Academy and frequenting the studio of Claudio Lorenzale (who had been influenced by Overbeck). Until receiving a stipend to study in Rome in 1857 (departing in 1858), Fortuny earned a living by painting small pictures of religious and genre scenes. In Rome, he was affiliated with the colony of Spanish artists and attended the Academy Gigi at night.

In 1860, Fortuny interrupted his Roman stay by accepting a commission from the Consul General of Barcelona to paint a battle picture of the victory of Spain in Morocco (it remained unfinished). Striving for picturesque local color, he traveled to Africa several times and in 1860 was even imprisoned by the Moroccans. Fortuny visited Paris in 1866, where he studied with Gérôme. He also befriended and was influenced by the work of Meissonier, and procured many commissions from the renowned dealer, Goupil. While in Rome, he became an intimate friend of Henri Regnault, whose work, particularly in watercolor, was strongly influenced by Fortuny. In 1867, he married Cecilia, the daughter of Federico de Madrazo y Kuntz (president of the Madrid Academy of Painting), thus entering a famous artistic family. When he returned to Spain in 1868 to study Goya, Fortuny was an established and celebrated artist. Between 1869 and 1874, he traveled to England, Paris, Seville and Granada, but chose to remain an expatriate, spending the rest of his life in Naples and Rome, where he died at an early age of an infection. He should be considered an Italian artist, although the Spanish School also claims him.

Fortuny's œuvre can be divided into four periods, beginning in Barcelona and Morocco, when he freed himself from academicism, studied Gavarni's prints and developed an interest in Oriental subjects and brilliant color. During the second period, between 1860 and 1865, he developed his individual style. And, in the third period, between 1866 and 1868, Fortuny was influenced by his experiences in Paris, especially by Japanese prints and the work of Meissonier, resulting in increased chromatic effects. His opulent late works are among the best known and represent his most original contribution. His œuvre is largely comprised of genre scenes and portraits painted with a certain theatricality; there is an emphasis on decorative detail and a sophisticated technique of great virtuosity and dashing brushwork. Although Fortuny's work is occasionally marked by a superficial bravado, he was an excellent colorist and had a strong influence on the watercolorists of the late nineteenth century – both the Spanish and the Italian Schools, and above all, that of Naples during the 1870's. Fortuny was also a prolific and accomplished printmaker.

Jean Charles Davillier, *Fortuny: sa Vie, son Oeuvre, sa Correspondence*, Paris, 1875.

Luigi Alfieri, ed., *Fortuny, 1838-1874*, Milan, 1930 (?).

Charles Domingo, "Fortuny Ayer y Hoy," *Memorias de un Pintor*, Barcelona, 1944.

78. Seated Woman

Watercolor over graphite on cream paper. 15¾ x 12½ in. (400 x 318 mm.).

Red Stamp of the Fortuny sale at lower left (Lugt 943).

Bibliography: Fogg Art Museum, Harvard University, Cambridge, Massachusetts, *Drawings from the Daniels Collection*, Cambridge, 1968, no. 42, pl. 42; The Parrish Art Museum, Southampton, New York, *William Merritt Chase in the Company of Friends* (by Ronald Pisano), New York, 1979, no. 64, pl. 52.

Provenance: Atelier de Fortuny, Hôtel Drôuôt, sale, Paris, 26-30 April 1875, 54, no. 142; Shepherd Gallery, New York, 1966.

Lent by Mr. David Daniels, New York.

It has been suggested that the subject of this unfinished watercolor is the artist's wife, Cecilia Madrazo. The seated woman daydreams over a partially open book in her lap, her head characteristically against the wall. Fortuny did represent his wife in a similar type of heavy, embroidered dress and, in several photographs of his studio, there are objects like the unfinished, flowered wall hanging in the background (see: J. Ciervo, *El Arte y el Vivir de Fortuny*, Barcelona, n.d., pls. 1-9 and Alfieri, *Fortuny*, pl. 52). One photograph, in fact, shows Cecilia Madrazo in a similar pose in his studio (Fogg Art Museum, *Drawings from the Daniels Collection*, 42). This watercolor has an especially lyrical quality since the quickly sketched floral design in the background suggests the model's reveries. Two Roman watercolors executed between 1867 and 1869 have similar calligraphic backgrounds (see: Alfieri, *Fortuny*, pls. 10, 12), suggesting a date in the late 1860's for this work.

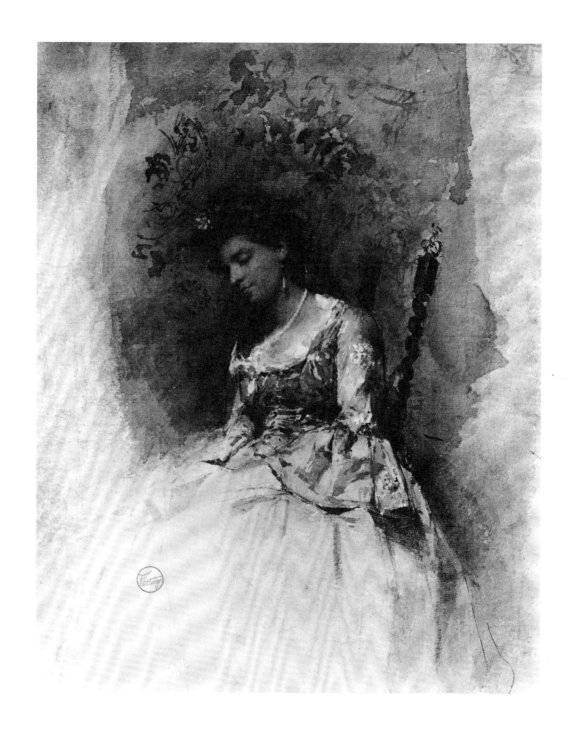

79. Portrait of an Arab

Watercolor on off-white watercolor paper with irregular borders. 8⅛ x 6¼ in. (206 x 159 mm.).

Verso inscribed in graphite: *#20/Fortuny/31.*

Lent by a Private Collection, Princeton.

Because of the subject's costume, it is tempting to date this watercolor to Fortuny's Moroccan period or to the years he spent in Spain. However, he continued to paint these exotic Arab subjects until his death (see: Alfieri, *Fortuny*, pls. 3, 13, 14, 16, 28). The figures in those compositions frequently wear white turbans and lean against walls, like the man in this sheet, but they seldom possess the simplicity and directness of this watercolor. The background calligraphy in dark green surrounding the head like a halo and the colors in the robe are similar to, but even more freely painted than in the *Seated Woman* in this exhibition, suggesting a later date. The sumptuous and vibrant color of the work demonstrates why Regnault and Théophile Gautier highly praised his watercolor technique.

80. Woman in a *Ciociara* Costume 1858 (?)

Watercolor on white paper. 10 x 5 in. (255 x 127 mm.). Stained at the edges.

Inscribed in graphite at upper left: *Fortuny.*

Verso inscribed: *Etude par Fortuny . . . (illegible) . . . 1858.*

Lent by the Fine Arts Museums of San Francisco, Achenbach Foundation for Graphic Arts, San Francisco, gift of the M. H. de Young family, 1941, 41-1-5-deY.

Fortuny's broader, almost abstract style is evident in this portrait of a contemplative peasant woman. Again, the brilliant reds and blues testify to Fortuny's extraordinary ability as a colorist. Several Roman watercolors of 1869 have similar broad areas of color (see: Alfieri, *Fortuny,* pls. 13, 20). Fortuny has concentrated on conveying the flattening effects of the bright Mediterranean sun, even though contemporary sources report that the artist, a compulsive worker, often painted in oils during the day and continued to work in watercolor at night.

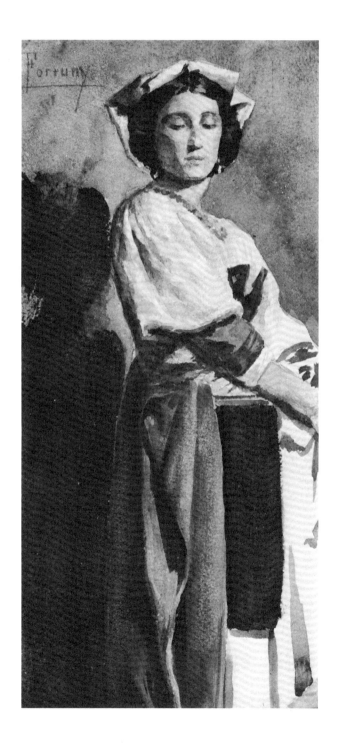

Guglielmo Ciardi (Venice 1842 – Venice 1917)

At eighteen, Ciardi entered the Venetian Academy, studying with Federico Moja and Domenico Bresolini. By 1866, he had exhibited landscapes of great promise. Ciardi freed his style from his academic training by employing broader brushstrokes and dabs of color, like the Macchiaioli. He subsequently spent a year traveling throughout Italy to study contemporary artistic trends. In Florence, he met the Macchiaioli and also painted in the countryside with T. Signorini (*q.v.*), making the acquaintance of Fattori (*q.v.*) and Silvestro Lega. While works of this period reveal a study of the chiaroscuro effects of Borrani (*q.v.*), Ciardi's innate tendency toward bright, clear light reasserted itself (between 1868-69). Ciardi also journeyed to Rome, where he met Nino Costa, and to Naples, where he met Morelli (*q.v.*), Filippo Palizzi and painters influenced by the Barbizon School. Returning to Venice, Ciardi concentrated more intensely on outdoor scenes, color and the blinding effects of light reflected off water (quintessential Venetian concerns). He resuscitated the century-old Venetian *veduta* or view painting. (These meticulous topographical studies first appeared in paintings by quattrocento masters, but eventually reached an independent status and were very popular with eighteenth-century tourists.) Ciardi also painted the Venetian Lagoon and the country near Treviso with its broad green horizons. In 1894, Ciardi assumed the chair of *veduta* painting at the Venetian Academy, left vacant by the death of his former teacher, Bresolini. His daughter and pupil, Emma Ciardi (1879-1933), was also a landscape painter.

G. Perocco, *Guglielmo Ciardi,* Bergamo, 1958.

Luigi Gaudenzio, *Guglielmo Ciardi,* Padua, 1971.

Ca'Da Noal, Treviso, *Guglielmo Ciardi* (by Luigi Menegazzi), Treviso, 1977.

81. Studies of Young Peasant Girls

Graphite on greyish paper. 7⁵/₁₆ x 11 in. (186 x 280 mm.).

Bibliography: Ca'Da Noal, Treviso, *Guglielmo Ciardi* (by Luigi Menegazzi), Treviso, 1977, 83, no. 10, pl. 10.

Lent by the Civico Gabinetto dei Disegni, Castello Sforzesco, Milan, B 727-2061.

This drawing, rendered outdoors, is one of a group of related sheets in the Castello Sforzesco depicting peasants (see: Menegazzi, *Guglielmo Ciardi,* 133-35, figs. 7-15). In its stark simplicity and concentration on figures in the raking sunlight, it is reminiscent of Winslow Homer's paintings. By comparing the drawing to Ciardi's œuvre, it is possible to date it c. 1869-75. Ciardi painted a similar peasant girl in an identical costume in *Mattino di Maggio* (1869); and the technique, together with that of the other drawings in the Castello Sforzesco, relates it to *Lungo il Sile* (1873) and *Mulino sul Sile* (1875)–(see: *Ibid.,* pls. 17, 23, 36). The drawing certainly dates after Ciardi's 1868-69 trip to Florence (where he attended the Caffè Michelangiolo and visited the Demidoff collection), Rome (where he was influenced by Nino Costa) and Naples. Ciardi's graphic technique is obviously similar to that of Fattori (*q.v.*), T. Signorini (*q.v.*) and Silvestro Lega.

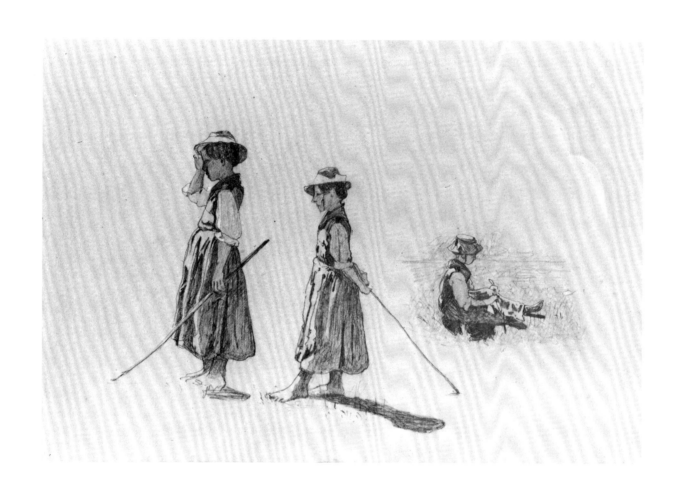

Giovanni Boldini (Ferrara 1842 – Paris 1931)

Boldini was the son of a minor painter, whose main source of income seems to have been from copying paintings. A precocious talent, Boldini first studied with his father, developing a fluid brushstroke and mastering a great variety of painting styles. At twenty, he left Ferrara with an already substantial reputation. Settling in Florence for six years, he first studied at the Academy with Enrico Pollastrini and Stefano Ussi, although he soon met the Macchiaioli, who opposed academic principles, preferring rapid and spontaneous execution. Boldini frequented their *ambiente* connected with the Caffè Michelangiolo and quickly absorbed their manner of painting. He concentrated mainly on landscape and portraiture, painting his friends—e.g. Cabianca (*q.v.*) and Diego Martelli; it was clear that he already had a facility with portraits. In 1870, however, Boldini executed one of his rare fresco decorations (composed of landscapes and seascapes) on the walls of the Villa Falconer (called ''La Falconiera'') near Pistoia.

In 1867, Boldini visited the *Exposition Universelle* in Paris; in 1869, he left Italy for London, where he established himself as a fashionable portraitist. By 1872, he had settled permanently in Paris, first, like De Nittis (*q.v.*), painting views of the city and exhibiting with Goupil. Boldini enjoyed a very successful career in Paris and was termed a ''monster of a talent'' by Degas. He was allied with the conservative artists, exhibiting his virtuoso paintings each year at the Salon, and was virtually untouched by the succession of pictorial revolutions, beginning with Impressionism in 1874, that swept Paris in the late decades of the nineteenth and the early decades of the twentieth century. Boldini also exhibited at many international shows, becoming a celebrated and prolific portraitist of cosmopolitan society (like Sargent in London), of aristocracy and intelligentsia alike. Among his most famous portraits are those of Robert de Montesquieu, James A. McNeill Whistler, Marcel Proust, Alexandre Dumas, the Marchesa Casati and Adolph Menzel.

Boldini, who was also noted for his work in pastel, had an elegant and spontaneous impasto style of painting. A trip to Spain in 1877, where he studied the works of Velásquez and Murillo, helped to solidify Boldini's mature style. Although Boldini is claimed by both the French and Italian Schools, his work never loses the characteristics which link him to late nineteenth-century Italian painting. He won prizes in the Italian section of the Universal Expositions in Paris in 1889 and 1900, and was nominated as the commissioner of the Italian section (1889). In 1897, he exhibited his works at Wildenstein in New York.

Casa Romei, Ferrara, *Mostra di Giovanni Boldini* (by E. C. Boldini, G. Gelli and Enrico Piceni), Ferrara, 1963.

Dino Prandi, *Giovanni Boldini L'Opera Incisa,* Reggio Emilia, 1970.

Carlo L. Ragghianti and Ettore Camesasca, *L'opera completa di Boldini,* Milan, 1970.

82. Two Dancers

Watercolor and graphite on white paper laid down. 14⅜ x 10⁹/₁₆ in. (365 x 268 mm.).

Signed in black chalk at lower right: *Boldini.*

Bibliography: Musée Jacquemart-André, Paris, *Boldini* (by J. L. Vaudoyer, E. C. Boldini and Enrico Piceni), Paris, 1963, no. 111; Casa Romei, Ferrara, *Mostra di Giovanni Boldini* (by E. C. Boldini, G. Gelli and Enrico Piceni), Ferrara, 1963, no. 103; Sotheby Parke Bernet Inc., sale catalogue, New York, *The Benjamin Sonnenberg Collection,* I, New York, 1979, 635, ill.

Provenance: Madame Jean Gabriel Domergue; Alex, Reid and Lefevre, London, 1966; Benjamin Sonnenberg, 1979.

Lent by Judge and Mrs. Paul H. Buchanan, Junior, Indianapolis.

Boldini's reputation for technical virtuosity is apparent in this unfinished watercolor. Because it is less flamboyant and more controlled than his mature and late works, it can be dated relatively early in his career. It is similar in style to a watercolor of a seated man, dating from c. 1870 (see: Ragghianti and Camesasca, *L'opera completa,* 90, no. 13, ill.), although it is slightly freer and more dashing. The watercolor no longer reflects the influence of the Macchiaioli, but rather that of Paris and Degas (a friend of Boldini's), especially in its subject, palette and point of view. Since Boldini first traveled to Paris in 1867, returning in 1871 and finally settling there in 1872, a date after 1870 seems likely for this watercolor.

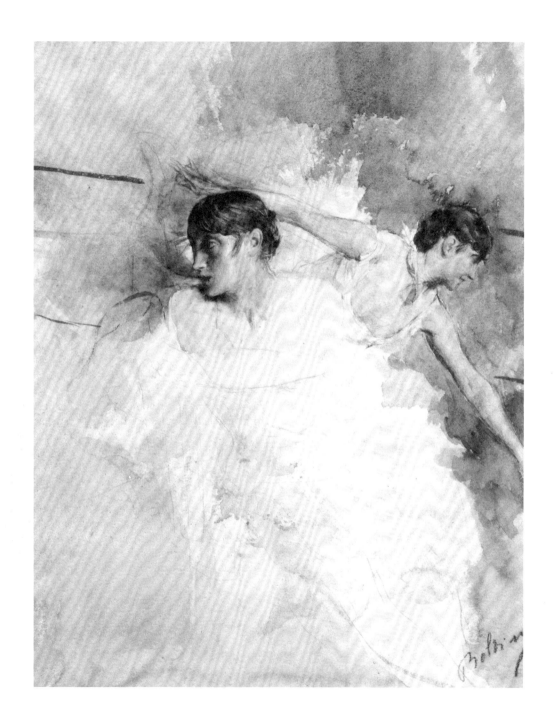

83. Portrait of a Famous Connoisseur

Graphite on off-white graph paper. 6⁵/₁₆ x 4³/₈ in. (160 x 110 mm.). Torn at upper corners.

Signed and dated in graphite at lower right: *Boldini/83 (85?)*.

Inscribed in graphite at upper right: *fameux connoisseur*.

Provenance: Hôtel Drôuôt, sale, Paris, 22 June 1949, no. 1; Robert Lehman, New York.

Lent by The Metropolitan Museum of Art, Robert Lehman Collection, New York, 1975.1.278.

From the background figures and the glass on the table, it is apparent that the present drawing is one of the sketches which Boldini frequently rendered in the cafés of Paris. Although it is impossible to determine whether Boldini has dated the drawing 1883 or 1885, its Menzel-like style is similar to two portraits of Degas by Boldini, the first undated (see: Ragghianti and Camesasca, *L'opera completa*, 85) and the second dated 1883 (see: Sotheby Parke Bernet, Inc., sale catalogue, New York, *The Benjamin Sonnenberg Collection*, I, New York, 1979, 633, ill.). It also closely resembles a self-portrait, dated 1882 (see: Ragghianti and Camesasca, *L'opera completa*, 83). The simple, psychological drawing lacks the more customary flamboyance of many of the artist's painted portraits, revealing his natural talent as a portraitist.

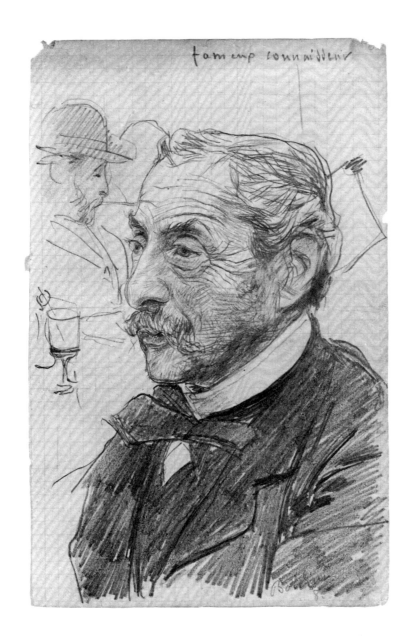

Gustavo Mancinelli (Rome 1842 – Naples 1906)

Gustavo, son of the painter Giuseppe Mancinelli, exhibited in Naples in 1855 when he was only thirteen, and was well-received. He later became a professor at the Institute of Fine Arts in Naples and was noted for his portraits of sovereigns and aristocrats. In addition, he painted historical and religious subjects, decorating many churches in Italy and abroad. His works are noted for their vivacity of color and their strong drawing. Several of his historical paintings are located in the Museo Nazionale di Capodimonte in Naples.

84. Portrait of a Young Man 1882

Graphite on off-white paper. 6⁹/₁₆ x 5¹¹/₁₆ in. (167 x 146 mm.).

Signed and dated in graphite at upper right: *Mancinelli/genajo 1882*.

Bibliography: Shepherd Gallery, New York, *Italian Nineteenth Century Drawings and Watercolors: An Album* (by Roberta J. M. Olson), New York, 1976, no. 155, pl. 45.

Provenance: Giovanni Piancastelli, Rome; Reverend Father Francis Agius, Inwood, Long Island; Shepherd Gallery, New York, 1976.

Lent by Mr. David Daniels, New York.

This sensitive portrait reveals that Mancinelli was an expert draftsman, capturing the romantic personality of the youthful sitter. The bold, free treatment of the garments contrasts with the traditional chiaroscuro modeling in the face, a vestige of his academic training.

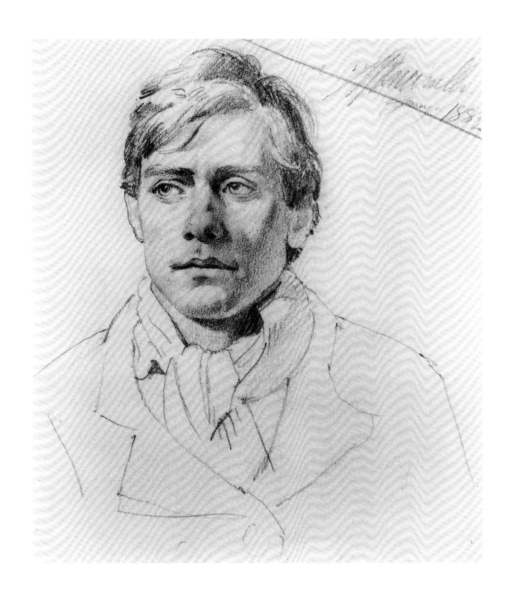

203

Pio Joris (Rome 1843 – Rome 1921)

From 1855 to 1861, Joris attended the Academy of San Luca in Rome where, although he studied under Achille Vertunni, he soon oriented himself toward the lush watercolor style of Fortuny (*q.v.*). Later, Joris worked in Florence, where he saw the works of Morelli (*q.v.*), Filippo Palizzi and Saverio Altamura in the Exposition of 1861. This experience stimulated him to concentrate on studies from nature and genre subjects. Joris returned briefly to Rome, before beginning a long period of travel and study in Italy, Spain, France and England.

Today Pio Joris is almost forgotten, but during his lifetime he received international recognition and critical attention, winning gold medals in Munich (1869) and Vienna (1873). He also exhibited in Paris during the decade of the 1870's (with a gold medal in 1875), as well as in Italy. Joris was a prolific artist (also a watercolorist and printmaker), whose best work consists of his paintings and sketches of the landscape and life around Rome, e.g. *The Fruit Market* and *The Via Flaminia,* although he also produced historical paintings.

Alfred Ruhemann, "Kunst und Künstler in heutigen Rom," *Allgemeine Kunst Chronik,* XIX, 1915, 477-80.

85. Italian Courtyard with Figures

Watercolor on heavy watercolor paper. 21 x 14⁹/₁₆ in. (533 x 370 mm.). Border stained from old mat.

Signed in brown ink at lower right: *P. Joris Roma-.*

Verso inscribed in ink at lower center: *C (?) 3645 Asxx.*
 Azxx

Provenance: Catherine Lorillard Wolfe, 1887.

Lent by The Metropolitan Museum of Art, New York, Lorillard Bequest, 87.15.2.

This Roman watercolor portrays three women engaged in winnowing grain, while a young boy looks on. The scene is set inside a complex of buildings and is a good example of the type of genre watercolor bought by tourists in the last quarter of the century. It reveals both the acceptance of Realism and the technically adept watercolor technique practiced during the period. The earthy color scheme and rectilinear composition lend it a quiet dignity.

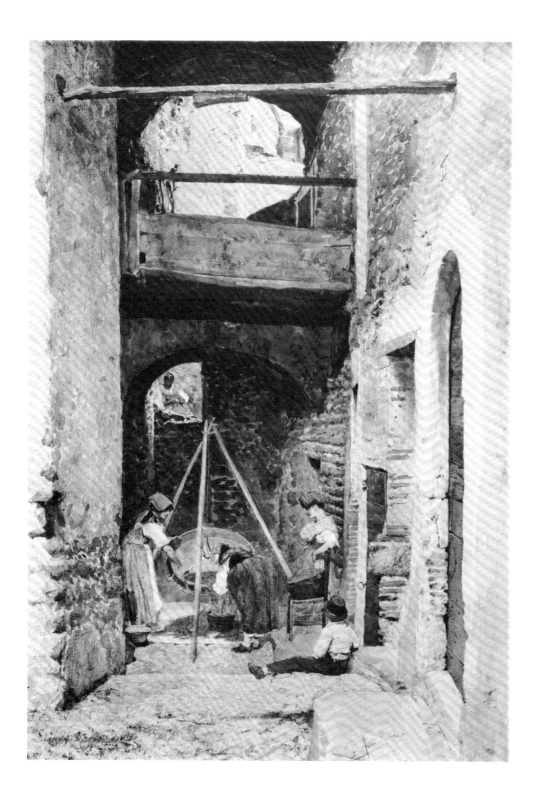

Daniele Ranzoni (Intra 1843 – Intra 1889)

After demonstrating an early aptitude for drawing, his father, a shoemaker, placed Ranzoni in the studio of Luigi Litta. At thirteen, Ranzoni attended the Brera Academy, transferring to the Albertina Academy in Turin (1857), where he remained until eighteen. In Turin, influenced by the works of Fontanesi (*q.v.*), he developed a freer style with shimmering light effects. In 1863, Ranzoni returned to the Brera after his plan to study in Florence was prevented by ill health. Ranzoni then became a student of Guiseppe Bertini, befriending other students in his class, including Cremona (*q.v.*), Mosè Bianchi and Giuseppe Grandi. He also met and joined other members of the progressive Milanese group of the 1860's and 1870's called "La Scapigliatura," a clique of romantic, idealistic artists, writers and musicians who were searching for broader aesthetic principles. The years between 1868 and 1873 in the Scapigliatura *ambiente* were the most decisive for Ranzoni's career. Ranzoni and Cremona, two of the most gifted artists of the group, derived their vaporous, quasi-Impressionist brushwork from the technique of Il Piccio (Giovanni Carnovali). Ranzoni, the more penetrating of the two, was also influenced by the sensual palette of Federico Faruffini, who had studied the sixteenth-century Venetians.

Ranzoni's work, almost exclusively portraits, is characterized by a lyrical sentiment and an emotional robustness. At the invitation of the English ambassador, he visited London between 1877 and 1879, when his portraits were rejected by the Royal Academy (1879). Returning to Italy embittered, Ranzoni learned of the death of his friend Cremona (in 1878). He then experienced an unhappy love affair, which contributed to a breakdown and hospitalization at Novara. He died at sixty-four, melancholic and mad.

R. Giolli et al, *La vita e l'opera di Daniele Ranzoni,* Milan, 1926.

Margherita Sarfatti, *Daniele Ranzoni,* Rome, 1935.

86. Bust of a Woman in Sixteenth-Century Costume

Black chalk on off-white paper. 4⁵/₁₆ x 3⁵/₁₆ in. (109 x 84 mm.). Stained and torn.

Provenance: Vittore Grubicy, 1920.

Lent by the Civico Gabinetto dei Disegni, Castello Sforzesco, Milan, A 1826-5654.

From the fragmentary sketch at the left of the paper, perhaps the shoulder of another figure, it appears that this sheet was once part of a larger composition. It depicts the bust of a woman in sixteenth-century costume, turned at an angle, who holds a sheet of lined paper (perhaps a music score) or a *cetra* in her left hand. Near her right hand, there are lines that suggest the neck of a musical instrument. Her coiffure, posture and heavy voluptuous type, together with the musical context, belong to the Giorgionesque tradition and recall the work of such artists as Giorgione, Titian and Palma Vecchio (almost identical poses appear as late as the paintings of Bonifazio Veronese). The tightness of the draftsmanship, in contrast to the freedom of Ranzoni's more typical style, suggests that this drawing may have been an early work, executed while Ranzoni was a student at the Brera studying the Venetian School (so important to his artistic development). In this drawing, one already finds the intimacy characteristic of Ranzoni's mature works.

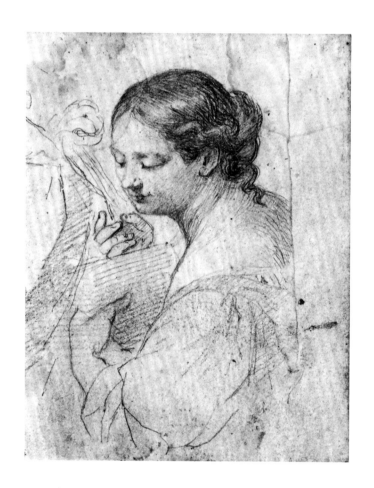

Giuseppe De Nittis (Barletta 1846–Saint-Germain-en-Laye, Paris 1884)

Born in Puglia, the precocious De Nittis entered the Neapolitan Academy in 1861, studying under Gabriele Smargiassi and Giuseppe Mancinelli. Rebellious and anti-academic, he was expelled from the Academy in 1863 for "contempt." He subsequently met Adriano Cecioni and joined the School of Resina or the School of Portici (1863-67), derivative of the Florentine Macchiaioli; he began painting landscapes outdoors in the company of Federico Rossano and Marco De Gregorio. In 1864, he received critical recognition when he exhibited two landscapes at the *Promotrice Salvator Rosa* in Naples. Restless, De Nittis traveled to Florence, where the Macchiaioli were already established. Although he befriended T. Signorini (*q.v.*) there, De Nittis soon left to visit other Italian cities, eventually arriving in Paris in 1867.

In Paris, through the critic Diego Martelli (who was the only Italian closely acquainted with the future Impressionists), De Nittis became friends with Pissarro, Sisley and Degas. Although the War of 1870 forced him to repatriate, De Nittis returned to Paris in 1872, where he remained until his death, except for several trips to London after 1874, often with Signorini. De Nittis was very successful in Paris and, in 1874, exhibited at the First Impressionist Exhibition at the studio of the photographer Nadar. His approach to nature was similar to that of the Impressionists, but his technique and vision differed markedly. Many of the Impressionists were reluctant to include De Nittis in their first exhibition, since he also showed at the Salon and had a contract with Goupil, a dealer of the official artists. It was only through Degas' support that he was included. However, his alliance with the most revolutionary group in Paris was short-lived; De Nittis never exhibited with them after 1874.

De Nittis' style was far removed from the officially sanctioned French art. Even more than the Impressionists, he relied on principles of abstract design to order his compositions, like his friend Degas. He had also greatly admired Corot in his early period and, like Degas, had an interest in Japanese art. (Martelli had observed several oriental objects in De Nittis' Parisian house during a visit in 1878.) He was interested in contemporary life, but unlike the Impressionists, tended to focus more on the fashionable and elegant elements of society. Late in life, De Nittis mastered pastels and also executed watercolors, prints and etchings.

Villa Comunale, Naples, *Mostra di Giuseppe De Nittis e dei Pittori di Resina*, Naples, 1963.

Mary Pittaluga and Enrico Piceni, *De Nittis*, Milan, 1963.

Raffaello Causa, *Giuseppe De Nittis*, Bari, 1975.

87. Seated Male Figure 1870

Pen and China ink with wash on white board. 10 11/16 x 13 7/8 in. (271 x 353 mm.).

Signed and dated in black ink at lower right: *De Nittis 70*.

Provenance: Daria Guarnati, 1938.

Lent by the Civico Gabinetto dei Disegni, Castello Sforzesco, Milan, gift of Daria Guarnati in memory of Dr. A. Bertarelli, C 269-2358.

The 1870 date of this drawing places it in the artist's second Neapolitan period, when he was again influenced by the realistic tradition of Filippo Palizzi and Morelli (*q.v.*). It seems to represent an old shepherd reclining outdoors against a wall. The diagonal composition, in which the left half is occupied by a figure and the right serves as negative space, is characteristic of De Nittis' work during this period (see: Enrico Piceni and Mario Monteverdi, *I De Nittis di Barletta*, Barletta, 1971, pls. V, VII). In technique, it resembles many studies of peasants' heads by De Nittis, also dating from the early 1870's (see: *Ibid.*, 19-22). The manner in which the artist used his pen, as in the crosshatching, is similar to his print technique.

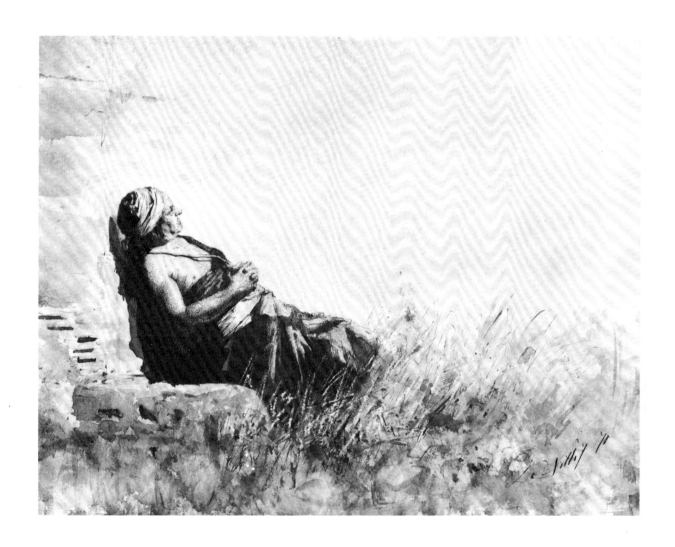

Luigi Serra (Bologna 1846–Bologna 1888)

After the death of his parents, Serra lived with his elder sister, beginning his studies at the Collegio Artistico Venturoli. He later studied with Puccinelli (*q.v.*) at the Academy of Bologna. In 1868, he won a stipend to continue his studies in Florence, where he became acquainted with the Macchiaioli at the Caffè Michelangiolo. Although he also worked outdoors, studying nature (like the Macchiaioli), he continued to produce historical and religious subjects. Above all, he remained temperamentally more inclined toward drawing than toward the individual facets of color favored by the Macchiaioli. Serra's drawings after works by fifteenth-century masters served to strengthen these graphic tendencies. The bold draftsmanship in his freer work also has certain affinities with the Post Impressionist/Symbolist styles which dominated continental art in the 1880's and 1890's. Like the Pre-Raphaelites, Serra was interested in the early Renaissance, although he was not inclined toward Romanticism. Rather, his analytical nature prompted a keen interest in the direct observation of nature.

Serra made several trips to Rome, where he executed prize-winning paintings and frequented the progressive society *In Arte Libertas*. In 1873, he traveled to Vienna and Munich and in 1875 to Venice, during which period he produced a series of rapidly executed works, including some watercolors. Serra, no doubt influenced by the Macchiaioli, finally became interested in contemporary subjects and places during the late 1870's and 1880's. His stress on detail and anecdote, however, contrasts with the sober, generalized prose of the Macchiaioli.

C. Ricci, *Disegni di Luigi Serra*, Rome, 1909.

Francesco Sapori, *Luigi Serra: Pittore Bolognese*, Bologna, 1922.

88. Cartoon for *The Church of San Carlo ai Catinari in Rome* 1884-85

Black chalk, pen and black ink with white heightening on ivory paper mounted on cardboard. 9¹/₁₆ x 25¾ in. (289 x 644 mm.). Paper discolored and some small spots.

Verso of mount: Label of the *Prima Esposizione Triennale*.

Bibliography: C. Ricci, *Disegni di Luigi Serra*, Rome, 1909, 35, pl. VII; Francesco Sapori, *Luigi Serra: Pittore Bolognese*, Bologna, 1922, 81, ill. 49; Galleria Nazionale d'Arte Moderna, Rome, *Aspetti dell'arte a Roma dal 1870 al 1914* (by Dario Durbé), Rome, 1972, 13, no. 87.

Provenance: Enrico Guizzardi; *Prima Esposizione Triennale*, Milan, 1891.

Lent by the Galleria Nazionale d'Arte Moderna, Rome, 1217.

This drawing is the meticulous cartoon for one of Serra's major works, *The Church of San Carlo ai Catinari in Rome* (1885) in the Galleria d'Arte Moderna, Florence (see: Sapori, *Luigi Serra*, pl. 179). The Galleria d'Arte Moderna in Rome has several of Serra's studies for individual figures in the painting, including the two in the center of the composition who are selling rosaries; the Pinacoteca Comunale in Bologna has two oil *bozzetti*. The intense, careful draftsmanship of the drawing produces a photographic effect, which is also created by the striking foreshortening and immediacy of the composition. Except for minor alterations and additions, the drawing is identical to the painting. The painting was commissioned from Serra by the gallery owner, Pisani. This cartoon was exhibited at the Italian Exhibition in London in 1888 and at several subsequent exhibitions (including the Serra retrospective at the Academy of San Luca in Rome in 1937).

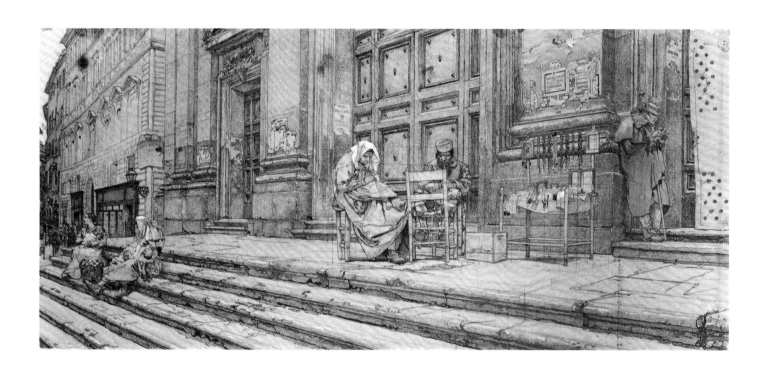

Giacomo Favretto (Venice 1849 – Venice 1887)

After apprenticing in his father's carpenter shop and working in a stationery store, where he copied religious prints, Favretto entered the academy of his native city (in 1864), studying under Michelangelo Grigoletti and Pompeo Marino Molmenti. Favretto soon won most of the prizes offered by the Academy and became an assistant to Jacopo d'Andrea at the Academy in 1877. Favretto studied the Venetian masters, such as Bellini, Carpaccio and Longhi, and became interested in the seventeenth-century Dutch painters, especially those specializing in interiors. He also was concerned with the color and light of the eighteenth-century Venetian School, which eventually led him to break with his academic training and official art. Two contemporary artists working in Venice interested Favretto: the Dutch artist, Remigius Van Haanen, and the Viennese artist, Ludwig Passini. In 1878, with his close friend Ciardi (*q.v.*), Favretto traveled to Paris. Despite his studies of light, Favretto was more interested in the work of Meissonier and Fortuny (*q.v.*) than that of the Impressionists.

Favretto is considered to be one of the foremost nineteenth-century painters of Venice, infusing new life into the art of that city. After 1880, however, the quality of his work tended toward common anecdotes of Venetian life. His decline may be attributed to the fact that he lost the sight of one eye in 1879. Favretto was one of the few painters to enjoy success in his own lifetime which, ironically, he achieved in the year of his death, at the age of thirty-eight.

Pompeo Molmenti, *Giacomo Favretto*, Rome, 1895.

Enrico Somaré, *Favretto*, Milan, 1935.

89. The Letter 1886

Black chalk on white paper, with a brown ink border. 5⅞ x 5⅝ in. (150 x 141 mm.).

Signed and dated in chalk at lower left: *G. Favretto 86*.

Bibliography: Gabinetto Nazionale delle Stampe, Rome, *Disegni dell'Ottocento* (by Enrichetta Beltrame-Quattrocchi), Rome, 1969, 71-72, no. 69, pl. 67.

Provenance: Filippo Palombi.

Lent by the Gabinetto Nazionale delle Stampe, Rome, F.N. 255.

Representations of a woman reading a letter were popular in art since the seventeenth century. This tiny drawing focuses on the subject in a most intimate manner, providing a close-up view of her upper torso and head, glimpsed through a window. The immediacy is heightened as one looks at the letter from an angle over the woman's shoulder. She has momentarily raised her finger to her chin in a pensive gesture, and the window shutter appears to have just been opened. The directness and humility of the scene is similar to the works of Rembrandt. It is characteristically Venetian in its intimacy, delicacy and attention to light.

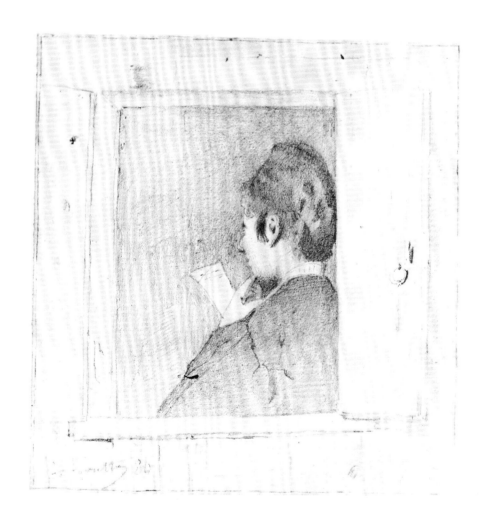

90. Sheet of Studies

Graphite with gouache on blue paper, with a section squared
for transfer. 10⅛ x 7⅛ in. (257 x 181 mm.).

Inscribed in graphite at lower right: *Favretto.*

Verso: Cellist in eighteenth-century costume.

Graphite, squared for transfer.

Provenance: Felice Pasquè, Milan, 1975.

Lent by a Private Collection, Columbia, South Carolina.

This drawing may be a preparatory study for one of Favretto's
later eighteenth-century costume pieces, because one side
of this double-faced sheet of assorted studies is completely
squared for transfer (another head on the recto is also squared).
The subject may have been a concert, for the drawing depicts a
flautist, a cellist and the heads of two women who appear to be
listening attentively. Favretto's technique is freer than in the
other sheet in the exhibition. The artist's naturalistic study of a
slightly withered leaf in gouache on the recto contrasts sharply
with the other costume studies.

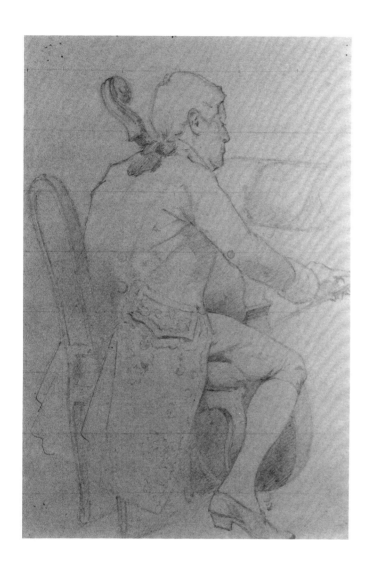

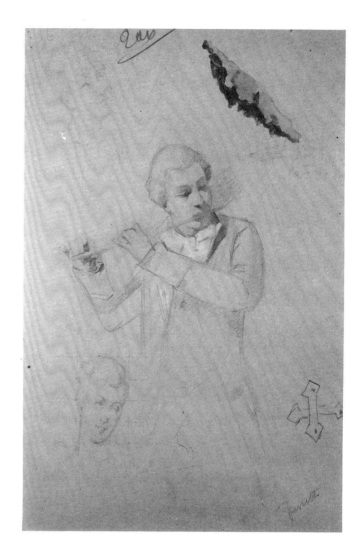

Segantini was born of Italian parents in a small Alpine village under Austrian rule. His mother died when he was five; his father subsequently abandoned the child to a poor half-sister in Milan. After a neglected childhood, which included running away to live in the country with peasants and over two years in a reformatory, Segantini entered the Brera Academy in 1876. Because of his rebellious nature and his outspoken opposition to academic principles, he was expelled before completing the curriculum. However, several of the professors had noticed his work, obviously influenced by the Scapigliatura group. Vittore Grubicy–propagandizer of Divisionism, impressario, art dealer, critic and artist–befriended Segantini and provided him with financial support. Segantini was then free to live independently in the country, tutored and affected by Grubicy's theories on art. He first lived in Brianza, near Como, from 1882-86, working on the peasant subjects of his "Millet period." Since Segantini had neither traveled to Rome and Florence nor to foreign cities, his mind was like a *tabula rasa* and he was greatly impressed by the collection of Millet (and Anton Mauve)

given to him by Grubicy and Grubicy's brother, Alberto. This period is characterized by the simplicity, sadness and solitude which is found in all his work. His paintings display more highly structured compositions and more monumental figures than those of Millet.

Obtaining his Italian citizenship papers in 1886, Segantini moved to Savognino in the Italian part of Switzerland, in order to live higher in the mountains. In Savognino, Segantini realized that his previous methods of rendering light and color were inadequate for the intensified natural appearance of these high altitudes. As a result, in 1886, he began to experiment more fully with a divisionist technique. (Incidentally, one year earlier, Seurat had completed *La Grand Jatte*. Although the Italian Divisionists had no contact with the Pointillists, and their aims were completely different, there were stylistic similarities.) Segantini participated in the exhibition organized by Grubicy in London in 1888. In 1891, he exhibited a drawing in the Belgian symbolist *Group des XX* exhibition, although he did not con-

(continued on page 218)

91. The Dead Hero

Pen and black ink on tracing paper mounted on cardboard. 15¾ x 11⁷/₁₆ in. (400 x 290 mm.).

Bibliography: Fortunato Bellonzi and Teresa Fiori, *Archivi del Divisionismo*, 2, Rome, 1968, 52, II.35, fig. 175; Francesco Arcangeli and Maria Cristina Gozzoli, *L'opera completa di Segantini*, Milan, 1973, 91, no. 34; Museum of Modern Art, Hyogo, Japan, *Giovanni Segantini* (by Annie-Paule Quinsac), Japan, 1978, 168, D.17, ill.

Provenance: C. Torelli, Milan, 1928; Felice Pasquè, Milan, 1975.

Lent by a Private Collection, Columbia, South Carolina.

This sheet is one of three extant drawings relating to a painting of the same title dated 1879-80 (see: Arcangeli and Gozzoli,

L'opera completa, 91, nos. 33, 35, 36). It was influenced by the extreme foreshortening of Mantegna's *Dead Christ* (c. 1456), which Segantini studied at the Pinacoteca di Brera. Despite the foreshortening, the face of the figure resembles Segantini (it is more clearly a self-portrait in the painting). Segantini seems to have been obsessed by this figure and continued to draw it throughout his life, although he eventually destroyed most of these drawings. All three extant drawings are thought to post-date the painting–the present drawing is usually dated c. 1880, while the other two date from a decade later. The use of tracing paper and the bold, angular line indicate that it may have been a reworking of an earlier drawing, a conclusion reinforced by the crisp lines of the body and the nature of the pen strokes in the face, which have the feeling of a print.

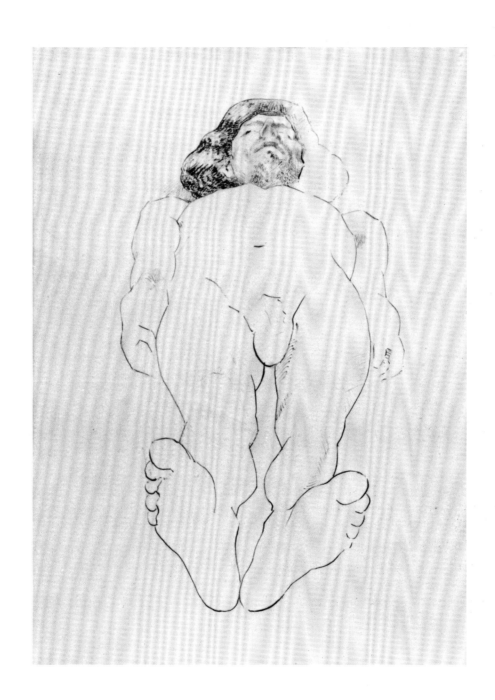

sciously ally himself with the Symbolist movement. Segantini created his most forceful works at Savognino. He remained there until 1894, when he moved to Maloja to be even higher up in the mountains, 6,000 feet above sea level. He lived there (until his early death) with his wife and children in a chalet, except for winters at Soglio. His style and sensibilities resemble those of Van Gogh, although it is unclear whether he knew the Dutch artist's work. Both adapted certain elements of Impressionism to their subjective visions, emphasizing pattern and flat surface with impasto strokes of paint.

Each of Segantini's geographic moves corresponds to a change in style. There are four periods then, beginning with realism and ending in a pantheistic symbolism. Like all of his work, the late fantastic allegories were painted outdoors, even in the snow. Segantini's rugged isolation seems to have accelerated his subjective, visionary tendencies and his personal, natural religious attitudes.

Even though Segantini received little formal education, nevertheless he read and wrote extensively (e.g. in *Cronaca d'Arte*, with Vittore Grubicy, and his own *Autobiografia, scritti, lettere, memorie*, Turin, 1910). And his works, while simple and tending toward abstraction, have literary and philosophical inclinations. He was a strong critic of the academies, declaring that an artist should pursue his education "in the fields, in the streets, in the theatres and in the cafés." He also was sympathetic to the socialists' hope for a new world order in which the artist would play a prominent role; however, like Gauguin and Baudelaire, he believed that the artist should serve as priest in the religion of art. Most people remember Segantini for his divisionist palette and unique style, though he himself regarded technique only as a means to convey his personal vision, not as an end-in-itself. He died of pigment poisoning while working on a series of three paintings dedicated to the theme of life.

Giorgio Nicodemi, *Giovanni Segantini*, Milan, 1956.

Francesco Arcangeli and Maria Cristina Gozzoli, *L'opera completa di Segantini*, Milan, 1973.

Museum of Modern Art, Hyogo, Japan, *Giovanni Segantini* (by Annie-Paule Quinsac), Japan, 1978.

92. The Washerwoman

Pastel on cardboard. 18½ x 12⅝ in. (470 x 320 mm.).

Signed at lower right: *Per la gentilissima Signora Luigia Archinti/G. Segantini.*

Bibliography: Giorgio Nicodemi, *La Raccolta Grassi, Comune di Milano*, Milan, 1962, 108, pl. 71; Fortunato Bellonzi and Teresa Fiori, *Archivi del Divisionismo*, 2, Rome, 1968, 80, III.220, fig. 321; Francesco Arcangeli and Maria Cristina Gozzoli, *L'opera completa di Segantini*, Milan, 1973, 109, no. 267, pl. XII.

Provenance: G. Pisa, Milan, 1935; Carlo Grassi.

Lent by the Civica Galleria d'arte moderna, Grassi Collection, Milan, 113.

The simple theme and composition of this pastel reveal Segantini's debt to Millet, as well as his socialist ideas. The work relates to a larger, unfinished oil painting (see: Arcangeli and Gozzoli, *L'opera completa*, 108, no. 266) of c. 1886-87. The structural simplicity of the landscape in both works corresponds to Segantini's Savognino period. The pastel postdates the painting and, as the inscription indicates, was presented to Signora Luigia Archinti. It is not a mere replica, but rather a reworking of the earlier, more freely painted work; Segantini has enlarged the washerwoman to make her more important. Moreover, instead of the flickering brushwork and the earthy palette of the painting, he has outlined the forms in black and has organized the composition in bold, blocky forms of bright, complementary colors. This second version of the subject is similar to the works of Gauguin and reveals the influence of Japanese prints on Segantini.

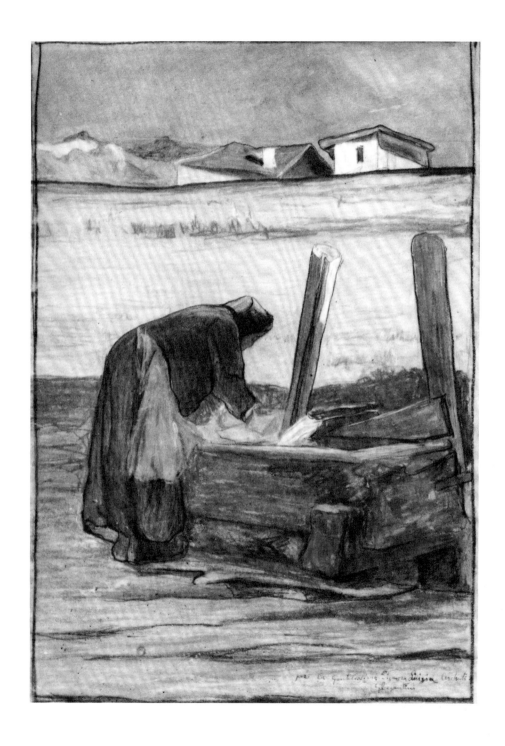

Giovanni Segantini

93. Self-Portrait 1890

Charcoal on white paper. 9 x 8 in. (230 x 205 mm.).

Monogrammed and dated in charcoal at lower right: ⊟/1890.

Bibliography: Fortunato Bellonzi and Teresa Fiori, *Archivi del Divisionismo,* 2, Rome, 1968, 81, II.267, fig. 328; Francesco Arcangeli and Maria Cristina Gozzoli, *L'opera completa di Segantini,* Milan, 1973, 112, no. 308, ill.

Provenance: F. Camesoni, 1913.

Lent by the Civica Galleria d'arte moderna, Milan, bequest of Camesoni, G.A.M. 1207.

There are around ten extant self-portraits by Segantini, all but two of which date after 1880. This drawing, dated 1890, is transitional and provides a link to his late symbolist self-portraits, which portray him as a prophet or seer – similar to the self-portraits of Sâr Joséphin Péladan, leader of the Rose+Croix in France. This work still retains vestiges of naturalism, such as the more concrete modeling of the heavy face and the light from a definite source at the left; yet the light already has a mystic, dematerialized quality. In contrast to his later frontal, more Byzantine self-portraits, Segantini has drawn his head slightly turned, with his eyes (while tending toward the hypnotic) focused on the viewer.

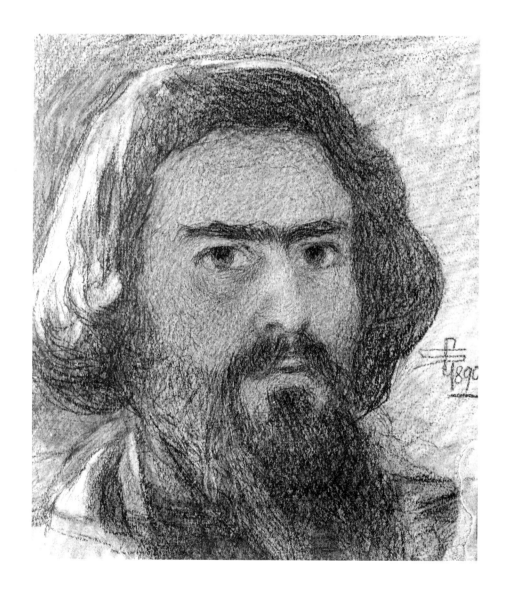

Carlo Randanini (Rome ? – Turin 1884)

Randanini was born in Rome, where he also studied. Since only three exhibition dates are recorded for him – 1881 in Milan, 1883 in Rome and 1884 in Turin – one is tempted to conclude that Randanini was a young artist in the early 1880's, thus placing his unknown birthdate in the fifties. He matured in the second half of the Ottocento, when the cultural *ambiente* was much influenced by the style of Fortuny (*q.v.*), who had arrived in Rome in 1858. Later, Randanini moved to Turin, where he enjoyed modest critical success as a genre painter, because his simple verism had a strong classical flavor, refreshing amidst the superficiality that characterized much of Turinese painting in the second half of the nineteenth century.

94. Head of a Young Girl in a *Ciociara* Costume

Opaque and transparent watercolor and black ink with traces of sanguine on white paper. 4½ x 4 in. (115 x 102 mm.).

Signed in black ink at lower right: *Randanini.*

Bibliography: Shepherd Gallery, New York, *Italian Nineteenth Century Drawings and Watercolors: An Album* (by Roberta J. M. Olson), New York, 1976, no. 29, pl. 52.

Provenance: Giovanni Piancastelli, Rome; Reverend Father Francis Agius, Inwood, Long Island; Shepherd Gallery, New York, 1976.

Lent by a Private Collection, New York.

This small watercolor of a young woman in a southern Italian headdress indicates why Randanini gained a reputation as a painter of genre subjects. The blinding effects of the Mediterranean sun on the face of the young peasant, together with the glint of the gold earring and the softness of her hair, are portrayed in an extremely realistic, nearly photographic manner. However, the artist avoids the sentimentality all too often present in the work of the late nineteenth-century Roman watercolorists. Randanini quickly painted extreme intensities of black and white, with few middle gradations, in a technique similar to that of John Singer Sargent. The squinting woman bears a strong resemblance to the noted model Rosa Lucaferni, who posed for other painters in Randanini's *ambiente* – e.g. Joris (*q.v.*) and Enrico Coleman (for her photograph, see: Augusto Jandolo, *Studi e Modelli di Via Margutta*, Milan, 1953, pl. L).

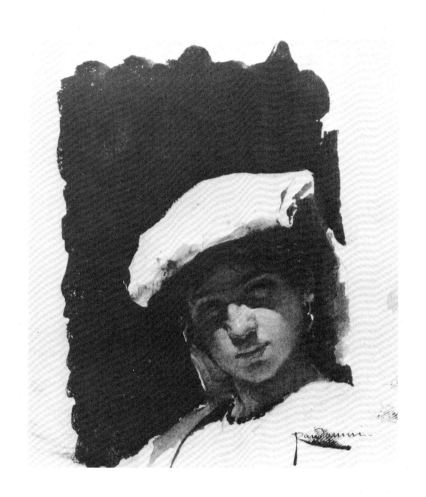

Francesco Paolo Michetti (Tocca di Casauria 1851 – Francavilla al Mare 1929)

Somewhat of a prodigy, Michetti began studying art in his native city and later, at seventeen, enrolled with a stipend in the Institute of Fine Arts in Naples. There, he took courses from Morelli (*q.v.*), Filippo Palizzi and Eduardo Dalbono. In his early years, he was oriented towards naturalism and, under the influence of Palizzi, painted many works of animals. Michetti also employed an impressionistic technique of applying paint with almost no pre-mixed pigments. Although he did not champion the theories of the French Impressionists, he was interested in luministic effects and spontaneous execution. His art is characterized by subjects drawn from everyday life, painted in fresh, blinding tonalities on an operatic scale.

In 1871, at twenty, Michetti's talent was noticed by the French dealer Reitlinger, brought to Naples by De Nittis (*q.v.*), who offered Michetti a contract. The Italian artist accepted, subsequently visiting Paris and exhibiting at the 1872 Salon. It was not until 1877, however, that Michetti's own city recognized his talent – when his *Procession of the Corpus Domini at Chieti* was exhibited.

During Fortuny's (*q.v.*) 1874 visit to Naples, he influenced Michetti towards an even more fluid technique. But by 1880, Michetti had discarded Fortuny's influence and turned to social realism and experiments with photography. He concentrated on religious themes and scenes concerning the peasants from the Abruzzi (as celebrated in a poem by Michetti's close friend, Gabriele D'Annunzio). Michetti attempted to portray them in a quasi-symbolist manner, painted in a realistic style. After 1900, he almost completely stopped painting. Isolated in the Abruzzi, he devoted the last twenty-five years of his life to experimenting with photography and making prints (see: Galleria Nazionale d'Arte Moderna, Rome, *Francesco Paolo Michetti entre pintura e fotografia* [by Marina Miraglia], Buenos Aires, 1977).

Tommaso Sillani, *Francesco Paolo Michetti*, Milan-Rome, 1932.

Alfredo Schettini, *Mostra del Centenario della nascita: Michetti e Dalbono*, Naples, 1952.

Mostra di Disegni, Incisioni e Pastelli di F. P. Michetti, Francavilla al Mare, 1966.

95. Self-Portrait (*Scherzo*) 1877

Pastel on dark brown paper. 18 x 11¼ in. (457 x 286 mm.).

Signed and dated in black chalk at lower right: *F. P. Michetti/ 1877- Napoli.*

Inscribed in black chalk at the left: *Scherzo.*

Verso: Fragment of a drapery study.

Black and white chalk.

Bibliography: Fogg Art Museum, Harvard University, Cambridge, *Drawings from the Daniels Collection*, Cambridge, 1968, no. 60, pl. 60.

Provenance: James Coats, New York, 1964.

Lent by Mr. David Daniels, New York.

This self-portrait depicts Michetti at the age of twenty-six, the year in which he first achieved public recognition in Naples. The immediacy and bravura pastel technique resemble other of his works dating from the late seventies and the early eighties, e.g. studies of his wife Annunziata (see: Maraglia, *Francesco Paolo Michetti entre pintura e fotografia*, pl. XX), many of which reflect the artist's use of his own photographs in place of live models. Michetti frequently transcribed images directly from photographs to his drawings and paintings. Interestingly, several photographs of his wife possess the same bold white background found in this self-portrait, which suggests that it may also derive from a photograph.

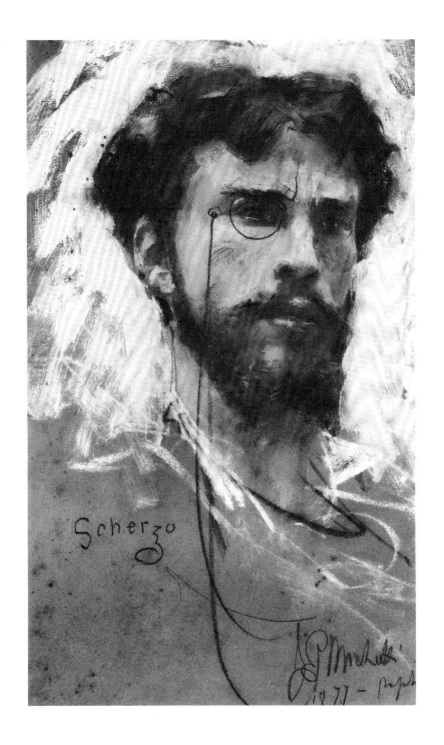

Scherzo

Antonio Mancini (Albano Laziale 1852 – Rome 1930)

At the age of twelve, the precocious Mancini entered the Institute of Fine Arts in Naples. He remained there for nine years, studying first under Filippo Palizzi and Morelli (q.v.). Like many Neapolitan artists of the period, Mancini was influenced by Fortuny (q.v.). He was also influenced by his friend, the sculptor Vincenzo Gemito, known for his expressionistic traits and genre subjects.

In 1872, the still impressionable Mancini, on the advice of Fortuny, traveled to Venice and Milan to study the sixteenth-century masters. In the same year, he exhibited two paintings at the Paris Salon. On his first trip to Paris in 1875, he met the Impressionists and painted for the art dealer, Goupil. Mancini's contact with the Impressionists pushed his art toward a more luminous, painterly style. After a brief visit to Naples, he returned to Paris where, together with Gemito, he worked for Mesdag, the Dutch dealer, collector and marine painter. His struggle to attain recognition, together with the cultural changes, seem to have eventually provoked a nervous breakdown (1877-79), from which he spent four years recuperating in Venice.

After he had regained his strength, Mancini traveled to Paris, London and the Hague, where he studied the seventeenth-century masters, especially Rembrandt and Hals, whose bravura styles have a great affinity with Mancini's own technique. In 1883, he settled permanently in Rome. By the late 1880's, his palette and technique had become experimental:

Mancini often added silver and gold paper, pieces of glass and sand to his thick impasto which, when viewed from a distance, produced vivid chromatic and exciting textural effects. These brilliant technical innovations overshadow any attempt at psychology or social commentary, and his works remain essentially visual showpieces.

In addition to many genre paintings, Mancini produced a great number of self-portraits. Like Fortuny, he had many imitators but no equal. In the early years of the twentieth century, Mancini traveled throughout northern Europe, sent by his patron, Otto Messinger, a German art dealer. (The Roman Marquis Giorgio Capranica del Grillo was another major patron.) In subsequent years, he painted extensively for English collectors and encountered Sargent, whose virtuoso style parallels that of Mancini. His fame grew in the twentieth century and, in 1929, he was nominated to the Italian Academy. Mancini's œuvre presents a paradox: although he pushed pigment beyond the abstract limits of the medium, he remained firmly rooted in the representational images of the nineteenth century.

Alfredo Schettini, *Vita di Antonio Mancini*, Naples, 1941.

Fortunato Bellonzi, *Verismo e tradizione in Antonio Mancini*, Rome, 1963.

Dario Cecchi, *Antonio Mancini*, Turin, 1966.

96. Portrait of a Violinist

Black and sanguine chalk on off-white paper. 22¾ x 16½ in. (578 x 419 mm.).

Signed in sanguine at lower right: *Antonio Mancini*.

Lent by Mr. James Dowell, New York/Dallas.

In this portrait, the artist was clearly more interested in the candid pose and the immediacy of his subject than in the features of the violinist. It is also apparent that Mancini was seated below the musician when he executed this drawing. The manner in which he rubbed the chalk and the bold calligraphy creates a sense of motion and intense concentration.

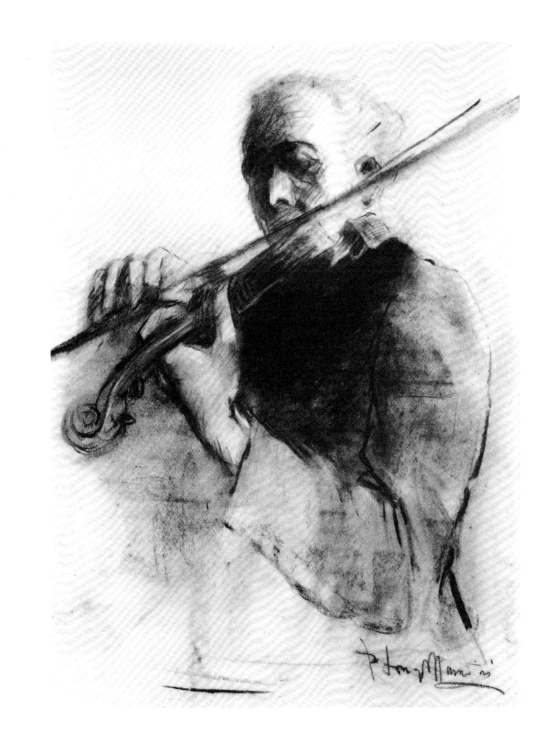

Antonio Mancini

97. Nude Woman Seated in an Interior

Pastel on brown paper. 15 x 14⅝ in. (381 x 372 mm.).

Provenance: Schweitzer Gallery, New York, 1971.

Lent by Mr. David Daniels, New York.

The firmly modeled body of this nude woman seems to be posed diagonally on a bed with a brass headboard, although the setting is obscured by the chaos of fluffy white material. She is ruffling the bedclothes, and may have broken open a feather pillow. The drawing reveals Mancini's taste for candid and spontaneous subject matter. He has employed pastels with great brio, which parallels the unorthodox and experimental techniques of his paintings during the 1880's.

Gaetano Previati (Ferrara 1852–Lavagna 1920)

Born into a pious, conservative family in the medieval (mystically oriented) town of Ferrara, Previati was naturally inclined toward the spiritual. At eighteen, he enrolled in the local academy and, in 1873, entered military service. In 1876, while in Florence, Previati studied with Cassioli (*q.v.*). The following year he took courses from Giuseppe Bertini at the Brera Academy in Milan, sharing a studio with Luigi Conconi. Influenced by his academic training, Previati initially painted historical subjects in a romantic/naturalistic style. Later, under the influence of Cremona (*q.v.*) and the Scapigliati, he developed a freer, more personal style characterized by dark impasto and dramatic light effects, probably derived from Baroque paintings of the seventeenth century. He also began painting overtly spiritual and visionary subjects and studied the works of Dante Gabriel Rossetti and the other Pre-Raphaelites. Moreover, Previati designed fourteen illustrations for the works of Edgar Allan Poe, a project that initiated him into Symbolism, already popular in countries north of the Alps. The art of Félicien Rops, Gustave Moreau and Redon influenced him, as well as the mystical literature of the contemporary symbolist writers, as can be seen in his 1891-96 illustrations for the 1900 Hoepli edition of *I Promessi Sposi* by Alessandro Manzoni.

About 1889, Previati met Vittore Grubicy, who served as a catalyst in Previati's adoption of a divisionist approach. (As with Segantini (*q.v.*), Grubicy's brother Alberto had a contract with Previati to sell the artist's work.) In 1891, his first divisionist painting, *Motherhood,* was exhibited at the Triennale at the Brera (later to become known as the official presentation of Divisionism and the first Italian Symbolist exhibition). The following year, through his associations with the Rose+Croix, Previati showed in Paris at an exhibition organized by Durand-Ruel.

Previati's style differed markedly from that of Segantini and the other Divisionists, although they all tended toward decorativeness. Previati's late, vibrant and mystical works, however, were most important for the Futurists, like Carlo Carrà and Umberto Boccioni, who themselves began in a divisionist idiom. Previati was also capable of more realistic paintings which he executed while on vacation with his family on the Ligurian Riviera at Lavagna.

An intellectual, Previati published three knowledgable books on the theory and technique of painting: *La Tecnica della Pittura* (1905); *I Principi Scientifici del Divisionismo* (1906); *Della Pittura, Tecnica e Arte* (1913) – as well as the posthumous *Lettere al fratello* (1946). Like Leon Battista Alberti, the Renaissance theoretician and architect, Previati believed that he was entering a new artistic age and should write treatises to guide artists.

Nino Barbantini, *Gaetano Previati,* Milan, 1919.

Vincenzo Costantini, *Gaetano Previati,* Rome, 1931.

Palazzo dei Diamanti, Ferrara, *Gaetano Previati* (by Fortunato Bellonzi), Ferrara, 1969.

98. Paolo and Francesca c. 1900

Charcoal with white heightening on grey paper. 18⅞ x 21⁷/₁₆ in. (479 x 544 mm.). Torn and mended at lower right.

Signed at lower right: *Previati.*

Verso inscribed in graphite: *Previati Paolo e Francesca/ Raccolta Stampe A. Bertarelli./ Castello Sforzesco/Milano/ GAB.DISEGNI.*

Bibliography: Fortunato Bellonzi and Teresa Fiori, *Archivi del Divisionismo,* 2, Rome, 1968, 182, III.504, fig. 892; Museum Boymans, Rotterdam, *Le Symbolisme en Europe* (by Phillipe Jullian and Luigi Carluccio), Paris, 1976, 166, no. 167, ill.

Provenance: Adele and Luisa Dalbesio, 1925.

Lent by the Civico Gabinetto dei Disegni, Castello Sforzesco, Milan, gift of Adele and Luisa Dalbesio, E 90-5365.

This large symbolist drawing serves to close the nineteenth century like a coda. It relates to a smaller but almost identical oil painting in the Galleria Civica d'Arte Moderna, Ferrara (see: Palazzo Reale, Milan, *Boccioni e il suo tempo,* Milan, 1973, 85, no. 79, ill.), exhibited at the Venice Biennale in 1901. Both works involve a reworking of a theme from the Renaissance which Previati had previously painted in his *Paolo and Francesca* of 1887 (see: Barbantini, *Gaetano Previati,* pl. 73) – exhibited at the Permanente in Milan. Previati chose different moments in Dante's story of Paolo and Francesca (*Inferno,* Canto V, 73ff) in each painting. In the 1887 version (which marks the artist's return to romantic Medieval themes), the death of the two adulterous lovers is illustrated. In the later, more spiritual drawing and painting, Previati portrayed their souls writhing together in the eternal darkness of the second circle of Hell. As with many symbolist works, this drawing is romantic and mystical. Previati used formal means – sinuous, curving lines and quasi-abstract forms – to accelerate the pathos of the theme. These elements establish whiplash rhythms which are close to Art Nouveau and also reveal why the Futurists Balla and Boccioni were influenced by Previati. His experience as an illustrator of romantic subjects, e.g. Poe and Manzoni's *I Promessi Sposi,* is evident in the drawing.

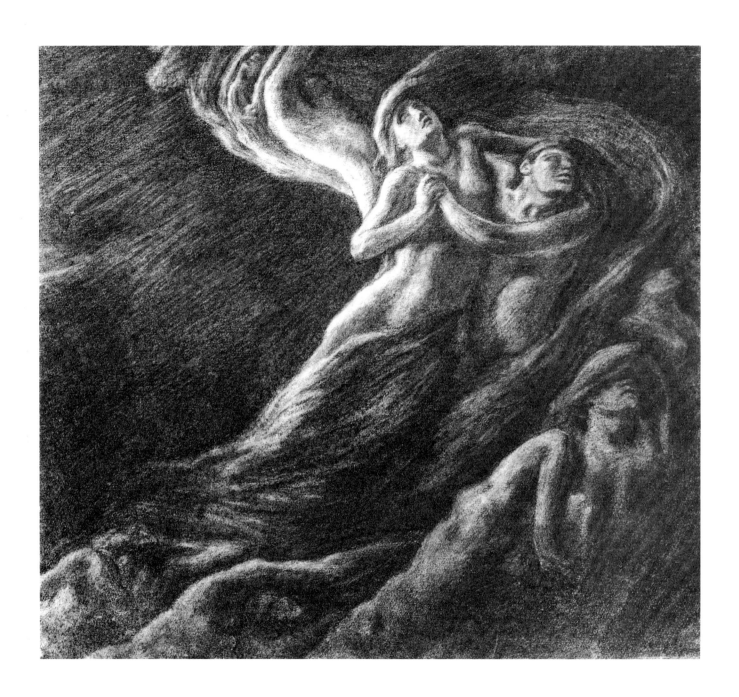

Giuseppe Signorini (Rome 1857–Rome 1932)

Signorini first studied at the Institute of Fine Arts in Rome, and then under Aurelio Tiratelli, who introduced him to many famous contemporary artists. Early, Signorini dedicated himself to the medium of watercolor, mastering it to the extent that, by the time he was eighteen, his work was sought by dealers in Italy, England and the United States. Although his first painting was exhibited in the *Mostra del Circolo Artistico* in Rome, he frequently won prizes at the Salons of Paris (1900, 1913). In fact, he lived in Paris for thirty-three years, where he became the director of the *Académie des Champs Elysées*. For more than ten years, his watercolors were handled by the American dealer Shilhaus in New York. His art consists of fashionable and exotic genre subjects rendered in a tour-de-force watercolor technique. (For photographs of Signorini's studio with its lavish accoutrements, see: Augusto Jandolo, *Studi e Modelli di Via Margutta*, Milan, 1953, pls. III, IV.)

99. Man Wearing a Turban Holding a Musket

Watercolor over graphite on off-white paper. 21⅛ x 14⅛ in. (536 x 358 mm.). Tears and lacunae along top and right edge; stained.

Signed in brown ink at lower right: *Signorini Giusep/Roma.*

Verso: Sketch of the same figure holding a musket.

Graphite with touches of watercolor.

Provenance: Frank Jewett Mather, Jr. (?).

Lent by The Art Museum, Princeton University, Princeton, gift of Frank Jewett Mather, Jr. (?), 68-195.

This unfinished drawing reveals Signorini's method of working, first sketching in the outlines of the figure, and then applying the watercolors of the model's drapery and headdress. The exotic subject matter is characteristic of Signorini and many other artists working in the late Ottocento.

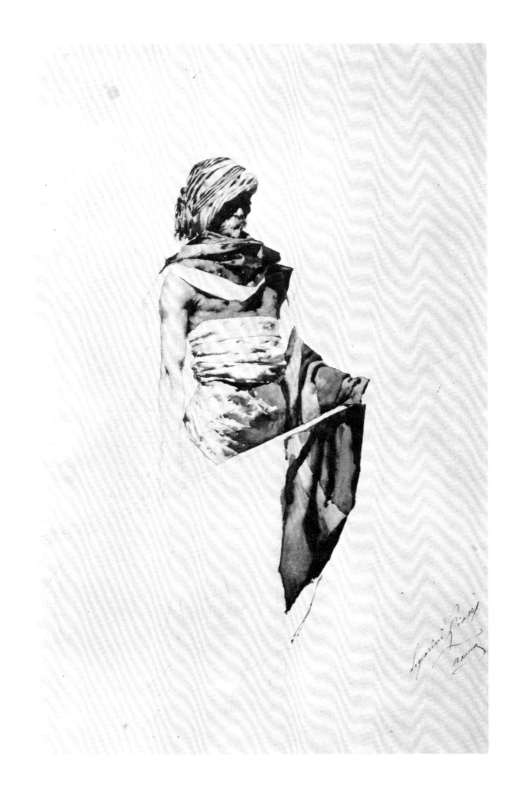

233

Giuseppe Signorini

100. Man in a Japanese Costume

Opaque and transparent watercolor over traces of graphite on off-white watercolor paper. 14⁹/₁₆ x 11¼ in. (370 x 286 mm.).

Signed in black ink at lower left: *Giusep. Signorini/Roma.*

Bibliography: Shepherd Gallery, New York, *Italian Nineteenth Century Drawings and Watercolors: An Album* (by Roberta J. M. Olson), New York, 1976, no. 41, pl. 55.

Provenance: Giovanni Piancastelli, Rome; Reverend Father Francis Agius, Inwood, Long Island; Shepherd Gallery, New York, 1976.

Lent by Mr. David Daniels, New York.

The subject of this watercolor is clearly the model's intricate, sumptuous silk robe. Signorini, who was interested in exotic subject matter, posed his model in order to show the complex design of the robe to best advantage. He has successfully used the medium to convey the shimmering quality of the silk.

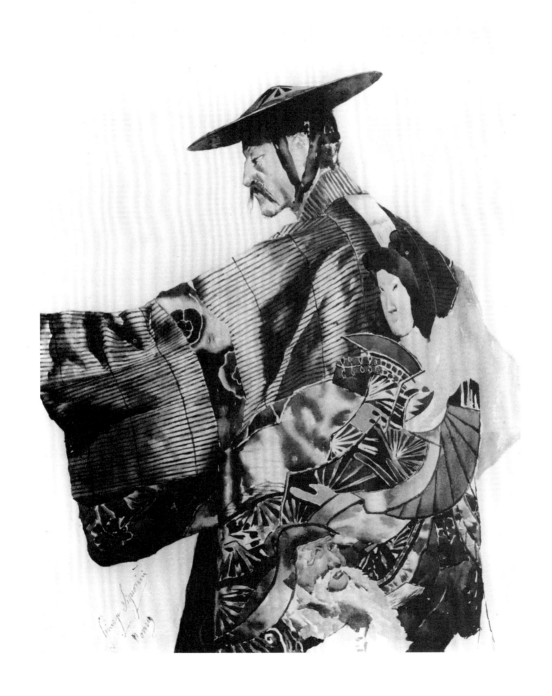

235

Oreste Silvestri (Pollone 1858–Milan 1936)

Silvestri first studied under his father, Carlo, a teacher at the Albertina Academy in Turin. Later, he studied at the Brera Academy in Milan, where he was one of Hayez' (*q.v.*) last pupils. Silvestri began to exhibit in Turin (1880) and Rome (1883). Despite his academic training, he eventually specialized in simplified pastoral landscapes and genre scenes, showing with Segantini (*q.v.*), Previati (*q.v.*) and other important Lombard artists at Grubicy's studio. In later years, he preferred engraving and became an accomplished printmaker. Silvestri also specialized in restoration—among his projects were rooms in the Castello Sforzesco and, significantly, the cleaning of Leonardo's *Last Supper,* which won Silvestri an appointment as its permanent conservator.

Oreste Silvestri, "Sei Relazioni sul Restauro di Illustri Pitture Seguite da Una Notizia Biografica," *L'Arte,* XVIII, LIII, 1953, 3-29.

101. Academic Male Nude

Charcoal on white paper. 19½ x 13 in. (496 x 330 mm.).

Lent by the Civico Gabinetto dei Disegni, Castello Sforzesco, Milan, D 508-6470.

There are other academic nudes by Silvestri in the collection of the Castello Sforzesco. Because Silvestri's mature interests tended toward landscape and restoration, this sheet probably dates from his student days in the academies, c. 1878.

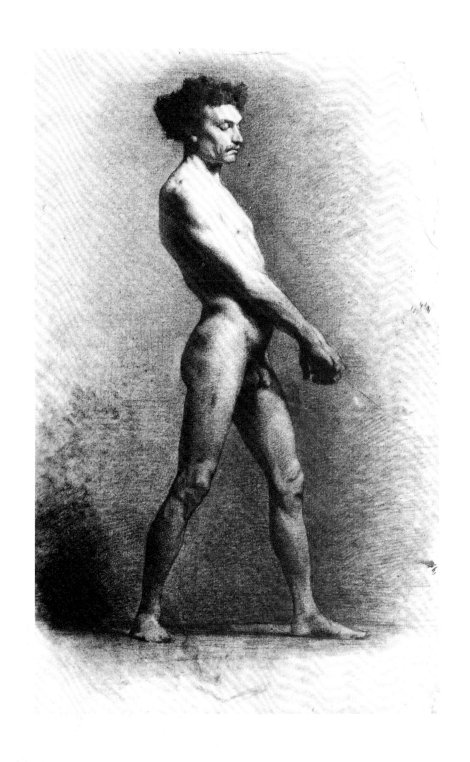

Giulio Aristide Sartorio (Rome 1860–Rome 1932)

Born into a family of Roman sculptors, Sartorio was first taught by his father, Raffaele, and his grandfather, Girolamo. In addition, he intermittently attended classes at the Academy, while also copying frescoes, mosaics and paintings of the Old Masters. At the age of seventeen, he began to paint under Fortuny's (q.v.) influence, producing pieces in an eighteenth-century mode. His juvenilia consists, therefore, mainly of facile works of fashionable subjects. Later, as a student in Paris, he studied under Gérôme, but did not adopt the French artist's almost photographically precise technique. Rather, he retained the more painterly style he had learned from Fortuny. Sartorio also came into contact with the work of Gustave Moreau, Dante Gabriel Rossetti and the other Pre-Raphaelites, as well as currents of the symbolist movement sweeping through western Europe. In 1882, he painted one of his most important works, *Malaria,* which was partially influenced by the style of his friend Michetti (q.v.). However, it suffered the fate of so many well-intentioned symbolist works: while it attempted to point up a serious social problem of the time, the theme was lost in an aesthetic, dream-like fantasy. At this time, Sartorio also produced studies of landscapes and animals in a vein similar to Filippo Palizzi. In these works, which are the antithesis of most of his other paintings, he achieved his most realistic statement. In 1883, he began to frequent the literary circles of Rome and joined the *Cronaca Bizantina* society; he also developed a significant friendship with Gabriele D'Annunzio, contributing illustrations to the writer's poem *Isotta Guttadauro* (1886). In 1889, he traveled to Paris with Michetti. In 1895, at the invitation of Grand Duke Carlo Alessandro, Sartorio departed for Weimar to teach for five years. His German period provided him with the opportunity to study the bizarre, unsettling works of Böcklin, Lenbach, Klinger and the German Symbolists. Interestingly, Sartorio also often visited the German philosopher, Nietzsche.

These influences encouraged Sartorio's inclination toward a suggestive, *fin de siècle* style—ambiguous and linear in its tendencies, a first faltering step toward the revolutionary movements of the next century. When Sartorio returned to Italy, he began to paint from nature, mainly the landscape of Lazio. Together with Raggio (q.v.) and Enrico Coleman, he founded the *Gruppo XXV della Campagna Romana.* In 1893, Sartorio became a member of Nino Costa's *In Arte Libertas,* the progressive international exhibition society. During the last decade of the century, Sartorio's contact with the Symbolists increased. Between 1895-98, he continued to collaborate with D'Annunzio, contributing to the important journal *Il Convito,* and published criticism, prose and poetry in numerous periodicals. He taught at the Academy of Fine Arts in Rome and fought in the First World War. His experiences in battle led to his illustrations of twenty-seven episodes of war, which reveal not only Sartorio's interest in photography, but also his abstract inclinations. He directed the restoration of the Villa Farnesina and, in 1929, was elected to the Italian Academy. Sartorio made the artistic transition into the twentieth century and worked on a film, "The Mystery of Galatea" (1918).

Shepherd Gallery, New York, *Giulio Aristide Sartorio,* New York, 1970.

Galleria Narciso, Turin, *Giulio Aristide Sartorio,* Turin, 1971.

Rome, *Mostra di G. A. Sartorio* (by P. Spadini), Rome, 1973.

102. Study for an Ex-libris of Gabriele D'Annunzio

Graphite with white heightening on off-white paper with a black border, mounted on cardboard. 11^{13}/16 x 11 in. (300 x 280 mm.). Paper discolored and some foxing.

Signed in graphite at lower right: *G.A. Sartorio.*

Bibliography: Regia Galleria Borghese, Rome, *Mostra delle Pitture di Giulio Aristide Sartorio,* Rome, 1933, 44, no. 16, pl. VII.

Lent by the Galleria Nazionale d'Arte Moderna, Rome, 1205.

The beginning of the friendship between Sartorio and Gabriele D'Annunzio, the symbolist poet and writer, in 1883 provides a *terminus post quem* for this drawing. Sartorio, who drew the inspiration for much of his œuvre from literature, illustrated several of D'Annunzio's works. The nudes are appropriate for D'Annunzio, whose *fin de siècle,* emotional writings celebrate erotic love and whose love affairs, like that with Eleonora Duse, were highly publicized. The standing figure in the drawing is a straightforward anatomical study, while Sartorio has exaggerated the curves of the reclining woman on the right. He has used both figures as decorative adjuncts to the blank white areas, intended to hold the lettering of the ex-libris: *Ex-libris Gabrielis Nuncii Porphyrogeniti.* The drawing has been dated c. 1890 (see: Regia Galleria Borghese, *Mostra delle Pitture di Giulio Aristide Sartorio,* 44) and contains poses similar to the sinuous contrapposto found in the figures of Sartorio's *Sons of Cain* (1885-88), which won a gold medal at the Paris Salon.

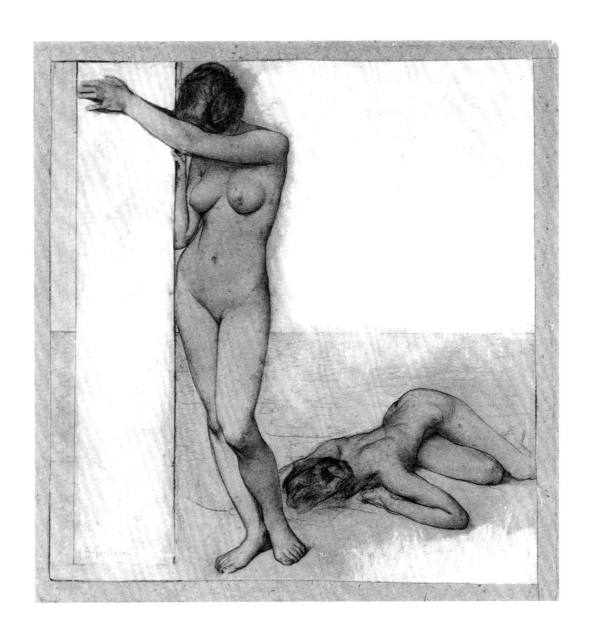

Selected Bibliography

Clarification of Bibliographical Citations in Text

Beltrame-Quattrocchi, *Disegni dell'Ottocento,* see: Rome, Gabinetto Nazionale delle Stampe.

Caramel and Pirovano, *Opere dell'Ottocento,* see: Milan, Galleria d'arte moderna.

Del Bravo, *Disegni Italiani del XIX Secolo,* see: Florence, Gabinetto Disegni e Stampe.

Del Bravo, *Ingres e Firenze,* see: Florence, Orsanmichele.

Durbé, *Aspetti dell'arte a Roma dal 1870 al 1914,* see: Rome, Galleria Nazionale d'Arte Moderna.

Durbé, *I Macchiaioli,* see: Florence, Forte di Belvedere.

Mazzi and Sisi, *Cultura dell'Ottocento a Pistoia,* see: Pistoia, Museo Civico.

Olson, *Italian Nineteenth Century Drawings and Watercolors,* see: New York, Shepherd Gallery.

The Royal Academy, *The Age of Neo-Classicism,* see: London, The Royal Academy.

Stanza del Borgo, *Eco Neoclassica,* see: Milan, Stanza del Borgo.

Susinno and Carloni, *Da Canova a De Carolis,* see: Rome, Galleria d'Arte Moderna.

Selected General Bibliography

(See the biographies of artists in this catalogue for monographs and articles on the individual artists.)

Andrews, Keith. *The Nazarenes.* Oxford, 1964.

Bacci, Baccio Maria. *L'800 dei Macchiaioli e Diego Martelli.* Florence, 1969.

Bargellini, Piero. *Caffè Michelangiolo.* Florence, 1944.

Becchetti, Piero. *Fotografi e Fotografia in Italia 1839-1880.* Rome, 1978.

Bellonzi, Fortunato and Fiori, Teresa. *Archivi del Divisionismo,* 2 vols. Rome, 1968.

Bellonzi, Fortunato. *Il Divisionismo nella Pittura Italiana.* Milan, 1967.

_____ . *La Pittura di Storia dell'Ottocento Italiana.* Milan, 1967.

_____ . *Socialismo e Romanticismo nell'Arte Moderna.* Rome, 1959.

Bergamo, Palazzo della Ragione. *Il Piccio e artisti bergamaschi del suo tempo.* Bergamo, 1974.

Bernardi, Marziano. *Ottocento Piemontese.* Turin, 1945.

Bolaffi, Giulio, ed. *Dizionario Enciclopedico Bolaffi dei Pittori e degli Incisori Italiani,* 11 vols. Turin, 1972–.

Bologna. *L'Arte del Settecento Emiliano.* Bologna, 1979 (in press).

Bologna, Palazzo Salina-Amorini. *Mostra di Pittori Emiliani dell'Ottocento.* Bologna, 1955.

Borghi, Mino. *Massimo d'Azeglio.* Milan, 1949.

Borgiotti, Mario. *Genio dei Macchiaioli,* 2 vols. Milan, 1964.

_____ . *I Macchiaioli.* Florence, 1946.

_____ and Cecchi, Emilio. *The "Macchiaioli." The First "Europeans" in Tuscany.* Florence, 1963.

Bramante, ed. *Storia della Pittura Italiana dell'Ottocento,* 3 vols. Milan, 1975.

Brescia, Palazzo della Loggia. *Pittori dell'800 Bresciano.* Brescia, 1956.

Brizio, Anna Maria. *Mostra della Scapigliatura.* Milan, 1966.

_____ . *Ottocento/Novecento.* Turin, 1939.

_____ and Dalai, Marisa Emiliani. *Pittura Italiana dell'Ottocento nella Raccolta Giacomo Jucker.* Milan, 1968.

Cannistraro, Alessio. *Pittura dell'Ottocento nelle Collezioni Private,* 2 vols. Florence, 1971.

Cappellini, Antonio. *La Pittura Genovese dell'Ottocento.* Genoa, 1938.

Carrà, Carlo. *Pittori Romantici Lombardi.* Rome, 1932.

Castelfranco, Giorgio. *Pittori Italiani del Secondo Ottocento.* Rome, 1952.

Causa, Raffaello. *Napoletani dell'800.* Naples, 1966.

_____ . *La Scuola di Posillipo.* Milan, 1967.

Cecchi, Emilio. *Pittura Italiana dell'Ottocento.* Milan, 1976.

_____ . *Pittori Italiani dell'Ottocento nella Raccolta di Enrico Checcucci,* 2 vols. Milan, 1929.

Chicago, The Art Institute of Chicago. *Painting in Italy in the Eighteenth Century.* By John Maxon and Joseph J. Rischel. Chicago, 1970.

Cleveland, The Cleveland Museum of Art. *Neo-Classicism: Style and Motif*. By Henry Hawley. Cleveland, 1964.

Columbia Museum of Art, Columbia, South Carolina. *Ottocento Painting in American Collections*. By Annie-Paule Quinsac. Columbia, 1973.

Comanducci, A. M., ed. *Dizionario Illustrato dei Pittori, Disegnatori e Incisori*, 5 vols. Milan, 1974.

Como, Villa Comunale dell'Olmo. *Pittori Lombardi del Secondo Ottocento*. Como, 1954.

Council of Europe, The Arts Council of Great Britain. *The Romantic Movement*. London, 1959.

De Grada, Raffaele. *I Macchiaioli*. Milan, 1967.

De Gubernatis, Angelo, ed. *Dizionario degli Artisti Italiani Viventi*. Florence, 1889.

De Logu, Giuseppe. *Pittura Italiana dell'Ottocento*. Bergamo, 1955.

Dini, Piero. *Diego Martelli*. Florence, 1978.

_____. *Lettere inedite dei Macchiaioli*. Florence, 1975.

Dragone, Angelo and Conti, Jolanda Dragone. *I Paesisti Piemontesi dell'Ottocento*. Turin, 1947.

Eitner, Lorenz. *Neoclassicism and Romanticism 1750-1850*, 2 vols. Englewood Cliffs, New Jersey, 1970.

Faenza. *Catalogo della Mostra degli Artisti Romagnoli dell'Ottocento*. Faenza, 1955.

Faenza, Palazzo Milzetti. *L'età neoclassica a Faenza 1780-1820*. By Anna Ottani Cavina et al. Bologna, 1978.

Florence, Biblioteca Marucelliana. *"Macchia" e Cultura a Firenze Intorno al 1860*. By Giancarlo Gentilini. Florence, 1976.

Florence, Forte di Belvedere. *Gli Alinari: Fotografi a Firenze 1852-1920*. By Wladimiro Settimelli and Filippo Zevi. Florence, 1977.

_____. *Aspetti della fotografia toscana dell'Ottocento*. By Fernando Tempesti. Florence, 1976.

_____. *I Macchiaioli*. By Dario Durbé. Florence, 1976.

Florence, Gabinetto Disegni e Stampe degli Uffizi. *Disegni del XIX Secolo*. By Carlo Del Bravo. Florence, 1971.

Florence, Galleria d'Arte Moderna. *Pittura Neoclassica e Romantica nella Toscana Granducale Sfortuna dell'Accademia*. By Sandra Pinto. Florence, 1972.

Florence, Galleria d'Arte Spinetti. *La Grande Stagione dei macchiaioli*. Florence, 1973.

Florence, Galleria Parronchi. *Momenti della Pittura Toscana dal neoclassicismo ai postmacchiaioli*. Florence, 1977.

Florence, La Meridiana di Palazzo Pitti. *Romanticismo Storico*. By Sandra Pinto. Florence, 1973.

Florence, Orsanmichele. *Ingres e Firenze*. By A. M. Maetzke and Carlo Del Bravo. Florence, 1968.

Florence, Palazzo Strozzi. *Macchiaioli e Naturalismo Europeo*. By Giuliano Matteucci. Florence, 1975.

_____. *Pittori Italiani dell'Ottocento*. By Marco Valsecchi. Florence, 1971.

Fortuna, Alberto Maria. *Il Gazzettino delle Arti del Disegno di Diego Martelli*. Florence, 1867.

Franchi, Anna. *I Macchiaioli Toscani*. Milan, 1945.

Franchi, Raffaello. *La pittura italiana dell'Ottocento al Novecento*. Palermo, 1929.

Galetti, Ugo and Camesasca, Ettore, eds. *Enciclopedia della pittura italiana*, 2 vols. Milan, 1952.

Gatti, Guglielmo. *Pittori Italiani dell'800 ad Oggi*. Rome, 1935(?).

Genoa, Galleria d'Arte Sant'Andrea. *Scuola Grigia Genovese*. Genoa, 1963.

Genoa, Palazzo Rosso. *Mostra di Pittori Liguri dell'Ottocento*. Genoa, 1938.

Girosi, F. *La Repubblica dei Portici*. Rome. 1931.

Gregori, Mina. "Il Conte Sommoriva e l'Appiani." *Paragone*, 273, 1975, 55-59.

Griseri, Andreina. *Il Paesaggio nella Pittura Piemontese dell'Ottocento*. Milan, 1967.

Guzzi, Virgilio. *Il Ritratto nella Pittura Italiana dell'Ottocento*. Milan, 1967.

Haskell, Francis. *An Italian patron of French neo-classic art*. Clarendon, 1972.

Hautmann, Carlo. *I Pittori Napoletani dell'800*. Florence, 1942.

Honour, Hugh. "The Italian Empire Style." *Apollo*, LXXX, 1964, 226-36.

_____. *Neo-Classicism*. Harmondsworth, 1968.

_____. *Romanticism*. New York, 1979.

Hubert, Gérard. *La Sculpture dans L'Italie Napoléonienne*. Paris, 1964.

_____. *Les Sculpteurs Italiens en France sous La Révolution, L'Empire et La Restauration 1790-1830*. Paris, 1964.

Iconografia Pittorica dell'Ottocento Italiano. Milan, 1940.

Lavagnino, Emilio. *L'Arte Moderna dai neoclassici ai contemporanei*. Turin, 1956.

Lecaldano, Paolo. *I Grandi Maestri della Pittura Italiana dell'Ottocento*, 3 vols. Milan, 1959.

Limoncelli, Mattia. *Napoli nella Pittura dell'Ottocento*. Naples, 1952.

London, The Royal Academy and The Victoria and Albert Museum. *The Age of Neo-Classicism*. London, 1972.

Luciani, Franco and Lidia. *Dizionario dei Pittori Italiani dell'800*. Florence, 1974.

Lugt, Frits. *Les Marques de Collections des Dessins e d'Estampes*. Amsterdam, 1921. Supplement, The Hague, 1956.

Maggiore, P. *Arte e Artisti dell'Ottocento Napoletano e Scuola di Posillipo*. Naples, 1955.

Mallé, Luigi. *La Pittura dell'Ottocento Piemontese*. Turin, 1976.

Maltese, Corrado. "L' Età Neoclassica in Lombardia." *Bollettino d'Arte*, XLIV, 1959, 285-89.

_____ . *Realismo e Verismo nella Pittura Italiana dell'Ottocento*. Milan, 1967.

Marchiori, G. *Scultura Italiana dell'Ottocento*. Milan, 1960.

Marconi, Paolo; Cipriani, Angelo and Valeriani, Enrico. *I Disegni di Architettura del Archivio Storico dell'Accademia di San Luca*, 2 vols. Rome, 1974.

Martinelli, Valentino. *Paesisti Romani dell'Ottocento*. Rome, 1963.

Milan, Accademia di Brera. *La Milano del primo Romanticismo*. By G. Ballo. Milan, 1969.

Milan, Biblioteca Nazionale Braidense. *Lettar mio, hai tu spasimato*. By Maria Cristina Gozzoli and Fernando Mazzocca. Milan, 1979.

Milan, Galleria d'arte moderna. *Andrea Appiani: Pittore di Napoleone*. By Mercedes Precerutti-Garberi. Milan, 1969.

_____ . *Opere dell'Ottocento*, 3 vols. By Luciano Caramel and Carlo Pirovano. Milan, 1975.

Milan, Stanza del Borgo. *Eco Neoclassica*. Milan, 1973.

Monteverdi, Mario. *Storia della pittura italiana dell'ottocento*, 3 vols. Milan, 1975.

Napier, Francis. *Pittura Napoletana dell'Ottocento*. Naples, n.d.

Naples, Palazzo Reale. *La Collezione Angelo Astarito al Museo di Capodimonte: Giacinto Gigante e La Scuola di Posillipo*. By N. Spinosa. Naples, 1972.

New Haven, Yale Center for British Art. *The Fuseli Circle in Rome: Early Romantic Art of the 1770's*. By Nancy L. Pressly. New Haven, 1979.

New York, The Metropolitan Museum of Art. *Drawings from New York Collections*. Vol. III: *The Eighteenth Century in Italy*. By Jacob Bean and Felice Stampfle. New York, 1971.

New York, Shepherd Gallery. *Italian Nineteenth Century Drawings and Watercolors: An Album*. By Roberta J. M. Olson. New York, 1976.

New York, Wildenstein and Co., Inc. *Exhibition of Italian XIX Century Paintings*. By Enrico Somaré. New York, 1949.

Nicodemi, Giorgio. *La Pittura Milanese Dell'Età Neoclassica*. Milan, 1915.

Ottino della Chiesa, Angela. *Il Neoclassicismo nella Pittura Italiana*. Milan, 1967.

Pagani, Severino. *La Pittura Lombarda della Scapigliatura*. Milan, 1955.

Paris, The Grand Palais. *I Macchiaioli: Peintres en Toscane Après 1850*. By Dario Durbé. Paris, 1978.

Paris, The Grand Palais; The Detroit Institute of Arts and The Metropolitan Museum of Art. *French Painting 1774-1830: The Age of Revolution*. Detroit, 1975.

Pavia, Castello Visconteo. *T. Cremona e gli Artisti Lombardi del Suo Tempo*. Milan, 1938.

Pavia, Galleria Gavazzi. *Disegni Italiani del Secondo Ottocento*. Pavia, 1977.

Perocco, Guido. *La Pittura Veneta Dell'Ottocento*. Milan, 1967.

Pevsner, Nicholas. *Academies of Art*. Cambridge, 1940.

Philadelphia, The Museum of Art; The Detroit Institute of Arts and The Grand Palais. *The Second Empire 1852-1870: Art in France Under Napoleon III*. Philadelphia, 1978.

Piceni, Enrico and Monteverdi, Mario. *Pittura Lombarda dell'Ottocento*. Milan, 1969.

Pinto, Sandra. "La linea 'positiva' della cultura dei macchiaioli." *Annali della Scuola Normale Superiore di Pisa*, V, 4, 1975, 1511-35.

Pistoia, Museo Civico. *Cultura dell'Ottocento a Pistoia*. By Cecilia Mazzi and Carlo Sisi. Florence, 1977.

Pordenone, AA. VV. *Michelangelo Grigoletti e il suo tempo*. By Giulio Carlo Argan, Giuseppe Maria Pilo, et al. Pordenone, 1971.

Praz, Mario. *On Neoclassicism*. London, 1969.

Predaval, Gustavo. *Pittura Lombarda dal Romanticismo alla Scapigliatura*. Milan, 1967.

Purificato, Domenico. *La Pittura nell'Ottocento Italiano*. Rome, 1959.

Quinsac, Annie-Paule. *La Peinture Divisionniste Italienne*. Paris, 1972.

Reggio Emilia, Casa Patrizie Reggiane. *Mostra delle Pitture Murali dell'800*. Reggio Emilia, 1959.

Rome, Gabinetto Nazionale delle Stampe. *Disegni dell'Ottocento*. By Enrichetta Beltrame-Quattrocchi. Rome, 1969.

Rome, Galleria Nazionale d'Arte Moderna. *Aspetti dell'arte a Roma dal 1870 al 1915*. By Dario Durbé. Rome, 1972.

_____ . *I Macchiaioli*. By Giovanni Carandente and Palma Bucarelli. Venice, 1956.

_____ . *La Pittura Storica e Letteraria dell'800 Italiano*. By

Stefano Susinno. Rome, 1976.

————. *Da Canova a De Carolis.* By Stefano Susinno and Livia Carloni. Rome, 1978.

Rome, Salone dell'Antiquariato. *Costume di Roma 800.* By Maurizio Fagiolo and Maurizio Marini. Rome, 1978.

Rosenblum, Robert. *Transformations in Late Eighteenth Century Art.* Princeton, 1967.

Russo, Ettore. *Pittori dell'Ottocento a Napoli.* Florence, n.d.

Schettini, Alfredo. *La Pittura Napoletana dell'Ottocento nella Col lezione Morra in Palermo.* Florence, n.d.

————. *La Pittura Napoletana dell'Ottocento,* 2 vols. Naples, 1967.

Somaré, Enrico. *La Pittura Italiana dell'Ottocento.* Novara, 1944.

————. *Storia dei Pittori Italiani dell'Ottocento,* 2 vols. Milan, 1928.

Sorrento, Museo Correale di Terranova. *Vedute dell'Italia Meridionale Nei Disegni dell'800 Napoletano.* By Luigi Buccino and Rubina Cariello. Naples, 1971.

Storrs, The William Benton Museum of Art, Storrs, Connecticut. *Rome in the Eighteenth Century: The Academy of Europe.* By Frederick den Broeder. n.p., 1973.

Valsecchi, Marco. *Pittori Italiani dell'800.* Milan, 1954.

Vaughn, William. *Romantic Art.* New York, 1978.

Venice, Museo Correr. *Venezia nell'età di Canova.* By Elena Bassi et al. Venice, 1978.

Venice, Sala Napoleonica. *Mostra di Pittori Veneziani dell'Ottocento.* By Guido Perocco. Venice, 1962.

Vitali, Lamberto. *Lettere dei Macchiaioli.* Turin, 1953.

Wackernagel, Martin von. "Die Italienische Maleri Im 19 Jahrhundert." *Studien zur Deutsch-Italienischer Geistes Geschichte,* 3. Cologne, 1959.

Willard, Ashton Rollins. *History of Modern Italian Art.* London, 1900.

Wunder, Richard P. *Extravagant Drawings of the Eighteenth Century.* New York, 1962.

Photograph Credits

All photographs, with the exception of those listed below by page number, have been provided by the lenders to the exhibition. We gratefully acknowledge their cooperation.

Bruce C. Jones, Centerport, New York, 169.

Otto E. Nelson, New York, 61, 93, 97, 109, 111, 113, 133, 203, 227, 229, 235.

Taylor & Dull, Inc., New York, 101.

Index

THE AMERICAN FEDERATION OF ARTS

BOARD OF TRUSTEES

OFFICERS

Arthur D. Emil
 President
Irvin L. Levy
 Vice President
Dr. Evan H. Turner
 Vice President
John W. Straus
 Vice President
Frederick R. Mayer
 Vice President
Mrs. Brooke Blake
 Secretary
Mrs. Carroll L. Cartwright
 Treasurer

HONORARY TRUSTEES

Mrs. Jacob M. Kaplan
 President Emerita
Roy R. Neuberger
 President Emeritus
Lloyd Goodrich
 Honorary Vice President
John Walker

TRUSTEES

Mrs. James W. Alsdorf
Thomas N. Armstrong, III
Charles Benton
Robert I. Blaich
Mrs. Brooke Blake
Miss Jean Sutherland Boggs
Francis E. Brennan
J. Carter Brown
Mrs. Carroll L. Cartwright
George M. Cheston
Ralph T. Coe
Arthur Q. Davis
Mrs. Kenneth N. Dayton
Philippe de Montebello
Edward R. Downe, Jr.
Professor David C. Driskell
Arthur D. Emil
Bayard Ewing
Martin L. Friedman
Mrs. Julian Ganz, Jr.
Wilder Green
Allen Grover
Lee Hills
Gilbert H. Kinney
David Kruidenier
Dr. Thomas W. Leavitt

Irvin L. Levy
William S. Lieberman
Kynaston L. McShine
Frederick R. Mayer
A. Hyatt Mayor
Thomas N. Maytham
Mrs. John W. O'Boyle
Stephen D. Paine
Harry S. Parker, III
William D. Paul, Jr.
William S. Picher
David A. Prager
Mrs. Joseph Pulitzer, Jr.
Daniel Robbins
Mrs. Judith Rothschild
David M. Solinger
Morton I. Sosland
Mrs. Otto L. Spaeth
Theodore Ellis Stebbins, Jr.
John W. Straus
Dr. Evan H. Turner
Mrs. George W. Ullman
Willard Van Dyke
Mrs. Paul L. Wattis
Ian McKibbin White
Mrs. Katherine C. White
Mrs. Bagley Wright
Leonard C. Yaseen